OCEAN

OCEAN

Exploring the
Marine World

Phaidon Press Limited
2 Cooperage Yard
London E15 2QR

Phaidon Press Inc.
65 Bleecker Street
New York, NY 10012

phaidon.com

First published 2022
© 2022 Phaidon Press Limited

ISBN 978 1 83866 478 7

A CIP catalogue record for this book is available from
the British Library and the Library of Congress.

Commissioning Editor: Victoria Clarke
Project Editor: Lynne Ciccaglione
Production Controller: Lily Rodgers
Design: Hans Stofregen
Layout: Cantina

Printed in China

Arrangement
The illustrations in this book have been arranged in pairs
to highlight interesting comparisons and contrasts based
loosely on their subject, age, purpose, origin or appearance.
This organizational system is not definitive and many
other arrangements would have been possible. A chrono-
logical survey can be found in the timeline at the back.

Dimensions
The dimensions of works are listed by height then width.
Digital images have variable dimensions. Where differences
in dimensions exist between sources, measurements listed
refer to the illustrated version.

The World Ocean

The Undiscovered Ocean

The ocean, vast, deep and diverse, is the heart and lung of our planet. Most of us have heard the statistics: the ocean covers more space on our planet than solid earth – 71 per cent of the planet is water and 96.5 per cent of this water is from the ocean. Yet we refer to our home as Earth instead of Ocean. Just imagine if it were called Ocean – wouldn't we all commit more to its protection? Wouldn't we all seek to know more about it? The ocean is a place of nostalgia and a place of romantic utopia, yet it is still terra incognita with less than 5 per cent of the ocean having been explored today.

We should also bear in mind that there is only *one* world ocean, consisting of several interconnected ocean basins and seas. The northernmost ocean is the Arctic, which is also the smallest, shallowest and coldest of them all. It is the connector between Greenland, Denmark, Iceland, Norway, Finland, Russia, Canada and the United States. The Atlantic, which is divided into the North and the South Atlantic, connects the continents of North, Central and South America with Europe and Africa. The Pacific, which is the largest and deepest ocean, links Asia with Oceania and the western seaboard of the American continent. The Indian Ocean lies between Africa, the Arabian Peninsula, India, Asia and Australia. It is the warmest of all ocean basins and so has less marine life due to the lack of plankton, the tiny organisms that are a crucial food source. Last but not least, the Southern Ocean, also called the Antarctic Ocean, stretches between the Pacific, the Atlantic and the Indian Ocean with the Antarctic Circumpolar Current flowing eastwards and circling around it.

In addition to the five named oceans, there are dozens of seas, which are found closer to land and are smaller than the ocean basins, located worldwide from the Wadden to the Weddell Sea, from the Mediterranean to the Caribbean Sea.

The ocean is also so much more than merely what is visible on the surface, whether calm and peaceful or wild with waves. The shore and coastlines, which are often either paradisiacal places for human leisure or places of commerce, also speak to cultural imprints on the land or are simply not reachable. There are coastal zones with rich biodiversity and unique phenomena like the tidal zone of the Wadden Sea in the North Sea (see p.312) or lagoons created by winds and river deltas where fresh- and saltwater merge in the Arctic Ocean (see p.249).

As you venture out deeper, the upper ocean, or epipelagic zone, reaches down to about 200 metres (655 ft). The waters in this region still offer light for plankton and algae to grow and provide enough food for whales, sharks, tuna, jellyfish and many others.

From 200 metres to 1,000 metres (655–3,280 ft) deep, we enter the mesopelagic zone, also called the twilight zone. There is still light but not enough for photosynthesis. Nevertheless, there are animals such as jellyfish and other fish, which feed from sunken biomass produced in the photosynthetic zone above (see p.145).

And then there is the deep sea, the least known part of the ocean, where fish and other animals as well as plants survive despite the lack of light (see p.100). The bathypelagic zone from 1,000 metres to 4,000 metres (3,3280–13,120 ft) is dark and cold, but still there is life. Squids, sharks and whales are just some of the creatures that can be found there.

From 4,000 to 6,000 metres (13,120–19,685 ft) deep we enter the abyss, with temperatures near freezing and high hydrostatic pressure. Yet marine life still abounds – as it also does in the next zone, the hadal zone, from 6,000 metres to 11,000 metres (19,685–36,000 ft). This section includes the deep seabed, where you still find sea cucumbers, crustaceans, worms, anemones and other organisms. The deepest place on Earth, the Mariana Trench, is located in the hadal zone, reaching 11,034 metres (36,200 ft) below the surface – a place totally inhospitable to humans and only accessible by specialized research vessels (see p.81).

Throughout the centuries, the ocean from surface to seabed has been a symbol of infinity, beauty, solitude, isolation, danger, happiness, weightlessness and longing in literature, music, art and philosophy. In the pages that follow, this book gives a broad overview of these contexts and provides insight into the ocean, spanning from the Eocene period around 55 million years ago through to the twenty-first century. While many works show a beautiful and awe-inspiring ocean, we are aware that today our beloved ocean is in trouble as a result of human activities since the time of the Industrial Revolution – a drama that many artists have captured in their works through photography, sculpture, film and performance.

Esther Horvath (see p.39), a Hungarian-German photographer who has accompanied the expeditions of the Alfred Wegener Institute to the Arctic and Antarctic in recent years, is capturing both moments of nostalgia and new scientific discoveries. In 2022 she was part of the Endurance22 expedition that located Ernest Shackleton's ship more than a hundred years after it was lost beneath the ice of the Weddell Sea (see p.38).

Ocean researchers and activists such as Sylvia Earle (see p.77) advocate for the ocean and highlight its fragility. In 2021 the Intergovernmental Oceanographic Commission of UNESCO launched the United Nations Decade of Ocean Science for Sustainable Development (2021–2030) in an effort to turn around the damage already done and to find solutions for the ocean's protection, not only through science and politics but also through social, cultural and educational activities. Marine sciences bring clarity to what exists and what is in danger in our oceans, and also help identify damage. Technical research and corporations are pivotal for finding solutions for that damage, while policymakers and judicial entities are expected to put into

place laws and protection acts. But civil society is also crucial to bringing the necessary day-to-day changes that will ultimately prevent further harm.

Consider how humankind and its survival are largely dependent on the ocean:

We eat: The ocean is the largest ecosystem on planet Earth. It provides food to 3.5 billion people.

We exist: The ocean is a climate regulator and the biggest carbon sink.

We breathe: The ocean produces more than half of the oxygen on Earth.

We move: Around 90 per cent of global trade is handled through ocean shipping.

We are connected: Geographically, humankind globally is interconnected through the ocean.

We heal: More than twenty thousand new biochemical substances have been extracted from marine flora and fauna over the last three decades for pharmaceutical use.

In the words of French poet Charles Baudelaire in his famous work 'The Man and the Sea' (1857):

Free man! the sea is to thee ever dear!
The sea is thy mirror, thou regardest thy soul
In its mighteous waves that unendingly roll,
And thy spirit is yet not a chasm less drear.

Through a collection of diverse and thought-provoking works, this book invites the reader to reflect on the treasures and the power of the ocean, on how much we are dependent upon it and on how much we can contribute to better protect the ocean in the future – not only our immediate future but also the future of the generations to come.

You will be guided through the history of the ocean, with important cultural facts about the regions represented by some of the included works, dive into recent scientific discoveries, and be taken on a journey into the nostalgic and symbolic ocean. The book combines the past with the present and the future, not simply because the climate emergency has made the ocean a more pertinent subject but also because it is equally important to look at past and present scientific findings that could, with contributions from our whole society, lead to an improved protection and future for the ocean.

The Curated Book

In order to make the content accessible and allow the reader to easily dive in at any point, the book has been structured as a curated sequence of images in which a dialogue is created between the two works on facing pages – whether they depict a common theme or underline different approaches to particular topics, sometimes even across centuries.

The approach allows the reader to easily comprehend the enormity of the ocean and its relationship with Earth as a whole, for example by looking at Bartholomew the Englishman's fifteenth-century illuminated manuscript opposite a NASA satellite image of the world taken in 1994 (see pp.42–43). The pairing of the *Map of the Distribution of Marine Life* by Edward Forbes and Alexander Keith Johnston and the depth chart of the North Atlantic by Matthew Maury, both created in 1854, gains additional meaning from the knowledge that Forbes and Johnston's attempt to map sea life was eventually proved wrong (see pp.108–9). Meanwhile, the images of Tan Zi Xi's installation *Plastic Ocean* and Daniel Beltrà's photograph of the 2010 Deepwater Horizon oil spill in the Gulf of Mexico show the extent of ocean pollution caused by fossil fuel products (see pp.154–55).

Contrary to popular histories, early diving advances were not only achieved by men but also by women, as can be seen in the juxtaposition of French biologist and underwater photography pioneer Louis Boutan and Sylvia Earle, the groundbreaking diver, marine biologist and oceanographer (see pp.76–77). The image of renowned French explorer and filmmaker Jacques Cousteau together with the underwater wreck of the *Titanic* make us reflect on the fact that the traces humans leave in the ocean, like shipwrecks, can sometimes be repopulated by marine life in a way reminiscent of an 'original' coral reef (see pp.78–79).

And even in works with seemingly disparate subjects, a deeper commonality can be found. Audun Rikardsen's image of an orca in the arctic Norwegian fjords might seem at odds with David Doubilet's of a coral reef in Kimbe Bay, Papua New Guinea, but, in fact, both photographers are deeply committed to using their work to further ocean conservation efforts (see pp. 16–17).

Looking beyond the individual works and instead considering the pairings in conversation together will open up better access to all the ocean has to offer.

Ocean Narratives: Past and Present

Over the past millennia, the ocean has enabled commercial and cultural connections, both beneficial and detrimental, to be established between the continents. The ocean has always been an important resource for humankind, as a source of food, oil and minerals, as well as tourism, transportation and migration.

But today science has provided us with even more proof of the ocean's importance. We now know that 50 to 80 per cent of the oxygen on Earth is produced by the ocean, which means that we wouldn't be able to breathe without an intact ocean. We also have learned that the ocean, particularly the deep sea, is the most important carbon sink on our planet, absorbing excess carbon dioxide (CO_2) that is mainly produced by human activities.

Despite this knowledge, many people only view the ocean as a means to an end rather than as a resource that needs to be respected and protected. Mass tourism not only moves millions of tourists across the ocean with yachts, cruise ships, Jet Skis and other vehicles for entertainment but also brings them underwater through dive expeditions to coral reefs and other endangered habitats. Efforts to feed the world have caused overfishing, resulting in pressure to fish populations and endangering other sea animals due to bycatch, fishnets and plastic pollution. Deep seabed mining has become a huge challenge for the ocean as well. Mining companies that want to obtain rare minerals on the seafloor, such as copper, nickel, gold, phosphorus, silver, europium and zinc (mainly for all sorts of electronics, including mobile phones), oversimplify the ocean bed in their marketing materials to make it seem as though the seabed is a flat desert where no life exists – even though today we know that the ocean floor is a rich, mountainous habitat (see p.83) with many creatures populating the deep dark. And new discoveries are still being made: in February 2021 the Alfred Wegener Institute found the largest fish-breeding area ever known, with around sixty million icefish (*Neopagetopsis ionah*) at the time of observation on the seabed in the south of the Antarctic Weddell Sea.

How can we give back to the ocean without using and exploiting it constantly? First, we have to understand it.

Oceanographic knowledge was already well established before marine sciences were invented and modern explorers photographed marine life. Before the common era, European depictions of the ocean were primarily in the form of mythological narratives but also depicted marine life – such as the lively assemblage of fish, crustaceans and an octopus in a remarkably preserved mosaic from Pompeii (see p.232). Today we also know of pre-Columbian works that offer rich illustrations of marine creatures such as the horseshoe crab (see p.202), which is now an endangered species. Meanwhile medieval illuminated manuscripts (see p.42) and cartography reveal how much was already known about marine geography. One of the famous cosmographers of the time, Sebastian Münster, included a 'catalogue of beasts' in his renowned publication *Cosmographia* in 1544

that contained a record of existing marine animals as well as more fantastical sea creatures (see p.196).

The quest to understand the world around us was a significant impetus for the exploration of the unknown territories. Early nature explorers crossed oceans in search of new knowledge, such as Swiss naturalist and illustrator Maria Sibylla Merian, who in 1699 was the first woman to travel independently from Europe across the Atlantic to South America on a scientific expedition. A century later, Alexander von Humboldt, a Prussian heir, was the first researcher to study a cold, low-salinity current along the western coast of South America. Although the current had already been known for centuries by local fishermen, it had never been officially examined, and was subsequently named after its researcher: the Humboldt Current. Free thinkers and naturalists such as Ernst Haeckel also brought attention to the ocean, making it more visible and understandable to society at large in the nineteenth and early twentieth centuries. A biologist and illustrator, Haeckel created meticulous drawings of marine microorganisms, sparking a boom of both land and marine expeditions (see p.207). Even today his works remain a source of inspiration for artists and photographers.

With the dissemination of these works among the scientific community, new instruments and technologies developed at a rapid pace, allowing the discovery of even the tiniest atoms and the consistency of water drops; machines and steam engines were invented, and the mass industrialization of the ocean began.

But exploration was also based on colonizing interests, the hunger for 'discovering' new territories, a desire to spread religions and economic motivations for gold and other exotic goods and natural resources.

Take industrial whaling, for example. Even though the hunt for whales and their oil was already pursued in prehistoric and medieval times for subsistence reasons (see pp.45, 132), the commercial whale hunt was introduced in Europe by the Basques in the eighth century. It transformed into a larger industry in the early seventeenth century and expanded from Europe to North America, the South Atlantic and even Japan (see p.128) and Australia. Early on, the main reasons for whale hunting were for meat and blubber, which were a source of food but also of specific vitamins and minerals. Later in the nineteenth century, blubber was refined to provide the main source of oil for lamps as well as machine lubrication, while whalebone was used to produce a variety of household tools, corsets and even toys and sleds. As an enduring symbol of the ocean and its mysteries, whales were also coveted by museums in Europe and the United States that wanted to own and display one of these huge, sublime animals. Hunters or explorers were commissioned to capture their exemplars, and new taxidermy techniques were invented in order to preserve them (see p.166).

Centuries of overfishing led to a dramatic decline of whales worldwide, and only a global moratorium on commercial whaling by the International Whaling Commission in 1986 gave some whale populations a chance to recover. Today commercial whaling is still practiced in Norway, Japan and Iceland, mainly as a source of food, while in parts of Alaska whale hunting endures for survival purposes as part of the traditions of local communities.

We now know that a balanced whale population is important for the health of the ocean due to whales' pivotal role in the food chain and production of oxygen. In a process called the Whale Pump, whales feed in the deep sea, mainly on krill and fish, and then come to the surface to breathe, where they also leave their faeces, which in turn feed phytoplankton. A diatom, phytoplankton are very small plantlike organisms that absorb approximately 30 per cent of manmade or anthropogenic carbon dioxide. So when we say the ocean absorbs CO_2, even more than the world's forests, it is actually this micro surface algae that transforms carbon dioxide through photosynthesis into the oxygen we breathe.

For many decades, common knowledge of the ocean was largely based on what we learned in school about all these topics – navigation, naval wars, conquering new territories on behalf of colonialism, commercial fishing, whaling. Maybe we also learned through geography lessons about the vastness of the ocean, its different layers, the fauna and flora. But then in the 1950s and '60s, the French oceanographic explorer Jacques Cousteau made significant advancements in underwater photography and filmmaking, bringing breathtaking images of the previously unknown underwater world into our living rooms (see p.78). Suddenly we could truly see for ourselves and understand what our seas contain, changing our awareness and causing many of us to fall in love with the ocean.

With this newfound awareness, contemporary artists and photographers began to work at the intersection of art and science with the goal of not only sharing the beauty of the ocean but also educating the general public through their projects. We can better understand the risk of mining or commercial fish farms to the ocean's health through the impactful images by Canadian photographer Edward Burtynsky (see p.173), or the importance of intertidal movements through photographs by Martin Stock (see p.312). Many contemporary photographers who choose the ocean as their subject are also advocates for its protection, such as Cristina Mittermeier, who cofounded the environmental nonprofit organization SeaLegacy in Vancouver, which uses inspiring imagery to drive action and conservation efforts (see p.140). And there are organizations that build a bridge between science and art, such as the Schmidt Ocean Institute (see p.292), which regularly invites artists on board their research vessels and develops interdisciplinary projects that encourage public engagement in their scientific missions.

Humanity and the Ocean

In museums and exhibition spaces today, artworks centred around the ocean, both contemporary and historical, mainly focus on the story of humankind in relation to the ocean, rarely on the ocean alone. This human-centric worldview is based on the current geological age dominated by humankind, also referred to as the 'anthropocene', from the Greek word *anthropos* for 'human'. We have been influencing the world around us for millennia – with major impacts on Earth's systems since the beginning of the Industrial Age in the eighteenth century – and this influence is reflected in the arts we create. This anthropocentric worldview includes all aspects of mythological, religious and traditional knowledge, following the timeline from ancient Egypt, Greece and Rome to the Middle Ages in both Christian and non-Christian cultures. It is not just limited to the visual arts but can also be seen in jewellery and design right up to African spiritual art in the twentieth century and today.

Only recently has society begun to question and become critical of this perspective, and nowhere more so than in the art world, where this so-called anthropocene has been debated and focused on intensely in the past years, such as in the work *Vertigo Sea* created by artist John Akomfrah (see p.174), among many others.

While this book inevitably reflects an anthropocentric approach, it also provides an impression of the ocean and its creatures without any human trace – and without the negative imprint we make upon it. Serene ocean surfaces and crashing waves, beautifully wild underwater flora and fauna, unreachable rocks, the deep sea, remote beaches where animals are still untouched. Contemporary underwater photographers have captured images of sea creatures that we previously had not been aware even existed.

When Jacques Cousteau invented his *Calypso* submersible and 35mm underwater film camera in the 1950s, he brought images of life in the ocean into popular culture and sparked a boom in underwater photography (see p.78). Interest only gained momentum with marine biologist, oceanographer and explorer Sylvia Earle's pioneering dives in the 1960s and '70s, which radically impacted our view and understanding of the ocean. (The 'queen of marine conservation', Earle founded Mission Blue in 2009 to further advocate for marine protection, see p.77).

More recently, with advances in technology and the growth of a global travel industry, underwater photography became more widely accessible.

Suddenly remote places were reachable and the cost of cameras and equipment was less prohibitive. Scientific photography with new techniques such as confocal microscopy (see pp.161, 163) and scanning electron microscopy (SEM, see p.284) reveal details of marine animals that are only visible under intense magnification, opening new areas of marine biology. However, easier access has also caused an increase in stress factors for the ocean: commercial diving and expeditions to remote places can cause disruption to marine ecosystems and, when not handled respectfully, activity surrounding underwater photography, such as using intense lights to better capture images, can harm marine life.

Humans have endeavoured to record our relation to the natural world in a variety of other media too. Books and written records, of course, have always had an important role in the dissemination of knowledge and stories, and will continue to be influential in our future. Apps have become our everyday companion on smartphones, computers and other electronic devices. Artists and scientists alike are embracing the digital sphere, particularly as a means to visualize important data about our oceans. Canadian artist Colton Hash, for example, illustrates oceanic noise pollution in his interactive work *Acoustic Turbulence*, making an invisible phenomenon tangible (see p.106).

Film, especially in popular culture, is perhaps one of the biggest influences on our associations with the ocean and marine life. Was our impression of sharks not impacted by the movie *Jaws* when it was released in 1975 (see p.118)? Did we not experience the sheer power of the ocean in films such as *The Poseidon Adventure* (1972, see p.279) or James Cameron's *Titanic* (1997, see p.79)? But beyond some of the more horrific aspects of the ocean, fictionalized or not, films allowed us access to the unknown ocean, such as in Luc Besson's *Le Grand Bleu* (1988) through the mysterious world of free diving, or the animated film *Finding Nemo* (2003, see p.311), which taught us empathy for the ocean and even its smallest of creatures.

The Diverse and Endangered Ocean

While this book includes many beautiful pictures of the ocean as we want, or hope, to see it, it also gives insight into unique scientific and cultural phenomena from around the world, the environmental dangers and destruction caused by human activities and also the dangers the ocean can pose to us.

Subhankar Banerjee, an Indian-born aeronautical engineer turned environmental photographer and activist, fell in love with the Arctic many years ago, recording his experiences in photographs and books. Through his work, he not only explains environmental phenomena such as the merging of the waters of the Kasegaluk Lagoon and the Chukchi Sea but also creates narratives around the traditional life of the Gwich'in people in northern Alaska (see p.249).

Photographer Glenna Gordon has captured the Skeleton Coast of Namibia, a cemetery of capsized and stranded ships. Her images show how dangerous the ocean can still be for humans despite modern technological achievements, that it can still hold the power of life and death over humans (see p.84).

Reflecting on humankind's carelessness and the devastating impact that our behaviour has on marine life, Singaporean artist Tan Zi Xi made the large-scale installation *Plastic Ocean* from twenty-six thousand pieces of discarded plastic garbage (see p.154).

An avid collector of things, American artist Mark Dion created the installation *The Field Station of the Melancholy Marine Biologist*, the laboratory of an imaginary marine biologist that invites the viewer to look in from the outside (see p.299). Dion aims to enchant us with the crucial work marine biologists are executing for humankind and also to warn us about the not-very-bright-looking future for planet Earth and those living on it.

Down Under we find the aboriginal artist Dhambit Mununggurr, who in her work speaks about the traditional knowledge of the Yolngu people in the Northern Territory of Australia. In her painting *Gamata* (*Sea Grass Fire*), she portrays how marine life is sacred for them and subtly points out that their admired manatees have become an endangered species (see p.55).

The pages that follow contain so much more than images that are merely beautiful on the surface. Diving deeper into their meaning, they reveal their critical message, speaking to the many challenges of the ocean and standing as a call to action.

The Ocean Everywhere

We have all noticed that the ocean – its narrative, the topic of ocean protection and sustainable development, the blue economy, the ocean in the arts and in education – has recently become a hot-button topic in many contexts. In international policymaking, the previously mentioned UN Ocean Decade puts the ocean and everything related to it in the spotlight until 2030, bringing all stakeholders, including the general public, together under one framework to enact change.

In arts and culture communities worldwide, exhibitions, interdisciplinary projects, educational activities, university courses and artistic-scientific expeditions are being dedicated specifically to ocean-related themes. Artists have always been inspired and intrigued by the ocean, but today there is a new awareness that the ocean is not only a place for inspiration but a living ecosystem that has become endangered and needs to be protected.

This could not be more clear than at the 2022 Venice Biennale and the many institutions in the lagoon city that are engaged with the ocean. At the forefront are organizations such as the TBA21–Academy and their Ocean Space, where collaborative projects operating at the intersection between science and art have been lined up for more than a decade (see p.24). During the prestigious international art exhibition, Ocean Space presented two exhibitions: *The Soul Expanding Ocean #3* by South African multimedia artist Dineo Seshee Bopape and *#4* by Portuguese artist Diana Policarpo. At the Biennale itself, exhibitions at the Giardini, Arsenale and other National Pavilions throughout the city all highlighted the ocean: The Pavilion of Grenada presented works by the Cypher Art Collective of Grenada, which spoke to Caribbean culture and its connections to the ocean; the New Zealand Pavilion commissioned the artist Yuki Kihara, who brought ecological topics surrounding a paradisiacal Samoan island to the forefront; the Italian Pavilion was devoted entirely to a single artist, Gian Maria Tosatti, who created a large-scale site-specific environmental installation on humans' relationship with nature. And the Intergovernmental Oceanographic Commission of UNESCO partnered with the Italian Research Council and Ca' Foscari University, among others, to host the immersive Ocean & Climate Village to educate and reconnect visitors with the ocean.

For many thousands of years, the ocean has been a source of inspiration for artists: the vastness, the beauty, the depth, the unknown, the mystery, the layers of life, the nostalgia, the infinitely connected entity, the fluidity and the unpredictability. In this book are just some of the works created out of those sparks of inspiration. Spanning across epochs and mediums – from paintings and sculptures to jewellery and textiles – and serving purposes from religious, political and decorative to scientific and educational, all of the examples included underline the primary intention of this book: to create a visual journey that reveals a deeper understanding of the ocean. As with the UN Ocean Decade, the book reaches across disciplines worldwide in the hope of creating a common space to make the need for ocean protection visible and encourage real solutions.

After all, the ocean is everywhere.

Anne-Marie Melster
Interdisciplinary Curator, Cofounder and
Executive Director, ARTPORT_making waves

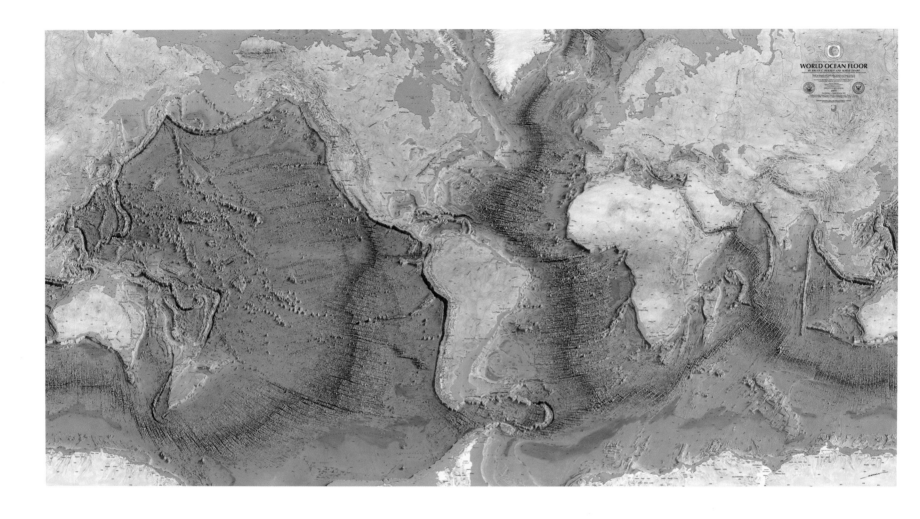

Marie Tharp, Bruce Heezen and Heinrich Berann

World Ocean Floor, 1977
Printed paper, 1.1 × 1.9 m / 3 ft 6 in × 6 ft 3 in
Library of Congress, Geography and Map Division, Washington DC

When it was published in 1977, the *World Ocean Floor* map created by Marie Tharp (1920–2006) and Bruce Heezen (1924–1977), and painted by the artist Heinrich Berann (1915–1999), revolutionized the understanding of Earth by supporting the theory of plate tectonics. The map reflects decades of research of ocean-floor data by geologist and cartographer Marie Tharp and her colleague, marine geologist Bruce Heezen. Tharp first proposed her theory of continental plates and the rift valley deep in the Atlantic Ocean to Heezen, her superior at the time, while working at the Lamont Geological Laboratory at Columbia University in 1952. Heezen initially dismissed her ideas but later came to accept Tharp's hypothesis. Announced in 1957, the theory was met with skepticism until a dive by explorer Jacques Cousteau (see p.78) confirmed the exact location of the rift valley mapped by Tharp. Tharp and Heezen's first map, in 1957, defined the North Atlantic floor; then came the South Atlantic in 1961 and the Indian Ocean in 1964. The maps revealed for the first time the varied landscapes of the ocean floor, such as the network of underwater mountains that form the volcanic mid-ocean ridge, Earth's longest mountain range at 65,000 kilometres (40,390 mi). Ridges appear in dark blue, most often found in the central areas of ocean basins. Here the outpouring of lava creates new ocean-floor crust, pushing older oceanic crust outwards – and thus causing the continents to 'drift'. After Heezen's death in 1977, Tharp completed the world map alone, and it was published by the Office of Naval Research later that year.

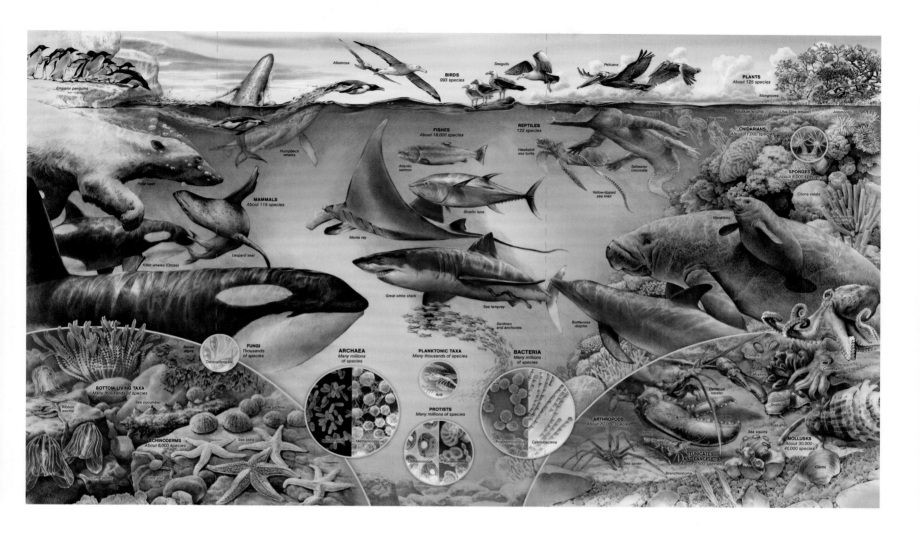

Bruce Morser and Hiram Henriquez

Home in the Ocean, from *National Geographic* magazine, 2015
Digital infographic, dimensions variable

This striking panoramic illustration of marine life brings together a wide assortment of animals from the oceans of the world, depicted in strikingly accurate detail. Both aesthetic and educational, the work is a collaboration between Cuban graphic designer Hiram Henriquez and American artist and illustrator Bruce Morser and was prepared especially for an issue of *National Geographic* magazine devoted to the ocean – the largest habitat on Earth. The artists have included a remarkable number of animals into a section of the sea viewed mainly from below the surface, while at the same time providing detailed information about the various species. There is a temperature gradient, from polar seas on the left through temperate oceans in the middle to tropical waters at the right. At left, a polar bear plunges into the cold ocean above a seal and orcas, while on the right a dolphin and manatees swim against a coral reef background below a saltwater crocodile and loggerhead turtle. The midwater transition is dominated by Atlantic salmon, a bluefin tuna and a great white shark. Above the waves from left to right, penguins dive and swim, great whales breach the surface, albatrosses glide over the open sea and gulls and pelicans fly over coastal waters. Clever use of a bubble technique highlights creatures of the seabed and coastal rocks, including starfish, sea urchins, shellfish, a lobster and an octopus.

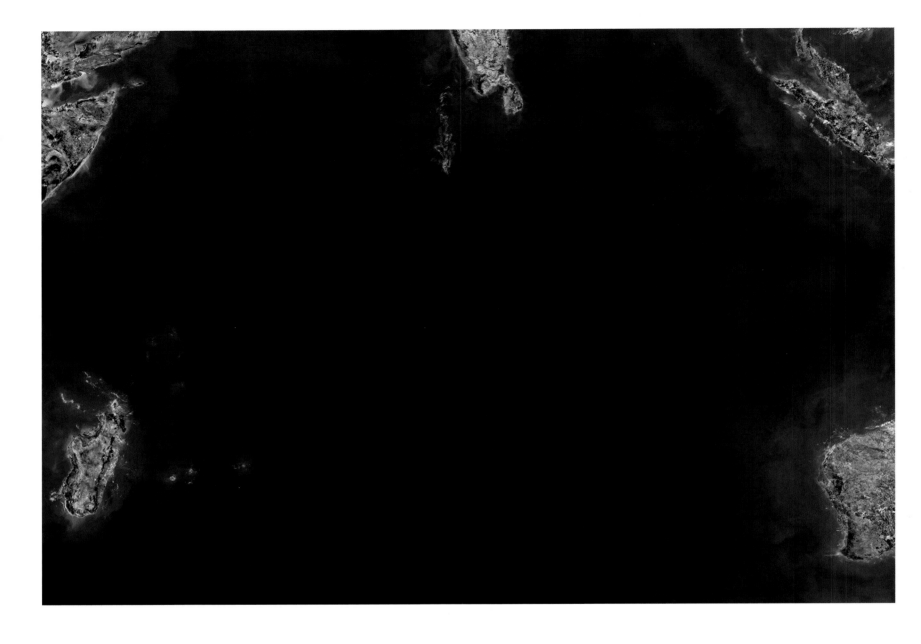

Andreas Gursky

Ocean I, 2010
Inkjet print, 2.5 × 3.5 m / 8 ft 2 in × 11 ft 5 in
Private collection

The vastness of the Indian Ocean is depicted as a sheer expanse of blue framed by, clockwise from the left, Madagascar, the Somali coast, Sri Lanka, Sumatra and the western coast of Australia. *Ocean I* represents the ocean in a way that is simultaneously new and banal, wondrous and yet flattened – aesthetic contradictions that are a stark departure from the usual romantic depictions of the ocean in painting and literature. The majestic power of crashing waves is here replaced by an otherworldly stillness. German artist Andreas Gursky (b. 1955) is renowned for large-scale photographs that explore contemporary notions of the nineteenth-century aesthetic sublime. His monumental images are digitally manipulated to produce a hyperrealistic and yet impossible view of the world. The idea behind the *Ocean* series came to Gursky in 2010, while following the flight-path map on a journey from Dubai to Melbourne. Exploring satellite imagery as a medium, he began to rework it into his own distinctive, objective photographic style, which challenges the viewer's understanding of their place on this planet and questions our subjective perception of time and space. While representations of tumultuous seas have often aimed to reflect humans' innermost turmoil, Gursky's visualization instead leaves us feeling small and insignificant in the face of nature's enormity.

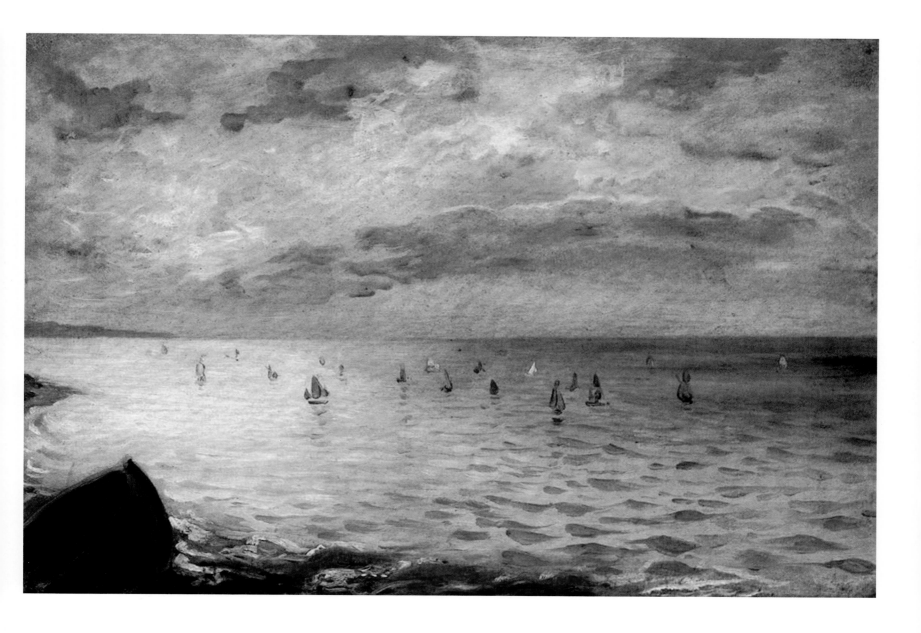

Eugène Delacroix

The Sea from the Heights of Dieppe, 1852
Oil on cardboard mounted on panel, 35 × 51 cm / 13¾ × 20 in
Museé du Louvre, Paris

On 14 September 1852, Eugène Delacroix (1798–1863) wrote in his journal, after a last visit to the beach at Dieppe that summer, that 'the soul attaches itself passionately to things we are about to leave. It was in remembrance of this sea that I made a study from memory: golden sky, boats awaiting the tide to come in.' He may have been writing about this small seascape, with its fractured rendering of cloud colours reflected in the sea and the sense of barely suggested sailboats rocking on the wind. Painted when he was fifty-four years old, in the smaller format he preferred in his later years and with expressive brushstrokes, it testifies not only to Delacroix's love of the sea but also to his role as a progenitor of Impressionism: indeed, this canvas has been heralded as the first Impressionist painting, twenty years before Monet's work that gave the movement its name. Like the Impressionists, Delacroix was entranced by the changing optical effects of light on a scene, and painted many sunsets, skyscapes and nocturnal views using the rapid brushstrokes that prefigure *en plein air* painting.

Delacroix was France's foremost Romantic painter and spent his life in a privileged and influential milieu. He began his training under the Neoclassical painter Pierre-Narcisse Guérin but was soon influenced by the rich colours of Peter Paul Rubens and by the work of his friend Théodore Géricault. He also admired the landscapes of the English painters John Constable and J. M. W. Turner (see p.29). His technical advances and use of colour profoundly influenced both Impressionist and Post-Impressionist painting.

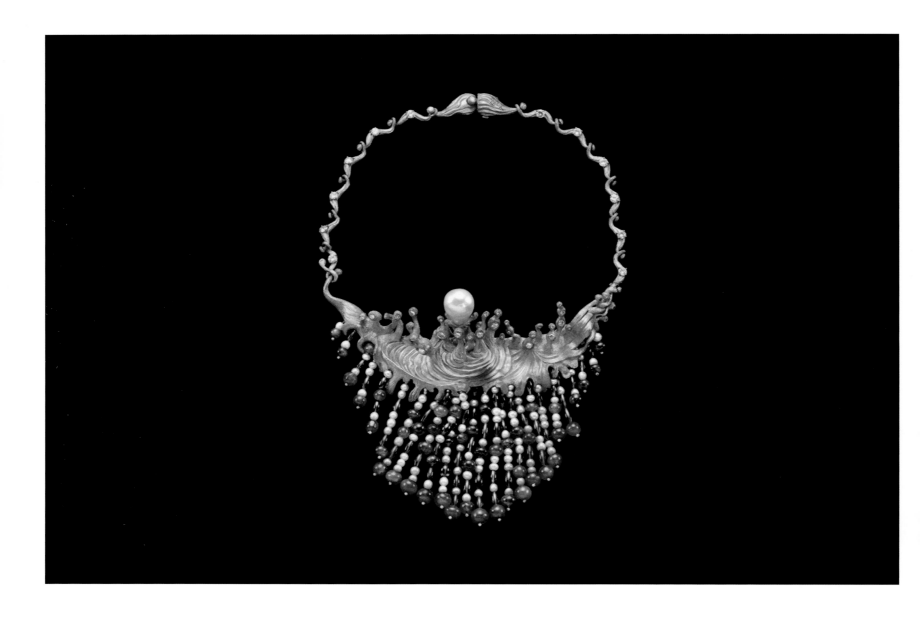

Salvador Dalí

Swirling Sea Necklace, 1954
18k gold with sapphire and emerald beads,
pearls and diamonds, L. 39 cm / 15⅜ in
Private collection

The Spanish Surrealist artist Salvador Dalí (1904–1989) made several fruitful collaborations with jewellers throughout his career, fashioning wearable, sculptural pieces that are every bit as theatrical, whimsical and abstruse as his painted and graphic works, and which typically turned to the natural world for inspiration. With the high-end jeweller Piaget, he crafted gold portrait medallions encircled by bare, twisted branches and here, for a lavish necklace created for a wealthy patron, São Schlumberger, Dalí and the master

Argentinian jeweller Carlos Alemany forged a vision of the ocean from precious metals and gemstones. Gold cascades in interlocking rivulets from a fluted clasp source to gather in a twisting, weltering, pooled mass of metal, whose rebounding droplet crowns shimmer with embedded diamonds and lift an enormous South Sea pearl to prominence at the necklace's centre. If the gold and diamonds represent the water's surface, below them, tumbling away into darkness, emerald and sapphire beads hung as tassels characterize the blue-green underwater world,

with light from the searchlight pearl above rebounding down, repeated by small pearls. For Dalí, who gave a lecture dressed in a full deep-sea diving suit during the 1936 International Surrealist Exhibition in London, the ocean was an inherently Surrealist realm. And the large baroque pearl, which Dalí's original design sketches show was intended to be a regal orb, topped by a crucifix, must have appeared to the artist as the perfect, shimmering expression of nature's more dreamlike aspect.

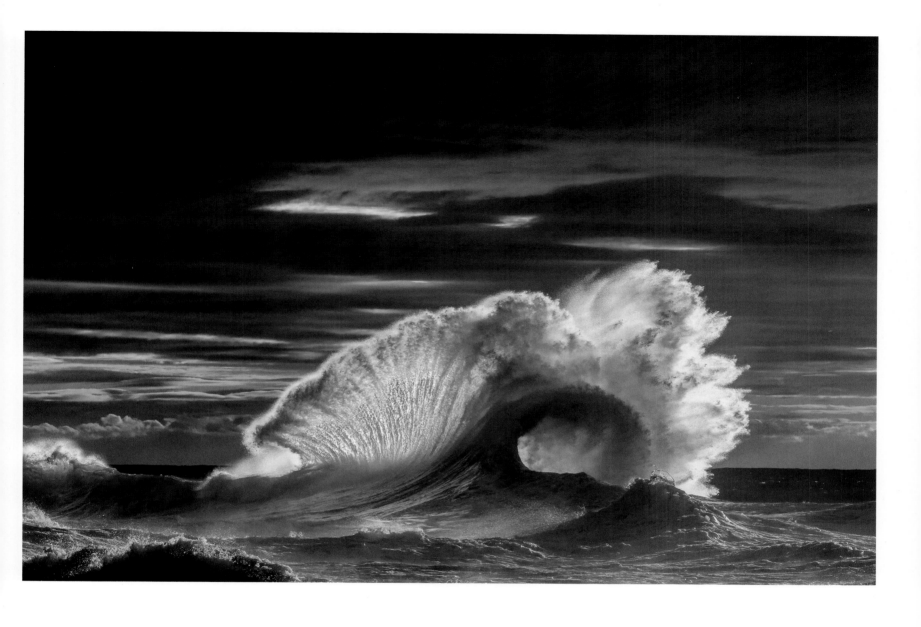

Scott Harrison

The Reward, 2018
Photograph, dimensions variable

Backlit against a dawn sky, a spectacular 9-metre (30-ft) wave unfolds like an enormous silk fan. In surf photography, this is known as a 'backwash wave', a phenomenon that occurs when two waves collide in opposite directions, creating an energetic explosion of water towards the sky. New South Wales–based surf photographer Scott Harrison (b. 1979) captured this moment on a July morning in 2018. The first photograph of surfing culture dates back to 1890; it shows a Hawaiian surfer standing in the ocean holding his board. In 1929, legendary surfer, board designer and photographer Tom Blake was one of the first to design a waterproof housing for a camera, and in 1935, *National Geographic* published a series of his photographs, elevating both the sport and surf photography. Harrison's focus on photography began serendipitously: one morning in 2014, he woke to an astounding sunrise, grabbed his camera and headed to the beach. Hundreds of mornings and tens of thousands of photographs later, he created this epic image. He prefers to shoot from land in the early mornings and against the light, waiting for that twenty-minute window when the conditions are just right. Harrison controls what he can – angle, framing, exposure, point of focus – and waits. When the sun isn't too high and nature is a willing collaborator, he catches that elusive moment. 'These two waves colliding a split second later would have been a completely different result', he says. 'The more you are there, the luckier you get.'

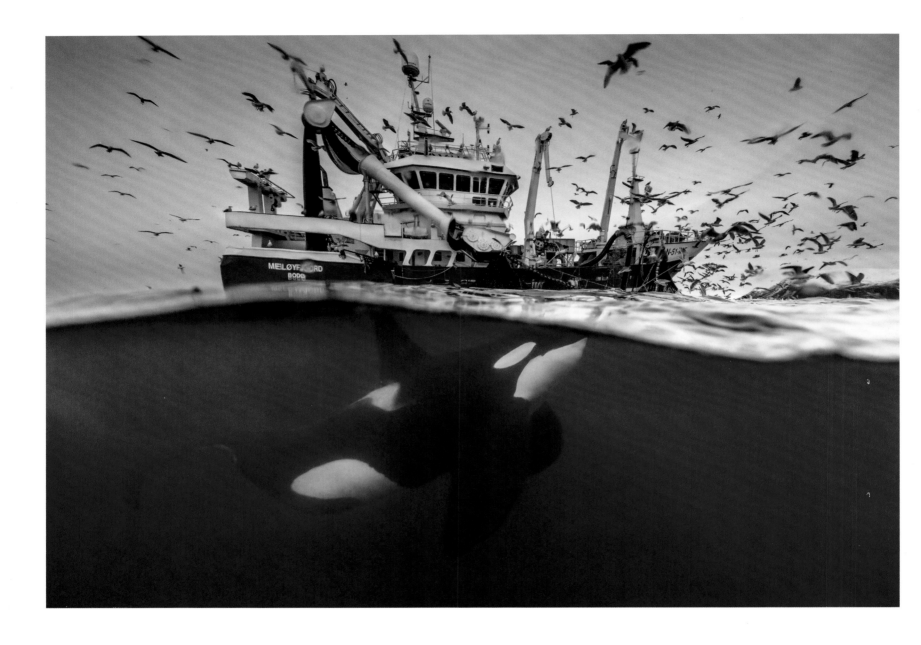

Audun Rikardsen

Sharing Resources, 2015
Photograph, dimensions variable

The Norwegian fjords north of Trømso, some 350 kilometres (220 mi) beyond the Arctic Circle, are home to the highest concentration of the world's orcas, or killer whales. Resident in the fjords, these orcas spend much of their time (as much as 40 per cent) swimming in search of herring, their food of choice. They are known to use a system known as 'carousel feeding', whereby the whales work together to surround a shoal of herring, circling the fish closer and closer together until they force them into a ball close to the water's surface. Then the whales use their huge tails to slap at the shoal, leaving the herring either dead or sufficiently stunned to allow a leisurely feed. Another, perhaps easier, way for whales to get their herring is to follow a herring trawler and surround its nets, sometimes actually getting inside the nets. In this split-level photograph, Norwegian photographer and marine biology professor Audun Rikardsen (b. 1968) captures just such an episode. 'People think I'm an underwater photographer,' Rikardsen says, 'but I'd rather call myself a surface photographer. I find it fascinating to see the few thin millimetres that divide these two totally different worlds'. To this end, Rikardsen has created his own dome housing for his cameras, which allows him to capture split images like this, below and above the surface. This unique perspective shows how the whales have adapted to the presence of the trawlers and how both take advantage of the vast herring shoals.

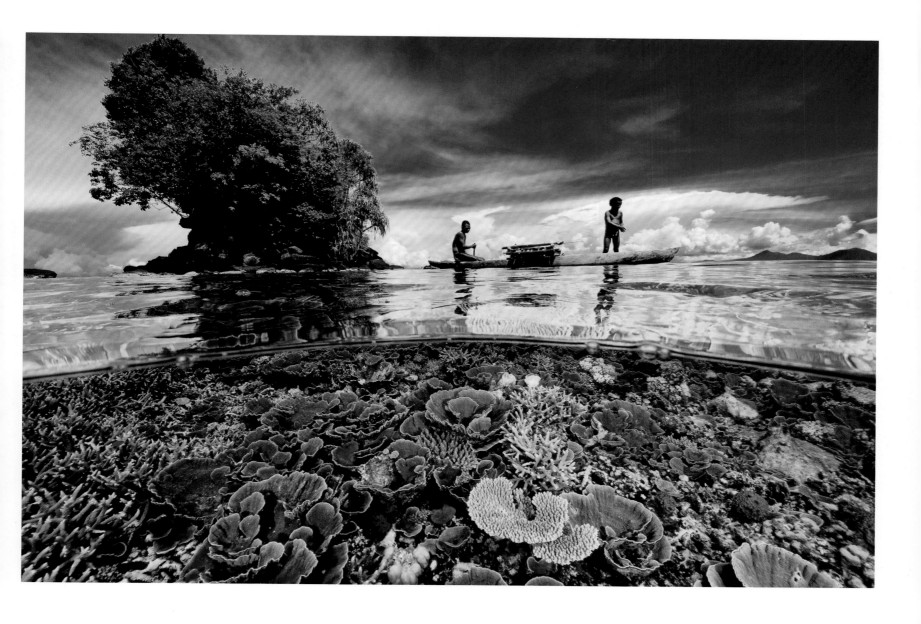

David Doubilet

Father and Son, Kimbe Bay, Papua New Guinea, 2013
Photograph, dimensions variable

This remarkable image taken on an island in Papua New Guinea was the result of planning and experience – with an element of good luck. American photographer David Doubilet (b. 1946) is renowned for images split by the waterline, but his long and distinguished career started when he took his first underwater photographs at age twelve. Doubilet was on assignment for *National Geographic* magazine's 125th anniversary edition when he headed to Kimbe Bay to search for a perfect image that summed up its unique coral-covered seamounts and reef slopes. That much was planned, but when Doubilet failed to get the shot he wanted, an acquaintance suggested that he try a distant island near the Willaumez Peninsula. The riot of corals reaching up to just beneath the surface gave him the underwater scenery he had been seeking – but the father and son paddling silently past in their outrigger was pure luck. There are many elements required to create a picture like this. The special front port for the underwater camera is a large-diameter curved dome of glass, optically corrected so that subjects above and below water are both in focus. The camera lens also needs to be super-wide angle to capture the full scope of the scene. Ideally the sea is calm, so there is a clean line of demarcation between sky and water. But here the water line is very slightly curved, giving the subtle impression that the coral reef is a different planet from what is above. The light above water may be in balance with the light below, but we are in no doubt that we're looking at two worlds. It's a paradise of our imagination.

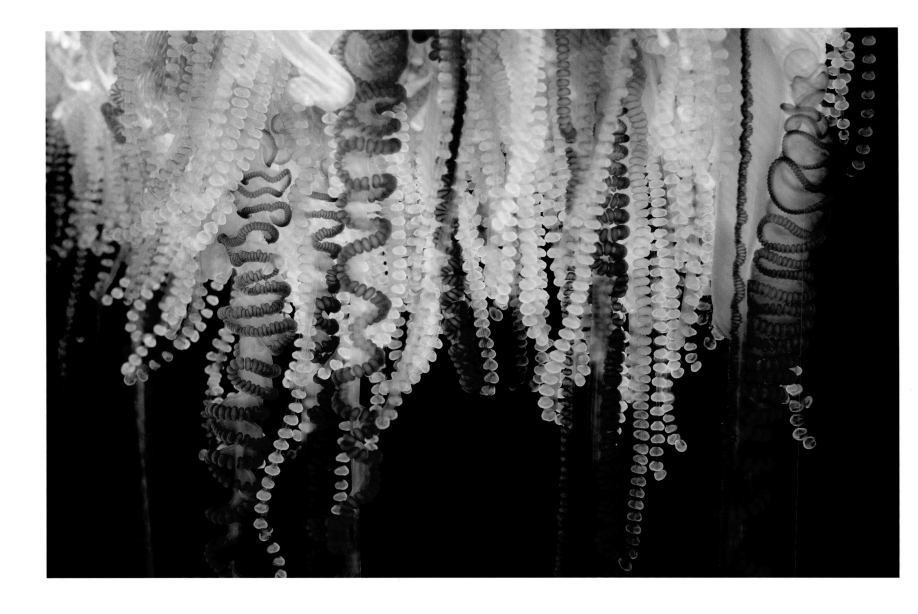

Solvin Zankl

Portuguese Man-of-War, Sargasso Sea, 2014
Photograph, dimensions variable

The Portuguese man-of-war (*Physalia physalis*) is one of the ocean's most feared coelenterates (phylum Cnidaria), the group that contains jellyfish and their relatives. Although it bears a superficial resemblance to a jellyfish, it is in fact a colonial animal, its body consisting of many smaller units called zooids. Specialized structures known as nematocysts, which are present on some of the creature's trailing tentacles, inject venom on contact with prey such as larvae or fish, causing paralysis or death and providing food for the colony. This photograph, captured by German wildlife photographer Solvin Zankl (b. 1971) in the Sargasso Sea, Bermuda, reveals the complex beauty of the curtain of intricate pink and purple tentacles that dangle down from the main body of the animal as it floats on the surface of the sea, buoyed by a gas-filled bladder called a pneumatophore. The animals have no means of propulsion, so they are moved by the wind catching a raised fin or 'sail' on their backs or by ocean currents and tides. The tentacles of this remarkable marine organism are usually about 10 metres (30 ft) long but can reach up to 30 metres (100 ft). Portuguese man-of-war live near the surface and are distributed widely across tropical and subtropical oceans, including the Sargasso Sea. The Sargasso Sea is a region of the Atlantic Ocean east of Bermuda that is distinguished by its relatively calm blue waters and the sargassum seaweed they support. It lies in a gyre created by four ocean currents that circle an area about 1,100 by 3,200 kilometres (680 by 2000 mi), depositing marine plants and creating an important nursery for species such as eels and sea turtles.

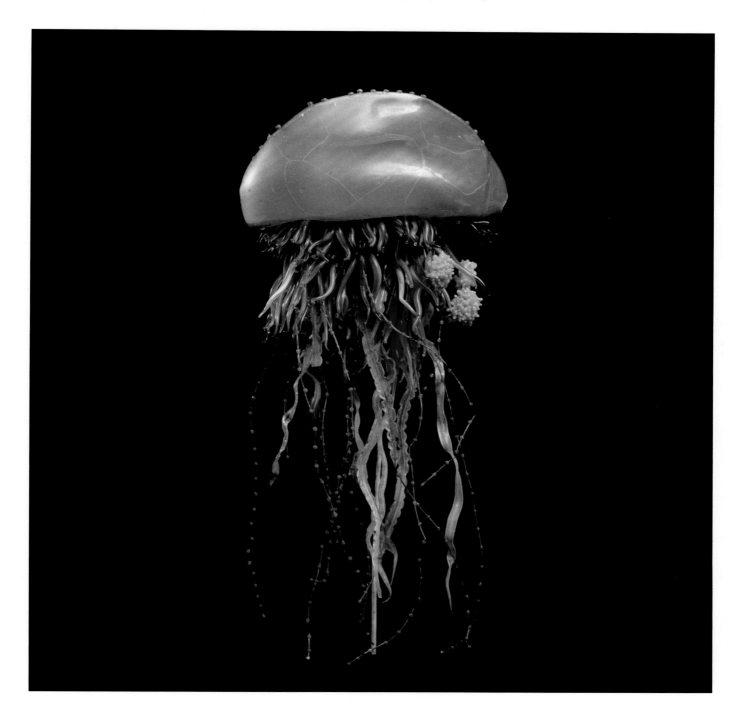

Leopold and Rudolf Blaschka

Portuguese Man-of-War (Physalia arethusa), mid-to-late 19th century
Coloured glass with copper wire, 24 × 5.5 × 9 cm / 9½ × 2⅛ × 3½ in
National Museum Wales, Cardiff

Found in the Atlantic and the Indian Ocean, the Portuguese man-of-war is not a jellyfish but a siphonophore: a remarkable, compound organism made of cooperative colonial zooids. The name is an homage to the caravel, or Portuguese sailing warship, which the gas-inflated upper part of the animal's body resembles. Highly poisonous, the Portuguese man-of-war trawls sea waters with tentacles 10 to 30 metres (30 to 100 ft) long that sting and paralyze its prey. This painstakingly realistic model of a Portuguese man-of-war is the work of Leopold Blaschka (1822–1895) and his son Rudolf (1857–1939). Descendants of a long line of Bohemian glassworkers, the Blaschkas produced in their workshop in Dresden, Germany, thousands of glass models for museums and universities all over the world. With accessible public education and a widespread interest in the sciences in the mid-to-late nineteenth century, such models became an important teaching aid in classrooms. This complex model, along with around two hundred others, including marine and terrestrial invertebrates such as sea anemones, jellyfish, octopuses, sea cucumbers, marine worms and land snails, is in the collection of the National Museum Wales. Famous worldwide for the impeccable realism of their work, the Blaschkas helped scientists and researchers bypass one of the most pressing problems in natural history: the preservation of soft-flesh invertebrates. Jellyfish and siphonophores are invertebrates made almost entirely of soft collagen – a delicate protein that tears easily and is difficult to preserve.

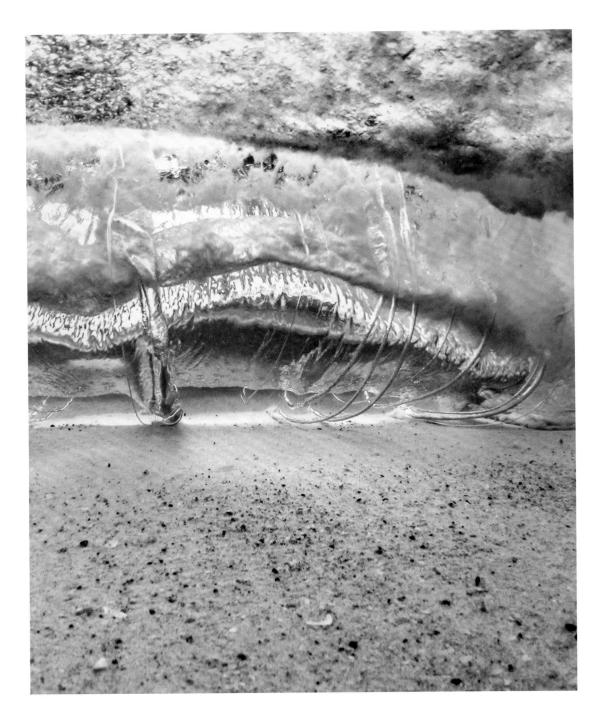

Mitchell Gilmore

Under the Waves, Burleigh Heads, Queensland, 2019
Photograph, dimensions variable

From beneath the surface, a wave travelling towards the beach presents a contrast between the energy of the approaching roller and the foaming surf left by the last wave on one hand and the stillness of the sandy seabed on the other. Wrapped around the roller are rib vortices, strands of tight, spinning water that form at the edges of breaking waves. As waves reach the shore, it seems as if they are made up of water travelling across the ocean. In fact, waves are not moving water but energy, which travels through the water in a circular motion that causes it to rise and fall. That changes as waves near the coast, where the water is not deep enough for their energy to complete its orbit. The lower part of the wave slows down, and the energy gathers at the top, pushing its crest higher into the air until eventually it overbalances and the wave crashes down, dissipating its energy into surf. Waves are usually caused far out at sea by the action of the wind on the surface of the ocean, creating a disturbance that gathers energy as it travels. Other forms of waves are caused by violent storms or underwater earthquakes, but these phenomena – known as a storm surge and a tsunami, respectively – reach the coast as a sudden dramatic rise in sea level rather than as a breaking wave. Australian photographer Mitchell Gilmore (b. 1986) started shooting underwater with a GoPro camera by chance on a day when he couldn't surf, and has since earned a reputation for revealing a remarkable view of waves from underneath.

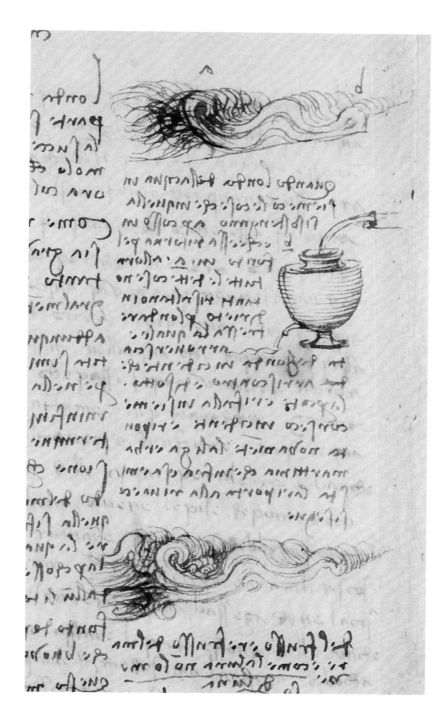

Leonardo da Vinci

Page from the *Codex Leicester* (detail), 1510
Manuscript, 30 × 22 cm / 11¾ × 8½ in
Private collection

Two serpentine sketches of waves, animated and tumultuous, are shown in cross section on a detail from a page of *Codex Leicester*, a sixteenth-century collection of writings, postulations and drawings by Italian polymath Leonardo da Vinci (1452–1519). The codex specifically focuses on the subjects of science and geography, including ideas on the properties of water, air and celestial light. Here, the waves are accompanied by a drawing of a pot acting as a container for the passage of water, poured in at the top and released in a trickle from a spout at the bottom: the same element, but this time calm and controlled. Surrounding the illustrations is Leonardo's renowned mirror writing, in which he diligently describes the movement and structure of ocean waves, including an exceptionally detailed examination of how a wave might crash on the shore: moving in two parts, the top rushing forwards while the bottom drags on the friction caused by the seabed. Here Leonardo considers how water might translate into different energetic states, on the one hand, wild and driven by uncontrollable elemental forces, and on the other, placid as it is harnessed by the human hand. The stylized wave drawings render visible his theories and observations of bodies of water that pound the coastline with a relentless energy.

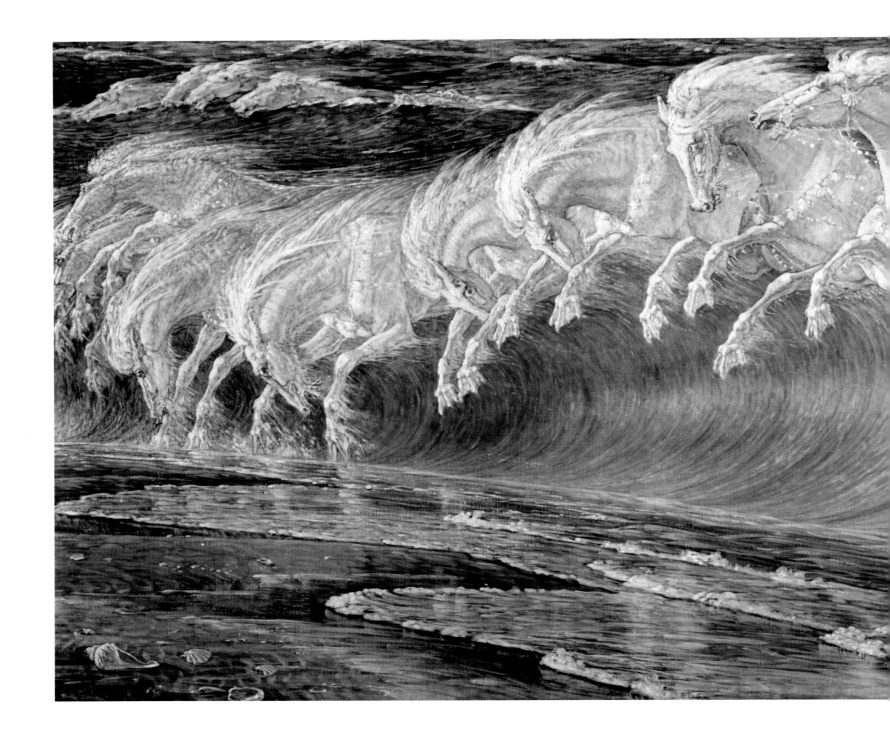

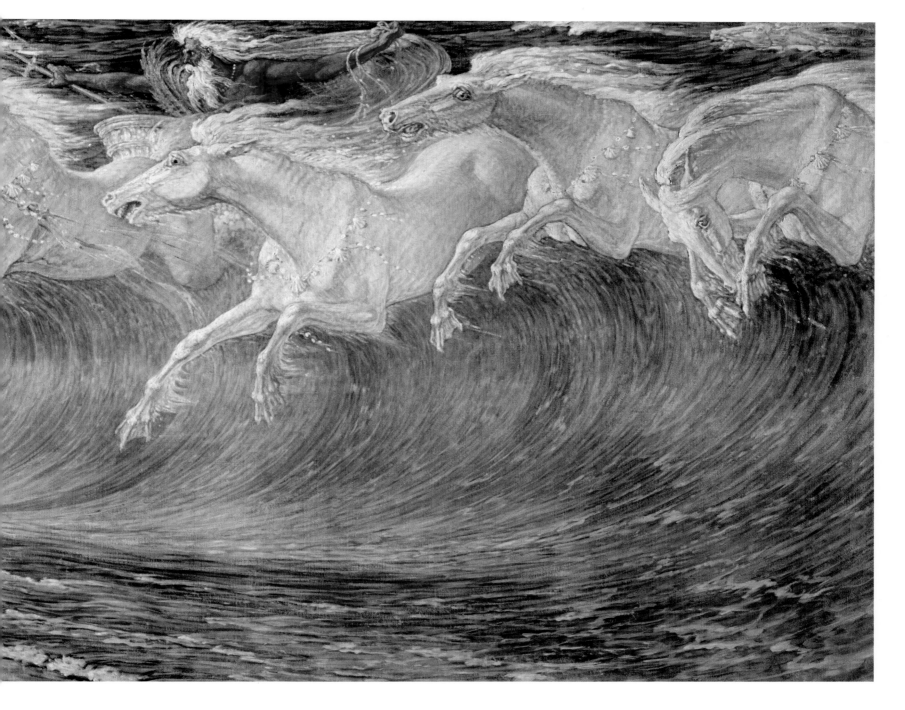

Walter Crane

Neptune's Horses, 1892
Oil on canvas, 8.6 × 2.1 m / 7 ft × 3 ft 2 in
Neue Pinakothek, Munich

A line of white galloping horses rears up above a sweeping expanse of blue-green water, approximating the form of a giant tubular wave. The heads of at least ten horses are visible, but the receding line suggests many more make up this mass of water. The animals' raised front legs and webbed hooves define the wave's arc, and their whipped, white manes suggest foaming wave caps produced by a violent storm. Beneath the mythological sea god Neptune, holding the chariot's reins and wielding his trident to spur on his charges, a few of the horses have begun to fall forward as the towering swell collapses under its own immensity. Walter Crane (1845–1915) was an English artist and illustrator, much sought-after for his Arts and Crafts book decorations, and his prolific work as a children's book creator was a major influence on the genre in the second half of the nineteenth century. As a follower of the teachings of the critic John Ruskin and the Pre-Raphaelite artists, mythological scenes and subjects were central to Crane's work, as was a fascination with the natural world. Crane recalled of the work that he was 'inspired, no doubt, by the close companionship of the ocean' during a trip to the coast of Nantucket, Massachusetts. Today Cisco Beach on the island's southern coast is a popular destination for surfers seeking out such rolling Atlantic waves that, on a good day, can measure up to 300 metres (984 ft) in length.

Joan Jonas

Moving Off the Land II Mermaid, based on
the series *My New Theater*, 1997–ongoing
Video still, dimensions variable

A sleeping woman, resembling a mermaid, lies on a chaise longue entangled in white tendrils of seaweed, her right hand serving as a headrest, her eyes closed, a beautiful, tender smile on her face. The delicate painting dissolves on the right edge into a background scene of a coral reef, the water blue, the coral white. This seemingly incongruent juxtaposition of imagery is a still from *Moving Off the Land II* by pioneering American visual artist Joan Jonas (b. 1936). Consisting of five videos with a total duration of about fifty minutes, the installation was first presented as the inaugural exhibition at Ocean Space (by the arts advocacy organization TBA21-Academy) in Venice in 2019. Each video was displayed in an individual open wooden house, the viewer experiencing the moving images in miniature theatrelike spaces within the old church of San Lorenzo, the home of Ocean Space. The work was made in collaboration with marine biologist David Gruber (see p.164) and contains some of his underwater video footage as well as video sequences from Jonas's own filming in aquariums and, on and off the land, in locations from Jamaica to Cape Breton Island in Nova Scotia, Canada. All these scenes are interwoven with scripted actors and drawings from the artist, who also lends her voice to the narration. A poetic experience reinforced by the music of Ikue Mori, María Huld Markan Sigfúsdóttir and Ánde Somby, *Moving Off the Land II* is a filmic collage that pulls the viewer into the miracles and wonders of the ocean, both underwater and on dry land. Exhibited worldwide, Jonas's work is an important call to action for marine conservation, raising awareness about the dangers and challenges that face our ocean.

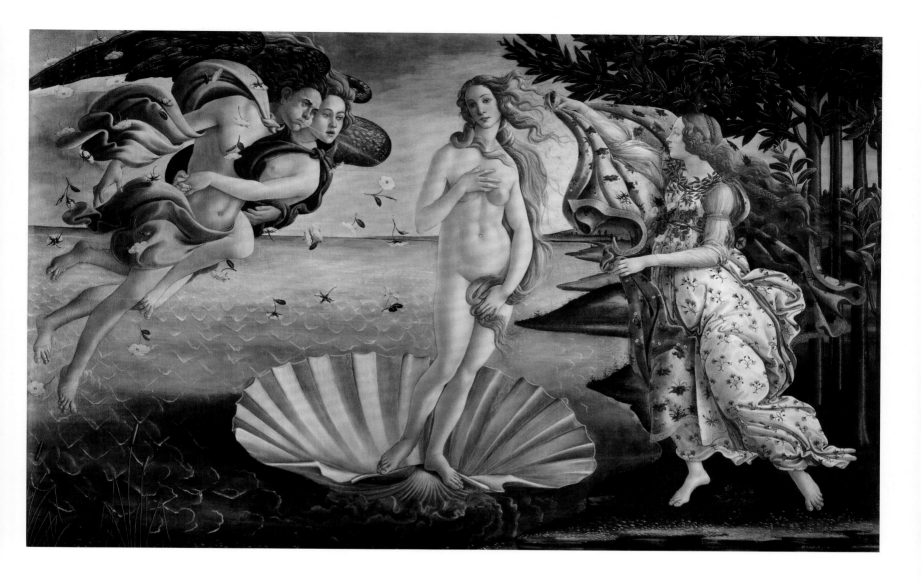

Sandro Botticelli

The Birth of Venus, 1483–84
Tempera on canvas, 1.7 × 2.8 m / 5 ft 7 in × 6 ft 9 in
Galleria degli Uffizi, Florence

One of the most famous paintings in the world, *The Birth of Venus* by Sandro Botticelli (1445–1510) is a Renaissance masterpiece immortalizing a fantastical story of Roman marine mythology, derived from the original Greek tales. Thought to have been commissioned in the mid-1480s by the powerful Medici family of Florence, the painting shows Venus, the goddess of love and beauty, placed on a giant scallop shell as a beautiful and perfect pearl. The daughter of Jupiter and Dione, Venus was born out of the waves – an ethereal creature of the sea. On the left of the painting, the incarnation of Zephyrus, the west wind, carries the goddess of breezes, Aura, their powers pushing Venus to shore. On the right, awaiting the arrival of Venus, and ready to cover her modesty, is Hora of Spring, one of the three Greek goddesses of the seasons. While art historians still disagree about its meaning, the painting is understood as a celebration of the benevolent auspice of love. Scallop shells have long been painted as symbols of Christian values in Western art. In Botticelli's case, the shell has been interpreted as a reference to baptismal fonts, which in Italy were often shell-shaped. A scallop shell was also often used to scoop water over the baptized's head. Perhaps even more meaningful to the subject of this painting, shells have often been associated with fertility – a property that we still today call aphrodisiac after Aphrodite, Venus's original name in Greek mythology.

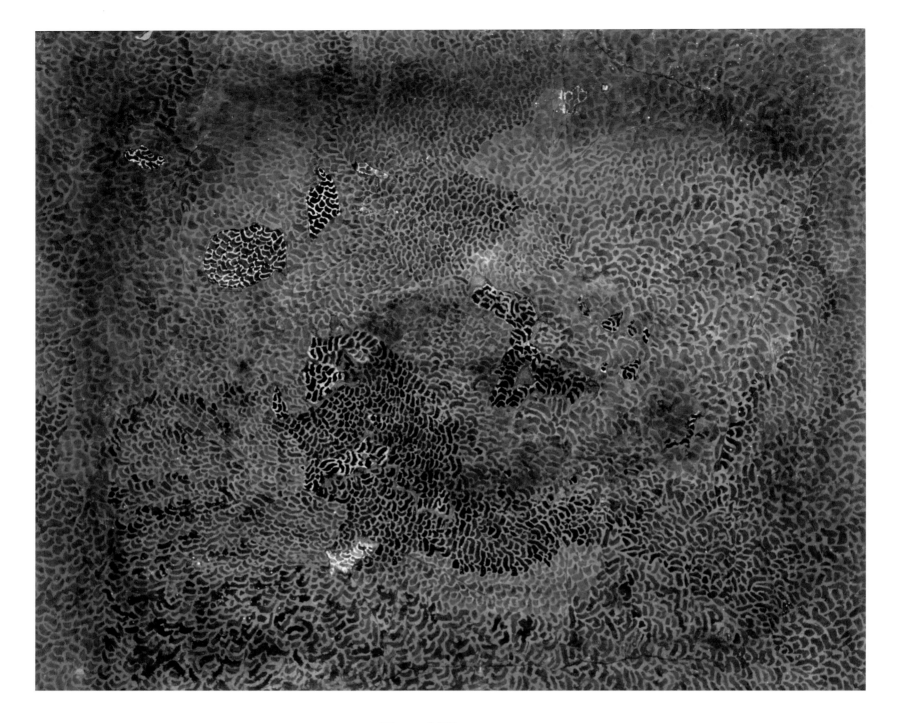

Yayoi Kusama

Pacific Ocean, 1959
Watercolour on paper, 57 × 69.5 cm / 22½ × 27⅜ in
Takahashi Collection, Tokyo

The texture of thousands and thousands of tiny segments swirl together into ambiguous shapes that emerge to mark places where the dark waters of the Pacific Ocean meet scattered islands. The effect of this painting by the renowned twentieth-century Japanese artist Yayoi Kusama (b. 1929) – inspired by looking down on the ocean during a flight between Japan and the United States – is mesmerizing, dragging the viewer's eye into the painting and suggesting the infinite vastness of the sea. Kusama is well-known for her paintings and installations that use repetition and the concept of infinity as a way of making viewers feel psychologically engulfed, be it by using many thousands of polka dots on the surfaces of her paintings or mirrored rooms filled with lights that viewers can walk inside yet offer no real possibility of orientation. Here, the same disorientation takes hold – the water and the land swirling together, the dark tones suggesting the ocean's depth while the dynamic shapes reflect its ever-moving surface. As a child, Kusama was prone to hallucinations, taking the form of kaleidoscopic patterns and infinite, multiplying fields of dots, among other visions, which later informed her artistic practice. At the age of nineteen, she began studies at the Kyoto City University of Arts, where she trained in the traditional Japanese *nihonga* style of painting. Soon, however, she was drawn to the avant-garde works appearing in Europe and the United States, eventually relocating to New York in 1958, where she was involved in the Pop art movement of the 1960s.

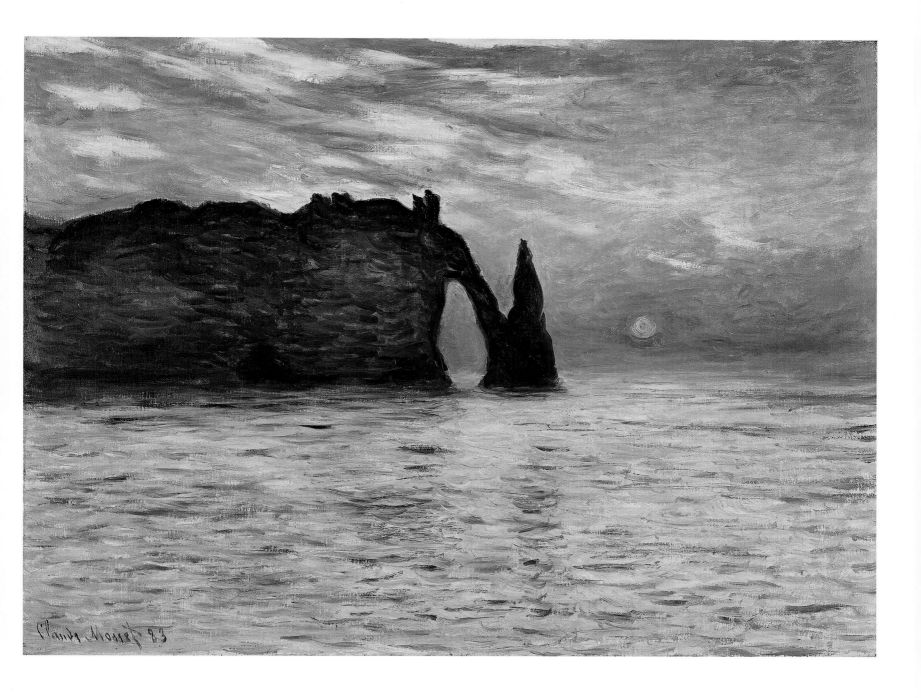

Claude Monet

The Cliff, Étretat, Sunset, 1882–83
Oil on canvas, 60.5 × 81.8 cm / 23¾ × 32¼ in
North Carolina Museum of Art, Raleigh

The sun sets between two distinctive rock formations on the coast of Normandy, France, known for their shapes as the Elephant and the Needle. The obsession of French artist Claude Monet (1840–1926) with the chalk cliffs of Étretat in his native Normandy resulted in at least eighteen views produced over the course of one three-week period. What fascinated Monet, apart from the beauty of the landscape and the peculiarity of the rock formations, were the atmospheric conditions and the changing tides – a phenomenon explained by the meeting of the North Sea with the Atlantic Ocean just off the Normandy coast. In stark contrast with the work of some of his peers, such as Eugène Boudin and Gustave Courbet (see p.122), Monet created a less tranquil and more dynamic picture of an area where the light changed constantly and was echoed by the equally constant movement of the sea, captured in many separate brushstrokes. Famed as the founder of the Impressionist movement – named for another of his paintings of the sea, *Impression, Sunrise*, showing the harbour at Le Havre – Monet set up an easel on the beach in order to create his sketches, applying new layers of paint over others that were still wet so that they only partially blended. Parallel to the paintings and sketches he made on his visit to Étretat, Monet also produced a vast amount of literature on the subject, mostly in the form of letters to his then wife Alice, often outlining the long wait for favourable meteorological circumstances and his enthusiasm and frustration at the challenge of capturing the nuances of the water.

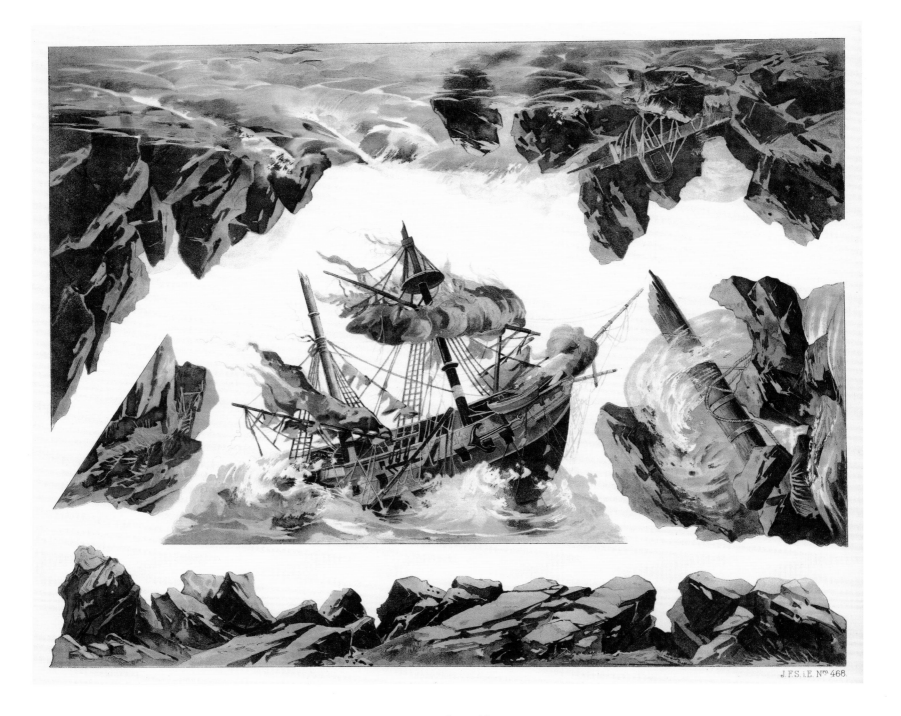

J. F. Schreiber

Paper Theatre, 1886
Lithograph, 36.8 × 41.3 cm / 14½ × 16¼ in
Poppenspe(e)lmuseum, Vorchten, the Netherlands

An unexpected consequence of the rapid expansion of the German children's publishing market in the nineteenth century was the emergence of the paper theatre. At the heart of the boom was the publishing house J. F. Schreiber, originally established by Johann Ferdinand Schreiber in Esslingen in 1831 to print art and play texts. When Johann's son Ferdinand (1835–1914) took over the company, he decided to concentrate on children's books – and his decision paid off handsomely. Improved printing techniques and high-quality products ensured that Schreiber dominated the market. Looking to expand, Ferdinand and his brother Max published an instruction book for making paper theatres, *Das Kindertheater* by Hugo Elm, that set the standard for paper theatres in Germany. Intended to mirror the grandeur of Europe's great stages, the theatres were made from printed paper that was cut out from the book, glued to cardboard and then mounted on a wooden frame to provide backdrop, flats, props and actors. The beautifully designed and carefully executed designs introduced children and their parents to a unique visual entertainment. The popularity of the Schreiber cut-out sheets meant that the company soon expanded beyond paper theatres to dolls, Christmas nativities and models of aeroplanes and ships. The theatre shown here – number 468 in the series – captures the drama of a sinking ship. Alongside the paper cut-outs of jagged rocks, a sinking ship and two friezes with rocks is the snapped pole that once anchored the ship. Once assembled, such a theatre provided the impetus for countless hours of storytelling.

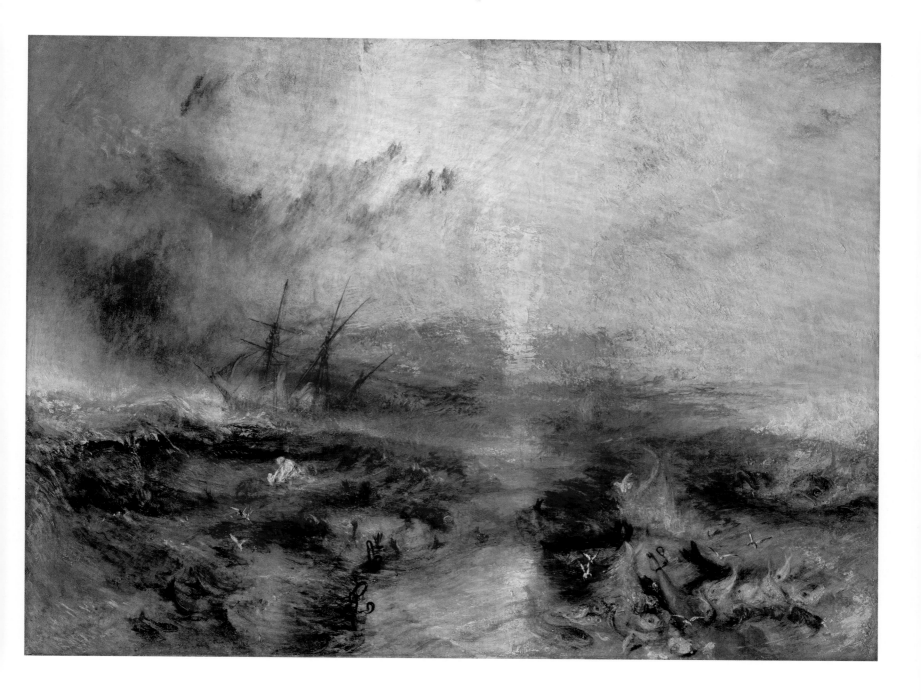

Joseph Mallord William Turner

The Slave Ship, 1840
Oil on canvas, 90.8 × 122.6 cm / 35¾ × 48¼ in
Museum of Fine Arts, Boston

A leading artist of Romanticism, Joseph Mallord William Turner (1775–1851) is one of Britain's most celebrated painters of seascapes. The first oil painting he ever exhibited, in 1796, was *Fisherman at Sea,* a dramatically moonlit maritime scene. While many of his maritime works represent the natural phenomena of the atmosphere – the swirling energy of storms or vibrant colours of a sun setting over the horizon – this painting, which became one of Turner's most famous, looks beyond the natural world to reference a more overtly political subject matter. Originally entitled *Slavers Throwing overboard the Dead and Dying – Typhoon Coming On,* the work was inspired by the events of the Zong Massacre of 1781, when 132 captured Africans were thrown overboard into the Atlantic Ocean after drinking water and supplies ran low following navigational errors. An insurance claim was made for the lost human 'cargo', but the legal dispute that ensued brought the case to wider attention, including that of early campaigners for the abolition of slavery, who used the shocking account of inhumanity to further their cause. Turner's painting was first exhibited at the Royal Academy of Arts, London, in 1840, to coincide with two international anti-slavery conventions. Its graphic depiction of a shackled limb amid swarming fish and birds in the turbulent waves of the foreground, while the dark clouds gather beyond the fleeing ship, was a powerful visualization of the brutal realities of the transatlantic slave trade.

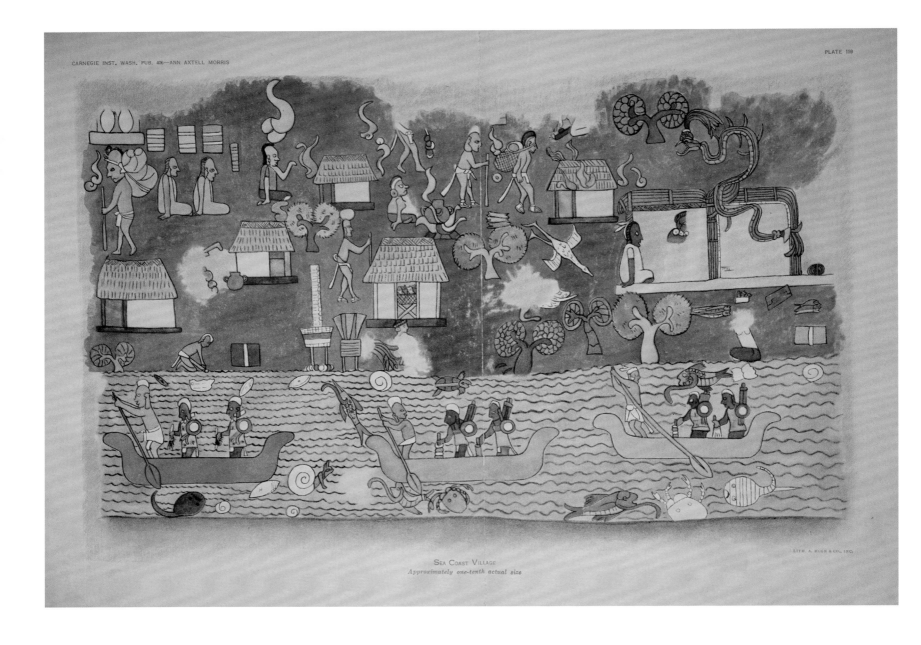

SEA COAST VILLAGE
Approximately one-tenth actual size

Ann Axtell Morris

Plate 159, Sea Coast Village, from *The Temple of the Warriors at Chichen Itzá, Yucatan*, 1931
Lithograph, 32 × 45 cm / 12½ × 17¾ in
University Library, University of Illinois Urbana-Champaign

Once painted on a wall of the Temple of the Warriors, part of the sacred Mayan complex of Chichén Itzá in Mexico's Yucatan peninsula, this restored panel showing coastal village life had disintegrated into fifty-eight pieces when it was discovered in the early 1900s. The restoration of Chichén Itzá, which had been abandoned in the fifteenth century, began in February 1925 under the American archaeologist Earl H. Morris of the Carnegie Institution of Washington DC. Fellow archaeologist (and Earl's wife) Ann Axtell Morris (1900–1945) undertook the pioneering restoration of the mural. The stones were reassembled and repaired to enable Axtell Morris to painstakingly trace the design onto transparent paper before she used carbon sheets to transfer the image onto watercolour paper. Using the stone as a model, she duplicated the painted images in colour before finally cutting the paper to the original size of the stone. Her groundbreaking work revealed a scene of Mayan daily life painted in a characteristically flat style: the sky and sea are delineated by the use of different colours, with the blue surface of the water crossed by undulating black lines representing waves. Fish and the sea dominate the image: not only are there plenty of fish and other marine creatures in the blue waters but, among other purposes, the houses in the village appear to be used to store the day's catch, indicating the importance of fish to the lives of the people. Three canoes float on the sea, each with an oarsman and two armed warriors, while overseeing the busy village in the top right-hand corner is the omnipresent Plumed Serpent, the most sacred of the Mayan deities.

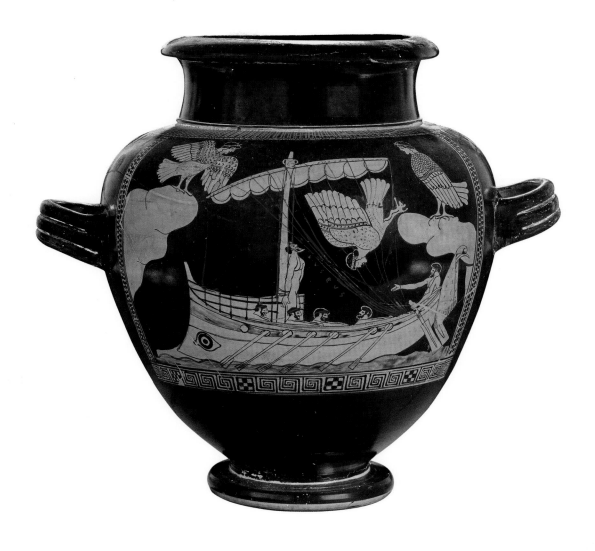

The Siren Painter (attrib.)

Siren Vase, c.480–470 BC
Glazed terracotta, 34 × 38 × 29 cm / 13½ × 15 × 11½ in
British Museum, London

'First you must pass the enchanting Sirens, but any who hear their sweet song will never go home again.' So Circe warned Odysseus in Greek myth, as she helped him build the ship that would finally take him home to Ithaka. If he insisted on listening, he must have his crew bind him to the mast and he must stop up their own ears with beeswax, and when he begged them to loosen his ties, as he would on hearing the Sirens' enchanting songs, they must bind him even tighter. Thus Odysseus listened, and the Sirens were so upset that a mortal heard

their song and escaped that they threw themselves into the sea and drowned. The scene is enacted on this *stamnos*, a storage jar for liquids: two Sirens perch on rocky outcrops, while one, eyes closed, plunges into the sea. The Sirens were originally handmaidens of Persephone, who was abducted by Hades to be his queen. The goddess Demeter gave the women the bodies and wings of birds to help in the search for her daughter. When Jason had passed them in an earlier myth, on the way to steal the golden fleece, he was saved by Orpheus,

who drowned out their song with music. The vase provides interesting details of the rigging of a classical sea-going ship. In the stern, the steersman manipulates two steering oars, attached with ropes to the side of the ship; a raised forecastle occupies the prow. At the top of the mast are metal loops through which the halyards run. Other ropes secure the furled sail and are attached on deck within reach of the steersman.

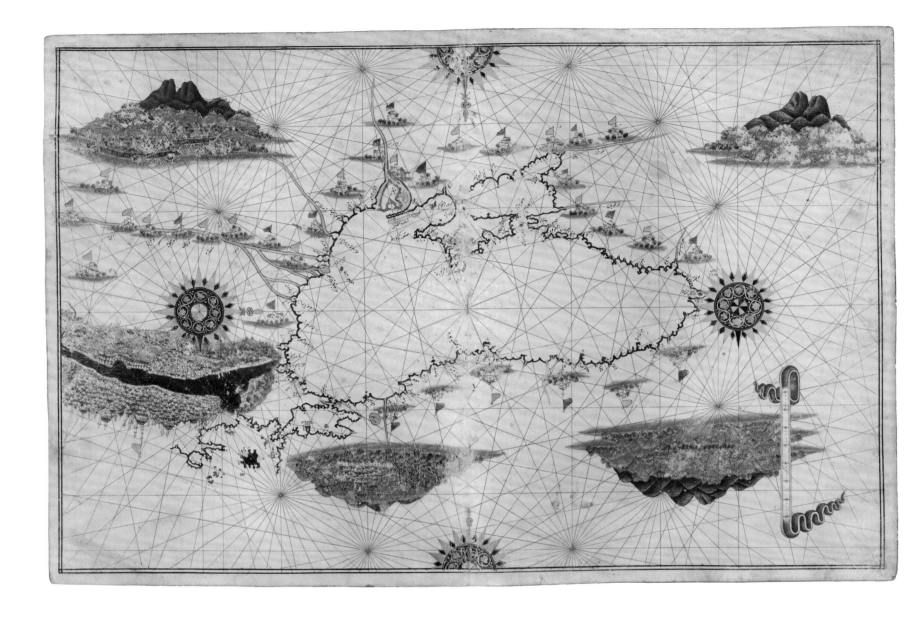

Anonymous

The Black Sea, from the *Walters Deniz Atlası*, 16th century
Opaque pigments on parchment, 30 × 45 cm / 11¾ × 17¾ in
Walters Art Museum, Baltimore

This double-page sea map is the first in a unique early Ottoman atlas – this is the sole surviving copy – showing, on the right, the Black Sea and the Sea of Marmara and, on the left, the Black Sea and the city of Istanbul. While the Black Sea is largely landlocked, it is connected to the Sea of Marmara through the Bosporus Strait and then the Aegean Sea through the Dardanelles Strait. The map is oriented with south at the top, and geographical place names are written in Arabic *nasta'līq* script in the Turkish language. The other nautical charts in the atlas cover the Aegean and eastern Mediterranean Sea; the central Mediterranean and the Adriatic Sea; the western Mediterranean Sea and Iberia; northwest Europe; Europe, the whole of the Mediterranean and North Africa; and the Indian Ocean, East Africa and South Asia. There is also a world map in oval projection. The detailed city vignettes are a distinguishing feature of this atlas. Sea charts originated in fourteenth-century portolans, which showed compass points and prevailing wind directions and were used by sailors to navigate from one harbour to the next. By the mid-sixteenth century, the Ottoman court was awash with maps, charts and atlases, commissioned by the sultan or his courtiers. It has been suggested that this atlas was prepared in Italy for a Turkish patron, possibly a member of the court, based on similarities in content and style with contemporary European atlases and on the elaborate and expensive illustrations. It was probably never meant to be used as a sea chart but is a beautiful example of cartographic artistry that illustrates the growing appreciation among the Ottoman elite of the wider world, suddenly grown much larger.

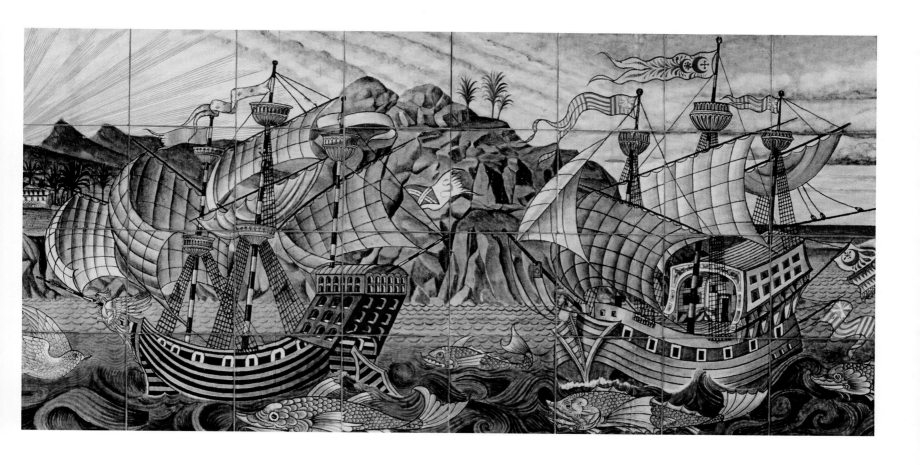

William De Morgan

Galleon Tile Panel, 1895
Tin-glazed earthenware, 60.9 × 152.4 cm / 24 × 60 in
De Morgan Foundation, London

Monstrous oversized fish swim through stylized waves beneath two equally stylized galleons with boldly coloured sails and pennants, prominent crow's nests for observation and huge stern castles that would have housed the quarters of the captain and other officers. Although the rigging supporting the masts of both vessels is a nod to realism, the way the sails billow in different directions betrays the fact that this is an imaginary scene in which reality is less important than aesthetic beauty, emphasized by the many curving lines that create a sense of flowing movement. Elements such as the sun's rays, parallel rows of jagged waves and the lack of linear perspective might seem to suggest that this is a work from the Middle Ages, but in fact, these earthenware tile panels are from the late 1800s, a beautifully preserved example of early work by William De Morgan (1839–1917), one of the finest English ceramic artists of his generation. Closely associated with the Arts and Crafts movement, De Morgan produced the tiles at his Chelsea pottery, and their matte surface decorations share similarities with those made by William Morris during the same period. The sea was a popular theme in Victorian art and provided a significant source of inspiration for De Morgan, whose designs also featured fish, dolphins, sea lions and seahorses. Celebrated for their vibrant colours and captivating imagery, his tiles were seen in many domestic spaces and public buildings throughout Britain during the late nineteenth century. They even sailed on the seas themselves, commissioned by architect and designer T. E. Collcutt as decorations for the sumptuous interiors of P&O ocean liners.

Anonymous

Stick Navigation Chart, Marshall Islands, 1940s–1950s
Carved wooden sticks, cowrie shells, twine lashing, 128 × 100 × 4.5 cm / 4 ft 2 in × 3 ft 3 in × 1¾ in
National Museum of Natural History, Smithsonian Institution, Washington DC

Marshallese society is profoundly influenced by the surrounding ocean – as a source of food, trade and transport, but also sometimes as a source of danger and destruction. Stick charts like this were used by navigators of the Marshall Islands of the South Pacific until about the time of World War II. Shells and pieces of coral record the positions of islands, while the palm ribs show the locations and directions of ocean swell patterns. Such charts were probably used in conjunction with celestial observations to sail outrigger canoes between the hundreds of islands and atolls in the group, sometimes over long distances. These distinctive maps were first reported by missionaries in 1862, when the islands were still a Spanish colony; after Spain sold the islands to the German Empire in 1885, the charts were comprehensively described by a Captain Winkler of the German Navy in 1898. Winkler identified three types: *mattang* charts were for the instruction of future navigators and did not necessarily correspond to real geography; *meddo* charts were actual maps, locating islands, currents and swells; *rebbelith* charts resembled *meddo* charts but had greater detail. The charts were created by individual navigators and were specific to their makers, varying in shape, size and scale. Although no longer in use, stick charts are such an important part of the iconography of the Marshall Islands, which achieved independence in 1986, that they are featured on the national seal.

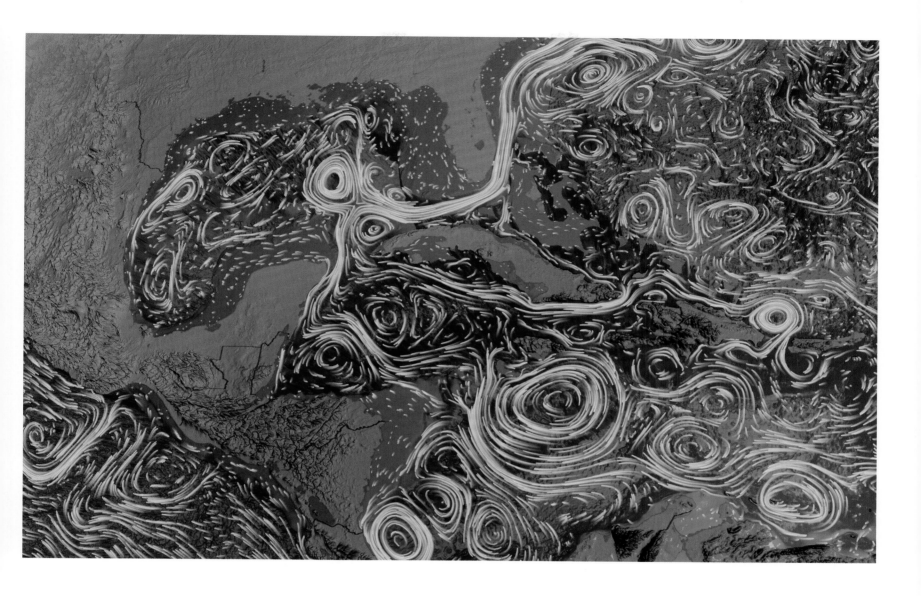

NASA

Perpetual Ocean, 2011
Digital, dimensions variable

Resembling the swirls of a Van Gogh canvas, this image is a still from a visualization of tens of thousands of ocean surface currents converging on the Central American isthmus, captured between June 2005 and December 2007 by satellites for the ongoing NASA project Estimating the Circulation and Climate of the Ocean (ECCO). By combining images from satellites with sophisticated numerical tools, the project set out to model how oceanic circulation evolves over time. ECCO aims to quantify the role the oceans play in the global carbon cycle by charting how changes in the polar oceans affect water temperatures around the globe. With this data, NASA will better understand the complexities of interactions between ocean, atmosphere and land. The swirls in the image represent slower-moving eddies that continually circulate around the world's coasts, and although the visualization only represents larger eddies – and they look more perfect than in reality – the maths behind it reflects one of the largest computation exercises ever undertaken, a joint initiative between NASA's Jet Propulsion Laboratory and the Massachusetts Institute of Technology. The visualization gives a realistic picture of the ordered chaos of the circulating waters of the oceans. Travelling at speeds of more than 6 kilometres per hour (4 mph), some of the larger currents, such as the Gulf Stream in the Atlantic Ocean and the Kuroshio in the Pacific Ocean, carry warm waters thousands of kilometres through the oceans like a great conveyor belt.

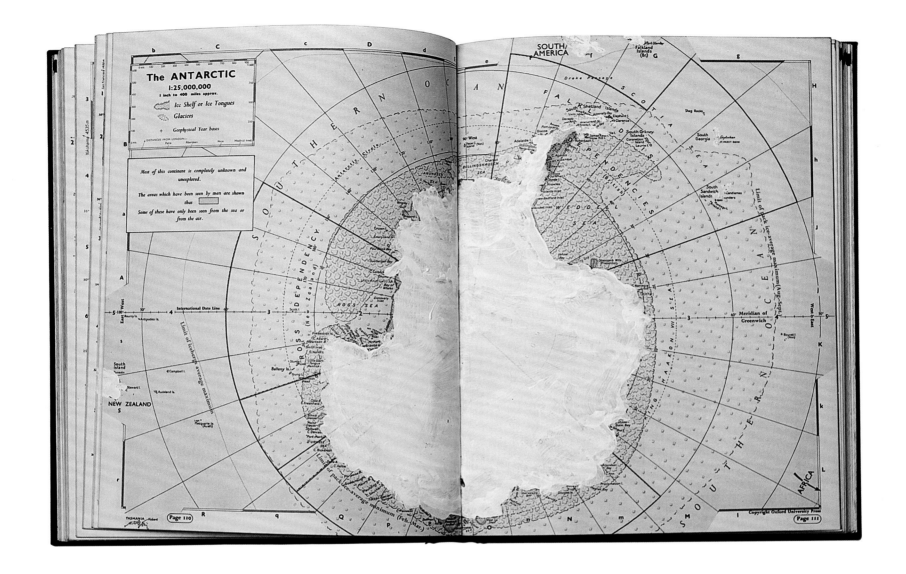

Tania Kovats

Only Blue (Antarctica), 2013
Gesso on printed paper, 25 × 45 cm / 9¾ × 17¾ in
Private collection

The icy landscape of Antarctica is obscured by white paint layered on top of an antique atlas, hiding the continent's topography and locations so that names remain visible only in coastal regions. British visual artist Tania Kovats (b. 1966) has altered numerous old atlases in this way, obliterating landmasses to leave just the surrounding blue ocean. By drawing attention to the bodies of water encompassing countries and continents, the artist proposes an ocean-centric way of thinking about the world, contrasting the longevity of the seas with the transience of human boundaries and territories. This atlas, which dates from the mid-twentieth century, includes geopolitical details such as the British and New Zealand dependencies, highlighting the absurdity of nations laying claim to portions of the uninhabited continent and its waters. Such territorial claims have been suspended since the Antarctic Treaty came into force in 1961, setting aside the region for science. Also visible on the map are the average minimum and maximum limits of pack ice, which are no longer accurate due to atmospheric warming. Significant and rapid declines in sea ice have occurred off Antarctica's west coast in recent decades, while off the east coast sea ice has paradoxically – and curiously – increased since the late 1970s, though at a very slow rate. The oceans have historically shaped much of our world and will continue to do so, especially as climate change-induced sea-level rise threatens to imminently redefine both our coasts and maps. Kovats's project is a timely reminder that any atlas will sooner or later be superseded.

Matthew Cusick

Fiona's Wave, 2005
Inlaid maps on panel, 1.2 × 2 m / 4 ft × 6 ft 6 in
Private collection

At first glance, *Fiona's Wave* appears to be exactly what it seems: a naturalistic painting of an ocean wave nearing shore. On closer inspection, however, the piece reveals its true nature: this image is made up of a collage of details taken from dozens of maps. As New York-born artist Matthew Cusick (b. 1970) says, 'Maps have all the properties of a brushstroke: nuance, density, line, movement and colour.' Cusick has worked as a painter and book artist but is best known for intricate map collages not just of seascapes but also of landscapes and portraits. *Fiona's Wave*

belongs to a series of wave collages named for women that was originally inspired by Japanese art, and particularly Katsushika Hokusai's famous woodblock print *The Great Wave* (see p.127). Cusick's decision to work with cartographic materials sprang from the chance discovery of a boxful of maps in his studio. Fascinated by their potential, he began to experiment, cutting the maps into various shapes and juxtaposing the different shadings and palettes to create his own images. By giving new form to the maps, he also imbued their colours with an emotion and power

that they previously lacked. His ocean pieces use the vibrancy of the maps' blues and off-whites to create an image that appears to move when seen from a distance. Close up, the lines and names are clearly visible, giving the image an added three-dimensionality that is lacking in a two-dimensional map. As Cusick neatly expressed his thinking: 'Maps provided so much potential, so many layers. I put away my brushes and decided to see where the maps would take me.'

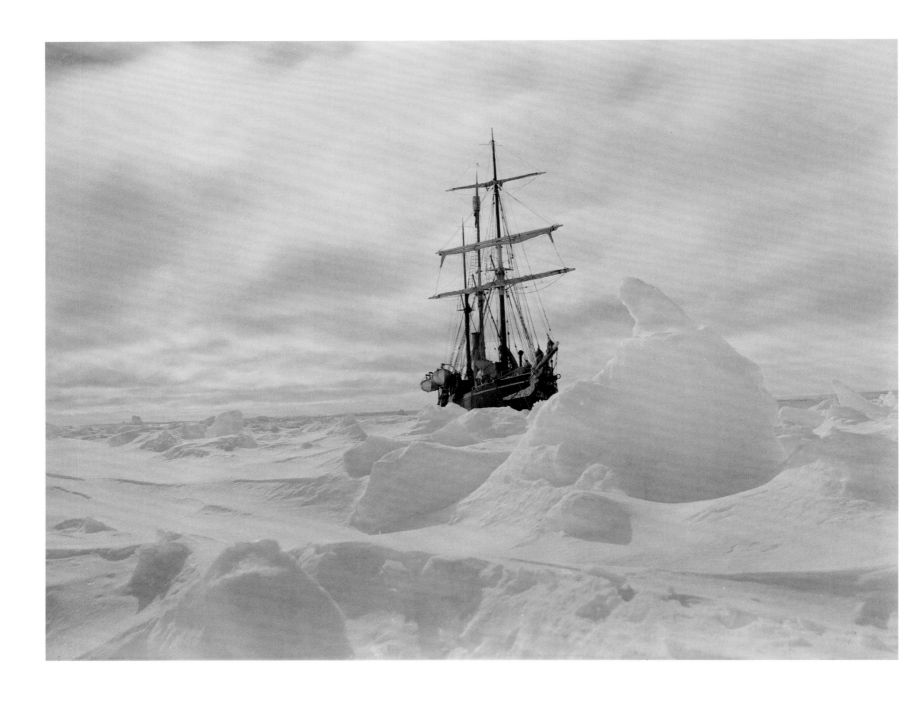

Frank Hurley

Endurance *Frozen in the Ice, Antarctica*, 1914
Photograph, dimensions variable
Royal Geographical Society, London

The beauty of this image belies the grave situation it depicts. In it, the ship *Endurance*, which had safely carried the twenty-eight men of Ernest Shackleton's 1914–16 British Imperial Trans-Antarctica Expedition south from England is seen held fast in the frozen Weddell Sea. At the time the image was taken by the expedition's photographer, Frank Hurley (1885–1962), the men hoped the spring melt would eventually free the ship. In fact, *Endurance* was crushed by the ice and sank on 21 November 1915. That this image survived is down to Hurley's dedication to his cause.

Shackleton had insisted that Hurley leave the glass negatives on board the sinking ship, but carpenters made a hole in the vessel's side through which Hurley retrieved them. Of 550 negatives, he saved around 150; he relinquished all his other equipment apart from a pocket camera and three rolls of film. The crew took to *Endurance*'s lifeboats and eventually reached Elephant Island on 15 April 1916. From there, Shackleton and five others undertook a perilous 1,300-kilometre (800-mi) journey in a rowing boat to South Georgia to seek help. Hurley was among

the group who remained on Elephant Island until all the men were rescued alive on 30 August 1916. In 1917, he shifted from documenting exploration to conflict, at the western front of WWI, but after the war he returned to Antarctica twice, in 1929 and 1931, with the Australian explorer Douglas Mawson on the British Australia and New Zealand Antarctic Research Expeditions. The *Endurance* itself was photographed again in 2022 when the wreck was located 3 kilometres (1.9 mi) below the surface.

Esther Horvath

Gentoo Penguins on Denco Island, Antarctica, 2018
Photograph, dimensions variable

Since 2015, Hungarian ecological photographer Esther Horvath (b. 1979) has focused almost exclusively on the polar regions, raising awareness of the effects of climate change. This image of gentoo penguins (*Pygoscelis papua*) was taken in 2018 during an expedition onboard the Greenpeace vessel *Arctic Sunrise* to document 4,500 square kilometres (1,735 sq mi) of the Weddell Sea in the Southern Ocean – five times the size of Germany – that has become the Antarctic Ocean Sanctuary. The aim of this marine reserve is to protect the fast-declining populations of gentoo and Adélie penguin colonies,

along with their habitats. Gentoo penguins often live in giant colonies of many thousands that gather on ice-free coastal areas. Upon reaching maturity, pairs form long-lasting bonds and takes turn incubating their eggs, which are laid in a circular nest made of grass, stones, feathers and moss. Gentoo couples are exclusively monogamous for life, and infidelity is often punished with banishment from the colony. Cumbersome waddlers on land, gentoo penguins are dexterous swimmers who can cut through currents at the speed of 35 kilometres per hour (22 mph) – faster than any other

diving bird. While hunting krill, squid and fish, they can remain underwater for up to seven minutes and dive to depths close to 200 metres (655 ft). Horvath has taken part in more than a dozen polar expeditions, including visiting remote communities of military personnel and scientists, and in 2022 she was the photographer on the Endurance22 expedition that discovered the wreck of Ernest Shackleton's wooden ship *Endurance* (see p.38) on the seabed about 3,000 metres (1.9 mi) beneath the Weddell Sea, whose cold waters had preserved it so perfectly the ship's name was clearly legible on its stern.

Tupaia

Maori Trading a Crayfish with Joseph Banks, 1769
Watercolour on paper, 26.8 × 20.5 cm / 10½ × 8 in
British Library, London

Eighteenth-century voyages of discovery were not for the fainthearted, nor for those for whom decent food was essential: weevil-infested hardtack (a dry flour biscuit) and dried, salted beef were staples. Once ashore, fresh fruits, vegetables and water were what every sailor wanted, and a large lobster or crayfish was worth bartering for. This drawing was made by Tupaia (c.1725–1770), a Polynesian high priest who played a crucial role in the success of Captain James Cook's first expedition to New Zealand in 1769, acting as translator, navigator and

negotiator. It shows Sir Joseph Banks, president of the Royal Society, which was funding the voyage, attempting to trade a piece of cloth for a Maori's lobster. Neither party appears to entirely trust the other: Banks holds tight to his cloth, and the Maori keeps the lobster on a string lest it be taken prematurely. Diaries of those who sailed with Cook indicate that Tupaia was a tattoo artist who was encouraged to draw by the naturalists and artists on board HMS *Endeavour*. Banks and others returned to Britain with tattoos probably created by the priest. Tupaia

joined Cook's voyage in July 1769 at Tahiti, and his local knowledge and ability to understand the Maori language when the Europeans arrived in New Zealand were invaluable. Surviving oral histories there make it clear that the Maori believed that Tupaia captained the ship and the Europeans were under his command, a belief he no doubt encouraged.

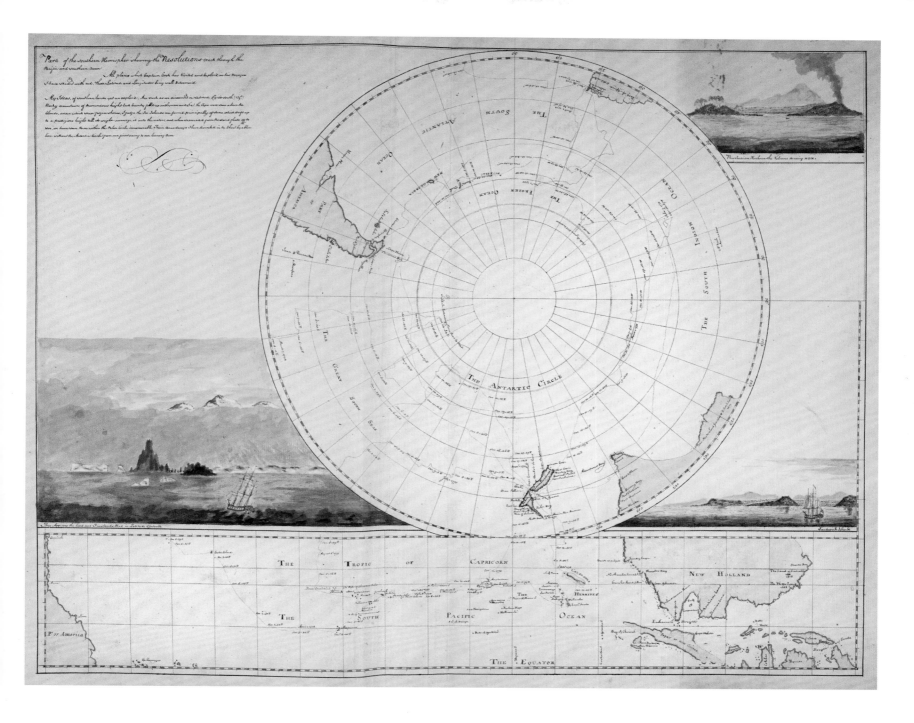

Joseph Gilbert

Chart Showing the Southern Hemisphere and the Route of Cook's Second Voyage, 1775
Pen and ink, wash and watercolour on paper, 51 × 65.3 cm / 20 × 25 in
British Library, London

The second voyage of British seafarer Captain James Cook through the southern Pacific and Antarctic Oceans between 1772 and 1775 was one of history's greatest feats of exploration. Commissioned by the British government, Cook was tasked with circumnavigating the globe as far south as possible to determine the existence of the postulated continent of Terra Australis. He set sail from Plymouth Sound, England, on 13 July 1772 in command of the HMS *Resolution* while English navigator Tobias Furneaux commanded the HMS *Adventure*. Often sailing in subzero temperatures, Cook's voyage took him to Easter Island, Tahiti, the Tonga Islands, the New Hebrides, South Sandwich Islands and South Georgia, among other places, many of which he named as he went. Created by the voyage's surveyor, Joseph Gilbert (1732–1831), and an unidentified draughtsman, this chart, which marks in red the places visited by the expedition, was the first European map to accurately plot many of the Pacific islands. Three inset coastal landscapes show some of the sights, including Mount Yasur, a smoking volcano on Tanna Island, Vanuatu. The lower left image shows the *Resolution* approaching Freezland Rock, a sharp-pointed crag surrounded by floating ice in the South Sandwich Islands, while on the lower right, labelled 'Sandwich Island', is the island known today as Efate, in Vanuatu. In searching for Terra Australis, and establishing its nonexistence, Cook's remarkable voyage of discovery included the first crossing of the Antarctic Circle and two long circuits of the southern Pacific. His expedition inspired further exploration of the region, and in the nineteenth century more than one thousand ships travelled to the Antarctic.

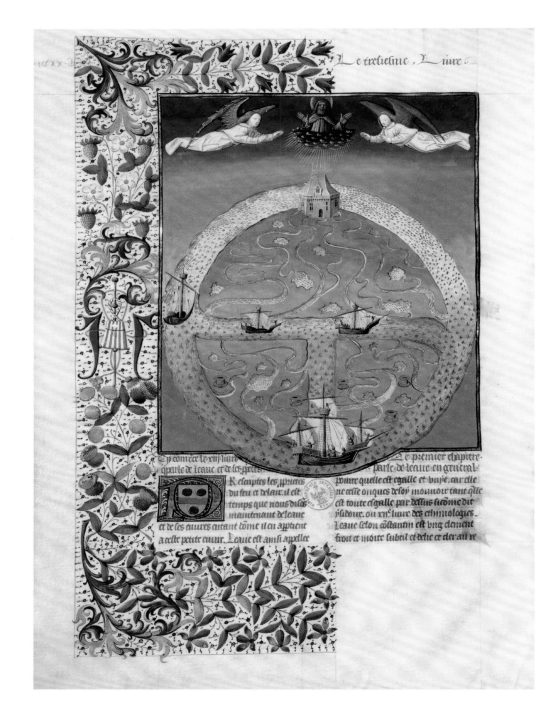

Bartholomew the Englishman and Évrard d'Espinques

The Properties of Water (Les propriétés de l'eau), 1479–80
Parchment, 42 × 32.5 cm / 16½ × 12¾ in
Bibliothèque nationale de France, Paris

This miniature from a medieval illuminated manuscript on parchment features floral ornaments and text accompanying a large illustration that depicts the medieval concept of Earth in an arrangement known as a T and O map. The map presents the three parts of the inhabited Earth in a circle that represents the impassable ocean. The three continents are separated from one another by a T made up of large bodies of water: the vertical Mediterranean between Europe and Africa, the Tanaïs (the River Don) between Europe and Asia, and the Nile between Asia and Africa. At the top of the O, between Heaven and Earth, a golden house marks the Garden of Eden, from which the Book of Genesis said four rivers flowed: the Pishon, the Gihon, the Tigris and the Euphrates. The page is crowned by two angels and a central figure in blue and gold. This miniature comes from Book XIII ('On the Properties of Water') of *On the Properties of Things (De proprietatibus rerum)*, written by Bartholomew the Englishman (Barthélémy l'Anglais, c.1190–after 1250), an English-born Franciscan monk who lived in Paris until 1230 and then Magdeburg, Germany, and was illuminated by French artist Évrard d'Espinques (active 1440–1494). *On the Properties of Things* was translated into several languages and became a bestselling encyclopaedia of the Middle Ages for, as Bartholomew wrote in his epilogue, 'the simple and the young, who on account of the infinite number of books cannot look into the properties of each single thing about which Scripture deals, can readily find their meaning herein – at least superficially'.

NASA

Earth Science, 1994
Photograph, dimensions variable

From 35,800 kilometres (22,300 mi) above Earth, the planet is largely a brilliant blue in this satellite image taken in September 1994 that shows the vast Pacific Ocean to the left, with the Atlantic Ocean and the Caribbean to the right. Brilliant white clouds form and swirl in the atmosphere, while North and South America are fully illuminated by the sun, greens and tans identifying their various ecosystems. Nearly 71 per cent of the world's surface is covered by the ocean, comprising 1.3 *billion* cubic kilometres of water, or about 97 per cent of all water found on

Earth, which is why one of the first photographs to show the whole planet, taken by astronauts onboard *Apollo 17* in 1972, was nicknamed the Blue Marble. When seen from space, geopolitical boundaries and divisions disappear, and the enormity of Earth's oceans becomes inescapable, and that original Blue Marble is often credited with changing humanity's understanding and appreciation for our planet, as well as each other, and for inspiring the development of the environmental movement to protect Earth's obvious fragility. There have been more Blue Marble

images in the half-century since the original, but many, including this one, are at least somewhat deceptive. Unlike the original image – simply snapped with a camera through the window of the spacecraft – this image combines elements taken from two different images from two different satellites. Both satellites were part of the system of Geostationary Operational Environment Satellites (GOES) placed in orbit above particular locations on Earth to watch for atmospheric triggers for major events such as tornadoes, hurricanes and flash floods.

Coument alexandres se fist avaler en la mer ou tonnel de voirre

Anonymous

Alexander the Great's Voyage Under the Sea, from *The Novel of Alexander*, 1300–25
Illumination, watercolour and opaque colour on parchment, 25.9 × 18.8 cm / 10 × 7½ in
Kupferstichkabinett, Staatliche Museen zu Berlin

In a sea teeming with fish – including one so large it might very well represent a whale – a king is lowered to the seabed in a glass vessel, wearing his crown and holding his sceptre, illuminated by burning torches. On the seabed he sees trees, sheep and dogs, and a naked couple playing fishlike musical instruments. Despite his medieval dress, the king in the diving bell is Alexander the Great, ruler of the ancient Greek kingdom of Macedon who created one of the largest empires in history in the fourth century BC. The story of the king's trip to the seabed is recounted

in the *Alexander Romance*, one of a number of medieval collections of fabulous tales about Alexander's life. Here Alexander, having conquered much of the world, determined on also conquering the depths of the sea. In a German version of the story, the diving bell is held in place not by sailors but by one of his mistresses, holding the end of a long chain attached to the vessel. As soon as the king had sunk beneath the waves, she eloped with another lover, dropping the chain and leaving Alexander to devise his own escape. However,

the king returned to shore, and the story reported that Alexander was shaken by the experience, seeing how easily big fish swallowed little fish – and concluding that trying to conquer the seas was folly. The idea of a glass vessel that could be used to travel beneath the oceans was first recorded in ancient Greece – though some centuries after Alexander's time – but the first practical diving bell was not built until the mid-1500s.

Anonymous

Whale Effigy, c.AD 1000–1700
Soapstone and clamshell beads, 9.2 × 11.4 cm / 3⅝ × 4½ in
Portland Art Museum, Oregon

Measuring just over 11 centimetres (4½ in) long yet communicating a sense of immense weight, this carved soapstone whale with an exaggerated dorsal fin was made by craftspeople of the indigenous Chumash culture of California. It was likely created at a time when Spanish conquistadors were only just beginning to map the southern and central coastal regions the Chumash had inhabited for thousands of years before Europeans arrived in 1542. Chumash carvers prized easily worked soapstone (steatite), mined from the offshore island of Santa Catalina for such effigies, as well as implements such as pipes and cooking vessels, including a characteristic skillet known as a *comal*. The Chumash are an ocean-oriented people, who traditionally fished the stretch of California coastline from Morro Bay in the north to Malibu in the south, using sturdy canoes known as *tomols*, constructed from split redwood or pine planks, which could head far out to sea in search of large catches including swordfish and even whales. Whale bones from hunted animals or washed-up carcasses – likely most often belonging to the grey whales that are common to the area – were used as tools for splitting the planks to make boats and as supports in dome-shaped and thatched 'ap' houses. The Chumash monetary system used small shell beads (the name *Chumash* translates as 'bead maker'), very similar to the inset eyes and mouth of this whale, made from clamshell beads drilled and carved with quartz tools. The Chumash used such shells to trade with other tribes throughout southern California, for food, animal hides and other resources.

Susan Middleton

Pacific Giant Octopus, 2014
Photograph, dimensions variable

Seen against a pure white background, the almost otherworldly form of a tiny, translucent juvenile Pacific giant octopus (*Enteroctopus dofleini*) is captured in remarkable detail by American photographer Susan Middleton (b. 1948): the bubblelike body, iridescent eye, and furling tentacles of this beautiful mollusc, as well as the coloured spots that cover its body. Although this young specimen measured only about 2.5 centimetres (1 in) in length, an adult Pacific giant octopus can weigh as much as 50 kilograms (110 lbs) with a tentacle span of

6 metres (20 ft), making it the largest of all octopus species. Living mainly in coastal waters of the North Pacific Ocean, from California north to Alaska and west to Japan and Korea, the Pacific giant octopus is also one of the longest surviving of all octopuses, living up to five years. Females lay up to around one hundred thousand eggs, which they attach to underwater rocks and keep clean of algae, blowing water over the spawn. The female remains in position for up to six months, slowly starving as she uses up her body's supplies; she dies soon after the spawn

have hatched. Like other octopuses, the Pacific giant octopus is renowned for its intelligence, and has become a popular attraction in aquariums around the world, where it is said to recognize individuals with which it comes into frequent contact. Middleton often photographs specimens against plain backgrounds rather than in their natural habitat in order to focus attention on their physiology; she has carried out seven years' worth of research into marine invertebrates such as octopuses, animals that make up more than 98 per cent of known marine species.

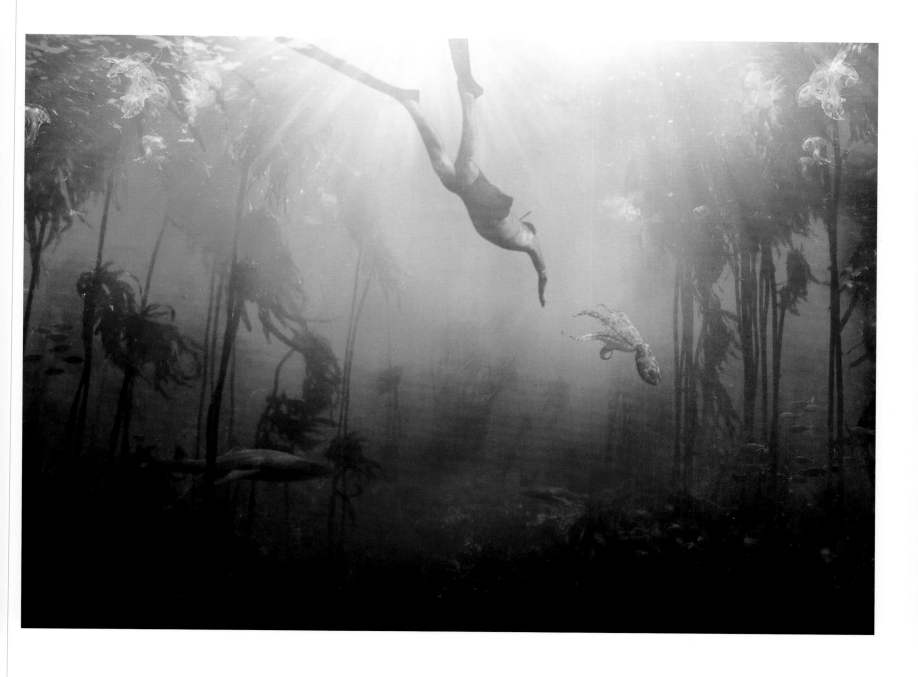

Craig Foster

My Octopus Teacher, Netflix, 2020
Promotional image, dimensions variable

Winner of the 2021 Academy Award for best documentary feature, the Netflix film *My Octopus Teacher* tells the story of an unlikely friendship forged between a female common octopus and the South African naturalist and underwater photographer and filmmaker Craig Foster (b. 1968). The two met during Foster's diving sessions in False Bay in South Africa's West Cape, undertaken as a way of dealing with the professional burn out and depression he was suffering from. Foster started to explore and document the underwater kelp forests near Cape Town, swimming without a breathing apparatus – he can hold his breath for six minutes at a time – or a wetsuit, which he felt helped him get closer to the underwater animals. Over the period of a year, Foster recorded his interactions with the female octopus, which was living in a nearby kelp forest. Extensive studies of the common octopus – a mollusc found in many of the planet's oceans – have revealed its ability to change colour to blend in with its surroundings and, while hunting at dusk, its ability to jump on prey molluscs and use its beak to break their shells. Highly intelligent, octopuses can distinguish the position of objects as well as their shape, size and brightness. Over the course of the film, Foster not only recorded the daily life of the octopus but also the improvement of his mental health, which he credited to the octopus's lessons about the fragility and value of life. The film includes footage of the octopus surviving a shark attack by clinging to the shark's back and records her death, from natural causes, as she looked after the eggs she had just laid.

Juan Carlos Muñoz

Mangrove Wetlands of the Everglades National Park, 2012
Photograph, dimensions variable

The Everglades National Park is the jewel in the state of Florida's crown, a vast area of tropical wetlands, covering some 600,000 hectares (1.5 million acres) towards the state's southern tip, not far from the urban metropolis of Miami. Made up of coastal mangroves, sawgrass marshes and pine flatwoods, the Everglades is, in essence, a huge network of slow-moving grassy rivers. It is also home to hundreds of animal species, many of which are endangered, such as the West Indian manatee and leatherback turtle. The Everglades' ecosystem is unique: under the grass are layers of porous, water-retaining limestone fed by water that originates in the rivers of central Florida and drains southwards, making the Everglades a huge drainage basin. Mangrove forests – comprised of several species of trees that thrive in saltwater and harsh coastal conditions – are not only a vital habitat for marine animals but also provide essential protection against the high winds and storm surge of hurricanes. The Everglades has the largest continuous mangrove ecosystem in the entire western hemisphere. Taken from the air, this photograph by Juan Carlos Muñoz (b. 1961) captures not only the unique quality of the Everglades but also its sheer vastness. However, this is misleading: for much of the twentieth century, the Everglades has suffered from loss of habitat and degradation as a consequence of human activity. It once covered more than 1.2 million hectares (3 million acres) but is half its original size today. Human activity has even altered the course of the Everglades riverine system, threatening a fragile ecosystem that supplies drinking water to more than eight million Floridians.

Yoshitomo Nara

Sea Pig, 1993
Acrylic on canvas, 39.5 × 39.5 cm / 15½ × 15½ in
Private collection

Seemingly floating above the ground, the eponymous sea pig is the work of the contemporary Japanese artist, painter and sculptor Yoshitomo Nara (b. 1959). Against a neutral cream background – created by layers of paint in subtly varied pigments – with no perspective save a wavy green line, suggesting a sea plant, the cartoonlike sea pig, or *dugong*, pops off the canvas, occupying a space outside the constraints of time and place. The shy marine mammal lives in the shallow sea-grass beds around the Indian and western Pacific oceans, and Henoko Bay on the Japanese island of Okinawa is one of its last remaining habitats. Critically endangered and genetically isolated – its closest living relative is the manatee of Florida – the dugong is central to the creation mythology, folklore and rituals of the Okinawa islanders. A pioneering figure in contemporary art, Nara is influenced by Japan's subculture of comic books, animated films and video games, but while he is best known for his cartoonish, melancholic paintings of children – notable for their piercing eyes – animal paintings also form a significant part of his oeuvre. In 1988 Nara moved to Germany to study at the art institute in Düsseldorf, where he lived until 1993, the year he painted *Sea Pig*. In Germany, he began to synthesize Japanese and Western pop culture, celebrating the introspective freedom and independence of individuals while also revealing their loneliness and isolation, as in this wistful creature.

Flip Nicklin

Giant Kelp Forest, Channel Islands National Park, California, c.1977–82
Photograph, dimensions variable

Captured in almost painterly detail, this ethereal image by photographer and marine biologist Flip Nicklin (b. 1948) reveals the translucent blades and spherical bladders of a single stalk of giant kelp (*Macrocystis pyrifera*) in Channel Islands National Park off the coast of Southern California. Kelp forests, which grow best in cold, nutrient-rich waters, provide nurseries for a wide range of underwater species and are the basis of extensive underwater ecosystems. Despite resembling plants, kelp are actually large brown algae that are attached to the seabed but that rely on sunlight to grow; in order to thrive, they need shallow, clean water. Given the right conditions, giant kelp can reach lengths of up to 53 metres (175 ft) and can grow as much as 61 centimetres (2 ft) a day; such rapid growth means that kelp forests can easily develop in new areas of the ocean. It also makes kelp one of the most effective carbon sinks on the planet. Through photosynthesis, the macroalgae removes carbon dioxide from the atmosphere and then the kelp, carried by its gas-filled bladders, floats out to sea. From there, the plant detritus sinks to the deep sea where the carbon contained within it remains trapped, rather than being released back into the atmosphere. But kelp forests can just as easily disappear if conditions are less than optimal, making them important indicators of ocean health. Warmer seas and changes in currents are just two threats to the well-being of the algae, impacting not just the kelp but also the thousands of species of fish and invertebrates that spawn and live within it. The kelp forests provide not just protection for young creatures but also fertile hunting areas for sharks and other marine predators that patrol the channels between the algae.

Algæ - The Sea-weed Tribe.

Elizabeth Twining

Algae – The Seaweed Tribe, c.1840s
Watercolour on paper, 48.9 × 32.8 cm / 19¼ × 13 in
Natural History Museum, London

This watercolour shows four types of marine algae found off the coasts of Britain, including probably the best known of all seaweeds, bladder wrack (2, *Fucus vesiculosus*). Named for the round air bladders that allow it to float upwards in the water, bladder wrack grows in dense patches on rocky coasts between the low- and high-water marks. It was the original source of the chemical iodine, which is widely used in medicine as an antiseptic for wounds and for other uses. It is illustrated here by British artist Elizabeth Twining (1805–1889) along with three other seaweeds:

1, *Himanthalia lorea* (now named *Himanthalia elongata*); 3, *F. nodosus* (now named *Ascophyllum nodosum*); and 4, *Delesseria sanguinea* (sea beech). At the foot of the plate, a handwritten paragraph describes the biology of seaweeds in some detail. Known for her detailed botanical illustrations, Twining was born into the famous family of tea merchants in London and was much inspired by the Royal Horticultural Society's gardens at Chiswick, and notably by *Curtis's Botanical Magazine*, with its renowned botanical illustrations. Twining believed

strongly that her work was important not only for the science of botany but also for bridging the gap between the rich and the poor by making scientific knowledge more widely available. Large seaweeds and most small seaweeds are multicellular marine algae and are essential for the health of the oceans – and of the planet. Seaweed ecosystems provide nurseries and food for a wide range of marine life, including important commercial fish. Seaweed also captures large amounts of carbon dioxide from the atmosphere and produces more than 50 per cent of the world's oxygen.

Alice Shirley

Under the Waves, first edition, Spring/Summer 2016
Gouache on paper, 90 × 90 cm / 35½ × 35½ in
Hermès collection, Paris

Around a thin sliver of blue ocean water, a vivid depiction of the Great Barrier Reef, rife with marine flora and fauna, is arranged in a dizzying composition. Originally painted in gouache on paper, this scarf design by British artist and illustrator Alice Shirley (b. 1984) is one of numerous patterns inspired by the natural world that she has produced in collaboration with the renowned French house of know-how Hermès since 2012. Shirley delights in studying directly from specimen collections, such as with her life-size 9-metre (30-ft) portrait of a

giant squid in squid ink, produced while working as resident artist at London's Natural History Museum. Here, a kaleidoscopic assortment of colours and forms is underpinned by the same careful scientific observation, with an identifiable array of marine life, including a sea turtle, mandarin fish, clownfish, emperor angelfish and leafy sea dragon. The scarf represents Shirley's and Hermès's tribute to the Great Barrier Reef, a natural wonder whose existence is threatened by human activity and global warming. 'Humans are conspicuous by their absence in my

work', says Shirley, who believes that wild nature must be allowed room to recover and reassert itself for the sake of the planet. In *Under the Waves*, the near-abstract compression of nature in the classic 90-centimetre (3-ft) Hermès square resolutely leaves no room for human incursion. When worn as intended around the neck, however, the ruffles, creases, folds and knots suddenly transform its two dimensions to simulate the depths of the ocean and send the assorted sea life dancing in motion.

1 Añil *Plectropoma Indigo*
2 Gutagamba *Gummi-gutta* } *Poey.*
3 Rabiche. *Mesoprion caudanotatus*

Felipe Poey

Plate 3, from *Memorias sobre la historia natural de la isla de Cuba,* 1851
Hand-coloured engraving, H. 25 cm / 9⅞ in
Smithsonian Libraries, Washington DC

Illustrated in vibrant blues, yellows and pinks, these tropical fish are just one of dozens of plates in the eight-volume *Memorias sobre la historia natural de la isla de Cuba* (*Memories of the Natural History of the Island of Cuba*) by Cuban zoologist Felipe Poey (1799–1891), published between 1851 and 1861. Annotated with both the common Spanish name as well as the Latin, Poey depicts here the indigo hamlet (*Plectropoma Indigo,* now named *Hypoplectrus indigo*), the golden hamlet (*Plectropoma Gummi-gutta,* now *Hypoplectrus gummigutta*), and the blackfin snapper

(*Mesoprion caudanotatus,* now *Lutjanus buccanella*). All three of these fish are found mainly in the western Atlantic and Caribbean, including the waters surrounding Cuba. The indigo hamlet and golden hamlet are solitary species mainly living near coral reefs, while the blackfin snapper is highly social, often aggregating in small schools. Poey was a prominent Cuban naturalist who developed a keen interest in marine life, especially fish, partly through regular visits to fish markets, where he discussed the catch with local fishermen. Born in Havana, he moved with his family to France when he

was five. After studying law, he returned to Cuba, and in 1825 went back to Europe to work as a lawyer in Paris – bringing several fish specimens with him, which he sent on to Georges Cuvier for inclusion in Cuvier's *Natural History of the Fishes.* He again returned to Cuba in 1833, where he began cataloguing the native fish, eventually describing and illustrating more than seven hundred species in his book *Ictilogía Cubana* (*Cuban Icthology*). In 1839 he established the Museum of Natural History in Havana and in 1842 was appointed the first professor of zoology at the University of Havana.

Masa Ushioda

Green Sea Turtle being Cleaned, Kona Coast, Hawaii, 2006
Digital photograph, dimensions variable

Think of a cleaning station as an ecologically necessary spa for the denizens of a coral reef. It's where marine animals congregate on a regular basis to have those hard-to-reach parts of their bodies inspected by smaller fish or shrimps, and allow themselves to be picked clean of parasites. Large predators such as groupers open their mouths wide so tiny cleaner fish, such as wrasse, can do the job of piscine dental flossers, swimming into what would normally be the jaws of death to tug away at whatever they find in the spaces between the

grouper's teeth. It's a mutually beneficial symbiosis: the cleaners get food, the recipient of the service is kept healthy. You only need to look at this photograph by Japanese photographer Masa Ushioda to sense something of the casual attitude adopted by the creatures who use cleaning stations such as this one located off the Kona Coast of Hawaii. The everyday stresses of reef life – the threat of being hunted, the need to defend territory – are suspended in this underwater safe space. This green sea turtle (*Chelonia mydas*) is clearly prepared to float along while the

yellow tangs (*Zebrasoma flavescens*), gold-ring surgeonfish (*Ctenochaetus strigosus*) and saddle wrasse (*Thalassoma duperrey*) use their precise tweezer jaws to feed on the drag-inducing algae on the turtle's shell. The reptile remains perfectly stationary, surprisingly relaxed for an animal that weighs 160 kilograms (350 lbs). The turtle is neutrally buoyant in water only 8 metres (26 ft) deep, but with the ability to vary its buoyancy by how much air it has in its lungs when it dives, it can achieve that state equally well at 80 metres (260 ft).

Dhambit Munuŋgurr

Gamata (Sea grass fire), 2019
Synthetic polymer paint on Stringybark (*Eucalyptus* sp.),
1 × 2.1 m / 3 ft 4 in × 7 ft
National Gallery of Victoria, Melbourne

A few colours of acrylic paint – shades of blue, white, green – on a sheet of bark represent a modern twist on the traditional handcraft of the Yolngu, an Aboriginal people from coastal northeastern Arnhem Land in Australia's Northern Territories. The centre of the painting is dominated by the diagonal dark blue figure of the endangered dugong, an aquatic mammal related to the manatee. This central element is surrounded by lines in shades of clear blue representing a type of seagrass called Gamata, which is food for the dugong. There are

small fish in black and blue, small and large turtles in blue and green, and jellyfish, which burn and create the 'fire' of the painting's title, also a reference to the fact that the scene is bathed in sunlight. The white chainlike spots represent streams of oxygen bubbles. Dugongs, also known as sea cows, are mythical animals in the Northern Territories, where they traditionally represent female energy and gentleness. They are a threatened marine species, so the image is also a call for the urgent need to protect the oceans. The daughter of two prize-winning

Aboriginal artists, Dhambit Munuŋgurr (b. 1968) obtained special permission to use acrylic paints rather than natural pigments, which are difficult for her to grind after a car accident, in order to continue using the secret designs of the Yolngu. Painting on bark is a traditional handicraft of the Australian Aboriginal community, which uses the bark of the gadayka tree (stringybark gum), gathered just after the rainy season when it is still flexible.

Yves Klein

Relief Éponge Bleu (RE 51), 1959
Dry pigment in synthetic resin, natural sponges and pebbles on board,
103.5 × 105 × 10 cm / 3 ft 4¾ in × 3 ft 5⅜ in × 4 in
Private collection

Is this ultramarine blue painting alluding to underwater oceanic secrets or gesturing to an otherworldly cosmic dimension? Both interpretations are plausible. The sea sponges in this relief are familiar from images of the seabed, and yet in the conceptual world of French avant-garde artist Yves Klein (1928–1962), the colour blue also connoted a deep sense of existential spiritualism associated with the infinite. Klein's predilection for ultramarine was deeply rooted in philosophical and religious ideas shared across many cultures. During the Renaissance, ultramarine blue – its name refers to its origins 'beyond the sea', specifically from lapis lazuli mined in what is now Afghanistan – was five times more expensive than gold. It was associated with the infinite motherly love of the Madonna, who wears a blue cloak in Christian religious paintings, the commissions for which often specified the cost to be paid for the ultramarine pigment. In China, blue symbolizes immortality, while in India the colour is associated with Lord Krishna. Blue also played important symbolic roles in Egyptian art, and in many parts of Africa it is still associated with harmony and love. So fond was Klein of this specific vibrant hue of intense blue that he branded it IKB (International Klein Blue) and registered it as a trademark in 1957. Klein often used natural sea sponges and pebbles in reliefs that summon the dreamlike image of the ocean floor. Multicelled animals without a central nervous system or brain, sea sponges resemble coral in the way that they filter water, process carbon and collect bacteria, living up to two hundred years.

Roy Lichtenstein

Sea Shore, 1964
Oil, acrylic on two joined sheets of Plexiglas, Plexiglas frame
with painted glazing, 62.9 × 77.9 × 7.8 cm / 24¾ × 30¾ in
Whitney Museum of American Art, New York

Pared down to its essential elements of sky, sea and land, this striking coastal scene appears as if ripped from the pages of a vintage comic book. Its swooping clouds, bright yellow rocks and choppy blue waves are rendered with a mixture of strong unmodulated colours, black outlines and uniform dots. Although the colourful Pop Art style of renowned American artist Roy Lichtenstein (1923–1997) is unmistakable, the coastal drawings, collages, prints and paintings that he started producing in 1964 and continued working on over four decades are less well known.

Like many artists in the 1960s, Lichtenstein experimented with different materials, painting onto steel, brass and plastic. In this example, the design is painted onto two sheets of transparent Plexiglas that are layered together to create a subtle visual effect that corresponds to the shimmering of light on water. This is most apparent when looking at the American artist's signature Ben-Day dots, which he derived from the cheap mechanical printing method developed by Benjamin Henry Day Jr in 1879. In the 1970s, Lichtenstein lived on Long Island,

New York, where he had an oceanfront home in the town of Southampton. Although he was inspired by his coastal environment, it is impossible to identify any specific locations in his ocean views, which are all based on clichés from popular culture. Some compositions are derived directly from the backgrounds of comic strips, while others are based on tourist postcards or simply plucked from the artist's imagination.

Iris van Herpen

Sensory Seas, 2019
Fabric, dimensions variable

This diaphanous, iridescent sculpture, floating adrift in a sea of black is, in fact, a dress. The work of the Dutch fashion designer Iris van Herpen (b. 1984) from her Spring/Summer 2020 collection, 'Sensory Seas', the garment is inspired by the marine ecology of the oceans. Van Herpen is known for pushing the boundaries in her work, using fabrics and techniques not normally associated with the fashion world. For this collection, she constructed shell-like dresses using lasers to cut pearlescent exoskeletons inspired by the 'butterfly' effect: the idea that a small change, such as swapping scissors for lasers, will have multiple and unpredictable outcomes. The result is a delicate, fluttering dress in shades of aquamarine and turquoise that resembles the sea creatures that undulate in the depths of the ocean. The originality and unpredictability of her vision were beautifully captured in the twenty-one dresses that made up 'Sensory Seas', which she intended to celebrate the mysterious quality of the deep ocean – of which, she points out, only 5 per cent has been explored – while also giving form to the pioneering drawings of the human brain created by Spanish neuroscientist Santiago Ramón y Cajal in the early 1900s. This is probably unsurprising from a designer who has previously visited the nuclear research facility at CERN for inspiration and who routinely works with the architect Philip Beesley in her striving to articulate the sensory processes of the human body. Pushing her work even further, in her Autumn/Winter 2021 collection 'Earthrise', Van Herpen partnered with nonprofit environmental organization Parley for the Oceans to create a look with upcycled fabric made from marine debris.

Romare Bearden

The Sea Nymph, 1977
Collage of various papers on fibreboard with paint and graphite,
118.1 × 87.6 cm / 46½ × 34½ in
Private collection

In Book V of the ancient Greek epic poem *The Odyssey*, Odysseus finally leaves the island of Calypso to make his way home to Ithaca. Bowing to the will of Zeus, Calypso helps the hero build a ship, and after sailing for eighteen days, he approaches Scheria, land of the Phaeacians. Just then, Poseidon sees him and realizes what was agreed among the other gods while he was away. Ever Odysseus's enemy, the sea god stirs up a storm that sinks the ship and threatens to drown the hero until a sea nymph comes to his rescue, wrapping him in a veil that keeps him safe as he is plunged beneath the waves and against the rocks. Finally, with Athena's help, Odysseus manages to stumble ashore, throwing the veil back into the sea as the nymph instructed. *The Sea Nymph* is one of twenty vivid collages by American artist Romare Bearden (1911–1988) in his series *A Black Odyssey*, in which every character in the myth is represented as Black. Bearden's series not only confirmed the relevance of the ancient tale to modern audiences but established the universality of the story of adventure and eventual homecoming. Inspired by Matisse's cut-outs, Cubism and jazz, Bearden drew parallels between Odysseus's travels and the movement of African Americans from South to North after the Civil War, part of his own family story. The search for home was always an underlying theme of his work: after half a century, he returned to his childhood home in 1976, and shortly afterwards began *A Black Odyssey*.

Ed Annunziata and SEGA

Still from *Ecco the Dolphin*, 1992
Video game, dimensions variable

A bottlenose dolphin may seem an unlikely hero for a video game, but in 1992 Sega's *Ecco the Dolphin* became a surprise hit. The fiendishly challenging puzzle adventure game was created by Ed Annunziata and originally released for the SEGA Mega Drive/Genesis console. Players guide Ecco on an underwater quest across the ocean to rescue his pod, who have been swept away from peaceful Home Bay by a great storm. Annunziata designed the game with twenty-seven levels of increasing complexity, from the relatively simple Bay of Medusa to the deviously difficult final stage, The Last Fight. Along the way, players traverse shark-infested waters, navigate complex deep-sea caverns and explore the sunken ruins of the city of Atlantis. At one stage Ecco even travels back through time by several million years. Each of the visually impressive levels has different gameplay mechanics and enemies, including seahorses, jellyfish, giant octopods and crabs, which can be attacked by ramming into them at high speeds. Several gameplay features are based on actual dolphin behaviour: one button activates Ecco's sonar, allowing him to communicate with other cetaceans and interact with objects. An echolocation function reveals a map of the immediate area, but players must exercise their memories in the more complicated levels. Just as real dolphins must make regular trips to the surface to catch a breath, Ecco too needs air to survive, and players need to keep an eye on his oxygen meter. *Ecco the Dolphin* requires great patience, and its difficulty has been key in ensuring its longevity and assuring its status as an ahead-of-its-time classic.

Walt Disney Pictures

Still from *The Little Mermaid*, 1989
Animated film, dimensions variable

Employing a dazzling array of effects, the artists at Walt Disney Animation Studios merged traditional hand-painted cels with novel computer animation to conjure a Technicolor undersea world for the 1989 feature film *The Little Mermaid*, written and directed by Ron Clements and John Musker. Light shimmers on gleaming rocks, vibrant seaweeds sway in unseen currents and character movements are accentuated by gleeful trails of more than a million hand-drawn bubbles. The plot of Disney's animated film is based on Danish author Hans Christian Andersen's 1837 fairy tale of the same name. The film's protagonist, Ariel, a mermaid and youngest daughter of Triton and Athena, rulers of the underwater kingdom of Atlantica, makes a deal with the sea witch Ursula to sacrifice her magical singing voice in order to realize her dream of becoming human so that she might marry the handsome Prince Eric. Disney's version of the tale diverges from Andersen's source material, notably in that Ariel regains her voice and with Eric defeats Ursula to live happily ever after as a human. Much of the film's lasting popularity stems from its memorable cast of colourful supporting characters, including Flounder – whose name hints more at his twitchy nervousness than his species (he is portrayed as a yellow-and-blue tropical fish rather than his namesake flatfish) – and Sebastian, the red crab whose showpiece 'Under the Sea', penned by Disney composer stalwarts Howard Ashman and Alan Menken, won the Oscar for Best Original Song in 1990. *The Little Mermaid*'s technical and creative ambitions paralleled earlier Disney landmarks such as *Fantasia* (1940) and ushered in a modern era of critical and commercial success for the company.

Sandro Bocci

Meanwhile, 2015
Stills from 4K video, dimensions variable

Taken from a five-minute film, these twelve stills capture just a fraction of the beauty and individuality of marine life under the waves. *Meanwhile* is the work of Italian filmmaker and documentary maker Sandro Bocci (b. 1978). Bocci's aim in his 2015 experimental film was to showcase highly magnified marine animals, such as sponges and corals, by creating macro timelapse sequences of images showing their long life spans. By concentrating on the beauty of a tiny part of the planet, Bocci hopes to encourage viewers to think about their behaviour in the face of the evidence of dangerous climate change. Set to the music of Maurizio Morganti and filmed in the shallow reefs of the Indo-Pacific Ocean, Bocci's film concentrates on wildly colourful corals, from the frogspawn coral (*Euphyllia divisa wilde*) and various large polyp stony corals, such as Symphyllia with its multiple colours, to the African sea star (*Protoreaster Linckii*) and the small giant clam (*Tridacna maxima*). By using various techniques such as filming with ultraviolet light, Bocci vividly depicts the beauty and infinite variety of reef life. His macro timelapses bring the coral and sponges to life as he sets out, in his own words, to weave a web between science and magic. Myriad colours assault the eye, from vivid purples to iridescent greens and yellows, to show the viewer how extraordinary is this hidden world that remains unseen by most of us.

NASA

Hawaii's Pearl and Hermes Atoll, 2006
Digital photograph, dimensions variable

Looking down from space, this Landsat 7 image taken in 2006 shows a section of the Pearl and Hermes Atoll, part of the Northwestern or Leeward Islands of Hawaii. The image is just one of a collection of more than 1,700 coral reef images from the Millennium Coral Reef Project, an Internet-based library funded by the National Aeronautics and Space Administration (NASA). International researchers working at multiple organizations and universities worked with NASA to create a comprehensive world data resource based on images from the orbiting Landsat surveying satellites to examine how well coral reefs are being protected. They compiled an updated inventory of all marine protected areas containing coral reefs and compared it with the most detailed existing inventory of coral reefs, using the detail and quality of NASA's satellite pictures to pinpoint exactly where coral reefs sit within costal marine ecosystems. The researchers discovered that less than 2 per cent of all reefs lie within areas designated to limit potentially damaging human activity. The Pearl and Hermes Atoll, named after a pair of English whaleships that were wrecked there in 1822, were first protected in 1909 after President Theodore Roosevelt created the Hawaiian Islands Bird Reservation. In 2006, President George W. Bush designated the Northwestern Hawaiian Islands a Marine National Monument, the largest protected marine area in the world. The submerged atolls, which are periodically washed over during winter storms, are an important wildlife habitat and are home to 20 per cent of the world's population of black-footed albatrosses.

Doug Perrine

Crown-of-thorns Sea Star Feeding on Acropora
Table Coral, Similan Islands, Thailand, 1997
Photograph, dimensions variable

'The alien plague that's destroying our reefs!' read one headline in a 1969 redtop Australian newspaper, reporting on the threat to the Great Barrier Reef from the starfish *Acanthaster planci*. The scientific truth is more prosaic but no less fascinating. In the late 1960s, there were indeed huge numbers of crown-of-thorns starfish (COTS) eating large areas of coral. But when scientists drilled into the reef and analyzed sample cores to find ancient COTS skeletons, the evidence was that this 'plague outbreak' was a naturally occurring high point in the species'

cycle of boom and bust. Starfish have hundreds of tiny gelatinous projections on the undersides of their legs. Increased water pressure created inside the starfish's body causes them to expand and elongate, so the starfish moves over the coral, crawling on hundreds of these tube feet. The mouth is in the centre of the underside of the star, and the animals feed by everting their stomach, throwing it out through their mouth to create a living blanket of tissue whose digestive juices dissolve the edible flesh of the coral. COTS eats and moves on, leaving

only the white, dead, calcium-carbonate coral skeleton, as seen in this image by American photographer Doug Perrine (b.1952) of Acropora table coral in the Andaman Sea off the coast of Thailand. The COTS challenge is more acute now, when some coral ecosystems around the world are already struggling to cope with the stresses of climate change. One theory holds that, as the water temperature continues to rise, COTS will be more successful, and major outbreaks could yet be a tipping point for coral reef survival.

Miquel Barceló

Kraken Central, 2015
Mixed media on canvas, 1.9 × 2.7 m / 6 ft 3 in × 8 ft 10 in
Private collection

Growing up on the Mediterranean island of Mallorca, Miquel Barceló (b. 1957) gained a lifelong passion for the sea. One of Europe's most celebrated contemporary artists, who works in a variety of media from ceramics to performance art, he is particularly renowned for his public-space commissions, including at the United Nations headquarters in Geneva, where, in 2008, Barceló covered a huge domed ceiling with vibrant multicoloured stalactites made from 32 tonnes (35 t) of paint. He then sprayed the ceiling with a blue-grey paint, which, depending on the viewer's perspective, changed its appearance from a multi-hued rainbow to a more sombre tone. Known for his desert paintings – Barceló has long been fascinated by the cultural and geographic diversity of Africa – and scenes of bullfighting, Barceló has repeatedly returned over his lengthy career to his love of the sea. His intensely coloured seascapes are achieved by meticulously applying layers of mixed media to create his signature heavily impastoed canvases. In this painting from 2015, Barceló has imagined how the legendary sea monster the kraken might appear in the depths of the ocean. According to legend, the kraken – feared by sailors as a huge man-killing octopus – lives off the coast of Norway. Featuring in Jules Verne's classic 1871 novel *Twenty Thousand Leagues Under the Sea* (see p.133), the monster's many tentacles are easily capable of bringing down a ship. Barceló's Kraken is altogether a more abstract monster, with its luminous tentacles hovering in the deep blue sea, seemingly suspended above the viewer.

Henley Spiers

The Safest Place, 2016
Photograph, dimensions variable

This striking image tells a fascinating story. A male yellowhead jawfish (*Opistognathus aurifrons*) holds in his mouth a brood of his offspring, soon to hatch from their transparent eggs. The eyes of the tiny fry are clearly visible in the eggs that nestle like a mass of jewels, safe from predators, within the mouth of the parent fish. In this mouth-brooding species, the male fish incubates and protects the eggs within his mouth cavity until they hatch after about a week. Mouth brooding is common among many types of fish – and other animals, such as some frogs – where it serves as an evolutionary adaptation to increase the chances of producing more young from fewer eggs. In some species the male holds the eggs, while in others it is the mother; whichever parent broods the eggs cannot eat while they do so, growing weaker and having to recover over time once the fry have hatched. In some species, free-swimming fry dart back into their parent's mouth at any sign of danger. The yellowhead jawfish is native to the Caribbean Sea and tropical west Atlantic, where it lives on coral reefs, inhabiting crevices or burrows dug into the substrate. British-French photographer Henley Spiers encountered the fish in Saint Lucia and became fascinated, diving repeatedly to the same location to observe their reproductive behaviour in detail. When the eggs are nearly at hatching stage, they turn silvery, and eyes become visible within each sphere. Then, close to sunrise or sunset, and often when the moon is full, the male jawfish releases the newly hatched young into the open water.

Brandon Cole

Golden Jellyfish, Jellyfish Lake, Palau, 2013
Digital photograph, dimensions variable

This stunning photograph of a bloom of golden jellyfish (*Mastigias papua etpisoni*) was captured by wildlife photographer and writer Brandon Cole in Palau, an archipelago of more than five hundred islands in the western Pacific Ocean. Across these rocky and inhabited islands some sixty marine lakes – created around 12,000 years ago – host gigantic colonies of jellyfish. Each saltwater lake is connected to the ocean by narrow underwater tunnels and crevices in the limestone that enable water circulation while keeping out predators.

As a result, many have become closed ecosystems in which some jellyfish species have evolved in substantially different ways from their relatives living along the coastlines. Thousands of years ago, individuals of the spotted jellyfish (*Mastigias papua*) entered the lake on Eil Malk and settled there, eventually giving rise to the subspecies known today. Evolutionarily defined by its closed ecosystems, the golden jellyfish also behaves differently from its marine ancestor. Golden jellyfish feed on plankton and are nourished by

a symbiotic relationship with Zooxanthellae algae that live in their tissue. To keep their photosynthetic symbiotic partners as healthy as possible, the jellyfish commute every day from one end of the lake to the other, following the sun as it moves across the sky. Staying away from the shadowed banks also keeps them safe from *Entacmaea medusivora*, an endemic anemone and fierce predator of this species.

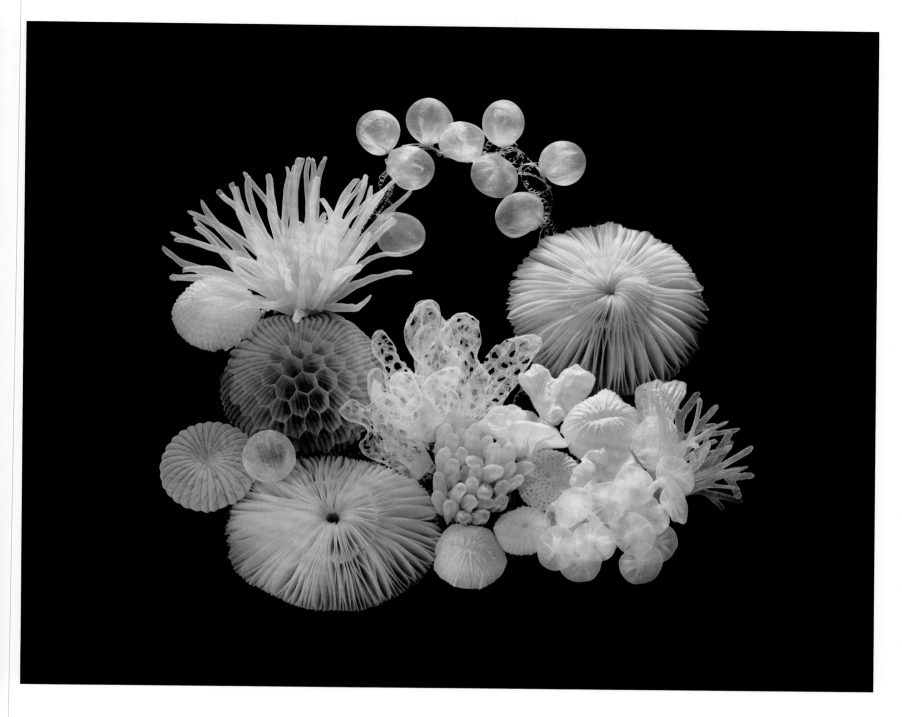

Mariko Kusumoto

Sea Creatures neckpiece, 2015
Polyester and monofilament, 9.5 × 31.1 × 30.5 cm / 3¾ × 12¼ × 12 in
Museum of Fine Arts, Boston

Crafted from mesh polyester fabric, bound with nylon wire, this necklace, by the Japanese-American artist Mariko Kusumoto (b. 1962) is as lighthearted conceptually as it is light to the touch. Her playful, diaphanous representation of a coral reef is based in part on observable specimens, including urchins and staghorn coral, but the translucence of her materials makes the visual experience an exploration of dreamlike layering, in which delicate colours merge and play. One of Kusumoto's signatures is the capturing of a fully formed shape within another,

as though floating away in a bubble. In *Sea Creatures*, the technique can be seen in the honeycomb-shaped urchin encased in a fluted orb. Each of the forms is created using a heat-setting technique applied to polyester that Kusumoto pioneered herself, as well as setting and moulding techniques that she first learned working metal for more traditional jewellery. More than just static sculptures, each work of art comes to life as a wearable jewellery piece. Seen as they were as embellishments to Jean Paul Gaultier's Spring/Summer 2019 collection at Paris Fashion

Week, the 'light as air' materials sway and bounce and provide focal points to the fashion designer's creations. Kusumoto envisions her work as investigating the potential of the materials that she works with – 'Almost half of my creative time is spent experimenting' she has said – making every newly created piece a journey of discovery as exciting as the exploration of a real coral reef.

Histoire Naturelle, *Vers Mollusques*.

Benard Direxit.

Jean-Baptiste Lamarck, Jean Guillaume Bruguière and Robert Bénard

Medusa, from *Tableau encyclopédique et méthodique des trois regnes de la nature*, 1791
Hand-coloured engraving, 27.9 × 22.9 cm / 11 × 9 in
Private collection

The term *medusa* was first introduced by the seminal taxonomist Carl Linnaeus (see p.316) in the fourth edition of his *Systema naturae* in 1744. Inspired by the Gorgon of Greek mythology, Linnaeus ascribed the name to what is now known to be the primary form of the jellyfish in its reproductive phase. This engraving comes from a reference work edited by the celebrated French polymath Jean-Baptiste Lamarck (1744–1829) and Jean Guillaume Bruguière (1749–1798) and engraved by Robert Bénard (1734–1772). It is included in a hugely ambitious encyclopaedia that appeared in France in the

eighteenth century, the publication of which eventually spanned more than 50 years and 150 volumes. Inspired by Denis Diderot's famed *Encyclopedie*, Charles-Joseph Panckoucke, an enterprising young publisher who had worked on that project, had the idea for the *Tableau Encyclopedique et Methodique*, a comprehensive exploration of contemporary knowledge of the 'three kingdoms of nature' that included the first scientific descriptions of many species. Lamarck was one of the earliest proponents of the theory of biological evolution (he also coined the word *biology*). Over time,

Lamarck's research led him to shift from a belief that species were unchanging to a belief that species evolved, although Lamarck's explanation of the mechanism by which change occurred was later corrected by Charles Darwin. Central to Lamarck's own theory was his work on molluscs. Invertebrates were considered a lowly branch of science at the time, but through his extensive studies, Lamarck elevated the field, as suggested by the rich detail of this plate. It was Lamarck's inclusion of invertebrates in the encyclopaedia that brought them to the public's attention for the first time.

René Lalique

Sea Urchin Vase, 1935
Glass with blue stain, Diam. 18.5 × 20 cm / 7¼ × 7¾ in
National Gallery of Victoria, Melbourne

René Jules Lalique (1860–1945) was a famous French jeweller and glassmaker who had a major influence on the Art Nouveau and Art Deco movements. In 1876 he worked as an apprentice with Louis Aucoc, a leading jeweller and goldsmith in Paris, and eventually set up his own Paris atelier in 1885. Dubbed 'the inventor of modern jewellery' by the renowned French glassmaker Émile Gallé, Lalique went on to create beautiful and delicate items such as necklaces, pendants and brooches using ivory, horn, semi-precious stones, enamel and glass. These were soon sought after by the affluent elite, including the actress Sarah Bernhardt. In 1913 he purchased the glassworks at Combs-la-Ville to the southeast of Paris, and in 1921 built a new factory, the *Verrerie d'Alsace* at Wingen-sur-Moder in the Vosges, now the site of the Lalique Museum. Lalique was inspired by the female human form, but also by flora and fauna, in this case by the beautiful symmetry of a sea urchin. Below the rim, this delicate glass vase with blue staining mimics precisely the body of a sea urchin and copies closely the spherical shell (test) of these fascinating echinoderms. In life, sea urchins are protected by sharp spines, among which protrude tube feet by which the animals move slowly on rocks or the seabed. When a sea urchin dies, the hard, globular test so faithfully represented by this exquisite vase is all that remains.

Emmy Lou Packard

(*Deep Sea Composition*), c.1950
Colour block print on paper, 25.4 × 35 cm / 10 × 13¾ in
Private collection

With a refined graphic style and muted palette, American artist Emmy Lou Packard (1914–1998) reduced a selection of ocean creatures, including sea urchins, anemone, corals and a mussel, to their elemental forms. Printed from a hand-carved woodblock, each animal in this semi-abstract illustration is assigned its own colour and set against a high-contrast background of black-and-white shapes. The image once adorned the staterooms of the SS *Mariposa* and *Monterey*, the Matson Navigation Company's luxury cruise ships operating in the Oceania and Australasia regions. It is one of ten designs Packard produced for the shipping firm alongside a series of eight murals for the *Mariposa*'s ballroom, the Polynesian Club. Packard took her cue from the folk art of the South Pacific region, specifically the indigenous wood carvings of Papua New Guinea and Australia, which she described as having 'tremendous vitality'. Packard was a notable mural artist and printmaker who for several years worked in Mexico, living with artists Frida Kahlo and Diego Rivera, for whom she worked as an assistant.

Packard's works, along with those of other artists, muralists and mosaicists commissioned by Matson, were first enjoyed by passengers travelling on the maiden voyage of the *Mariposa* from San Francisco to Sydney by way of Honolulu and Auckland in 1956. Packard also produced woodblock prints inspired by Pacific coral for the firm's SS *Lurline* and similar ocean-themed designs for its Princess Kaiulani Hotel in Honolulu.

Jean Painlevé

Oursin (Sea Urchin), 1927
Gelatin Silver Print, 23 × 16.8 cm / 9 × 6½ in
Archives Jean Painlevé, Paris

French artist Jean Painlevé (1902–1989) – whose oeuvre includes more than two hundred short documentary films, notable written works, a jewellery line, a diving club and a body of photography – was a trained biologist who sustained an interest in science, particularly in the marine world, throughout his life. A contemporary of Surrealists such as André Breton and Man Ray, Painlevé had a style that was both informational and mysterious, straightforward and playful, scientific and poetic. He employed novel camera techniques – some of which he invented himself – that allowed for underwater filming or extreme close-ups, such as in this highly detailed photograph of a sea urchin. While Painlevé used many innovative techniques, it was often easier for him to film his subjects in aquariums in his studio in Brittany, France, rather than shoot completely underwater. This work, and those like it, helped educate the public about the abundance, strangeness and beauty of life underwater. The same year that Painlevé captured this image, 1927, he shot his first three short films, one of which was also about sea urchins (*Les Oursins*). Using magnification and time-lapse cinematography, he challenged the conventional view of this small creature. In 1934 Painlevé completed perhaps his best-known film, *L'Hippocampe* (*The Seahorse*), which showed on film, for the first time, the unusual reproductive cycle of seahorses in which the male gives birth. At the time Painlevé was working, deep-sea diving and exploration were just becoming possible through inventions that allowed for pressure regulation and sustained airflow; hence, specifics about the scope of undersea life and details about its inhabitants were exciting and often conveyed new information.

Else Bostelmann

*Saber-toothed Viper Fish (*Chauliodus sloanei*) Chasing Ocean Sunfish (*Mola mola*) Larva*, 1934
Watercolour on paper, 47 × 62.2 cm / 18½ × 24½ in
Wildlife Conservation Society, New York

In this dramatic painting, the ghoullike head of a viper-fish emerges from the edge of the frame as it chases a helpless young ocean sunfish (*Mola mola*). The tiny larva is about to be engulfed in the gaping jaws of the fearsome predator whose skin shines with a metallic glint that lends it a distinctly otherworldly appearance. The work of German artist Else Bostelmann (1882–1961), this almost fantastical rendering was drawn from the notes and observations of the famous explorer and naturalist William Beebe (see p.75). After moving to the United States in 1909, Bostelmann joined the New York

Zoological Society (now the Wildlife Conservation Society) in 1929 as an artist for the Department of Tropical Research under Beebe's direction. During a 1934 expedition to Bermuda, Beebe descended more than 915 metres (3,000 ft) in a cast-iron submersible, the *Bathysphere*, from which he described the life of the deep ocean to fellow scientist Gloria Hollister on the ship above via telephone. From Hollister and Beebe's notes, Bostelmann produced more than three hundred illustrations of marine animals. Bostelmann's paintings were published in *National Geographic*

magazine, mainly in the 1930s and 1940s, and included highly specialized species such as this viperfish. The saber-toothed (or Sloane's) viperfish (*Chauliodus sloanei*) is one of several viperfish species, all adapted to life in the depths of the ocean where very little light penetrates. They have large eyes to capture what light there is, and their iridescent bodies carry rows of specialized light-producing organs called photophores. The viperfish flash these bioluminescent spots to lure in and catch prey. Highly predatory, viperfish have a huge, gaping mouth with a hinged jaw and sharp teeth.

ILLUSTRAZIONE DEL POPOLO

Il prof. Beebe, sceso con la sua «batisfera» a 1000 metri di profondità nell'Oceano Atlantico, osserva le strane forme di animali viventi negli abissi sottomarini.
(Leggere la notizia a pagina 2) (Disegno di Aldo Molinari).

Aldo Molinari

Professor Beebe in His Bathysphere 1,000 Metres
Below the Surface of the Atlantic Ocean, c.1934
Printed paper, 39 × 30 cm / 15¼ × 11¾ in
Private collection

A spherical submarine floats through this pale blue underwater seascape, with pioneering American naturalist, explorer and ornithologist Charles William Beebe (1877–1962) peering from the porthole. Two jellyfish and a large carnivorous creature lurk nearby while other marine life floats in the distance. Italian journalist, illustrator and filmmaker Aldo Molinari (1885–1959) depicted the historic moment – *Professor Beebe in His Bathysphere 1,000 Metres Below the Surface of the Atlantic Ocean* – for an illustrated supplement in the Italian newspaper *Gazzetta del*

Popolo. In 1928, Beebe, interested in deep-sea exploration but only able to reach a depth of 90 metres (300 ft) in his diving suit, teamed up with the engineer Otis Barton, who had designed a pressurized steel sphere capable of deeper exploration. Beebe named the vessel *bathysphere*, from the Greek prefix *bathy-* meaning 'deep'. The bathysphere was raised and lowered by a steel cable tethered to a ship above, while another cable supplied light and telephone wires. In 1930, Beebe and Barton met on Nonsuch Island, in Bermuda, to conduct test descents. Snug inside the pressurized steel globe,

they were lowered 434 metres (1,426 ft) into that watery world, deeper than any living humans had ventured. It was a great feat of courage and ingenuity: the steel casing was all that separated them from the crushing force of the water. In September 1932, they descended 670 metres (2,200 ft) and – speaking over the telephone wire – Beebe described bioluminescent sea creatures nobody had seen before. By 1934, they reached the spectacular depth of 923 metres (3,028 ft) – a record held until 1949. The Bathysphere is now on display outside the New York Aquarium.

Louis Boutan

Diver Emil Racoviță at Observatoir océanologique de Banyuls-sur-Mer, 1899
Photograph, dimensions variable

Air bubbles rise through the water as diver Emil Gheorghe Racoviță holds a sign that reads clearly – albeit upside down – 'Photographie sous-marine' (French for 'Underwater Photography'). The statement was worth making, as this was one of the first images created when both the subject *and* the photographer were submerged. The photographer behind the camera was eminent French biologist Louis Marie-Auguste Boutan (1859–1934), an innovator in the field of underwater photography. Racoviță, a Romanian zoologist, was a scientist on RV *Belgica*, the first

ship to overwinter south of the Antarctic Circle. In 1893 Boutan became a professor at the Laboratoire Arago at Banyuls-sur-Mer in southern France. An enthusiastic diver, he was inspired by the underwater wonders of the Mediterranean to develop an underwater camera with his brother, Auguste, making it possible to adjust the iris and shutter while submerged. In the gloominess underwater, it could take up to thirty minutes to capture enough light to expose the light-sensitive plates in the camera, so Boutan created artificial light by setting fire to magnesium ribbon

inside a bulb filled with pure oxygen. That method resulted in more explosions than successful exposures, so Boutan improved it by using a rubber bulb that blew magnesium powder into a burning alcohol lamp. The whole contraption had to be attached to a wooden barrel, making it extremely inconvenient and difficult to transport, but it was reliable – and it made exposure times much shorter. That is why the sea-grass fronds around Racoviță are in quite sharp focus despite being moved around by underwater currents.

Anonymous

Sylvia Earle in a JIM Suit, c. late 1970s
Photograph, dimensions variable

On 19 September 1979, off the coast of Oahu, Hawaii, American marine pioneer Sylvia Earle (b. 1935) descended to the seafloor in an atmospheric diving apparatus called a JIM suit, strapped to the front of a small submersible. She released herself at a depth of 381 metres (1,250 ft) and spent the next two hours exploring the bottom of the sea before returning – without decompression – to the surface. In so doing, she set a record for the deepest untethered dive ever carried out by a woman – it still stands today – and inspired her nickname: Her Deepness. The JIM suit that made the dive possible maintained a consistent internal pressure of 1 atmosphere despite increasing external pressures, meaning that decompression sickness (nitrogen narcosis) was not a danger. The suit was invented in 1969 and operated mostly in undersea oilfield operations, but by 1990 it was no longer used commercially. Sylvia Earle is a marine biologist, oceanographer and activist who earned a PhD from Duke University in algology, the study of algae. In 1970 she led an all-female team of aquanauts in a NASA-funded experiment called Tektite II, living for two weeks at a depth of 13 metres (43 ft) off St John Island, in the US Virgin Islands. She is a pioneer in the development of piloted and robotic undersea exploration equipment. In 2008 she founded Mission Blue to raise awareness of the threat to the world's oceans from overfishing and pollution. The foundation solicits support for Hope Spots – locations that are critical to the health of the ocean – and works with local communities to ensure their sustainability and preservation; there are more than 130 Hope Spots today.

Jacques-Yves Cousteau and Louis Malle

Still from *Le monde du silence*, 1956
Film, dimensions variable

Le monde du silence (*The Silent World*) was one of the first films to use new techniques of underwater cinematography to show the deep ocean in colour, for which it won an Oscar and the first Palme d'Or awarded by the Cannes Film Festival for a documentary. Codirected by renowned underwater explorer Jacques-Yves Cousteau (1910–1997) and Louis Malle (1932–1995), it was filmed from Cousteau's ship *Calypso*, the oceanographic research vessel he had converted from a British minesweeper, and was based on Cousteau and Frédéric Dumas's 1953 book

of the same name. Cousteau began experimenting with underwater filmmaking during World War II while a member of the French Resistance. In 1943, in collaboration with the engineer Émile Gagnan, he invented the Aqua-Lung, the first fully automatic compressed-air system for divers. He would go on to design a small, manoeuvrable seafloor submarine and various underwater cameras, and to experiment with new forms of lighting that would illuminate depths of more than 100 metres (330 ft). In 1973 he founded the nonprofit Cousteau Society, dedicated

to marine conservation, but in 1956 he was less environmentally vigilant, and *Le monde du silence* was criticized for damage done while filming. Cousteau used dynamite near a coral reef, and his crew annihilated a school of sharks drawn to the carcass of a baby whale that the *Calypso* had accidentally injured. When the film was remastered in 1990, Cousteau decided to retain the part showing the mass killing of the sharks – it showed, he believed, how far humans had advanced in their understanding and treatment of the animals.

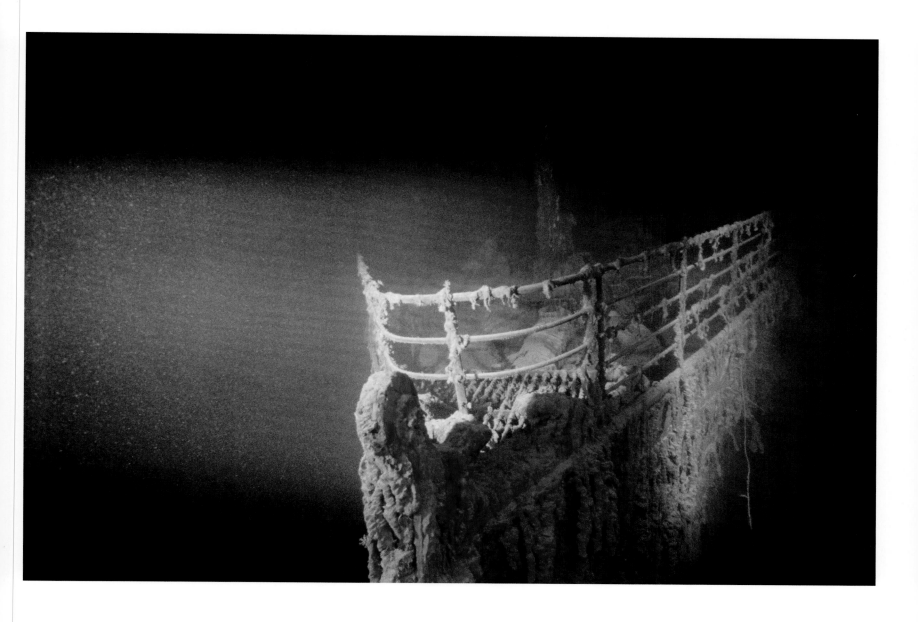

Emory Kristof

The Titanic, Atlantic Ocean, 1985
Photograph, dimensions variable
Private collection

In the depths of the North Atlantic Ocean, a ghostly glow illuminates the wreck of the RMS *Titanic*, bathing its decaying bow in a golden-blue light. The so-called 'unsinkable ship' struck an iceberg on 14 April 1912 during its maiden voyage from Southampton, England, to New York City, taking more than 1,500 passengers to a watery grave. With this image, taken 3,650 metres (12,000 ft) under the sea, Emory Kristof (b. 1942) was the first person to photograph the sunken liner. The trail-blazing American photographer is known for his remarkable deep-sea pictures of previously unphoto-graphed subjects, such as an 8-metre (26-ft) Pacific sleeper shark and the hydrothermal vents of the Galapagos Rift. His pioneering use of remotely operated camera systems and submersibles led him to collaborate with the American oceanographer and underwater archaeologist Robert Ballard, who had previously attempted to locate the *Titanic* without success. Together, they developed an unmanned deep-sea vehicle named *Argo* that was fitted with sonar and cameras that Kristof operated from a tow ship on the surface. Sponsored by the United States Navy on the condition that it could also be used for classified programs, the sophisticated system located the wreck around 610 kilometres (380 mi) southeast of Newfoundland. Taken on 1 September 1985, seventy-three years after the *Titanic* sank, Kristof's remarkable pictures were one of the inspirations behind James Cameron's hugely popular 1997 film *Titanic*, which incorporated both historical and fictional aspects of the ship's tragic sinking.

Bruno Van Saen

Into the Spotlight, 2018
Digital photograph, dimensions variable

Sea slugs, specifically nudibranchs, are among the most colourful and exuberantly shaped marine animals. Often tiny and much faster than their terrestrial cousins, which are bound to crawl the ground, sea slugs can flutter their petallike cerata – tendrillike growths on the upper surface of their bodies – to lift themselves off the seabed and navigate currents. Unlike other uniformly patterned species of sea slugs, the upper side of the cerata in *Cyerce nigra* is transverse-striped, while the dark underside is marked by yellow dots. As it swims,

the flickering of these contrasting patterns confuses predators. More than a simple aesthetic device, the spots on the cerata's underside are pustules from which this colourful marine invertebrate produces distasteful secretions that repel fish. First discovered and classified in 1871, *Cyerce nigra* lives in the Pacific and Indian Oceans and feeds on algae. In recent times, the sophisticated beauty of this tiny – it is about 22 millimetres (1 in) long – marine creature has turned the animal into an 'icon species' for tourist brochures and posters. This macro photograph was taken by

award-winning scuba diving photographer Bruno Van Saen (b. 1967), who travelled to Romblon in the Philippines specially to photograph the species. Over the years, Van Saen has developed an international reputation as one of the most talented underwater photographers in the world. This image earned him a high commendation for macro photography at the 2019 *Underwater Photographer of the Year* contest.

NOAA

Jellyfish in the Marianas Trench Marine National Monument, 2016
Video still, dimensions variable

This otherworldly glowing globe of bright yellow and red with long tentacles that seems to hang motionless in near-total darkness is, in fact, a never-before-seen species of jellyfish filmed during the US National Oceanic and Atmospheric Administration's (NOAA) exploration of the area around the Mariana Trench in the western Pacific Ocean in 2016. The crescent-shaped trench, which stretches about 2,550 kilometres (1,580 mi), is the deepest oceanic trench on Earth, with a maximum depth of nearly 11 kilometres (6.8 mi). At such depths, there is no light, the temperature does not rise above 4 degrees Celsius (39° F) and the pressure exerted by the water above is more than one thousand times higher than normal atmospheric pressure at the Earth's surface. The trench remains largely mysterious thanks to the inhospitable conditions of the aphotic zone, or dark ocean, but it has been mapped from the surface and has been explored by crewed and uncrewed submersibles. The first crewed descent took place in 1960, the most recent in 2019. In 2012 Canadian film director James Cameron used a submersible to reach the bottom of the Challenger Deep, the deepest part of the trench, retrieving sixty-eight new species, mainly of bacteria but also of small invertebrates. The only light available at such depths is generated by the organisms adapted to live there: this jellyfish was photographed by a NOAA remotely operated vehicle at a depth of approximately 3,700 metres (2.3 miles). Other inhabitants of the deep include the giant squid, the anglerfish and the vampire squid. Despite the lack of light and freezing conditions, more than two hundred known microorganisms and small creatures have found a way to survive and flourish in this mysterious part of the ocean.

NASA

Phytoplankton Bloom in the Barents Sea, 2011
Digital photograph, dimensions variable

Akin to the brushwork on the canvas of an Abstract Expressionist painter, these smokelike swirls of different shades of blue are the result of a phytoplankton bloom: the reproductive cycle of the single-celled marine plants called Coccolithophores. Millions of tiny vegetal organisms begin to reproduce in a spectacular dance that can only be truly appreciated from high above the surface, as viewed from satellites. This image taken by NASA documents the bloom that takes place every August in the Barents Sea in the Arctic Ocean between the coast of northern Russia and Scandinavia. Blooms often occur when water temperature and availability of nutrients in the water allow the phytoplankton to reproduce at such speed that the surge in numbers alters the colour of the water. Hard to predict, and sometimes detrimental to tourism, blooms can last from a few days to several weeks. Phytoplankton are photosynthesizing microscopic organisms that often inhabit the sunlit uppermost layers of bodies of water. Scientists have estimated that 50 to 80 per cent of the oxygen in the atmosphere is produced by marine photosynthesis and that phytoplankton are responsible for most of it. Indispensable to the health of marine ecosystems, phytoplankton are also an essential source of food for zooplankton, communities of microscopic animals that in turn provide food for larger marine species.

Kim Picard

Broken Ridge, 2019
Digital, dimensions variable

The colours of this rocky landscape in the deepest depths of the ocean are a vivid echo of tragedy. On 8 March 2014, Malaysia Airlines flight MH370 disappeared somewhere between Kuala Lumpur and Beijing with 239 people on board. A two-year deep-ocean search followed the disappearance, as trackers determined the aircraft had reversed course and flown south over the Indian Ocean, where, it is believed, it ran out of fuel. Through a joint effort of scientists from Geoscience Australia and the Australian Transport Safety Bureau, an area of the southeast Indian Ocean the size of New Zealand was mapped in an attempt to find traces of the aircraft, producing views of the seafloor with an unprecedented level of detail. The search, which centred on a feature named Broken Ridge, used deep-water, high-resolution acoustic and optical imaging instruments to create 3D images like this depiction of a chain of extinct submarine volcanoes. The largest volcano in the chain reaches about 2,200 metres (7,220 ft) tall. In the foreground, the volcano has three peaks with a large fault line running through it, which continues across the seabed – an indication of the tectonic activity in the area. The global ocean covers 71 per cent of Earth's surface, but studies of the ocean floor and knowledge of its topography remain scarce. Light cannot penetrate the deep ocean and acoustic mapping techniques are comparatively inefficient, although here data from a high-resolution multibeam echo sounder revealed the topographic complexity of the ocean floor some 5.8 kilometres (3.6 miles) beneath the surface and the tectonic, sedimentary and volcanic processes that shaped it.

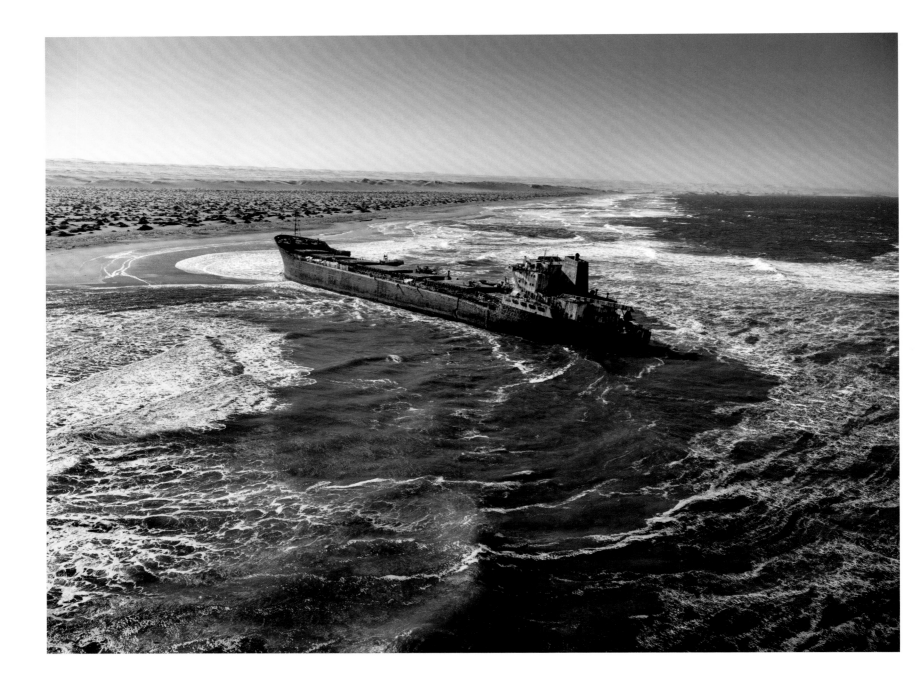

Glenna Gordon

Shipwreck, 2019
Photograph, dimensions variable

On 25 February 2013, the thirty-four-year-old Brazilian cargo ship *Frotamerica* was being towed to scrapyards when it broke loose from its tow. The 31,751-tonne (35,000-ton) vessel – unmanned at the time – went aground near Anichab Rocks off northern Namibia to join hundreds of ghostly wrecks along the Skeleton Coast. That coast, along northern Namibia and southern Angola, was given its nickname in the nineteenth century, after the whale and seal carcasses that once littered the desert sands, the results of the whaling industry and South Atlantic seal hunts. Today, the wooden and iron bones of more than a thousand ships and boats wrecked on the rocky coast make the name still relevant. The perils of this coast derive from a dangerous meeting of hot desert winds with the cold Benguela current, making it one of the foggiest places on Earth, despite an almost total lack of rainfall. When ships were powered by sail, the constant heavy surf meant that it was possible to get ashore but impossible to launch a vessel – so for sailors unlucky enough to wreck on these beaches, the only escape was through marshes accessed via miles of arid desert. The San tribes of Namibia called the coast the Land God Made in Anger, while Portuguese sailors referred to it as the Gates of Hell. Today, wrecks like the *Frotamerica* are being reclaimed by nature to become artificial reefs, where black cormorants roost, fur seals play and past which humpback whales migrate towards their feeding grounds.

Kerry James Marshall

Untitled, 2008
Acrylic on fibreglass, 2 ×2.9 m / 6 ft 7 in ×9 ft 7 in
Private collection

Born in Birmingham, Alabama, American artist Kerry James Marshall (b. 1955) has gained an international reputation for his masterful paintings, particularly those depicting Black lives and questioning Western art history, well before the Black Lives Matter movement. This untitled large-scale painting from 2008, which was shown in Marshall's *Black Romantic* exhibition that same year, breaks down the Western understanding of the depiction of a romantic walk on the beach. Throughout the many centuries of 'traditional' art history, the Western viewer became accustomed to seeing only white couples in romantic scenes, such as watching the sun set over the sea or walking along the shore. Marshall does not only play with the idea of anachronism by presenting a contemporary painting that makes use of a rather outmoded motif – which throws us back in time to Caspar David Friedrich and Joaquín Sorolla – but he also plays with the inherent bias of what the spectator is used to seeing, the cultural imprint. Marshall has said that his paintings try to appeal to the emotional need of Black communities to see positive representations of themselves. The colours are abundant, if not opulent, with the sky and the ocean painted in exceedingly vibrant shades of blue. The idyllic atmosphere points to the transience and ephemerality of the moment, reflected in the so-called vanitas symbols: waves, clouds, shells, a stranded tree trunk. While Marshall's painting speaks to how society is constructed today – and how the ocean can be a backdrop to those constructions – it also invites the viewer to reflect about our expectations and judgements.

Erté (Romain de Tirtoff)

L'Océan, costume design for *Les Mers*, George White's Scandals, 1923
Gouache on paper, 33 × 47.2 cm / 13 × 18½ in
Metropolitan Museum of Art, New York

In this costume design by the renowned Russian-born French artist and designer Erté (born Romain de Tirtoff, 1892–1990), a central figure representing all the world's oceans wears a skin-tight suit featuring a lurid purple and gold biomorphic pattern, redolent of the pulsating colour changes of a camouflaged octopus. Pictured mid-balletic leap, she throws aloft her nautilus shell headdress and extends arms that culminate in serpent's heads with mouths expelling an impossible mix of deep-sea fire and orange curling tentacles. Behind her, a dramatic train is supported by three water nymph caryatids, whose plaited silver hair transforms into the swirling, bubbling crests of dark green waves. Born to Russian nobility, Erté moved to Paris around 1910 and, following a stint working for the renowned couturier Paul Poiret, found huge success as a costume designer for jazz-age cabaret theatre performances. Erté's sinuous linear style – all curlicues and excessive decoration against flat blocks of colour – captured the mood of the Art Nouveau era perfectly, and his illustrations were much in demand for picture periodicals including *Harper's Bazaar*, for which he designed more than two hundred covers. George White, the American theatre impresario, saw Erté's costume designs for *Les Revue des Femmes* at Les Ambassadeurs in Paris in 1922, and successfully transplanted its *Les Mers* section to his popular Broadway revue George White's Scandals, featuring music by George Gershwin, for which these new designs were commissioned. Other costumes Erté created for *Les Mers* included figures for the Mediterranean, the Baltic and the Red and White seas, each with the same air of complex beauty and mystery as the seas they represented.

Alexander McQueen

Oyster Dress, 2003
Ivory silk georgette and organza, beige nylon
and silk chiffon, white silk, L. 1.8 m / 6 ft
Metropolitan Museum of Art, New York

Thousands of tightly coiled and overlapping layers of chiffon, fused together, create this show-stopping gown by the celebrated British fashion designer Alexander McQueen (1969–2010) that was presented in his iconic runway show *Irere* as part of his Spring/ Summer 2003 collection. The hypnotic effect draws the eye from the tossed wavelike skirt draped on the floor up the spiralling midsection to a bodice of boned tulle and shredded chiffon. The thick scalloped edges of the dress become an embodiment of the shape and texture of an oyster, with its

distinctive rutted shell. With the layers of the dress we also find reference to the production of pearls, whereby the mollusc repeatedly covers invasive internal objects with nacre, also known as mother of pearl, to protect itself. During McQueen's catwalk show, the dress played a pivotal role. To begin with, McQueen commissioned a film in which a model wearing the Oyster Dress was shown submerged and then rescued from the water. The film was used as a projected backdrop to the first part of the collection, which had a motif of shipwrecked pirates. At the

end of the section, the dress itself appeared on the catwalk, followed by two further parts featuring gothic mythological spirits and pieces inspired by birds of paradise, respectively. The Oyster Dress ultimately acted as a fulcrum for both the collection and the various ideas that McQueen was exploring, in particular the transformative power of the ocean.

Ivan Konstantinovich Aivazovsky

Wave, 1889
Oil on canvas, 3 × 5 m / 10 ft × 16 ft 6 in
State Russian Museum, St Petersburg

Mountainous waves roar down on a sinking ship to which desperate sailors cling. A signal flag streams from one mast as men climb in a doomed attempt to survive the merciless storm. It is all but impossible to tell where the sea stops and the sky begins as the dark storm clouds meet the churning waves and the stricken ship is lost to the depths. Ornate prose is appropriate to describe this vast work by the Romantic painter Ivan Konstantinovich Aivazovsky (1817–1900). At 3 by 5 metres (10 by 16 ft 6 in), the enormous canvas makes viewers feel

as though they are in the midst of the cold, salt-laden wind, deafened by the howls of the waves. On a sea voyage crossing the Bay of Biscay, off the Atlantic coast of Spain, Aivazovsky's ship was caught up in a storm of such intensity that the Parisian press reported, erroneously, that the vessel had sunk and the artist had died. Aivazovsky was renowned for his visual memory, which enabled him to reproduce scenes only briefly observed, and this painting may be a memory of that voyage. Aivazovsky was an Armenian Russian from Crimea known for his

seascapes, which he painted almost exclusively; many depict storms and foundering ships. He maintained his devotion to Romanticism, with images of a wild and destructive sea that fit well with the Romantic view of nature as a vast, sublime and ultimately terrifying force.

Rachael Talibart

Rivals, 2016
Giclée print 60 × 105 cm / 23⅝ × 41⅜ in
Private collection

While others are battening down the hatches and sheltering indoors from storms, British photographer Rachael Talibart runs towards the sea with her camera, ready to capture dramatic scenes such as these tempestuous waves threatening to engulf Newhaven Lighthouse on England's south coast. Although the mighty water appears to be the dominant force, the Victorian structure at the end of Newhaven breakwater in East Sussex has been taking beatings from the ocean since 1891. Specializing in coastal photography, Talibart records the ocean's shifting moods, from stormy and turbulent to serene and tranquil. Although she enjoys working with colour, she frequently uses black-and-white, which allows her to powerfully enhance the emotion of a scene. A love for the sea was instilled in her from an early age; growing up on the south coast of England, close to the shore, she remembers falling asleep on stormy nights to the sound of pounding waves. Her father was a yachtsman and frequently took her out on the water, though seasickness prevented her from becoming a sailor herself. Talibart continues to be enthralled by the ocean's might and majesty, which she now explores through her lens from the relative safety of terra firma. This image captures something of what it feels like to stand amid the exhilarating wind, watching the churning waves fill the air with salt spray. It speaks to humanity's enduring struggle with the sea, the lighthouse standing as a beacon of resistance against the forces of nature that would otherwise see ships dashed on the rocks.

Gottfried Ferdinand Carl Ehrenberg

*Aegir, c.*1880
Woodcut
Private collection

At the top centre of this chaotic scene stands an ethereal visage of the Norse god Aegir, the personification of the sea. His wife is Ran, and together they reflect the powers of the oceans in their varying aspects. Stories of Aegir often depict him as a gracious host, welcoming guests to his mansion beneath the waves; Ran, on the other hand, is frequently linked to the more dangerous qualities of the sea, dragging drowned sailors down to her underwater home. In this scene, however, it is Aegir who presides over a deadly maelstrom, holding his arms wide as if

to whip up the wind and waves. The sailors in a wooden ship, some wearing armour and helmets, are no match for the towering waves or, even more terrifying, the crowds of mermaids and mermen who seem intent on sinking the ship. Two of the creatures cling to the fishtail at the stern, while three more attempt to climb over the gunwales on the port side; another is locked in a fight with the steersman for his oar. In the waves, ghostly naked bodies of the drowned – men, women and children – cry out for rescue that will not come. Gottfried

Ferdinand Carl Ehrenberg (1840–1914) spent most of his working life in Dresden, Germany, where he executed a series of murals based on twelve illustrations depicting the gods and goddesses of Norse mythology, published in 1885 as *Bilder-Cyclus aus der Nordisch-Germanischen Götter-Sage* ('Picture Cycle from Nordic-Germanic Mythology'); this image was one of the first of these illustrations, recreated as a woodcut for publication.

Pietro Bracci

Oceanus, detail from the *Trevi Fountain*, 1762
Travertine, H. 5.8 m / 19 ft
Piazza di Trevi, Rome

It seems rather cunning that the most famous fountain in the world should also be adorned with sculptures that celebrate the essence of rivers and the ocean. Designed by Italian architect Nicola Salvi and completed by Giuseppe Pannini in 1762, the Trevi Fountain in Rome, Italy, is familiar from movies such as *La Dolce Vita* (1960) and *Three Coins in the Fountain* (1954), a reference to the tradition of throwing coins into the fountain for luck. Originally built by the ancient Romans, the fountain was fed by water from a spring situated 13 kilometres (8.1 mi) from the city and carried there by an aqueduct. Today's fountain is the result of renovation work in the 1600s and 1700s, when a series of popes and artists collaborated on an iconographic sculptural theme that celebrates water as a life-giving and world-forming element. At the very centre of the composition is this sculpture by Pietro Bracci (1700–1773) of Oceanus, the father of the gods of rivers and streams and water nymphs. In Greek mythology, Oceanus and his wife, Tethys, were said to have given birth to all other gods, which has an echo in the contemporary scientific understanding that life on Earth originally emerged from the sea. The Greeks also referred to Oceanus as the 'great world-encircling river', 'the perfect river', or the 'deep swirling river'. These conceptions appear to be linked to the uncertain etymology of the word *oceanus*, which came from the Greek 'ōkeanos' via Latin. The association between the sea and fresh waters denotes an early understanding of the hydrological flow that connects often remote and very different bodies of water across the planet.

Anonymous

Triumph of Neptune and Amphitrite, c.AD 300–25
Mosaic, 3.2 × 2 m / 10 ft 6 in × 6 ft 6 in
Museé du Louvre, Paris

This late Roman mosaic should, properly, be called *Poseidon and Amphitrite* (see p.286), because the consort of the god Neptune, the Roman syncretization of the Greek god Poseidon, was not Amphitrite but Salacia, goddess of salt water. Roman depictions of Neptune, especially in North African mosaics, were heavily influenced by Hellenistic iconography, however, and this is part of a vast mosaic from Cirta (modern Constantine) in Algeria. Here, Neptune/Poseidon and Amphitrite cross the sea in a chariot drawn by hippocamps (fish-tailed horses), the god holding a trident and both attended by winged erotes or cupids. Beneath the two deities are a pair of fishing boats, and around them are creatures of the sea: fish, dolphins, cephalopods and sea snails. Neptune was probably introduced to the Roman pantheon in the fifth century BC and was a fairly minor god in the Roman cult. Though he was closely identified with Poseidon, he was also considered the god of fresh water – rivers, springs and even wells – which helps to explain his necessary association with Salacia, goddess of salt water. The Greek Poseidon was also the god of horses and earthquakes and may have originally been portrayed in equine form; these associations are absent in Neptune's cult, which was exclusively concerned with his power over water in all its forms. Amphitrite, too, was solely associated with the sea in both Greek and Roman religion.

Mathaeus Wallbaum

Nautilus cup, 1610–25
Nautilus shell, silver, shell and gold,
51 × 11.4 × 22.2 cm / 20 × 4½ × 8¾ in
National Museum, Oslo

This nautilus cup, by the German goldsmith Mathaeus Wallbaum (1554–1632), features Aphrodite/Venus, who was born from the sea foam after Kronos castrated his father and threw the genitals into the sea. She stands on a golden winged orb as if on a ship, and holds a mantle blown by the ocean wind. An accompanying cupid reins in a huge sea monster, possibly the whale that swallowed the biblical Jonah (see p.131), judging from the bearded figure between the creature's teeth; a second cupid carries a quiver and bow on his back, attributes of the son of Venus.

A fish-footed Triton, son of Poseidon and Amphitrite (see p.286), supports the cup. Two further tritons decorate the shell, linked by chains sporting sea turtles and crabs. At the front is a horned personification of nature's plenty, perhaps the goat-god Pan; at the back is a malevolent face, mouth open in a scream. Nautiluses (*Nautiliae*) are native to the Indian Ocean and the South Pacific and are the only cephalopods to grow a shell. Considered exotic novelties in Europe, the shells – composed of a matte white exterior and an iridescent white inner layer,

with the innermost portion a pearlescent blue-grey colour – captured the imagination of Renaissance and Baroque artists. After 1600, as the Dutch East India Company increased its trading ventures in South and East Asia, they were picked up from the sea surface in ever-increasing quantities. A prestige object such as this would have been commissioned for display in a *Wunderkammer*, a cabinet of curiosities.

Georg Wolfgang Knorr

Plate B, from *Deliciae Naturae Selectae*, 1751–67
Hand-coloured engraving, 44.5 × 34 cm / 17½ × 13⅜ in
Smithsonian Libraries, Washington DC

Nautilus shells were among the earliest and most coveted collectibles of the Renaissance. Often encased in ornate silver and gold mounts, the shells were considered a symbol of perfection, beauty and fertility, and collecting such natural objects enhanced the reputation and social status of wealthy individuals. This beautifully detailed illustration by German naturalist Georg Wolfgang Knorr (1705–1761), from his 1751 book *Deliciae Naturae Selectae,* might at first appear to represent two different species of nautilus. But unlikely as it may initially seem, the plate depicts the before and after of a refining process. The shell at the top of the plate shows the original striped, tigerlike pattern typical of the nautilus, which is believed to help the animal camouflage in the marine environment. The completely white shell below, of which Knorr has also skilfully rendered the subtle mother of pearl iridescence, is a polished specimen of the same species. The white mother of pearl is revealed when the surface layer containing the orange pigmentation is stripped away. Between the fifteenth and eighteenth centuries, polished nautilus shells were especially sought after across the European aristocracy. Knorr based his illustrations of the marine animals, corals and shells in *Deliciae Naturae Selectae* on preserved specimens in private collections, including his own. Indicative of the growing interest in shells, Knorr's book was a publishing success in its own time and became a prototype for many other natural history volumes.

Adolphe Millot and Claude Augé

Mollusques, from *Nouveau Larousse illustré:*
dictionnaire universel encyclopédique, vol. 6, 1897
Lithograph, 32 × 24 cm / 12½ × 9½ in
Natural History Museum, London

This beautiful illustration of shells and molluscs adopts an unusual solution to the problem of illustrating undersea life both as it exists on the seabed – here in the central image – and as it existed in the experience of many readers, which was as empty shells collected at the seaside for their beauty. This plate by Adolphe Millot (1857–1921) comes from the *Nouveau Larousse illustré*, a French encyclopaedia edited by Claude Augé (1854–1924) and published by Éditions Larousse in 1897 to educate young adults (see p.212). Augé's new encyclopaedic model, based on the *Grand dictionnaire universel du*

XIXe siècle (*Great Universal Dictionary of the 19th Century*) by Pierre Larousse, featured hundreds of engraved illustrations and colour plates made possible because of the substantial technological improvements that made quality image reproduction both more affordable and more accurate. The inclusion of colour images in encyclopaedias was a significant step forward in the popularization of general knowledge at the turn of the twentieth century. The ingenious illustration of this page allows the reader to get a sense of the diversity of marine molluscs while also identifying shells. The

largest part of the illustration presents a collection of shells arranged like a specimen drawer in a natural history museum. Each shell is numbered and named, although the arrangement follows aesthetic principles rather than taxonomical parameters, and the shells are not reproduced in scale. At the centre of the image, the illustration of an imaginary seascape features an octopus in its den and different species of squid. At a time in which underwater photography and film did not exist, illustrations such as these truly brought to life otherwise inaccessible marine life.

ὄφις θαλάτιος, Græcis: Serpens marinus, Latinis: Draco marinus & Ophidion,
Plinio: *Serpent de mer*, Gallicé.

Sea Serpent or Dragon

Pierre Belon

Sea Serpent, from *De Aquatilibus*, 1553
Hand-coloured woodcut, 11.1 × 18 cm / 4⅜ × 7 in
Houghton Library, Harvard University, Cambridge, Massachusetts

Titled above in Greek, Latin and French, this woodcut revealed to the Renaissance world the cusk eel, a bony fish from the *ophidiidae* family (from the Greek *ophis*, meaning 'snake'). Though eellike in form, the fish is actually related to seahorses and tuna. The image appears in a two-volume work by French naturalist Pierre Belon (1517–1564) entitled *De Aquatilibus* (*On Aquatic Animals*). *De Aquatilibus* – Belon's second book, an expansion of an earlier volume mostly on dolphins and porpoises – includes descriptions of 110 species, all illustrated, and effectively established modern ichthyology, the zoological study of fish. Belon's work, which was not superseded until the seventeenth century, based its system of classification on Aristotle's ordering of animals, which included aquatic mammals, molluscs and even hippopotami among 'fishes'. Belon was one of the first naturalists to rely on his own research, dissecting animals himself and frequenting the markets of cities on his travels in search of birds and fish to investigate. As was not unusual for educated men during the Renaissance, Belon had many interests: he was a diplomat, physician, naturalist, traveller and artist, and he studied and wrote on topics ranging from ichthyology, ornithology and botany to architecture, classical antiquity and Egyptology. He is known today for his pioneering work in comparative anatomy, in which he was the earliest proponent of homology – the similarity between different taxa as a result of shared ancestry – which he proposed after studying the anatomical relationships between humans and birds.

Huang Yong Ping

Serpent d'Océan, 2012
Aluminium, L. 130 m / 426 ft
Saint-Brevin-Les-Pins, Pointe de Mindin, France

As the tide flows out of the Loire Estuary on the Atlantic coast of France, a huge skeletal sea serpent with silvery vertebrae and spindly metal ribs emerges from the depths. At times, the enormous aluminium creature seems to snake gracefully through the water, its head emerging as if to take a breath. At low tide, however, the monster appears stranded on the sands. The permanent installation was commissioned from Chinese artist Huang Yong Ping (1954–2019) as part of the 'Estuaire' art exhibition, which between 2007 and 2012 invited international artists to create large-scale works for the environment surrounding the Loire River between Nantes and Saint-Nazaire. Drawing on ancient Chinese mythology, Huang's sculpture recalls the legendary Jiaolong, a menacing dragon said to be aquatic or river-dewlling. Although the skeleton is fixed and remains static, it is animated by the tides, which cover and uncover it twice a day. The serpent's sinuous form echoes that of the nearby Saint-Nazaire bridge, while its relatively recent construction material links notions of modern progress to ancient beliefs and traditions. Huang was a prominent yet controversial figure in Chinese avant-garde art of the 1980s. In 1989 he moved to France, where he became naturalized as a French citizen. His choice to introduce a traditional Chinese motif to European shores with *Serpent d'Ocean* speaks to the notions of identity and cultural hybridity that defined many of his works and biography.

Adriaen Coenen

Pages from *Visboek*, 1577–79
Watercolour on paper, each page 31.7 × 21.5 cm / 12½ × 8½ in
National Library of the Netherlands, The Hague

Arranged like scientific specimens, these hand-drawn fish are accompanied by meticulous annotations relaying detailed information about each creature and its habitat. Painted in watercolour and decorated with ornamental frames and borders, this folio represents a handful of the thousands of illustrations filling the idiosyncratic *Visboek* (*Fish Book*), a scrapbooklike tome comprising 410 pages produced over three years by Dutch fisherman and fish auctioneer Adriaen Coenen (1514–1587). *Fish Book* is packed with information on the sea,

coastal waters, fishing grounds and marine life, with much of its content gleaned from Coenen's experiences in the Dutch port of Scheveningen, and later as wreck-master of Holland, which gave him access to all manner of strange creatures that washed ashore. His vast knowledge of the sea won him respect from the academic community, who gave him access to various learned works from Leiden University and The Hague. Extracts from these appear throughout his book, which mixes factual material with folkloric tales of mermen,

mermaids and sea bishops. Among its peculiar anecdotes is a sea monster 5 metres (16 ft) long spotted standing on its hind flippers and a tuna fish discovered to have sailing ship tattoos on its body. Coenen charged a small fee to view his finished book, displaying it alongside his collection of dried fish at the annual Scheveningen fair. Today, its detailed descriptions have helped scientists to better understand the impact of sea fisheries on marine ecosystems and how such habitats have changed since the sixteenth century.

Anonymous

Votive Plaque Showing Scylla, c.450 BC
Terracotta, H. 12.5 cm / 5 in
British Museum, London

After escaping from the island of the Sirens (see p.31), Odysseus must next negotiate the narrow straits guarded by Scylla – a sea monster with six long necks at her waist ending in fierce dogs' heads – and Charybdis, an insatiably hungry woman who personified a whirlpool. Circe advises him to keep away from Charybdis, who will scuttle the entire ship, in favour of Scylla, who will only take six men. The Roman poet Virgil's *Aeneid* associates the sea passage with the Strait of Messina, between the toe of Italy and the northeast

tip of the island of Sicily. This votive plaque from Aegina, called the Melian Relief after its suggested place of manufacture in the Cyclades, shows two of the dogs' heads and the tail of a sea serpent. Scylla's origins are various. She was said to have been a beautiful naiad – a nymph of freshwater springs, pools and rivers – who was desired by Poseidon but resented by a jealous Amphitrite, queen of the sea (see p.286). Amphitrite poisoned the spring in which Scylla bathed, turning her into a sea monster. According to the Roman poet Ovid, the patron god

of fishermen, Glaukos, fell in love with her. When she spurned him, fleeing to a promontory above the straights, he asked the witch Circe for a love potion, unaware that Circe herself had fallen for him. Spurned in turn, the jealous Circe poured poison into the pool in which Scylla bathed, transforming her into a ravenous creature of terror to sailors.

Anonymous

Deep-sea Scene with Luminous Fishes, from *Die Naturkräfte*, 1903
Chromolithograph, each page 25 × 19 cm / 10½ × 7½ in
Private collection

The dark waters of the deep ocean are illuminated by the shining flank of a scaly dragonfish swimming above a seabed teeming with marine fauna. The unnamed artist of this book illustration has taken liberal artistic licence in seeking dramatic lighting for their undersea showcase, ascribing a strong biolumi-nescence to both the dragonfish and the snaking, spindly Brisingid sea stars at the lower middle of the image, as well as inserting a seemingly contrived corallike plant at the far left whose branches glow with orbs like lightbulbs. The remaining specimens,

however, demonstrate careful observational accuracy in crafting a highly choreographed record of deep-sea life. The work shown was first published in the German-language popular encyclopaedia *Meyers Konversations-Lexikon* (see p.111), illustrating specimens dredged up by the French oceanographic steamship the *Travailleur*, which from 1880 to 1882 undertook exploratory expeditions in the Mediterranean and North Atlantic oceans in search of deep marine life. The discoveries made by the *Travailleur* and the subsequent 1883 journey of the *Talisman* were rapturously received by

the French public and popularized by an immersive exhibition at the National Museum of Natural History, Paris, and illustrated accounts of the voyages. Analysis shows the *Lexicon* work to be an elision of multiple direct copies of A.L. Clement's illustrations for Henry Filhol's inaugural account of the two expeditions, *La Vie au Fond Des Mers* (1885), including the pink glass shrimp that hangs above the dragonfish's head, the fearsome fang-filled face of the stoplight loosejaw and the spiny fierce king crab at the bottom left.

R. Koehler del. Lovatelli pinx. Werner & Winter Francfort ʃ M.

GORGONOCEPHALUS AGASSIZI

René Koehler, Albert I, Prince of Monaco, Jules de Guerne and Jules Richard

Gorgonocephalus agassizi, from *Résultats des campagnes scientifiques
accomplies sur son yacht par Albert I^{er}, prince souverain de Monaco*, 1909
Chromolithograph, 35.5 × 28 cm / 14 × 11 in
Marine Biological Laboratory, Woods Hole Oceanographic Institution Library, Massachusetts

Both before and during his reign, Albert I, Prince of Monaco (1848–1922), was also a pioneer of the oceanographic sciences. After serving in the Spanish and French navies, Albert began his scientific career in his early twenties and went on to make several expeditions with the aim of furthering the studies of oceanography, zoology, hydrography, topology and meteorology. In 1899 he founded the Musée océanographique de Monaco, followed by the Institut Océanographique in Paris in 1906, which today manages two oceanic museums and promotes the conservation of marine animals and environments. Albert's passion for marine sciences led him to travel extensively across the globe in search of new species and to devise techniques and instruments to measure and catalogue them for the institute. It was during one of his explorations that he commissioned this detailed illustration of the echinoderm Gorgon head (*Gorgonocephalus agassizi*, now *G. arcticus*), a species from the deep, cold-sea waters of the Arctic and the Antarctic that is related to the more common starfish. This illustration shows the underside of the animal's body, at the centre of which lies a mouth filled with sharp teeth capable of cutting through the hard shells of the crustaceans that it captures with the help of five thousand finely ramified tentacles. These tentacles can stretch up to 70 centimetres (28 in) across and are covered in spines and hooks designed to immobilize the prey. Its distinctive looks and predatory habits earned the creature its name in reference to the mythical Gorgon Medusa, who had snakes for hair and whose gaze induced paralysis.

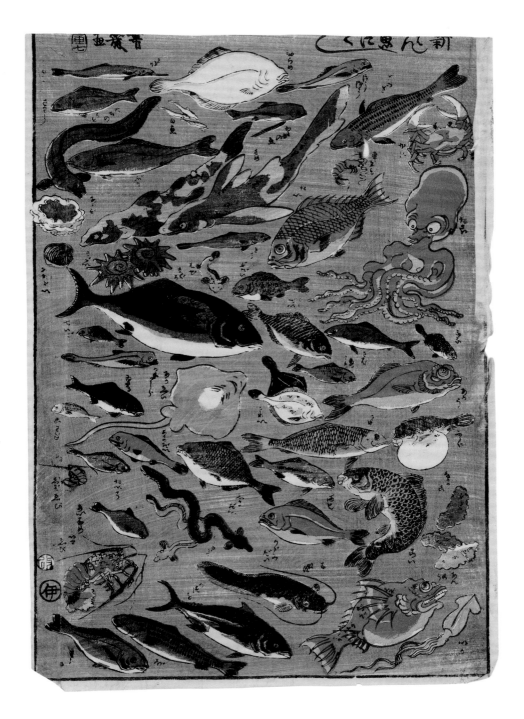

Utagawa Yoshiiku

A New Collection of Fish, 1854
Woodblock print, 36.2 × 24.8 cm / 14¼ × 9¾ in
Museum of Fine Arts, Boston

Featuring an array of vibrantly coloured marine animals from Japanese waters against a uniform green background, this colourful woodblock print by Utagawa Yoshiiku (1833–1904) showcases a collection of creatures that would have been caught locally for food. Utagawa was a popular artist and printmaker during the Meiji period (1868–1912), which saw the opening of Japan to the West and a flowering of artistic styles and subjects. He studied with Utagawa Kuniyoshi (see p.135) and like many other prominent contemporary artists produced work mostly in the style known as *ukiyo-e*, with subjects such as women in beautiful costumes, kabuki actors and warriors, as well as landscapes, folk tales and flora and fauna, such as the marine life in this Edo period print. Utagawa includes mostly fish, but also a crab, a spiny lobster, shrimps, an octopus, a squid, shellfish and starfish. Although the drawings are not highly detailed, they do contain enough characteristic features to allow many of the species to be identified. Among others are: Japanese halfbeak, flounder, red gurnard, Japanese grunt, Japanese bullhead sharks, flying fish and red sea bream. The large fish at left centre is a tuna, below which is a skate. Towards the bottom right a golden-bronze carp is depicted in typical curved leaping posture with, to its left, a red rockfish and, above it, a pufferfish with a distinctive inflated belly. A pair of eels slither down towards a catfish, to the right of which is a scorpionfish with sharp, spiny fins.

Ferdinand Bauer

Phyllopteryx taeniolatus, 1801
Watercolour on paper, 33.6 × 50.8 cm / 15¼ × 20 in
Natural History Museum, London

Native to the south Australian coast, weedy seadragons are among the most remarkable examples of camouflage in marine life. Related to seahorses, seadragons have slender and colourful bodies ornamented by ramified, or branched, appendages that resemble the appearance of underwater vegetation. This evolutionary adaptation makes the fish almost impossible to spot in the kelp-covered rocky reefs it commonly inhabits. While it does not have many natural predators in the wild, the species has been under threat due to human poaching – either by unethical 'collectors' for domestic aquariums or for use in Asian medicine, which considers the seadragon an aphrodisiac. This realistic representation of a pair of seadragons by renowned Austrian illustrator Ferdinand Bauer (1760–1826) shows the minute, and yet important, morphological differences between males and females. At the beginning of the nineteenth century, Bauer developed a reputation for his outstanding ability to capture anatomical accuracy in exacting detail at a time when photographic documentation was not available. To expediently and faithfully immortalize his specimens during his travels in Australia between 1801 and 1805, Bauer developed a method similar to 'colour by numbers'. He would quickly sketch the animal body and annotate details about colouration and texture through a colour-coding system he devised. Bauer could then focus on the nuances and intricacies of the colouration at a later time, in the calm and concentration of the studio.

Anonymous

Mola (Textile Panel) with Interlocking Fish, 20th century
Cotton plain weave with reverse appliqué and embroidery, 38.1 × 44.4 cm / 15 × 17½ in
Los Angeles County Museum of Art

This vibrant orange textile panel, with its bold interlocking fish design and variegated geometric decoration, is typical of the traditional hand-stitched *molas* produced by the Kuna people living in the San Blas Islands of Panama in the Caribbean Sea. The panels are produced in pairs and incorporated into women's clothing, usually with one *mola* serving as the front of a blouse and another as the back. Originating in the mid-1800s, *mola*-making developed from an earlier tradition of body painting and employs a technique of reverse appliqué. The term *mola* comes from the Kuna word for 'cloth', and each textile comprises numerous layers of fabric, reflecting Kuna origin stories about how Earth was created in various coloured layers. Depending on the complexity of the design, *molas* can take from two weeks to six months to complete and often contain thousands of individual stitches. Animals are a common motif, especially sea creatures inspired by the wealth of fish, lobster, crab and octopus in the San Blas Islands, where fishing has been essential to survival for generations. The archipelago comprises about 365 islands, of which 49 are inhabited. The Kuna people originally migrated there from Panama in the 1700s to escape conflicts with other indigenous peoples and Spanish conquistadors. In colonial times the people supported European corsairs and pirates, which angered the Spanish to such an extent that conquistadors vowed to exterminate the entire culture. The Kuna endured, but their way of life is now threatened by rising sea levels due to climate change, which could eventually make the islands uninhabitable.

Mian Nusrati

Sea Serpent Swallows the Royal Fleet, folio from a manuscript
of *Gulshan-i 'Ishq* (*The Rose Garden of Love*), c.1670
Opaque watercolour and ink on paper, 39.3 × 23.5 cm / 15½ × 9¼ in
Aga Khan Museum, Toronto, Ontario

A huge sea serpent coils itself around a fleet of ships, one of which has already fallen victim to the creature's hungry malice. Sailors on the next vessel to be devoured lift their hands in prayer for deliverance, while the unfortunate ones being swallowed attack the sea serpent ineffectually with spears; on the largest ship, a sailor with a musket takes aim at the monster from the yardarm. One man appears to have drowned, and two others are sinking, only their heads above water. In the sea around them, fish are being swallowed by demon-headed sea creatures, while a mermaid and merman swim among giant crabs, turtles and schools of small fish. This lively painting by an unknown artist has been identified as illustrating a scene from the *Gulshan-i 'Ishq* (*The Rose Garden of Love*), probably created during the reign of Sultan 'Ali II ibn Muhammad 'Adil Shahi, ruler of the independent kingdom of Bijapur, in the Indian Deccan plateau, in the mid-1600s. While the exact origin is unknown, it may have been made for an aristocratic courtier. The poem, a heroic epic composed in Urdu by the Sufi poet Mian Nusrati, is based on a Hindu love story adapted to Islamic mystical Sufism, with the lovers standing as a metaphor for the relationship of the soul to God. The idea of a disaster at sea is part of the standard picaresque type of romantic adventure, involving heroes who journey through exotic lands and meet with dangers on land and at sea.

Colton Hash

Acoustic Turbulence, 2019
Still from interactive data art installation, dimensions variable

Visible pollutants such as oil, plastics, effluence and agricultural run-off all have devastating consequences for ocean life, but not all pollution can be seen. Underwater noise created by global shipping might be invisible but has a serious impact on many marine animals, impeding whales, dolphins and porpoises, and other species that rely on echolocation to communicate and find food. Every day, container ships, cargo vessels, tankers and other types of ships crisscross the world's oceans, their engines and propellers generating noise that severely disrupts marine ecosystems below. Large ships are particularly noisy, especially when travelling at higher speeds. The low-frequency sound waves they generate travel much further and more rapidly through water than through air, and are often further amplified by a ship's metal hull. Seeking to raise awareness of acoustic noise pollution by visualizing the problem, Canadian data artist Colton Hash created *Acoustic Turbulence*, an interactive artwork that allows users to see as well as hear these disruptive sounds in the Salish Sea in the Canadian province of British Columbia. Using a computer keyboard, users can switch a virtual camera between a serene ocean view and a noisy submarine environment where the chugging, whirring and whining created by various classes of vessel can clearly be heard. The recordings, made with underwater microphones 2 kilometres (1.25 mi) below the surface, are accompanied by an abstracted visualization of the sound waves. Together, they expose a normally unseen aspect of our global economy's impact on the ocean.

目 (mé)

Contact, 2019
Mixed media, 2.3 × 7 × 8 m / 7 ft 6½ in × 22 ft 11½ in × 26 ft 3 in
Installation view, 'Roppongi Crossing 2019: Connexions', Mori Art Museum, Tokyo

Much of the magic evoked by classical paintings and sculptures revolves around their ability to forever immortalize a moment in time. Their stillness enables us to temporarily elude the relentless passing of time to more deeply contemplate the beauty of our world. *Contact* by Haruka Kojin, Kenji Minamigawa and Hirofumi Masui, members of the Japanese art collective 目 (mé), pushes this idea to the extreme. The work, which was installed at the Mori Art Museum in Tokyo, aims at manipulating the perception of the physical world and making us look at it afresh.

目 (mé) means 'eyes' in Japanese – a clear reference to the trompe l'oeil aesthetics that make the artists' collective work so striking and engaging. *Contact* is in itself a complete paradox. Its three-dimensional monumentality appears fluid, but it is thoroughly solid; it evokes uncontainable movement, yet it is unnervingly still; it summons the roaring sound of crashing waves while remaining perfectly silent. These apparent contradictions overwhelm the senses. The experience surprises the mind, destabilizes the body and triggers a primordial feeling of vulnerability

as the viewer is confronted by the sublime enormity of nature. An impossible scene, *Contact* brings us closer to the power of oceanic water in the safe and contained environment of the gallery space, reminding the viewer that the ocean is in a constant state of flux.

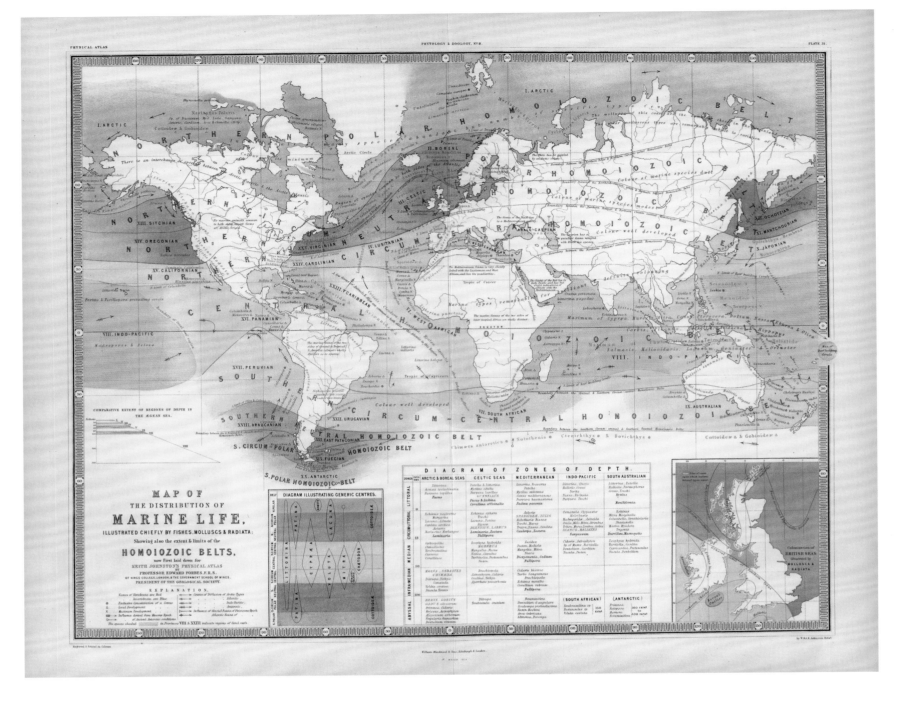

Edward Forbes and Alexander Keith Johnston

Map of the Distribution of Marine Life, 1856
Colour lithograph, 52 × 63 cm / 20¾ × 24¾ in
David Rumsey Map Collection, Stanford University, California

Dating from 1856, this thematic map illustrates the distribution of marine life, including fishes and molluscs, across the oceans as it was then understood. The pastel shades join regions of similar marine lifeforms – biogeographic zones known as homoiozoic belts – among white and empty landmasses. The map is the work of Scottish cartographer Alexander Keith Johnston (1804–1871) using the research of Edward Forbes (1815–1854), from the Isle of Man. Forbes was one of the first scientists to study and identify ocean zones in scientific terms. He also

posited the now-discounted azoic hypothesis, which stated that the deeper the ocean, the less likely any living organisms would exist there. In 1848, Johnston published *The Physical Atlas*, a series of thematic maps with notes illustrating the geographical distribution of natural phenomena based broadly on the *Physikalischer Atlas* by Heinrich Berghaus, which appeared in Germany in 1845. In turn Berghaus had followed the example of renowned naturalist and explorer Alexander von Humboldt, who had used a thematic map to convey information earlier in the

century. Berghaus was the first cartographer to see the value of producing a whole volume of thematic maps, and planned to work with Johnston on an English version of his atlas. When the project fell through, Johnston published his own book, based on the German work but using new kinds of thematic maps inspired by Scottish and English research. Realizing that a smaller atlas would garner a wider audience, he published a pocket version, the popularity of which led in 1856 to a second edition, in which this map appeared.

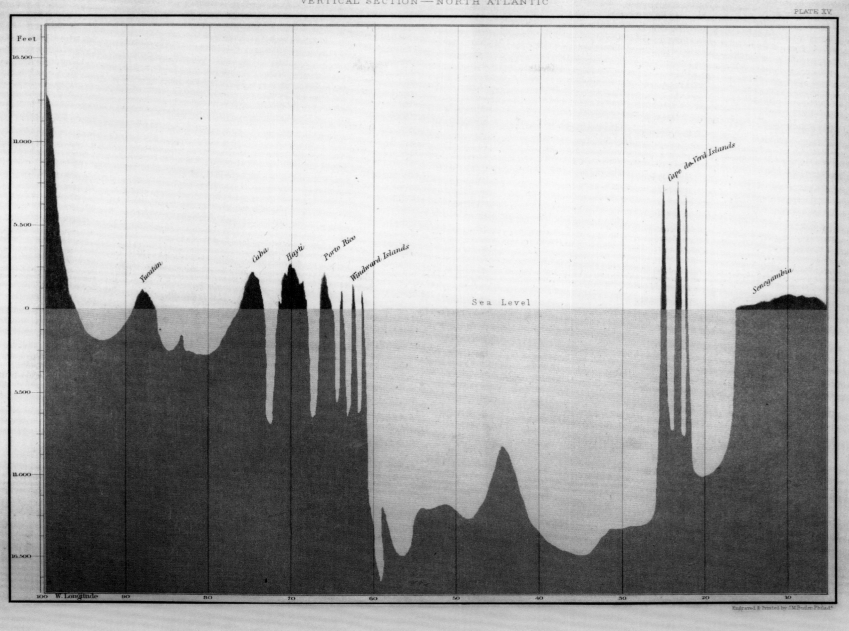

Matthew Fontaine Maury

Vertical Section – North Atlantic, 1854
Ink on paper
NOAA Central Library Historical Collection,
Silver Spring, Maryland

Before the nineteenth century, oceans were places of myth and romance, both feared and respected. Voyages were confined to established trading routes, and although captains kept detailed logs, the lessons they recorded were unavailable to others and were soon forgotten. This changed in the nineteenth century, when commercial and political interest in the sea expanded to include scientific endeavours. In the forefront of this work was the American Matthew Fontaine Maury (1806–1873). When an accident forced him to give up his seagoing naval career, Maury was put in charge of the Depot of Charts and Instruments (precursor to the US Naval Observatory) in 1842. There he discovered thousands of old ships' logs, from which he gathered details of currents and winds that he made available for the first time to all ships' captains. Maury's contributions to oceanography also included the earliest profile of the North Atlantic Basin. Between 1849 and 1853, he sent survey ships to make systematic depth soundings in the North Atlantic, creating the first map of the ocean basin, with zones shaded to show depths of 1,000, 2,000, 3,000, 4,000 or more fathoms (1 fathom = 1.8 m / 6 ft). In the chart shown here, Maury depicts a section of the North Atlantic, showing the elevation of various landmasses, including the islands of Cuba and Puerto Rico, relative to sea level. He conceded that there was conjecture in the map, but it nevertheless gave a general idea of the shape of the North Atlantic Basin. In the process, Maury discovered the submarine mountain range – now known as the Mid-Atlantic Ridge – on the ocean floor, naming it Dolphin Rise. It would later be shown to stretch the entire north-south extent of the ocean.

Natural History Museum, London

The Jersey Seaweed Album, 1850s and 1860s
Pressed seaweeds mounted on card, approx. 46 × 62 cm / 18⅛ × 24⅜ in
Natural History Museum, London

Arranged on squares of white paper, whose corners are slotted into a foldable card grid, twenty species of seaweed are arranged in this nineteenth-century naturalist album. Their pale, glassy hues and the overlapping buildup of translucent tones appear at first to be delicately washed watercolour illustrations but are in fact preserved and pressed specimens, collected around the shores of the British channel island Jersey, each accompanied by an annotated scientific name. They offer a colourful chorus of marine plant variety, from the ashen sienna brown of sugar kelp (*Saccharina latissimi*, top row, middle) to the crumpled, camouflaged green of sea lettuce (*Ulva lactuta*, second row, second left) and red cocks comb (*Plocamium cartilagineum*, third row, second right) that looks every bit the crown of an autumnal tree in leaf. Particularly popular among young women, for whom it was seen as a wholesome means of amateur scientific enlightenment, 'seaweeding', or the collection and pressing of algae specimens as a leisure pastime, boomed in popularity during the Victorian era, satisfying the new enthusiasm for the cataloguing and presentation of the natural world. Compared to the equally popular pursuit of flower pressing, however, the processes of preservation were more demanding. The samples would be thoroughly cleaned before being mounted onto blotting paper by use of tweezer and needle to artfully spread out the strands and coils of the plants, then pressed by heavy weights in order to flatten and dry them. Seaweed is also a natural source of agar agar, which helpfully adheres the specimens to the paper following pressing.

ALGEN.

Meyers Konv.-Lexikon, 4. Aufl. Bibliographisches Institut in Leipzig. *Zum Artikel »Algen«*

Hermann Julius Meyer

Algen, from *Meyers Konversations-Lexikon*, fourth edition, 1890
Chromolithograph, 25 × 17 cm / 9¾ × 6¾ in
University of Toronto

In an array of reds, blues and greens, this colourful lithographic plate shows in impressive detail the interconnectedness of marine algae with its surrounding environment and other inhabitants, including fish, birds and human civilization. By bringing both the shallow and deeper waters of the ocean closer to the reader, the illustration also depicts the importance of algae and where to find it. In a single lithograph, *Algen* (*Algae*), the unknown artist has illustrated twenty different marine algae of the Alaskan coast, including seaweeds – the largest and most complex algae – such

as *Laminaria digitata* (8), *Laminaria bongardiana* (6) and *Laminaria saccharina* (7). This plate is part of the first volume of *Meyers Konversations-Lexikon*, first published in 1885, which was the most important encyclopaedia in Germany and other German-speaking countries from its foundation in 1839 until the end of the twentieth century and beyond. The encyclopaedia was created by German industrialist and publisher Joseph Meyer (1796–1856) in Leipzig – later editions were published by his son Hermann Julius (1826–1909) – and was originally directed at the 'educated classes'.

Envisioned as an important source of information for an increasingly literate society, the series extended its reach to the broader public and became a standard reference book for students and all segments of society. Between 1960 and 1990 – before the Internet age – most German families had this encyclopaedia on their bookshelves as a general source of information. Meyer wanted to provide deeper knowledge about a diverse range of topics to a broader audience, going far beyond the level of information contained in other contemporary reference works.

William J. Darton Jr

The Royal Game of the Dolphin: An Elegant, Instructive and Amusing Pastime, 1821
Hand-coloured engraving, mounted on board, 40.6 × 51.4 cm / 16 × 20¼ in
MIT Museum, Cambridge, Massachusetts

The large body of the eponymous dolphin splits this hand-coloured board game diagonally from left to right, while above and below flying fish leap and arc back into the water, evading its jaws – apart from one that has already been captured. The fishes' bodies are divided into numbered sections, from one to twenty, along which players advance their pyramid counters following the roll of a teetotum, or spinning dice. Each section shows a colourful feature, including an hourglass, knights on horseback and an otter, whose fish-in-mouth pose is a miniature re-creation of that of the dolphin. William Darton Jr (1781–1854) was a British publisher of children's books and games who inherited his business from his father, to whom he had been apprenticed at the age of fourteen. The delicate lines shading the choppy seas that form the lower portion of the artwork, as well as the scales of the flying fish and rocks above, reflect the family's background as accomplished engravers. The game's vibrant outlook hides a deeper tension, however. On one hand, the game includes representations of the expanded horizons of the British Empire: the large sailing ships flying a Union Jack at top left and the flying fish, the symbol of Barbados, where Britain controlled large numbers of enslaved people on sugar plantations. On the other, the works of the Darton family sought, by encouraging children to play, learn and discover, to express the ideals of their Quaker faith, which encouraged them to actively campaign for the abolition of slavery and for universal literacy.

Aage Rasmussen

Friske Fisk, 1946
Lithograph, 100 × 62 cm / 39 × 24½ in
Danish Poster Museum in Den Gamle By, Aarhus

A vast purse seine fishing net beneath the ocean's surface draws a shoal of fish tightly together as it starts to close in this poster promoting the Danish fishing industry. With a coastline of 7,300 kilometres (4,500 mi), Denmark has always relied on fishing and is one of the world's leading exporters of fish today. Since the introduction of industrial fishing in the 1940s, Danes have relied on the commercial fishing of, among other fishes, Atlantic cod, Norwegian pout and North Sea sprat. In this image, the catch is celebrated. The work of leading Danish illustrator Aage Rasmussen (1913–1975), the diagonal formed by the netted fish dominates his poster – the trawling ship is scaled down – as the eye is drawn to the considerable bounty beneath the sea's surface. Rasmussen's style was influenced by the work of the highly successful Ukrainian (though French-born) poster artist Adolphe Jean-Marie Mouron, better known as Cassandre, whose distinctive illustrations gathered the poster's message into a single, dominant element. This was the same style Rasmussen used for his breakthrough poster design for the Danish State Railway, the DSB, in 1937. To celebrate the arrival of express trains, his image showed the new locomotives in the foreground while in the background the old-fashioned steam trains disappeared down the track. Its success led to more commissions for DSB and for many other Danish companies, such as the shipping company Maersk, and organisations including Danish Book Week and the fishing industry. *Friske Fisk* (*Fresh Fish*) was just one of several posters Rasmussen produced to promote the country's fishing industry, which is unique among fishing nations because the value of each catch is always distributed equally between the ship's entire crew.

113

Giorgio Liberale

Bottlenose Skate, 1558
Painting on parchment, 64 × 87 cm / 25¼ × 34¼ in
Austrian National Library, Vienna

This sixteenth-century painting of the underside of a skate presents the fish as if laid out on a fishmonger's slab, the pallid body contrasting with the gold tint of the background and presented within a decorative frame. The anatomical features are faithfully shown, with the mouth at the base of the snout below the nostrils and the tail curved to the right flanked by a pair of claspers, indicating that this specimen is a male. This large painting on parchment was executed by the Italian artist Giorgio Liberale (c.1527–1579) while working for the Imperial Court in Prague. It is one of many illustrations prepared for an edition by the physician Pietro Andrea Mattioli of the famous first-century herbal of Dioscorides, *Materia Medica*, under the patronage of Ferdinand I, the Holy Roman Emperor. Liberale designed nearly six hundred large illustrations for the Prague edition, to be cut into blocks for final woodcuts for printing. Shown here is the bottlenose (or white) skate (*Rostroraja alba*), a bottom-dwelling fish found mainly in coastal waters of the eastern Atlantic Ocean, including the Mediterranean Sea. A large species of skate, it reaches up to 2 metres (6 ft) long and has a long, broad-based snout that inspires its common name. In earlier times it was caught for food and was regarded as something of a delicacy. It has suffered from overfishing, sometimes by accident during trawling for other fish, and is now listed as endangered.

Christopher Dresser for Wedgwood

Skate Vase, c.1872
Terracotta, moulded and enamelled, H. 16.5 cm / 6½ in
Ashmolean Museum, Oxford, UK

Boldly painted in shades of blue and set in a gold frame against a brown background, the contours of this terracotta vase follow and reflect the diamond-shaped outline of a skate – a family of flat cartilaginous fish related to sharks and rays. Indeed, the whole vase is also shaped like a fish, with the open top resembling the mouth, below which is a gold eyespot, while the flared base resembles a tail fin, emphasized by vertical gold stripes. This charming object was created by British designer Christopher Dresser (1834–1904) for Josiah Wedgwood and Sons Ltd around 1872, a company widely famed for its fine earthenware, stoneware and other ceramics. Born in Glasgow, Dresser studied at the Government School of Design in London, where he developed an interest in botany, a subject that influenced some of his work. In 1860 he was elected Fellow of the Edinburgh Botanical Society and the following year Fellow of the Linnean Society of London. Dresser became an essential figure of the Aesthetic Movement of the late nineteenth century and one of the first major independent designers, creating pieces for manufacturers of a wide range of objects, including furniture, fabrics, ceramics and silverware. He held that design should embody the principles of Truth, Beauty and Power: that the materials used should be true (based closely on reality) rather than imitated, that beauty should be founded in science, and that these two qualities combined to produce power in an object.

Anonymous

Il Mare, from *The Illustrated World*, c.1900
Colour lithograph
Private collection

A diver brandishing an axe explores the bottom of the sea surrounded by a collection of corals, starfish, many representatives of fish species, and a shoal of jellyfish that would be impossible in the natural world. The illustration was designed to educate children about the wonders of technology at the turn of the twentieth century. On the water's surface, various crafts ranging from a recreational sailboat and submarine to a large industrial ship and a hot-air balloon show how the ocean can be explored from above. Dominating the lower portion of the illustration, readers can see how not even the most impervious and potentially dangerous of marine environments is inaccessible to humans. Invented in the early eighteenth century, the standard diving dress, like the outfit worn by this diver – also known as hard-hat or copper-hat equipment – protected the body from cold water and contact with sharp and abrasive underwater objects. Earlier models of diving suits date back to the early fifteenth century and were originally made of leather. The suits became essential for rescue operations but were also subsequently used to explore the marine environment. In this case, the long, weighty tubes pump air to the diver, making longer explorations possible. Early twentieth-century models such as this could be used to sink to depths of up to 180 metres (600 ft). A weighted belt as heavy as 35 kilograms (80 lbs) and weighted shoes of around 15 kilograms (34 lbs) ensured stability on the seabed.

Palitoy

Action Man – Deep Sea Diver, 1968
Mixed media, dimensions variable
Private collection

For a whole generation of British children growing up in the late sixties and seventies, this Deep Sea Diver with his complementary equipment would have produced a heady rush of excitement. For them, Action Man, of whom the diver was just one incarnation, represented the exciting opportunity of unlimited reenactment possibilities. Derived from his American cousin, G.I. Joe, the Action Man toy was first manufactured in 1966 by Palitoy, now owned by Hasbro. The figure's novelty sprang in part from its moveable limbs – the toughened plastic body had

riveted joints that allowed his elbows, knees, ankles and wrists to move – and partly from his different-coloured hair (four shades available) and hand-painted facial features. A marketer's dream, the original figure was only the initial purchase that opened the way to an increasing number of accessories and outfits that were bought separately to change Action Man's activity. The Deep Sea Diver appeared in 1968, building on the highly successful Action Man, Action Soldier and Action Pilot as part of the Action Sailor Range. The Deep Sea Diver's kit included a waterproof

diving suit and helmet. The user controlled the figure's descent and ascent in the water by blowing air through a tube to inflate the suit. As he surfaced, Action Man blew air bubbles 'just like the real divers who risk their lives exploring the ocean's depths', according to the accompanying Equipment Manual, which included detailed instructions to prepare Action Man for his underwater odyssey. The self-styled moveable fighting man could even chase off the accompanying plastic shark as he ventured to the depths of the bathtub.

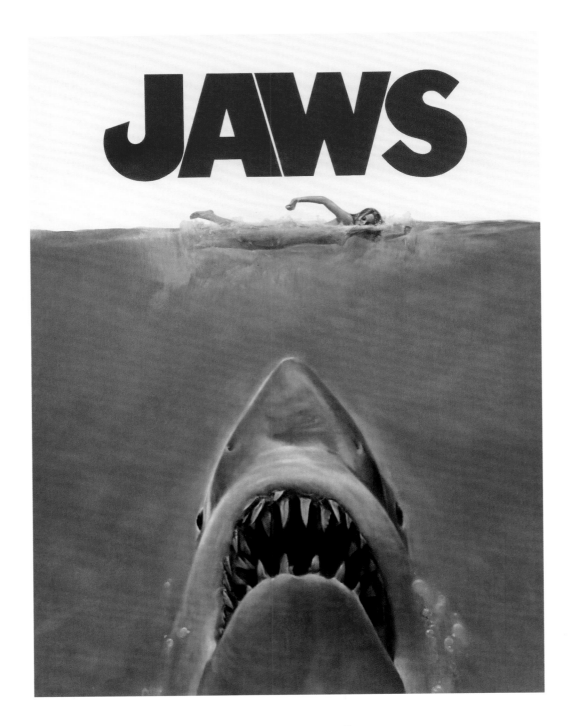

Roger Kastel

Jaws, 1975
Poster, 104 × 68.5 cm / 41 × 27 in

One of the most iconic and instantly recognizable images of the twentieth century, the poster for the 1975 Steven Spielberg movie *Jaws* was created by American artist Roger Kastel (b. 1931), based on a book cover designed by Paul Bacon for the hardback edition of Peter Benchley's novel the previous year. The poster itself had almost as big a cultural impact as the film it was promoting: the image speaks to somewhere deep in our subconscious, conjuring up the nameless fear many people have of deep water and whatever lurks beneath the surface. More than forty years after its first release, the film still grips and shocks in equal measure. In the film, Jaws is a great white shark (*Carcharodon carcharias*), yet the poster depicts a predator far bigger than any living shark, with characteristics drawn from several species (the teeth are not those of a great white shark, for example). Regardless, the poster grasped public attention and *Jaws* became the highest-grossing film in history (until *Star Wars* appeared two years later).

Over the years, humans' relationship with sharks – which are for the most part benign and fascinating animals – has largely turned negative, mainly due to upsurges in shark fishing. In the last forty years, shark populations have plummeted, with as many as 100 million being killed for food and sport every year. Many of the larger species are at serious risk of extinction.

Laurent Ballesta

700 sharks into the dark, Fakarava Atoll, French Polynesia, 2017
Film still, dimensions variable

This still from the documentary film *700 sharks into the dark* captures the moment when an immense group of grey sharks descends upon a tiny marine channel between coral atolls in their hunt for food. It is the work of French-born underwater photographer and biologist Laurent Ballesta (b. 1974), winner of London's Natural History Museum's Wildlife Photographer of the Year award in 2021. This work dates from 2017, when Ballesta led the Gombessa IV expedition to French Polynesia to film sharks in the southern pass of

Fakarava Atoll. After three years of planning, Ballesta wanted to study the grey sharks to better understand their hunting methods. Ballesta and his team filmed the sharks over 350 hours, producing 85,000 photographs. Among their findings, the team noticed a pattern of cooperation among the sharks that was unknown among other atoll sharks in Polynesia. The sharks worked together, instinctively forming a pattern to circle and trap their prey, the camouflage groupers that also use the pass. However, once the fish were cornered,

any cooperation vanished as each shark competed for their own food. A total of some five years of research showed that sharks are not as solitary as previously thought, confirming a growing body of evidence that some species of the predators hunt in groups. As well as sharing his finds in *700 sharks into the dark*, Ballesta also created a 12-minute immersive video for the City of the Ocean display at the Biarritz Aquarium in France, taking visitors into the heart of the shark pack's hunting ground for a stunning 360-degree experience.

Vincent van Gogh

Seascape Near Les Saintes-Maries-de-la-Mer, 1888
Oil on canvas, 50.5 × 64.3 cm / 19¾ × 25¼ in
Van Gogh Museum, Amsterdam

In this simple seascape, Vincent van Gogh (1853–1890), widely regarded as one of the world's most influential painters, captures the true colours of the ocean. Seen up close, the water and waves that appear mainly blue and white from a distance are revealed to also include shades of green and yellow, applied with characteristic short, bold strokes of a palette knife, producing a convincingly natural effect. The son of a minister, Van Gogh was born in the southern Netherlands. He left school at sixteen and worked for an international art dealer, initially in The Hague and later in London.

After short spells teaching at schools in England, van Gogh returned to the Netherlands in 1876. Supported and encouraged by his brother Theo, he began to focus on his drawing technique, at last finding his true vocation. In 1886 he moved to Paris, where he admired paintings by Claude Monet (see p.27), Henri de Toulouse-Lautrec and Émile Bernard, and where he developed a brighter style of his own. Yearning for more light, in 1888 van Gogh moved to Arles in the south of France, where the nearby scenes served as subjects for some of his most famous

paintings. He also visited the coast, especially the village of Les Saintes-Maries-de-la-Mer, where on the beach he painted this view across the waves of the Mediterranean to a trio of sailing boats. Grains of sand still lie between the layers of paint.

Dana Schutz

Mid-Day, 2019
Oil on canvas, 2.2 × 2.2 m / 7 ft 4 in × 7 ft 4 in
Private collection

A small boat is filled to capacity with white female human bodies – a lascivious mermaid sunbathing, the bust of the Virgin Mary – heads of birds and fish and other parts of animals, children's hands on the wooden edge and a diver's manometer, or pressure gauge. The calm blue ocean holds the captainless boat afloat but simultaneously signals an obvious peril, teeming with a school of dangerous-looking fish – a random convergence of dolphins, sharks and sardines. The colour of the ocean is reflected in lighter shades and dusky purples in the clear sky,

dotted with fluffy clouds and the sun (or perhaps the full moon) as a small white spot in the top left corner. At the centre of this seemingly chaotic cluster of objects, American artist Dana Schutz (b. 1976), has painted the Virgin Mary with her eyes closed as a metaphor for lost hope. The Christian iconography continues with the symbol of a boat packed full with humans and animals that is also reminiscent of Noah's Ark. Subtly indicated by the overloaded boat, this beautifully vibrant contemporary painting speaks to the disasters taking place on the world's

oceans and seas today. It reflects on the juxtaposition between a grotesque human world, the unfounded human fear of being attacked by unknown dangers in the oceans' depths, the disruption and damage inflicted on the ocean by humans for entertainment – sunbathing, diving, fishing – and a de facto calm and peaceful ocean, which is only defending itself against humans using the marine life within its waters to swarm and attack the boat.

Gustave Courbet

The Wave, c.1869
Oil on canvas, 46 × 55 cm / 18 × 21½ in
National Galleries Scotland, Edinburgh

A baleful wave rises up – its crest hitting the exact centre of the painting – and is depicted in the moment of its greatest strength and power. On the right-hand side of the image, ridged with foam created by its tumultuous movements, the wave begins to crash down on the shore, several obscured rocks in the foreground attesting to its presence. At the same time, the rip current at the bottom of the wave pulls at the seabed, crunching rock on rock. Behind, several more waves line up to repeat the process, a reminder that this wave is not unique but simply part of an endless cycle of nature. *The Wave* is one of a series of seascapes created by French painter Gustave Courbet (1819–1877) while he spent the summer at Étretat on the coast of Normandy in 1869. Depicting the power and vastness of the ocean, the single-wave paintings were inspired by the same motif found in Japanese prints, which were popular in Paris at the time. Courbet was strongly associated with the Realist movement in French painting, which, understood as a specific art-historical movement, sought to first choose subject matter that was considered ordinary or everyday and then to portray that subject with total honesty, avoiding anything artificial or additive. Here Courbet applies Realist rigour to the simple subject of the sea. Rather than seeking to romanticize or trying to avoid neutrality, he instead speaks to the sea's character, its energy and its essential part in everyday life.

Snøhetta

Under, 2016–19
Installation, 495 m² / 5328 sq ft
Lindesnes, Norway

A large bunkerlike structure appears to be sliding off the side of the coast into an angry sea, its foundation having been wrenched away by the relentless force of the water. However, the location and orientation of the building are entirely intentional, as *Under* was designed as a partly submerged coastal restaurant and marine research centre by the Norway-based international architecture firm Snøhetta, which has for decades created notable public and cultural projects around the world, always incorporating landscape into their design. *Under* can be found in Lindesnes on the southernmost point of the Norwegian coast, a location where natural elements collide, including storms from both the north and south that mix the briny and brackish waters, leading to a unique abundance of biodiversity. Visitors can gain an unparalleled look at this environment by descending 34 metres (110 ft) down the building until they are 5 metres (16 ft) below the surface, where a massive window allows views of the seabed on which the building rests. The building's mono-lithic structure is designed to gradually become integrated into its marine environment, with walls 50 centimetres (20 in) thick to withstand the water pressure outside, and a rough concrete exterior that will function as an artificial reef, becoming covered with limpets, kelp and other organisms. Cameras and other measurement tools on the outside of the building are used by marine biologists to observe and document the number and behaviour of the species that live around the restaurant as part of an effort to manage key marine species and improve marine resource management.

SN-16015
A Capitol Re-Issue

THE NO. 1 SURFING GROUP IN THE COUNTRY **THE BEACH BOYS**
SURFIN' U S A

Capitol RECORDS

SURFIN' U.S.A. · FARMER'S DAUGHTER · MISIRLOU · LONELY SEA · SHUT DOWN
NOBLE SURFER · HONKY TONK · LANA · LET'S GO TRIPPIN' · FINDERS KEEPERS

The Beach Boys and John Severson

Surfin' USA, Capitol Records, 1963
Studio album, 31.4 × 31.4 cm / 12⅜ × 12⅜ in
Private collection

Rarely was a band more associated with surfing than the famously non-surfing Beach Boys (only one of the group surfed). Released on 25 March 1963, *Surfin' USA* was the West Coast band's second album. It stayed in the highly influential pop charts for the next seventy-eight weeks, reaching No. 2, and made stars of the band (although it belied their later musical sophistication). The album's iconic cover – a photograph of a surfer riding a wave – was taken by the Californian creator of surf culture John Severson (1933–2017), a Hall of Fame surfer and founder of *Surfer* magazine. Despite the band's West Coast credentials, Severson shot the image not in California – the waves are not that high – but at the North Shore on Oahu in Hawaii in January 1960. Alongside lyrics that extolled a life riding the waves – 'Surfing is the only life, the only way for me' – the cover photograph captured the thrill and freedom of the surf world. Emerging from the postwar world into the excitement of the 1960s, the idea of a carefree life lived both on and off California's beaches captured the imaginations of a whole generation of teenagers not just in the United States but across the world. In the Beach Boys' universe, life was about freedom and fantasy: doing nothing more than jumping in the car with a surfboard to head to the beach for a day of swimming, surfing and hanging out with great-looking young people. If the songs captured the heady thrill of the West Coast, Severson's image also seared itself into the minds of a whole generation as an expression of a sense of freedom.

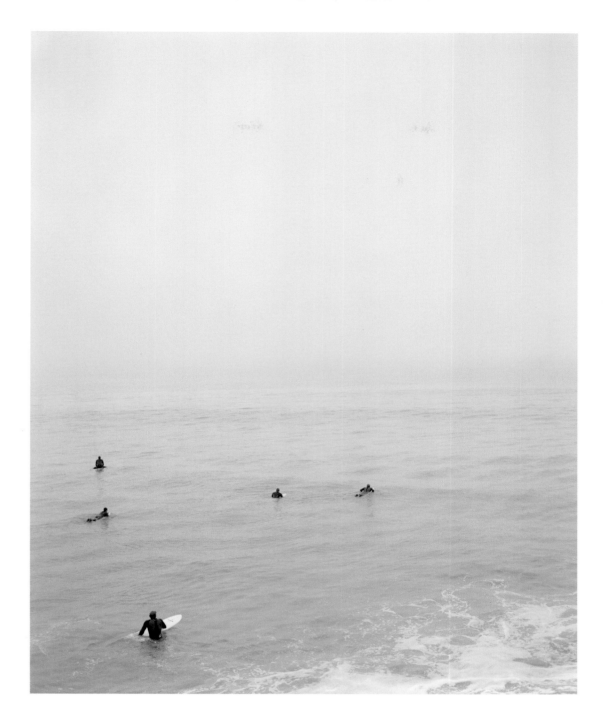

Catherine Opie

Untitled #4 (Surfers), 2003
C-print, 1.3 × 1.2 m / 4 ft 2 in × 3 ft 4 in

The grey sea fades into a hazy sky with no horizon in this photograph taken off Malibu Beach in California, perfectly capturing the feeling of frustration these surfers must be experiencing as they wait for the monotonous, blank sea to come to life. The word *surfer* evokes images of blue skies, colossal crashing waves, and fit daredevils, but the images in the *Surfer* series by American photographer Catherine Opie (b. 1961) are the antithesis of this cultural cliché. In these images, surfing is defined not so much as an activity but as a community in a relationship with a landscape. In that way, they echo Opie's interest in subverting expectations: her *Freeways* series from the mid-1990s features highways but no people or vehicles, while *Wall Street* (2001) also shows New York's financial district empty of people. Her interest in the surfing subculture – *Surfer* also included portraits of young surfers with their boards – reflects her practice of applying traditional portraiture to nontraditional subjects, such as Los Angeles's lesbian and gay community. Although they are engulfed by the immensity of the endless ocean, these surfers without surf remain a community sharing an experience familiar to all surfers: studies suggest that surfers only spend 8 per cent of their time in the ocean riding waves, the rest being spent paddling or waiting for the right wave. Surfing is generally believed to have been invented by the Polynesians in Hawaii in around AD 400, although some people claim it was practiced in Peru far earlier. It was introduced to the West Coast in July 1885, when three teenage Hawaiian princes took a holiday in Santa Cruz.

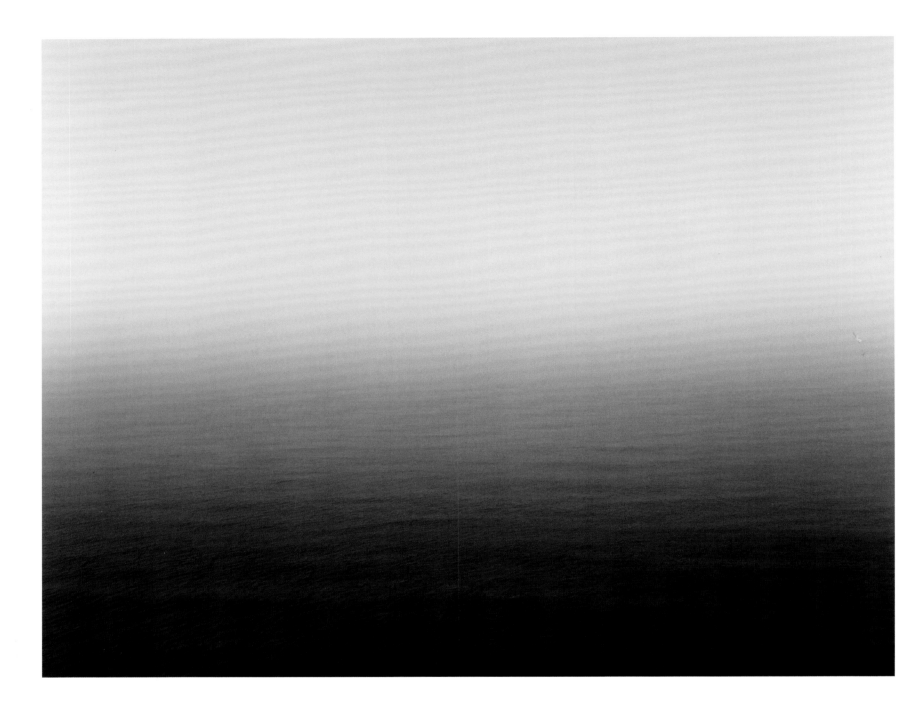

Hiroshi Sugimoto

North Atlantic Ocean, Cliffs of Moher, 1989
Gelatin silver print, 42.3 × 54.2 cm / 16⅝ × 21⅜ in
Metropolitan Museum of Art, New York

The frame of this black-and-white photograph is split horizontally, with the top half occupied by the sky and the bottom half by the ocean. Where they meet, the horizon is a hazy blur softened by fog. Ripples on the water look like slight creases in the smooth surface of the sea. It is a timeless image – a chance to see the world, for a moment, as it must have appeared to early civilizations. *North Atlantic Ocean, Cliffs of Moher* is part of a series of 'Seascapes' by the Japanese photographer Hiroshi Sugimoto (b. 1948). Since 1980, Sugimoto has

documented 'the ancient seas of the world' – from the Atlantic Ocean to the Ligurian Sea to the Bay of Sagami. The series is inspired by his childhood memories of visiting the ocean and standing in front of that epic, unobstructed horizon. He uses a large-format camera, natural light and, sometimes, long exposures to create meditative works that are reminiscent of Mark Rothko's series of black-and-grey paintings. The constraints of the format – black-and-white tones and the frame always divided between sea and sky – allow for endless variations.

Each photograph is a bracing reminder of humanity's precarious existence: this seascape was here before us and will be here long after we are gone. It is also a reminder of the primordial pull of the ocean, or in Sugimoto's words: 'Every time I view the sea, I feel a calming sense of security, as if visiting my ancestral home; I embark on a voyage of seeing.'

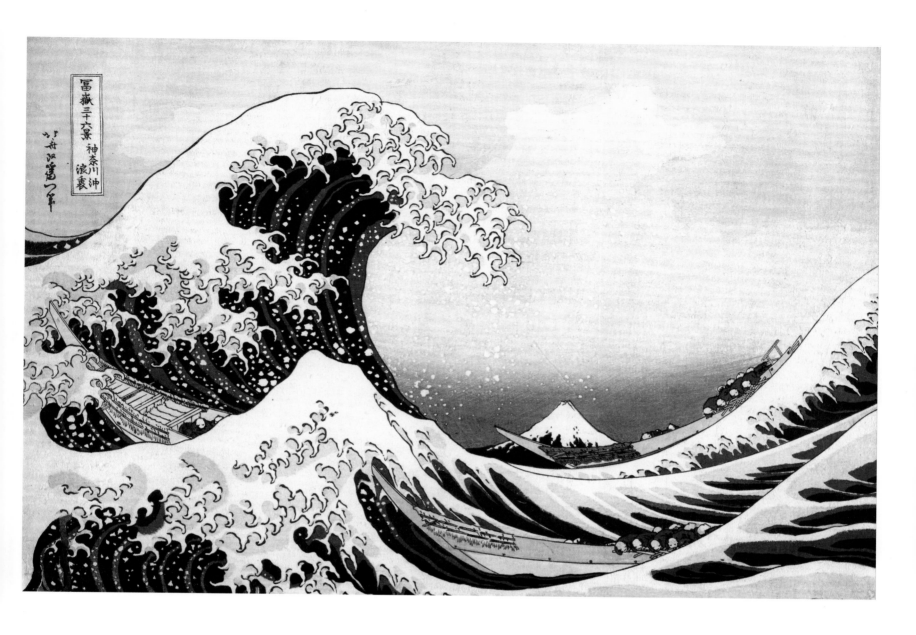

Katsushika Hokusai

Under the Wave off Kanagawa (or *The Great Wave*), c.1830–32
Polychrome woodcut, 25.7 × 37.9 cm / 10⅛ × 15 in
Metropolitan Museum of Art, New York

Arguably the most famous woodcut print in the history of Japanese art, *The Great Wave* has greatly influenced Western artists including Claude Monet (see p.27), Edgar Degas and Vincent van Gogh (see p.120). This marine scene is one of a series of prints titled *Thirty-six Views of Mount Fuji*, made by Katsushika Hokusai (1760–1849) between 1826 and 1833. At the centre of the image, Japan's most famous volcanic mountain is dwarfed by the imperious power of a massive wave menacingly cresting above three fishing boats. An intricate layering of indigo and imported Prussian blue, countered by the bright and crisp white surf, conveys depth and intense dynamism. At the mercy of swelling waves, the fishermen appear small and insignificant. The message is clear: nature's power is uncontainable and can wipe away humanity in an instant. Like many marine scenes from around the world, *The Great Wave* carries an existentialist meaning: the turbulence of the waves symbolizes the unpredictability of life while Mount Fuji exemplifies a quintessential Buddhist and Daoist notion of solemn stillness and immortality. Hokusai's career spanned more than seven decades, through which he is said to have produced more than 30,000 works and illustrations for more than 250 books. *The Great Wave*, his best-known, was finished in 1832, when the artist was seventy-two years old.

Hasegawa Settan or Tsukioka Settei

Whales and Whale Oil, 1829,
Woodblock printed book, 22.8 × 16 cm / 9 × 6¼ in
Metropolitan Museum of Art, New York

Whales once played a vital part in the economy of many nations, including the northeastern seaboard of the United States in the 1800s, but they were particularly important in Japan, as shown by this woodblock book illustration by Edo period artist Hasegawa Settan (1778–1843) or Tsukioka Settei (1710–1786). The whales that take up the bottom half of the image are labelled to show their different parts and their uses, while the upper right-hand page illustrates how whalers used nets to surround a whale with fishing boats to corral and kill it more efficiently. The Japanese have hunted whales in the Pacific Ocean for thousands of years, using nearly every part of the mammal: the meat, blubber and organs were a valuable source of protein, fat and minerals, while oil from the blubber was crucial as a fuel for lamps and waxy ambergris from the intestine was used as medicine. Today, Japan is one of just two countries – Iceland is the other – that continue to hunt whales despite global conservation rules. Both countries claim to hunt whales for permitted scientific purposes, but the fact is that the whale meat is widely sold for food. During the Edo period, woodblock printing proliferated, allowing an increasingly literate Japanese population access to all kinds of printed material. Images were drawn onto thin Japanese paper then glued to a smooth wooden block (often cherry) that was chiselled away to leave the lines of the illustration to be inked and pressed against the paper.

Sebastião Salgado

Southern Right Whale Navigating in the Golfo Nuevo,
Valdés Peninsula, Argentina, 2004
Gelatin silver print, dimensions variable

In the late eighteenth century, an estimated 55,000 to 70,000 southern right whales occupied the southern oceans; by the 1920s, there may have been fewer than 300. With protection, the total has recovered to some 14,000 today. This image shows a behaviour unique to these whales: tail sailing by elevating their flukes to catch the wind, which appears to be a form of play often seen off the coast of Argentina. The black-and-white images of Brazilian photographer Sebastião Salgado (b. 1944) are, deliberately, the size and shape of easel paintings, with rich tonal variation and dramatic contrasts of light and dark that evoke the Baroque works of Rembrandt or Georges de la Tour and bring to mind the work of Ansel Adams (see p.261). This photograph forms part of the *Genesis* series, undertaken between 2004 and 2012 as an attempt to capture nature in its still-pristine state. Following *Workers* (1993) and *Migrations* (2000), Salgado wanted to show not the degradation of the planet but its beauty – the places and creatures (including humans) who, he believes, still inhabit an earthly Eden. He wanted his 'love letter to the planet' to provide an incentive to preserve the beautiful places that remain. The project is rooted in his return in the 1990s to his childhood home in Brazil, which he remembered as a paradise but which he found deforested and eroded. He and his wife established the Instituto Terra to reforest the property. The animals, birds and plants returned, and the idea of *Genesis* was born.

Peder Balke

The North Cape by Moonlight, 1848
Oil on canvas, 62 × 85 cm / 24½ × 33½ in
Metropolitan Museum of Art, New York

This spellbinding nocturnal seascape by Norwegian artist Peder Balke (1804–1887) captures the solemn majesty of the North Cape in the island of Magerøya, northern Norway. This location is the northernmost point of Continental Europe, and it is famous for the flat plateau ending in a dramatic 307-metre-high drop (1,007 ft) to the sea below. Although Balke travelled there only once, in 1832, well before tourism put the cliff on the map, he painted the subject multiple times throughout his career, often experimenting with different lighting and meteorological effects. The high contrast and almost monochromatic palette make this nighttime depiction one of his most remarkable. Tenebrous and cloud-strewn nocturnal skies had become fashionable in northern European painting during the second half of the eighteenth century, as the Industrial Revolution began to drastically alter the natural world. A full moon peering through the clouds and bathing sea waters in silver lighting imbued the image with a spiritual undertone – a reminder of bigger and purer things than the soot and grime that dominated life in the growing European cities. In this context, the northern seas offered a rare, metaphorical encounter with uncontaminated truth. The candour of snowbanks glistening in the distance heightens the sense of longing for a primordial and raw nature uncompromised by human greed. Channelling the cultural mood of his time, Balke accentuated the greatness of the natural landscape by reducing the size of humans, who appear frail and vulnerable aboard a small vessel shrouded in darkness.

Pieter Lastman

Jonah and the Whale, 1621
Oil on oak panel, 36 × 52.1 cm / 14¼ × 20½ in
Museum Kunstpalast, Düsseldorf

The prophet Jonah hurtles through the air, having just been expelled from the belly of a monstrous sea creature. His naked, twisting body mirrors the creature's flailing tail, while his modesty is protected by a flowing red cloth that spews from the fish's mouth like a giant tongue. This small painting by Dutch artist Pieter Lastman (1583–1633) was commissioned by the wealthy merchant Isaak Bodden for his Amsterdam shop, which some speculate may have sold the type of cloth covering Jonah. It illustrates a scene from the Old Testament in which the

prophet, after being commanded by God to proclaim judgement against the city of Nineveh, flees on a ship headed for Tarshish. A violent storm arises on the sea and Jonah is thrown overboard and swallowed by a great fish (commonly believed to be a whale, a symbol in Christian art for the devil and his duplicity). After languishing in its stomach for three days and nights, he prays to be rescued and is duly disgorged. Humbled, and having experienced divine deliverance, he returns to preach at Nineveh. Lastman paints the story's crucial turning point:

the moment of Jonah's liberation. In showing him without clothes, he hints at rebirth, alluding to Christ's New Testament teaching that one must be 'born again' to enter heaven. The dramatic pose and the play of light and shadow on Jonah's body shows the influence of Caravaggio, whose work Lastman saw in Italy in the early seventeenth century. Lastman was important in the development of Dutch history painting and counted Rembrandt among his students.

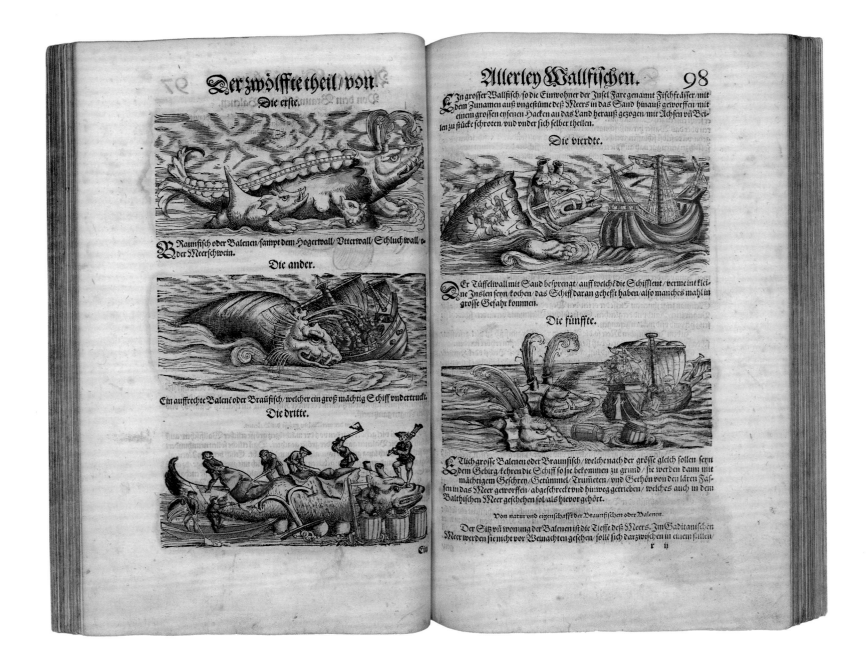

Conrad Gessner

Pages of *Fischbuch*, from *Historiae animalium, Lib. I. de quadrupedibus viviparis*, 1598
Hand-coloured woodcut print, each page 39 × 25 cm / 15¼ × 9¾ in
Lower Saxony State and University Library in Göttingen, Germany

In these five hand-coloured woodcuts, whales, depicted as monstrous creatures, are shown swimming through the high seas, attacking a ship and, ultimately, being hunted and killed. Created by Swiss polymath Conrad Gessner (1516–1565), the illustrations were included in the first encyclopaedia of fish – the *Fischbuch*, or *Piscium & aquatilium animantium natura*, the fourth volume of *Historiae animalium,* first published between 1551 and 1558. The first systematic work of the Renaissance, the four volumes of *Historiae animalium* laid the groundwork of modern zoology and gained significant success. The *Fischbuch* alone consists of 700 woodcuts and engravings describing more than 750 fish species. Gessner collected the largest number of fish species ever published, surpassing even Guillaume Rondelet's famed *Libri de Piscibus Marinis* (1554–55). Gessner's sources were diverse, from the most important scholars of his time to farmers and fishermen. Due to a lack of classical literature on this topic, he gathered contemporary research as well as firsthand observations. Gessner's morphological knowledge was so precise he was able to deduce whether an illustration of an unknown species was realistic or not. His extensive network also allowed him to describe fish from other regions outside of Switzerland. Gessner has been referred to as the Leonardo da Vinci of Switzerland and the father of both modern zoology and bibliography, the latter thanks to his *Bibliotheca universalis* (1545–49), in which he listed all works then known that were handwritten or printed in Hebrew, Greek and Latin.

Walt Disney Productions

Film poster for *20,000 Leagues Under the Sea*, 1954
Printed paper, dimensions variable

Adapted from Jules Verne's 1870 novel, Walt Disney Productions released the science-fiction adventure film *20,000 Leagues Under the Sea* in 1954. Shot in spectacular widescreen, the visually stunning film tells the reimagined story of Captain Nemo (played by James Mason) as the commander of the submarine *Nautilus*, and the incredible exploits with his captives, Professor Aronnax (Paul Lukas), his assistant Conseil (Peter Lorre) and the harpooner Ned Land (Kirk Douglas). Depicted in this promotional poster for the film, the attack of a giant squid on the *Nautilus* was an epic, unforgettable highlight. Filming it was a major challenge as the original animatronic squid suffered from a number of malfunctions. Directed by Richard Fleischer, the scene was initially shot against an orange sunset backdrop on a flat, calm sea. But the result appeared fake and lacking in drama. The studio embarked on a $350,000 reshoot ($3.5 million today) using a rebuilt version of the squid, now ominously black, with specially designed tentacles that could move and coil like snakes thanks to hydraulics and air pumps. The sunset was replaced with gale-force winds, storm-battered actors and white-capped waves that contrasted with murky dark blue skies. It wasn't until 1987 that the word *steampunk* was coined by science-fiction writer K. W. Jeter to describe a subgenre that incorporates retro-futuristic technology inspired by nineteenth-century industrial steam-powered machinery. Thirty-three years earlier, art director Harper Goff's design for the *Nautilus* submarine was much braver than the original streamlined concept for the film. With prominent brass rivets over its hull, the Gothic-inspired *Nautilus* was a perfect example of steampunk, years ahead of its time.

Taf. LXXIX.
Polypus levis Hoyle.

Verlag von Gustav Fischer in Jena.

Carl Chun

Polypus levis, from *Die Cephalopoden*, 1910–15
Colour lithograph, 35 × 25 cm / 13¾ × 9¾ in
Marine Biological Laboratory, Woods Hole Oceanographic Institution Library, Massachusetts

This dramatic illustration of an octopus (*Muusoctopus*, formerly *Polypus levis*) was drawn from a specimen collected in the waters near the Kerguelen Islands in the extreme south of the Indian Ocean. The species, which inhabits subantarctic waters down to about 400 metres (1,300 ft) and is a predator of brittle stars, was first described in 1885 following the British oceanographic research expedition undertaken by HMS *Challenger* from 1872 to 1876. That expedition in turn inspired German marine biologist Carl Chun (1852–1914), professor of zoology at the University of Leipzig, to persuade the German government to fund an expedition of its own to study the marine life and geology of the deep ocean. The German Deep-Sea Expedition duly set out from Hamburg on the steamer *Valdivia* on a one-year mission on 31 July 1898, with a distinguished scientific staff led by Chun himself. The ship was outfitted with state-of-the-art facilities, including laboratories, scientific libraries and space for specimen storage. After confirming the position of Bouvet Island deep in the South Atlantic, the expedition made detailed studies of the subantarctic seas and gathered a large collection of botanical and zoological specimens for detailed scientific research. The results of the expedition were detailed over twenty-four volumes, published from 1902 to 1940. In 1910 Chun published *Die Cephalopoda*, his seminal work on cephalopod molluscs – octopuses, squids and their relatives – with ninety-five illustrations, including this one, some of which were based on specimens and observations from the expedition.

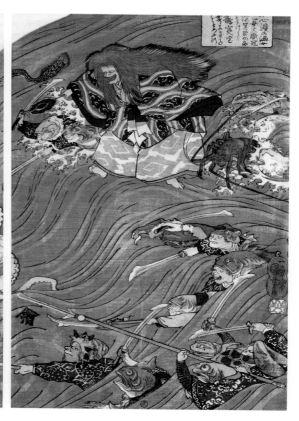

Utagawa Kuniyoshi

Retrieving Treasure Ball from the Dragon Palace, 19th century
Woodblock, triptych, each 35.6 × 24.8 cm / 14 × 9¾ in
Victoria and Albert Museum, London

A giant octopus, its tentacles writhing in foam in a trough between mountainous waves, is on the cusp of catching Princess Tamatori, known in Japanese legend as the Sea-wife. In her left hand, the princess clutches a giant pearl wrapped in a blue cloth to her chest as she raises a dagger above her head to fend off the sea monster. She has stolen the pearl back from the Dragon-king – depicted here flying over the crest of the wave – who took it from her father, who had originally received it as a gift from the then-dynastic emperor. Elsewhere in the

image, the king is supported by many fish-headed warriors. In this image we see the moment just before the princess cuts open her breast to hide the pearl, as a result of which her blood clouds the water and helps her to escape and return the jewel to her son and husband – although she herself perishes from her wound. Japanese artist Utagawa Kuniyoshi (1797–1861), one of the last great masters of the *ukiyo-e* style of woodblock prints and painting, uses all the metaphors that the sea can muster to heighten the drama of the scene. The foam around

the princess's feet looks like grasping talons while the deep undulations of the waves emphasize the closeness of the contest between the opponents in the struggle. The effect is to plunge the viewer deep into the scene, lurching from side to side as if joining in the pursuit of the escaping princess.

Billy Doolan

Patterns of Life – Minya-Guyu (Fish Spawning), 2005
Acrylic on linen, 88 × 203 cm / 34⅝ in × 80 in
Collection of Hans Sip, Wangaratta, Victoria, Australia

A passionate environmentalist, Billy Doolan (b. 1952) has said that he paints 'to share with people my dismay and frustration at what destruction people inflict on Mother Earth, its waters and oceans and the life within'. To that end, the native Queenslander completed a series of paintings entitled *Patterns of Life*, which includes *Minya-Guyu*, or *Fish Spawning* (2005), to reflect his sense of foreboding regarding the state of the world's oceans. Fish are central to Doolan's view of the world, which reflects his Australian Aboriginal coastal roots and upbringing.

In *Fish Spawning*, nature's natural symmetry and organization are seen in the graceful movement of the fish, which Doolan imbues with a sense of rhythm and life that underscores his belief that 'Mother Nature provides the fish with life cycles to ensure survival by replenishing the oceans and waterways. We are responsible for helping Her by keeping the environment clean and not overfishing.' As a Palm Island Aboriginal elder, Doolan takes seriously his responsibility to educate as many people as possible and uses his art to inform while

also conveying the beauty and symmetry intrinsic to nature. His work is about storytelling; with no written language, Australian Aboriginal cultures have always used images to tell stories and convey meaning. In *Fish Spawning*, Doolan shows the viewer not only the dynamism of the fish's life but also its centrality to the life cycle of the ocean. The frothy white spawn, detailed against the dramatic black background, represent the future.

Scottie Wilson

Blue Fish, c.1950s
Coloured pencil, gouache on black paper,
54.6 × 57.1 cm / 21½ × 22½ in
American Folk Art Museum, New York

Only becoming an artist at the age of forty-four, Scottie Wilson (1888–1972) attracted admirers including André Breton and Pablo Picasso. A leading figure in the world of 'outsider art', Scots-born Wilson (born Louis Freeman) served on the Western Front in World War I as a teenage drummer boy before emigrating to Canada, where he ran a junkyard in Toronto. Years later, Wilson described how he was listening to the composer Mendelssohn one day when 'all of a sudden I dipped the bulldog pen into a bottle of ink and started drawing – doodling I suppose you'd call it – on the cardboard tabletop'. His early work was peopled with malevolent figures he called 'evils and greedies'. Later he produced a body of work, always signed with his nickname 'Scottie', that was much happier and joyful, representing goodness and truth, as he saw them in nature, in drawings of sea birds, ducks, flowers and fishes. *Blue Fish* was likely produced in the 1950s, by which time Wilson had relocated to Europe, where he spent time in London and France. The playful underwater scene was created using coloured pencils and gouache on black paper. Surrounded by a green border, the spotted and striped fish swim in different directions around an upright seaweed. Wilson's father was a skilled taxidermist, which might help explain his cross-hatching technique with its tendonlike aesthetic. Avowedly antimaterialistic, Wilson sold his work for a fraction of its value, believing that the less well-off deserved the chance to buy art for themselves.

潮時　1964　　　　176/

Shirō Kasamatsu

Tidal Hour, 1964
Colour woodblock print, 36.8 × 24.8 cm / 14½ × 9¾ in
Los Angeles County Museum of Art

Born in Tokyo, Shirō Kasamatsu (1898–1991) started his career as a painter, training under Kaburagi Kiyokata, who had specialized in portraits of beautiful women before turning to woodblock printing. Kiyokata gave his student the name Shirō with which he would later sign all his works. Switching to engraving and printing landscapes in 1919, Kasamatsu began to design woodblocks for the famed publisher Watanabe Shōzaburō, who would publish many of his prints. Later, in the 1950s, Kasamatsu concentrated on a series of bird, animal

and flower prints, as well as his *Eight Views of Tokyo*. It was only later in his career that he carved and printed his own woodblocks as part of the movement called *Sōsaku-hanga*, which appeared in Japan in the early twentieth century. In this movement, the artist was the sole originator and producer of their own work, responsible for everything from conception to execution. This print, *Shiodoki* or *Tidal Hour*, was one such work. Between 1955 and 1965, Kasamatsu produced almost eighty prints this way. Produced in 1964 as an edition of two hundred prints, *Tidal Hour*

shows a shoal of fish swimming in the tide. Against a gorgeous deep blue background, his blue-and-yellow-striped fish appear to move as the tide carries them along. Each fish is unique: Kasamatsu detailed every part of each fish slightly differently, their fins, bellies and tails all show their own characteristics, and paid homage to the importance fish play in Japanese life and culture.

Cristina Mittermeier

Mo'orea, French Polynesia, 2019
Photograph, dimensions variable

A young boy explores an alien sapphire world in an explosion of light and chaos that creates a vibrant mix of shapes and detail, with flashes of intense colour and a feeling of raw energy. The image was taken off the coast of Mo'orea in the Tuamotus, a collection of around eighty coral islands and atolls in French Polynesia that comprises the largest chain of atolls on Earth, stretched across an area the size of Western Europe. The archipelago includes Rangiroa, a lagoon enclosed by a circular reef that has been hailed as the world's largest natural aquarium, and the circular reef and lagoon at Fakarava, which has been made a UNESCO Biosphere reserve thanks to its endemic species (of twenty-seven bird species in Tuamotus, ten are endemic) and its value as a nursery for fish and other marine life. Each July, Fakarava is the location of a spectacle known as the 'wall of sharks'. Thousands of groupers arrive to spawn, creating an easy supply of food that attracts up to three hundred sharks of a range of species, the most numerous being the grey shark (*Carcharhinus amblyrhynchos*). Mexico-born marine biologist, conservationist and photographer Cristina Mittermeier (b. 1966) is a cofounder and president of SeaLegacy, an organization that sets out to use images and cinematography to tell a story about the importance of ocean conservation. That drive can clearly be seen in this piece and its composition. The conflict between humans and the seas is one that needs to be settled, and images like this play a key role in that healing process, as a reminder that we can have a healthy relationship with our oceans that benefits life both above and below the waterline.

Farshid Mesghali

Illustration from *The Little Black Fish*, 2015
Watercolour and block print, 25 × 25 cm / 10 × 10 in

First published in Iran in 1967, the children's book *The Little Black Fish* gained a devoted following within the country. Written by Samad Behrangi and illustrated by Farshid Mesghali (b. 1943), the beloved picture book is, like all classics of the genre, both simple and profound. The eponymous black fish wonders whether there might be more to life than the stream in which it swims. The story describes the journey the black fish makes to explore the world and the characters it meets along the way. Written at a time when Iran was ruled by the Shah, the book spoke of the freedoms denied to most Iranians and, as a result, was banned. In post-revolutionary Iran, the book has remained a cherished part of Iranian life, partly because of Mesghali's bold and dynamic illustrations. In this image, the outsized black fish is swimming against the current towards the sea and a brighter future, accompanied by many other fish who are swimming in the same direction. Mesghali realizes the water with three large, bold horizontal strokes of different shades of green, showing that the black fish really does dream big.

Mesghali won the prestigious Hans Christian Andersen Award in 1974 for his illustrations, but readers in the West had to wait much longer to enjoy an English translation of the Persian classic. It was only published in the United States in 2019 following its UK publication in 2015. Isfahan-native Mesghali studied painting at Tehran University before working as a graphic designer and illustrator. Since 1986 he has lived in Southern California, where he continues to work today.

Knapp & Company for W. Duke, Sons & Co.

Fishers and Fish, 1888
Colour lithographs, each card 3.6 × 7 cm / 1½ × 2¾ in
Metropolitan Museum of Art, New York

Set against ocean backgrounds, complete with seaweeds and corals, the colours and textures of six fish are captured in faithful detail on a set of lithographic trading cards. These cards, examples from a set of fifty for the *Fishers and Fish* series, were printed in 1888 by the New York-based Knapp & Company for W. Duke, Sons & Co. to promote their brand of cigarettes. Lithography started in Europe, notably in Germany in the 1830s, and became popular in America from about 1840. Chromolithography is one of the most successful methods of

printing in colour, as it enables both fine detail to be preserved and subtle shades to be reproduced. From around 1880 until the 1940s, cigarette and other companies utilized the technology along with mechanized printing to mass-produce collectible cards such as these. With limited series, featuring images from pop culture and sports figures to flora and fauna, the cards became a popular form of advertisement and created the hobby of card collecting. While this series included both freshwater and marine fish, together with images of young

women fishing in a range of whimsical outfits, the species depicted here are (clockwise from top left): blue fish (*Pomatomus saltatrix*), Spanish mackerel (probably *Scomberomorus maculatus*), pompano (probably *Trachinotus falcatus*), lamprey eel (probably sea lamprey *Petromyzon marinus*), red snapper (*Lutjanus campechanus*), and bonito (probably *Sarda sarda*).

Anonymous

Festival Kimono, first half of 20th century
Resist painting on cotton, 1.1 × 1.3 m / 3 ft 8 in × 4 ft 3 in
Minneapolis Institute of Art, Minnesota

This elaborate festival robe celebrates the marine life of the subtropical waters of Okinawa, the southernmost of the Japanese islands, which is famed for its great natural beauty, a flavour of which is reflected here. Before it became a subject of the Satsuma clan in 1609, Okinawa (then called Ryukyu) had been an independent kingdom, and it retains many of its ancient traditions, including the characteristic decorative methods used to create this kimono. One of these methods is known as *bingata* (*bin* meaning 'colour'; *gata/kata* meaning 'pattern'),

a process that typically involves the use of a stencil to draw the design onto the textile followed by a technique of dyeing traditionally practiced in Okinawa. This example is more correctly described as a *bingata tsutsugaki*. In *tsutsugaki*, the motifs are drawn by hand and then painted with a rice paste that resists the dye. The aquatic creatures depicted are mostly marine and include flatfish, shellfish, a lobster, a sea urchin and an octopus, all artistically placed against a dark blue background, and the pattern of sea creatures continues around onto the

front of the robe. They may not all have been based on direct observation of a sea catch, however, and the large grey fish at the top is probably a carp, a freshwater species that symbolizes vigour and strength, while the lobster above it, its back bent like that of an elder, represents longevity.

Mandy Barker

SOUP: Tomato, 2011
Photograph, 1.5 × 1.1 m / 5 ft × 3 ft 6 in
Private collection

Bottle tops, balloons, toothbrushes, combs, pens, food packaging, cigarette lighters and children's toys are among the plethora of red objects in this constellation of waste plastic. In this image from her *Soup* series, British photographer Mandy Barker (b. 1964) highlights the staggering scale of global marine plastic pollution. The term 'plastic soup' was coined by oceanographer Captain Charles Moore to describe the patches of marine debris he observed in the North Pacific Ocean in the late 1990s. Also known as the Garbage Patch, this mass accumulation of waste caught by ocean currents spans the waters from North America's west coast to Japan. All of the plastics photographed for Barker's series were salvaged from beaches around the world, and many objects had been drifting in the sea for years before being washed ashore. For each image, the items are organized by colour or type and individually photographed against a black background before being digitally collaged to appear as if suspended underwater. Between 4.8 and 12.7 million tonnes (5–14 million t) of plastic end up in the ocean every year, and while much of it sinks to the seafloor, the rest is left floating in the water, where, rather than biodegrading, it breaks down into smaller pieces that are ingested by sea creatures. Barker works alongside scientists to raise awareness about ocean pollution and its harmful environmental impact. By drawing attention to the reality of what is dumped in the sea and the damage it causes, she aims to inspire public outcry and catalyze legislative action.

Euphausia superba (the krill) × 3

Typical sample of deep-sea pelagic life from a depth of 1,000 metres.

Alister Hardy

*Typical Example of Deep-sea Pelagic Life from a Depth of 1,000 Metres
and Detail of Euphausia superba (the Krill), 1925–27*
Painting, 38 × 26 cm / 15 × 10¼ in
National Maritime Museum, Greenwich, London

Professor Sir Alister Clavering Hardy (1896–1985) was a distinguished English marine biologist and one of the leading experts on marine ecosystems, with a particular interest in zooplankton: small floating animals that lie at the base of many complex oceanic food chains. Between 1925 and 1927, Hardy was the zoologist on board the Royal Research Ship *Discovery*, which explored the Southern Ocean around Antarctica. From this vessel he was able to collect and analyze samples of plankton using a monitoring device he had invented, the Continuous Plankton

Recorder (CPR). This machine, versions of which are still used, collects plankton on a moving band of silk and preserves them in formalin. Painted by Hardy, this illustration was included in his 1967 book *Great Waters*, which was based on journals he wrote during his time onboard the *Discovery* investigating the ecology of whales. His New Naturalist book *The Open Sea* (1956), subtitled *The World Of Plankton*, is still regarded as one of the finest references on the subject. Depicting a 'typical sample of deep-sea pelagic life from a depth of 1,000 metres', the

painting contains an assemblage of zooplankton, including amphipods, copepods, shrimps, jellyfish and small fish, many in larval stage, and gives an impression of the richness of this floating planktonic 'soup'. In pride of place at the top is a detailed depiction of Antarctic krill (*Euphausia superba*), a relative of shrimps that swarms in huge numbers and on which many other animals feed, including baleen whales.

Anonymous

Textile with *Japonisme* Pattern, c.1880–1921
Printed cotton, dimensions variable
Musée de l'Impression sur Etoffes, Mulhouse, France

Stylized sinuous nets repeat in a swirling pattern around fish set against a marbled blue background with breaking waves in this late nineteenth- or early twentieth-century *Japonisme* textile design from Alsace. Surrounding the bright red crayfish or lobster at the centre, its long antennae curving upwards, the two grey fish with pale undersides likely depict tuna, commonly caught for food, while the red fish may be sea bream. With its beautiful pink or red colour, sea bream is regarded as a 'good luck' fish in Japan, with its Japanese name, *tai,* linked to the word for

'celebration', *omede-tai.* The image of the leaping red fish is also widely used on Japanese nautical flags to encourage good fortune at sea. The textile is a prime example of the strong historical connection between the Alsace region of France and Japan. As early as 1863, as Japan began to open to the West, kimono wholesalers in Osaka made direct contact with the famous fabric makers of Alsace, especially those in Mulhouse, and ordered woollen kimono material to be printed with designs supplied from Japan. Images from traditional Japanese culture such as figures

in formal dress, bamboo, birds and fish, began to appear on garments and in Western art more generally. Thus began an export trade that developed into a general fashion known as *Japonisme,* which continues to have a following today.

Verdura

Lion's Paw Brooch, 1942
Natural scallop shell, sapphire, diamond and gold,
7.1 × 7.4 × 2.3 cm / 2⅞ × 3 × ⅞ in
Verdura Museum Collection, New York

For the society ladies of New York City in the early 1940s, there was only one brooch to be seen with: the lion's paw shell brooch designed by Sicilian aristocrat Duke Fulco di Verdura (1899–1978), which was made using a natural scallop shell set with real diamonds. Verdura's career started in Paris in the 1920s, where, among other things, he helped his celebrated friend Coco Chanel design her iconic Maltese Cross cuffs. Moving to the United States in 1934, Verdura designed jewellery for the leading stars of the day, including Marlene Dietrich and Greta Garbo. Legend has it that the lion's paw shell brooch was created after a trip to the American Museum of Natural History in 1940. In the gift shop, Verdura bought a number of large, striped scallop shells that he took across Central Park to his workshop, where he had his craftsmen set diamonds and sapphires along the crevices of the shells. For Verdura, the sparkling diamonds captured the moment the tide, shining in the sun, recedes from the shell on the beach, while the protruding knobs and bumps on the shell's ridges give the scallop the kind of distinctive rough texture he favoured. He also used smaller, more colourful scallop shells for his designs, wrapping them in gold wire or setting them in a wave of diamond 'foam'. The lion's paw brooch, which first appeared in *Vogue* in 1941, became highly sought after, appearing on the lapels of style icons such as Tallulah Bankhead, Betsey Cushing Whitney and Millicent Rogers, all of whom owned the piece of jewellery.

Valter Fogato

Diorama of the Madreporian Reef in the Maldives Islands, Indian Ocean, 2013
Mixed media, 4 × 3.5 × 2.3 m / 13 ft × 11 ft 6 in × 7 ft 6 in
Natural History Museum of Milan

For decades, natural history dioramas – large-scale models – have been a highly effective way to give museumgoers worldwide the opportunity to experience remote and inaccessible natural environments. Introduced at the start of the twentieth century, dioramas were used to enthuse audiences about the marvels of the natural world and promote habitat preservation. At a time when photography and film were still technologically limited, dioramas played an important educational role, portraying scientifically detailed scenes of natural habitats most visitors would never be able to experience in their lives. This outstanding diorama of marine life in the Maldives created by Valter Fogato at the Natural History Museum in Milan, Italy, depicts precisely the habitat of madreporian corals typical of tropical shallow waters. Literally meaning 'mother of pores', the name *madreporian* relates to the texture of the calcium carbonate reefs, impressive architectural structures in which sometimes hundreds of thousands of individual, minute polyps capture their food by using stinging cells located on their tentacles. The bright and intense colourations visible in this diorama are true to healthy coral colonies, but climate change has negatively impacted coral around the world, causing it to discolour – a phenomenon known as coral bleaching. This happens in response to the rising water temperatures as the polyps expel the algae (zooxanthellae) that symbiotically inhabit their tissues, turning reefs completely white. While the polyp can survive this traumatic event, coral bleaching has been read as a stark warning of the destructive powers that human activities can have over the natural world.

Courtney Mattison

Our Changing Seas IV, 2019
Glazed stoneware and porcelain,
335 × 518 × 55 cm / 132 × 204 × 22 in
Private collection

This swirling constellation of organic forms is inspired by the fragile beauty of ocean coral. Comprising several hundred handmade sculptures, the enormous wall installation is one of several produced by Los Angeles-based ceramicist and ocean advocate Courtney Mattison (b. 1985) to raise awareness of the devastating impact of human activity on ocean habitats. Greenhouse gas emissions, marine pollution and overfishing all threaten the future of coral reefs to the extent that, if left unchecked, many scientists predict they could be lost altogether. In her intricate ceramic sculptures, Mattison seeks to balance the beauty of coral reefs with their peril, reflecting their remarkable diversity of shapes and colours while highlighting their vulnerability. Her delicate forms are created by pinching together coils of soft clay and using simple tools, including chopsticks and wire brushes, to add texture before they are fired in the kiln. Some pieces have thousands of tiny holes poked into them to mimic the surface of coral. Mattison's palette of colours reflects the vibrant hues of healthy reefs, which she juxtaposes with white glazes to echo the damaging effects of coral bleaching, a process in which coral loses its colour due to changes in water temperature, light or nutrients. Mattison, who has a background in marine conservation, hopes that the emotional impact of her work will move viewers in ways that scientific data rarely can, prompting people to value and protect these precious ecosystems before they are destroyed forever.

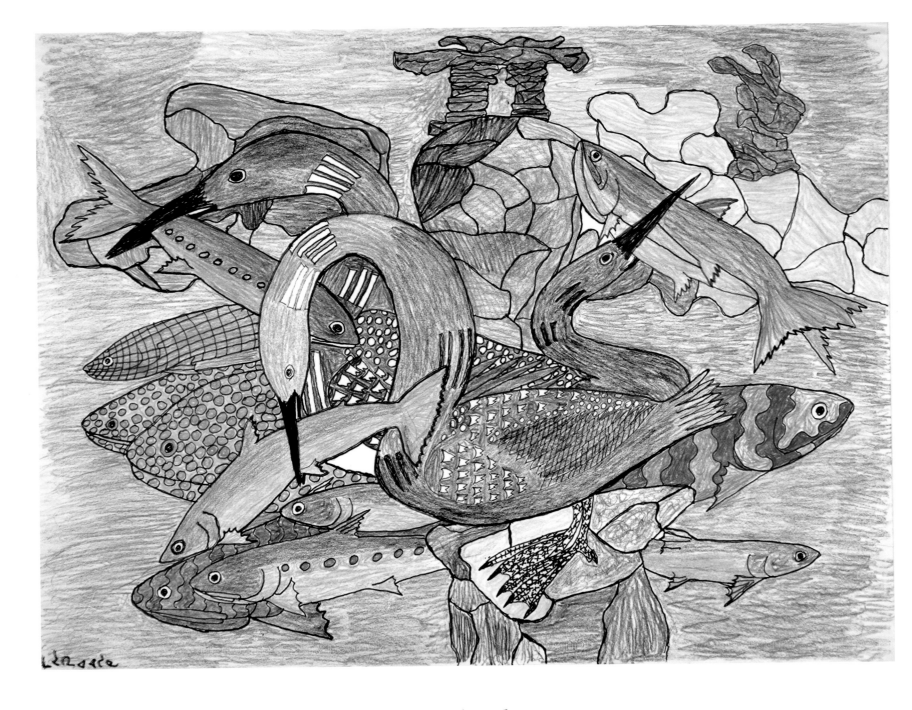

Mayoreak Ashoona

Untitled, 2013
Coloured pencil, ink on paper,
49.9 × 64.9 cm / 19⅝ × 25½ in
Private collection

In this coloured pencil drawing by the Inuit artist Mayoreak Ashoona (b. 1946), three loons are shown on a rocky outcrop with their fish catch of the day. Using finely drawn lines, Ashoona edges her birds and fish in black ink before adding colour, thereby differentiating the salmon from the Arctic char and trout. Drawing her influence from the natural world, Ashoona depicts Inuit life based on the many years she spent in the remote Arctic outpost of Kinngait, Dorset Island, Canada. Here she illustrates a plentiful feast for the birds that catch fish when the ice has melted and the seas are once again teeming with life. In her drawing, it is not only the variety of fish but also their sheer quantity that reflect the supreme significance fish play in Arctic life. The fish feed not only the birds but also the Inuit, who rely on them year-round. The more bountiful the fish, the easier life is for them. Self-sufficiency is essential for survival, and on Dorset Island preparing skins and sewing clothes was just part of a daily routine that also required Ashoona to earn a living through her art.

Uniquely among Arctic Inuit culture, the West Baffin Eskimo Cooperative, to which Ashoona belongs, focuses on the arts and artists within the community. Following in the footsteps of her mother – one of the first generation of Inuit female artists – Ashoona has used her drawing skills to make a living, working in a variety of styles from the abstract to the figurative.

Alex Mustard

Brandt's Cormorant Hunts for a Meal in a School
of Pacific Chub Mackerel beneath an Oil Rig, 2015
Photograph, dimensions variable

A Brandt's cormorant (*Urile penicillatus*) is silhouetted against the blue of the ocean within a circular space formed as a school of Pacific chub mackerel (*Scomber japonicus*) flees from the predatory bird. The sturdy support legs and drill of the oil rig are otherwise partially obscured by a curtain of swirling masses of the small fish, which also gain some refuge under the shade of the structure. Captured by British photographer Alex Mustard (b. 1975), the image juxtaposes a natural wildlife encounter with a solid artificial structure. Drilling for oil raises

thoughts of environmental damage, yet here we can admire the opportunist flexibility of nature, the cormorant taking advantage of an unnatural intrusion into the marine habitat. The oil rig provides shelter for fish and other animals, and the cormorants dive to lurk behind the legs of the rig before emerging to chase the surprised fish. To capture this telling image, Mustard had to anticipate when the cormorants would appear and burst through the shoal of mackerel. Brandt's cormorants live along the Pacific coast of North America, from Alaska

south to the Gulf of California. Expert divers, they feed in small groups or singly, swimming underwater in pursuit mainly of small fish and shrimps. Mustard's images have been widely displayed in exhibitions and in diving and wildlife publications, and this photograph was a finalist in London's Natural History Museum's Wildlife Photographer of the Year competition of 2016. Mustard was made an MBE in the Queen's Birthday Honours in 2018 for his achievements in underwater photography.

Sue Flood

North Pole Sign in Melting Ice, 2007
Photograph, dimensions variable

The sign marking the Geographic North Pole leans at an angle thanks to the melting ice that has left it surrounded by water in an image that powerfully evokes the effects of climate change in the Arctic. At 90° N, the Geographic North Pole is the point on the globe's Northern Hemisphere where the lines of longitude converge and where Earth's axis of rotation intersects its surface. This image was taken when British wildlife photographer Sue Flood (b. 1965) was on board the Soviet icebreaker *Yamal*, which reached the Pole on 15 July 2007 to find melting, broken pack ice rather than a frozen ocean. Experienced at working in polar regions, Flood used an extreme wide-angle 14 mm lens to render the horizon curved, underlining the feeling of being at the top of the world. Her photograph won the Climate Change category in the Science Photographer of the Year award in 2020. The North Pole is very difficult to reach. The ice is constantly shifting, its drift affected by the currents in the ocean and the winds across the surface, making it impossible for polar adventurers to maintain a steady direction. They pitch camp and sleep in one place, then wake up somewhere new. Cracks that open and close between the ice floes add to the dangers. The first claims to the North Pole – by the Americans Dr Frederick Cook in 1908 and Admiral Robert Peary a year later – are now questioned. The first undisputed people to stand at the North Pole were Soviet scientists who landed by aircraft on 23 April 1948 to study its oceanography and the seabed.

Florian Ledoux

Above the Ice of Greenland, 2017
Photograph, dimensions variable

While the Inuit are often anecdotally said to have eighty words for snow, oceanographers have a more modest half dozen formally recognized but nevertheless elegantly onomatopoeic, descriptive terms for the stages of the formation of sea ice. French aerial photographer Florian Ledoux captures the transition of sea water into ice off the coast of Ammassalik Island, Greenland, that displays all six stages as you look from right to left across his image. The freezing point of normal-salinity seawater is –1.8° Celsius (28.9° F), and the transformation to ice that happens in the calm, cold days of autumn is quite different from the freezing of fresh water. Thin plates or spicules of frazil ice form in the water itself. As they float to the top, a thin layer of grease ice appears as a slick on the surface of the cold sea. Over a few hours, with falling snow adding slush and shuga (spongy white ice lumps) to the mix, the grease becomes porridge, a mushy slurry of ice crystals that still moves with any sea swell but in a heavier way. If the temperature stays low and waves jostle the ice, the porridge thickens further and small floes develop. This is pancake ice, where the edges of the floes are gently pushed up as the ice lumps bump together. Ledoux's distinctive photography derives from his passion for the preservation of nature, specifically of the Arctic. In his words, 'My biggest motivation is to bring nature to the centre of our lives and give those who cannot speak a voice.'

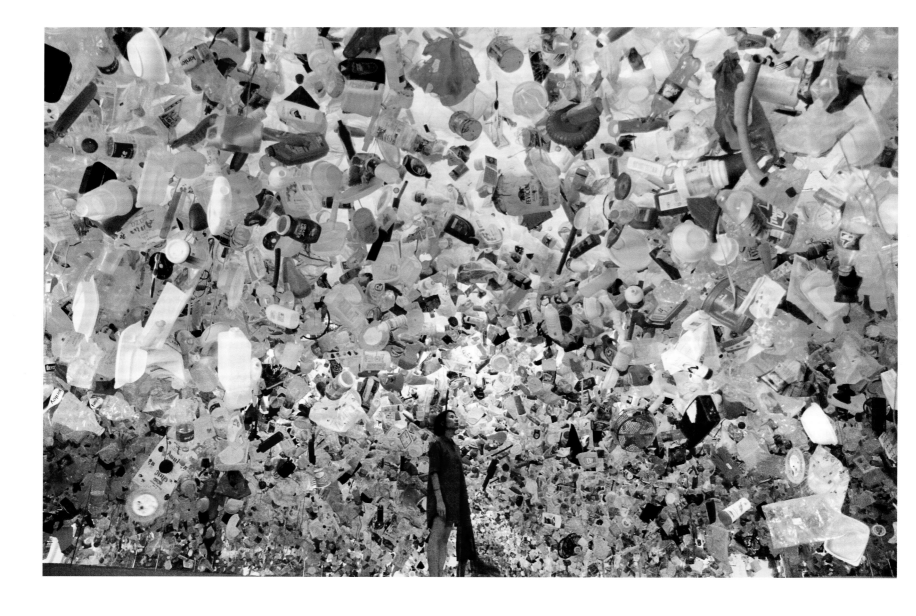

Tan Zi Xi

Plastic Ocean, 2016
Recycled plastics and nylon, installation view
St+Art India, Sassoon Dock, Mumbai

Singaporean artist Tan Zi Xi (b. 1985) often expresses environmental concerns in her illustrations, but she decided that the ongoing pollution to which the oceans have been subjected required a stronger response in the form of the comprehensive installation *Plastic Ocean*. Presented on the occasion of the exhibition 'Imaginarium: Under the Water, Over the Sea' at the Singapore Museum of Art in 2016, the piece is made of more than twenty-six thousand discarded plastic items purchased from the Dharavi recycling market in India – an organization that collects waste washed up on the country's coast. Collected, cleaned and sewn onto strings hanging from the ceiling, the objects float in the room in an immersive and deceptively friendly installation surrounded by infinity mirrors that underline the scale of the problem. Formed by the prevailing gyres, or circular currents, in the northern Pacific Ocean, the Great Pacific Garbage Patch – there is also a smaller western patch – is an area between California and Hawaii three times the size of France that contains an estimated 1.8 billion pieces of plastic rubbish from countries surrounding the ocean and from vessels such as fishing boats. The plastic is mistakenly eaten by sea creatures, which then die, while animals such as sea turtles get trapped in abandoned nylon fishing nets. Large objects are slowly broken down in the sea to become microplastics, in which state they are eaten by fish and other animals and eventually enter the human food chain. There are also two garbage patches in the Atlantic Ocean and one in the Indian Ocean.

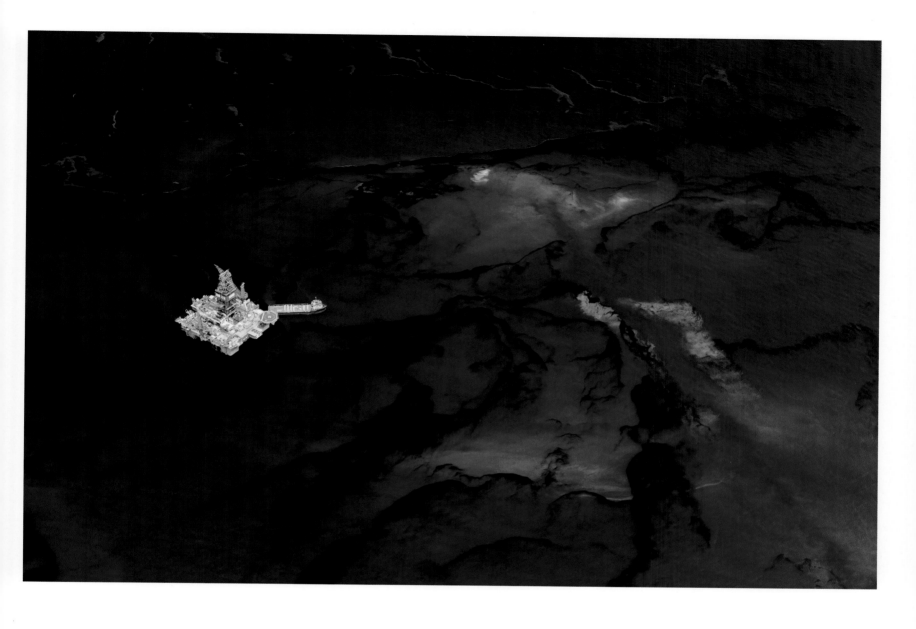

Daniel Beltrá

Oil Spill #4, 2010
Photograph, dimensions variable

This spectacular seascape shows the ocean's surface marbled with dark streaks, turquoise clouds and bursts of orange that resemble lava – but despite its evident beauty, the sea in this image is poisoned. Spanish photojournalist Daniel Beltrá (b. 1964) captured this image while flying over the site of history's worst offshore oil spill, caused in April 2010 when an explosion at BP's Deepwater Horizon oil rig resulted in five million barrels of toxic crude oil spewing into the Gulf of Mexico, bringing devastation to marine life and thousands of miles of American coastline from Texas to Florida. At 915 metres (3,000 ft) above the disaster zone, Beltrá captured the magnitude of the spill with arresting images showing the vast slicks of black oil rising to the surface and mingling with ineffective chemical dispersants. Beltrá says he prefers aerial photography because it reveals the planet's fragility from a unique perspective, allowing him to juxtapose the vast grandeur of nature with the destruction wrought by human activity. Such was the scale of the disaster that the American-based photographer's four-day assignment was extended to twenty-eight days, and even then the spill showed no sign of stopping, despite frantic efforts by BP to stem the environmental tragedy. On 19 September 2010, the well was declared dead, but smaller slicks continued to be reported for several years after and questions still remain regarding the spill's long-term environmental effects. Beltrá hopes that his artful images will instil a deeper appreciation for the natural world and the impact our modern lifestyles have upon it.

David Hockney

The Sea at Malibu, 1988
Oil on canvas, 91 × 122 cm / 36 × 48 in
Private collection

David Hockney (b. 1937) has always respected his art-historical forebears, and this rollicking painting of the Pacific includes nuanced influences from the Post-Impressionists to the Fauvists and Surrealists, as well as inspiration from Cubism and traditional Chinese landscape painting, with their multiple overlapping points of view. One critic compared the work to Hokusai's iconic woodcut of the great wave in front of Mount Fuji (see p.127), full of anger and defiance. The effect is to immerse the viewer in the roiling motion of vibrantly saturated colours and

an almost audible ocean roar. In front of the flecks of sea foam, a stepped wooden deck reflects the semantics of theatrical set design, lit from the left and opening out onto a dramatic seascape. Hockney is perhaps best known as a painter of California landscapes and views, works that reflect the love of a convert from the West Riding of Yorkshire, England, for the Pacific light. He settled permanently in Los Angeles in 1978, but until 1988 he had not painted the ocean. That year he bought a small 1930s beach cottage in Malibu, with a deck that was lapped

by the waves. That same year saw his return to painting, after years in which set design and photo-collage dominated his production. From Hockney's Malibu studio, the sea stretched all the way to Japan, inspiring him not so much by its infinite horizons as by its constant changing movement – 'like fire and smoke … endlessly fascinating'.

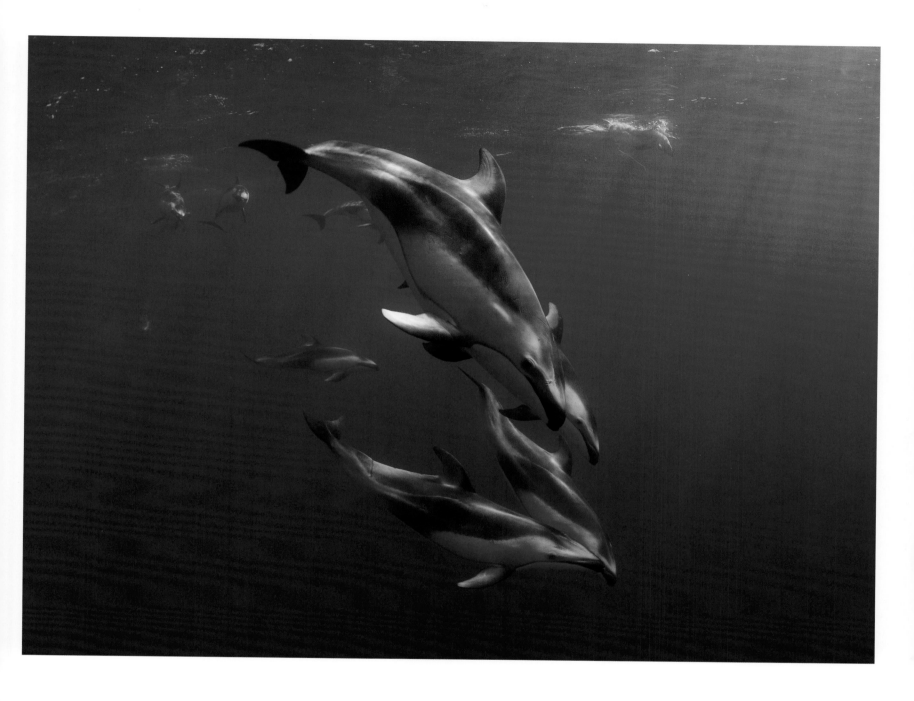

Richard Herrmann

Pacific White-sided Dolphin Pod, San Diego, California, 2008
Photograph, dimensions variable

With their short, thick snouts and the light grey patches on their flanks, this pod of Pacific white-sided dolphins (*Lagenorhynchus obliquidens*) is easy to recognize as they frolic underwater in a joyful image by photographer Richard Herrmann. Dolphins – there are more than forty species, living in a range of marine conditions around the world – live in social groups of up to a dozen animals, working together as they hunt to herd their prey, primarily small shoaling fish, pushing the shoal together to make it easier to attack. When dolphins are injured or sick, other members of the pod care for them, occasionally even helping lift them to the surface to breathe. Dolphins have a reputation as being among the most intelligent of all animals, communicating using whistles and clicks, and being observed to learn behaviour, grieve for dead companions and interact with humans. They are noted for joyful outbursts of play, blowing bubble rings, tossing captured seabirds from one to another and jumping acrobatically from the water. Dolphins can travel at speeds of up to 48 kilometres per hour (30 mph) when they are chasing their prey, and leaping from the water as they travel also saves them energy that they expend pushing against the resistance of the water. When they come closer to the shore to feed, it is not unusual to see dolphins approach boats bow riding – riding the pressure waves created by the boat – and leaping out of the water summersaulting as if in a choreographed display. It is this that makes dolphin watching such a popular tourist activity worldwide.

Doug Aitken

Underwater Pavilions, 2016
Installation view, Avalon, California

Two mysterious three-dimensional shapes float deep in the ocean. If at initial glance the geometric objects seem organic, their sharp corners and hollow mirrored interiors quickly inform the viewer that they are very much artificial. These two (of three) submerged pavilions were temporarily moored to the ocean floor off the coast of California's Catalina Island in the Descanso Bay, sited so that a snorkeler or free driver could make their way down and float inside the mirrored environment. Conceived by the genre-defying American artist Doug Aitken (b. 1968),

Underwater Pavilions sought to create an underwater space that highlighted the ever-varying rhythms of the ocean, as the perception of each sculpture changed with the currents and the time of day. The mirrored interiors reflect and refract the limited light in the depths and act in a way that both solidifies the objects and makes them indistinguishable from their surroundings – simultaneously alien objects in the natural world and potential habitats. Aitken's work spans photography, sculpture, film, multimedia installations and live performances. Produced in

partnership with the Museum of Contemporary Art Los Angeles and the marine conservation–focused group Parley for the Oceans, in *Underwater Pavilions*, Aitken merges the disciplines of architecture, land art and marine sciences to situate his sculptures as part of the larger discourse on the world's oceans.

Ingo Arndt

Female Olive Ridley Sea Turtles, Ostional, Costa Rica, 2012
Digital photograph, dimensions variable

In Costa Rica's rainy season, female Olive Ridley sea turtles (*Lepidochelys olivacea*) begin congregating offshore. On the darkest nights, a few days before a new moon, hundreds of thousands of them haul out on their natal beaches to dig nests in the sand and lay their eggs. This is the Arribada, the night of the turtles. The power of this image comes from the long four-second exposure time used by German photographer Ingo Arndt (b. 1968) for the shot. The waves are rendered as a misty blur and some of the turtles become unsharp, almost ghostly. The overall light on the scene is imbued with the effort these mature turtles are making to drag themselves from the ocean – where they are weightless – up through the sand to the higher reaches of the beach, where they will lay their eggs. Arndt's photograph stands witness to a scene that is timeless, yet ephemeral, when the rhythms of the lunar cycle drive the primal survival instincts of the turtles. Each turtle will lay eighty to one hundred soft-shell, round eggs in a shallow nest, which they refill with sand, rocking back and forth, making loud thumping sounds as they 'dance' over the nest to compact the sand and camouflage it. It was a longstanding mystery how the turtles returned to the same place every year to lay their eggs, but scientists now know that each beach has a distinct magnetic pattern, which is imprinted on a turtle's brain when it hatches.

Theo Bosboom

Limpets Exposed at Low Tide, Playa de Ursa, Portugal, c.2017
Digital photograph, dimensions variable

Captured just before sunrise, the rocks in this image by Dutch photographer Theo Bosboom (b. 1969) glow with purplish iridescence against the blue sky with a trail of limpets shown in sharp relief in the foreground. A composite image, Bosboom merged twenty-one photographs of the limpets and rocks until he had the precise view he wanted. By his own admission, the image was the result of a long, steep scramble in the dark to be in position to catch the blue light before sunrise. By using a small flashlight covered by a handkerchief, he illuminated the limpets so that they stood out against the jagged rocks behind. Limpets are aquatic snails commonly found on tidal shores where rocks are alternately covered by the sea and exposed to the air, and are notable not just for their conical shells but for the strength of their muscular feet, as attested by the phrase 'to cling like a limpet'. While exposed, the foot clamps the limpet against the rock, which stops the molluscs from drying out and also makes them extremely difficult to dislodge, remaining safe from most predators. As the tide comes in, the limpet moves over the rock, scraping algae and other edible material off the hard surfaces of the rocks with its radula, an organ that functions like a tongue. The radula bears tiny teeth, each only about as long as the width of a human hair, helping to scrape off the algae like a fine comb. Those teeth, made from a mineral-protein composite, are notable as being the strongest naturally occurring biological material known, supplanting spider silk, which is usually cited as holding that honour.

Evan Darling

Starfish Imaged Using Confocal Microscopy, 2015
Confocal Microscopy, 1 × 1 m / 3 ft 3 in × 3 ft 3 in

The beloved starfish captured here by American imaging scientist Evan Darling has been magnified to ten times its size using a technique known as confocal microscopy. By scanning the starfish with light from a laser through a standard microscope, multiple crystal-clear images are captured in optical sections that can then be stacked one upon another to create a three-dimensional digital reconstruction that reveals features the naked eye cannot see. This has advantages over conventional microscopes because it not only allows greater control of depth of field, but also allows accurate imaging of thicker specimens, such as the starfish, to reveal their cellular structure. Currently, there are around two thousand species of starfish – marine scientists usually call them sea stars because the starfish is not in fact a fish but an echinoderm more closely related to the sea urchin – living in all the planet's oceans, from warm seas to cold seabeds. The most common are the five-limbed sea stars but there are others with as many as forty arms. Famously, they are able to regenerate any lost limbs because most of their vital organs are found in these appendages – some species can grow an entire new sea star from a single damaged limb. The star's brightly coloured body is for protection, as is its calcified body, which deters most predators. With a life span as long as thirty-five years, the sea star has become a bellwether for climate change. In the warmer seas of the Pacific Ocean, many sea stars are already close to extinction, tracking the rise in water temperatures due to climate change.

Adam Summers

Scalyhead and Padded Sculpin, 2022
Photograph, dimensions variable

Unlike these extremely conspicuous, vibrantly coloured specimens, sculpin are small fish native to the eastern Pacific that normally use camouflage to blend unnoticed into their surroundings. Here, however, the fish have been artificially treated to allow their intricate internal structures to be seen and studied. The stunning images could easily be mistaken for X-rays but were in fact achieved by chemically staining the fish's innards using a process developed for the field of comparative vertebrate biomechanics, which seeks to better understand animals' physical functions. For Professor Adam Summers (b. 1964) at the University of Washington's Friday Harbor Laboratories, these studies have clear aesthetic as well as scientific value, and his strikingly beautiful fish photographs are appreciated by audiences both inside and outside of the lab. Summers used two dyes in the process: Alcian blue to stain the fish's skeleton and Alizarin red, which turns its soft tissue a shade of crimson. The specimen's flesh is dissolved with the enzyme Trypsin, which leaves the collagen and connective tissues intact, before being bleached with hydrogen peroxide to remove dark pigments. Finally it is submerged into a bath of glycerin, which works to reveal the stained skeletal forms. Summers then uses an LED lightbox to illuminate the fish from below and photographs it in various poses. The dyeing technique is most effective on specimens that are less than 1 centimetre (0.4 in) in thickness. Small fish such as these sculpins are quick to process, taking around three days, though larger marine species can take several months to achieve similar results.

Igor Siwanowicz

Barnacle, 2014
Confocal microscope photograph, dimensions variable

The complex feeding structures of a barnacle (*Chthamalus fragilis*) glow with rainbow colours against a uniform black background. Shown here in sharp anatomical detail, these highly modified limbs of the crustacean are scientifically fascinating in addition to being aesthetically beautiful. When submerged by the tide, a barnacle feeds by extending feathery appendages called cirri from its body, which are enclosed inside hard calcareous plates. Fine hairs and bristles on the cirri filter plankton and other edible particles from the water and transfer them back towards the mouth. The image was captured by Igor Siwanowicz (b. 1976), a biochemist and neurobiologist who has built a reputation as a leading exponent of the art of microphotography, especially by recording the intricate and often beautiful structures in the bodies of invertebrates, including many marine animals. This and several other photographs by Siwanowicz have been winners in Nikon's Small World, a leading forum for microphotography, and his barnacle image won third prize in the Olympus Bioscapes competition in 2014. His research into the cells of invertebrates' nervous systems involves the use of sophisticated instruments, notably a confocal microscope, enabling the capture of tiny structures within the bodies of a range of animals. As a child of biologist parents, Siwanowicz was surrounded by illustrated textbooks from an early age, but only took up photography at age twenty-six. Combined with his research, his new interest produced a true synthesis of science and art.

David Gruber

Diversity of Fluorescent Patterns and Colours in Marine Fishes, 2014
Digital photograph, dimensions variable

Much of the ocean world is glowing with brilliant fluorescent colours and patterns, though the bright reds, neon oranges and eerie greens present in many marine fishes are normally invisible to the human eye. The phenomenon, known as biofluorescence, involves an organism absorbing light of a certain wavelength and re-emitting it as another colour, resulting in brilliant, luminous hues. It was once thought that only a limited range of marine creatures, such as corals and jellyfish, had this ability, but in 2014, a team of researchers led by David Gruber and John Sparks at the American Museum of Natural History identified more than 180 species of fish that are capable of fluorescing. A small selection is shown in this image, which includes a swell shark, ray, sole, flathead, lizardfish, frogfish, stonefish, false moray eel, pipefish, sand stargazer, goby, larval surgeonfish and threadfin bream. The fish were photographed using cameras fitted with special filters to reveal the spectacular displays normally seen only by other marine life. The extensive study – which surveyed taxonomically rich waters near the Bahamas in the Atlantic Ocean, the Solomon Islands in the Pacific Ocean and freshwater sites in the Amazon and US Great Lakes – revealed that biofluorescence was far more widespread and variable between marine fish than was previously thought. Although its precise function is uncertain, it is believed that fish use it in communication, camouflage and mating. The report has prompted further research into identifying fluorescent proteins that might one day be used to develop new medicines for treating various diseases.

Eder u Valenta
Zanclus cornutus.
Acanthurus nigros.
Versuche mit Röntgen-Strahlen.

Josef Maria Eder and Eduard Valenta

Zanclus cornutus / Acanthurus nigros, 1896
Photogravure, 24.2 × 19.8 cm / 9½ × 7¾ in
Metropolitan Museum of Art, New York

This ghostly image of two tropical fish – revealing not only their shape but also details of their internal skeleton and organs, including the spine with its delicate ribs and the swim bladders that adjust buoyancy – is one of the earliest X-ray photographs, taken only a year after the accidental discovery of X-rays by German physicist Wilhelm Conrad Röntgen in 1895. The new technology prompted an outburst of activity as physicists rushed to use the invisible rays to 'see' inside all manner of creatures and objects. Here, the technique is used on the Moorish idol (*Zanclus cornutus*, top) and the greyhead surgeon-fish (*Acanthurus nigros*, bottom). The Moorish idol is a widespread inhabitant of tropical reefs in the Indo-Pacific region and is recognizable from its butterfly shape and dorsal fin that extends into a trailing filament. The greyhead surgeonfish is less distinctive in its shape but at the time was relatively new to science. Both species are now popular with aquarists, although the Moorish idol is notoriously difficult to keep. The Austrian photochemist Josef Maria Eder (1855–1944) researched photographic techniques and was particularly interested in the effects of X-rays on photosensitive material. With fellow chemist Eduard Valenta (1857–1937), he borrowed specimens from the collection of the Natural History Museum in Vienna for their X-ray experiments and amassed a somewhat eclectic collection, including not only tropical fish but also goldfish, frogs, snakes and a chameleon. The images they created were collected and published in a pioneering book, *Photographie mittelst der Röntgen-strahlen* (*Photography using X-rays*), in 1896.

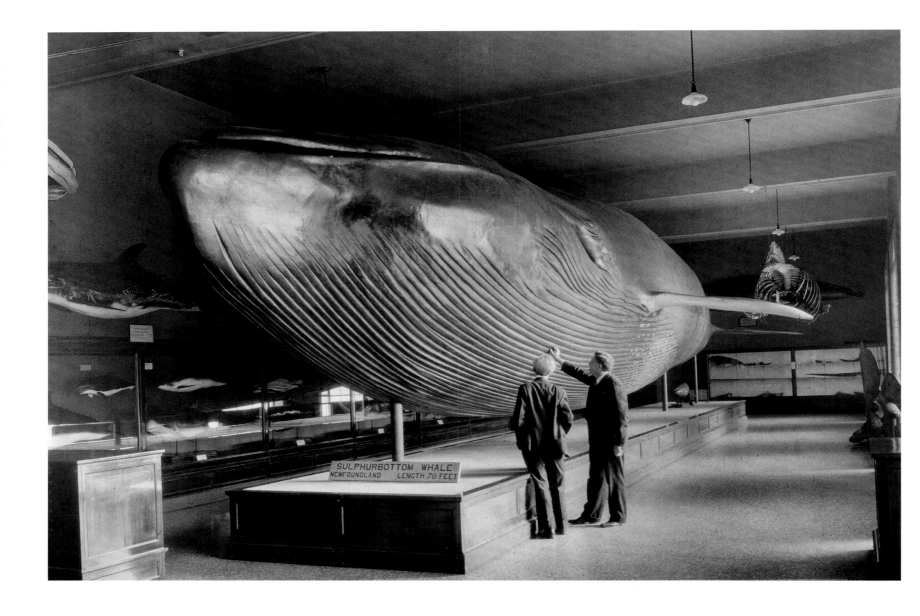

Frederic A. Lucas

Full-size Model of a Sulpher-Bottom Whale, photographed in 1910
Papier-mâché, L. 24 m / 78 ft
Smithsonian Insitution Archives, Washington DC

This remarkably realistic model of a blue whale was the first of its kind, bringing the wonders of marine life onto dry land. Commissioned by the Smithsonian Institution in Washington DC, it was completed in 1904 by chief osteologist and head of exhibits Frederic A. Lucas (1852–1929). Throughout the nineteenth century, attempts to taxidermy whales had miserably failed. The size, weight and fleshy thickness of the animal's skin made the task impossible. By the end of the century, researchers had come to the conclusion that casting the body

of the animal was the only way forwards, although casting such a large animal body also presented obvious challenges. Lucas masterminded a coordinated effort to cast the whale's body as it floated in the water. On 12 July 1903, he proceeded to test his new method on a blue whale from Hermitage Bay, Newfoundland, measuring 24 metres (78 ft) long and weighing 63.5 tonnes (70 t). The animal was towed to shallow waters, where Lucas and two assistants spent the better part of ten hours layering burlap and pouring buckets of plaster on its body.

Racing against the clock – dead whales decompose rather quickly – they cast the entire body, section by section, as one would reproduce a classical sculpture. It took eight months to build the enormous mannequin upon which the positive casts would be reassembled. Before joining the Smithsonian Natural History Museum displays in 1905, the whale was exhibited to great acclaim at the St. Louis World's Fair of 1904. In 1963, it was replaced by a more naturalistic model made with new materials and less demanding casting techniques.

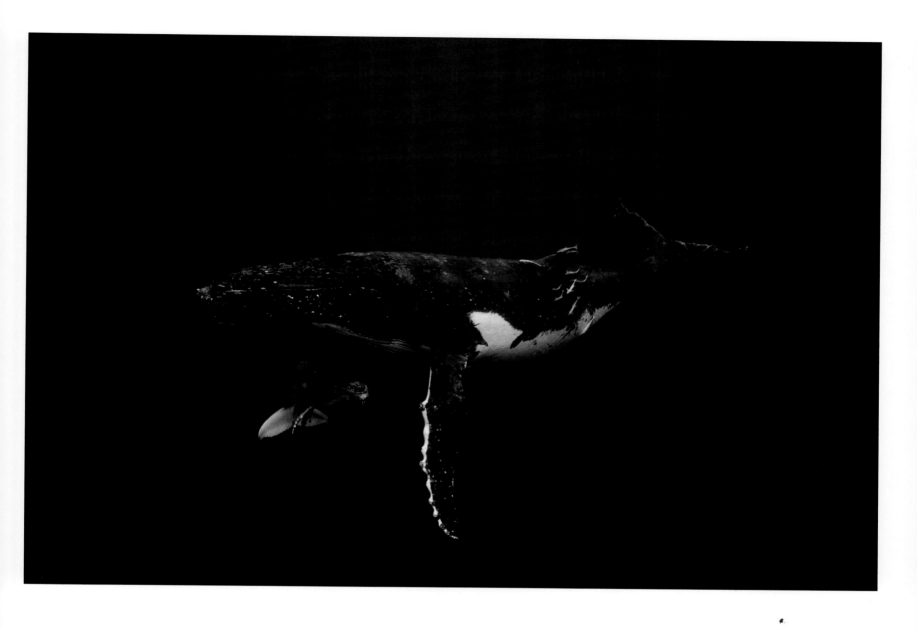

Jem Cresswell

Giants #28, 2015
Digital pigment print on archival cotton rag,
1 × 1.5 m / 3 ft 3 in × 4 ft 11 in
Private collection

An adult humpback whale swims with a calf close to the surface of the sea, the shining sky offering sharp contrast with the dark waters beneath. This image is from a limited-edition volume entitled *Giants*, published in 2020, that showcases more than a hundred black-and-white photographs of humpback whales by Australian photographer Jem Cresswell (b. 1984), chosen from more than eleven thousand images taken in the waters of the southern Pacific Ocean. The humpback whale (*Megaptera novaeangliae*) is a large species of baleen (filter-feeding) whale with a wide distribution in the oceans of the world. Females give birth every two years, usually to a single calf, which suckles from its mother for up to a year, although calves also begin to feed themselves after about six months. A migratory species, these magnificent creatures travel large distances, feeding mainly in the polar seas then swimming to the warmer waters of the tropics and subtropics to breed. Individuals have been known to travel up to 16,000 kilometres (10,000 mi) on a round trip. The arched body and long pectoral fins are distinctive, and these intelligent mammals are also known for their complex behaviours and haunting songs that can last up to thirty minutes at a time. Widely hunted, the global humpback population fell to as few as five thousand individuals in the 1960s, but whaling bans have allowed it to recover to around eighty thousand. From 2014 Cresswell worked on a five-year project to document the activities of humpback whales in the waters around the islands of Tonga, resulting in this and many more captivating photographs.

Lindsay Olson

Rhythmic Seas: Active Acoustics, 2020
Embroidery and beading on silk, hand-stitched background,
91.4 × 177.8 cm / 3 ft × 5 ft 10 in

At first glance, Lindsay Olson's five-panel artwork, *Rhythmic Seas: Active Acoustics,* looks more like an abstract tapestry than the visualization of the sea's sounds. Inspired by monumental tapestries such as the Bayeux Tapestry and the works of the Swiss embroidery artist Lissy Funk, Olson has handcrafted, embroidered and beaded her artwork. Deliberately choosing dupion silk, with its pronounced grain line, for the ocean, the work shimmers like the light on the water's surface. The top part of the panels shows the migration of zooplankton from the ocean depths

to the surface, a twice-daily occurrence, while the centre and side panels show how energy waves, such as sound pulses, behave when they scatter off a target. The bottom half of the panels describes the relationship between phytoplankton and atmospheric oxygen. At the bottom of the panels sits the marine 'snow', organic detritus falling from above, which has been deposited on the seabed over millennia. For this project, Olson spent three weeks at sea working with scientists using acoustic analysis to explore the ocean's sounds. As Olson

says, little is known about the ocean depths, where there is no light but sound still remains. Acousticians record the ocean's soundscapes, collecting the sounds of its myriad life forms, the abiotic sounds of the wind, waves, ice and seismic activity, and human-generated sounds such as those from shipping vessels. From their data, Olson transforms the soundscapes into a landscape, which, she hopes, unlocks some of the ocean's mysteries.

Songs of the Humpback Whale

Whale songs have probably been heard, though seldom recognized as such, ever since man began to make voyages by sea. In the literature of whaling alone there are many accounts of strange, ethereal sounds, reverberating faintly through a quiet ship at night, mystifying sailors in their bunks. Long after such experiences were first mentioned, scientists were able to explain what caused them . . . If the idea of whale "singing" seems odd, the cause may lie in the several meanings of the word "song." Quite apart from any esthetic judgment one might make about them, the sounds produced by Humpback whales can properly be called songs because they occur in complete sequences that are repeated. Bird sounds are called songs for the same reason. Birds sing songs that are repeated fairly exactly and Humpback whales too are very faithful to their own individual sequence of sounds. Humpback whale songs are far longer than bird songs. The shortest Humpback song recorded lasts six minutes and the longest is more than thirty minutes. The pauses between Humpback songs are no longer than the pauses between notes within the song: in other words, they are recycled without any obvious break. Again, in contrast with birds, who complete a song before pausing, it doesn't matter where in its song the Humpback starts or stops . . .

Capitol

Roger Payne

Songs of the Humpback Whale, 1970
Studio album, 34 mins 26 secs
Private collection

At the height of the Cold War in the 1950s, United States Navy engineer Frank Watlington was stationed at a top-secret listening station in Bermuda, where he developed underwater microphones to detect the sounds of Russian submarines. Watlington deployed his instruments 500 metres (1,650 ft) down, where they also picked up strange, eerie sounds. While he was baffled, the local fishermen assured him the sounds came from whales. When Watlington later passed on the information to biologist Roger Payne in 1968, Payne became obsessed. He listened to the sounds over and over again and realized that they were not random blurts of cavernous sound but patterns that repeated – sometimes after ten minutes but more often after half an hour. They were, by human definition, songs. At a time when more whales were being commercially slaughtered than ever before, Payne resolved to somehow 'build whale songs into human culture'. Highlights from the recordings formed the basis of his 1970 LP, *Songs of the Humpback Whale*. The album was an unexpected hit, quickly selling more than 125,000 copies and eventually going multiplatinum, becoming the most popular nature recording in history. Whale songs became such a powerful symbol of the majesty of the natural world that astronomer Carl Sagan included humpback calls on the golden record of 'sounds from Earth' fired into space (for potential discovery by extraterrestrials) on the *Voyager 1* and *2* probes in 1977. The first human-made artefacts to leave our solar system are carrying the song of the humpback whale – an album that is truly out of this world.

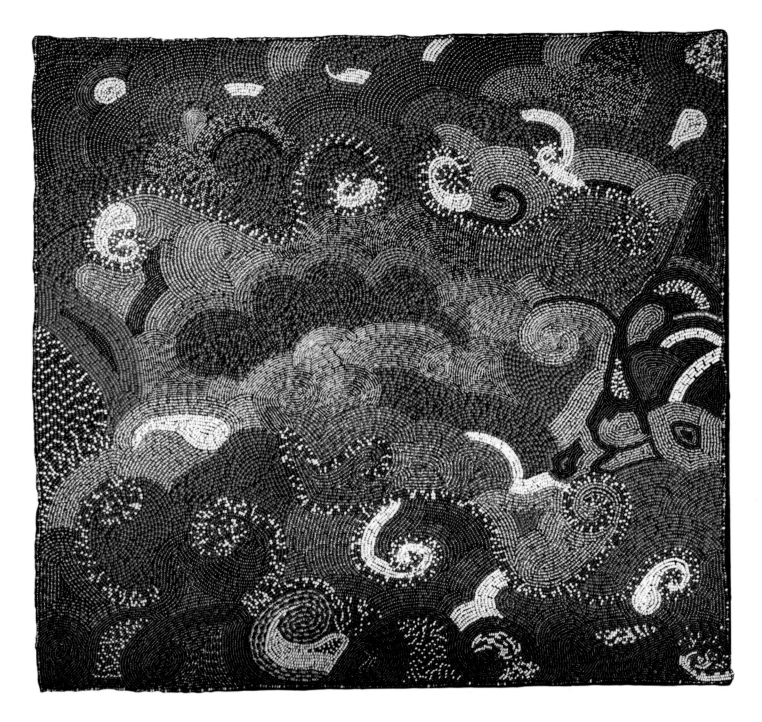

Ntombephi 'Induna' Ntobela

My Sea, My Sister, My Tears, 2011
Glass beads sewn onto fabric,
61 × 62 cm / 24 × 24⅜ in

The billowing waves and white surf of the Indian Ocean in this image are created by thousands of shimmering glass beads sewn on to black cloth, a form of art known as *ndwango* – 'cloth' – that was developed in rural South Africa by a group of female bead artists known as Ubuhle, which means 'beauty' in Zulu and Xhosa. The Xhosa artist Ntombephi Ntobela (b. 1966), who was a founder of Ubuhle, learned beading from her grandmother but has become a master beader in her own right whose honorific title, Induna, is a sign of the great respect with which she is held within the Ubuhle and within the Mpondo community more generally. Drawing on traditional Mpondo themes, Ntombephi created the first *ndwango*, giving rise to the new artistic genre that she uses to chart her life and the ideology of her people. Her body of work largely revolves around the theme of water: a precious resource in the KwaZulu-Natal region where the Mpondo live but also a symbol of the primary element forming the human body and a sociopolitical statement in a country with a long history of division across racial boundaries. As Ntombephi once has said: 'Under our skin we are all blue because we are all made of water. We are related by water and water is the source of all life.' On closer examination, however, her beads also speak of a personal turmoil. *My Sea, My Sister, My Tears* is a tribute to Ntombephi's sister Bongiswa, who died young, and uses the ocean's complex texture as a vehicle to express the artist's personal feelings.

Cy Gavin

Untitled (Wave, Blue), 2021
Acrylic, vinyl and chalk on canvas,
2.3 × 2.3 m / 7 ft 8 in × 7 ft 7 in
Private collection

A turbulent ocean wave, painted in vivid blue tones interspersed with swaths of white and flecks of red, occupies nearly the entirety of this large-scale canvas, leaving room only for a glimpse of a calm, clear blue sky at the upper edge. Measuring more than 2 metres (7 ft) square, this piece by American artist Cy Gavin (b. 1985) boldly confronts viewers with an example of just how powerful the ocean can be. Drawing upon his upbringing in Pittsburgh, Pennsylvania, as well as his Afro-Caribbean heritage and the environment surrounding his studio in Upstate New York, Gavin imbues his paintings with the influence of the beauty and power of the natural world, as well as the deep-rooted memories that the earth holds. In *Untitled (Wave, Blue)*, the bright colours of the ocean waters are dotted with small brushstrokes of red, which not only serve to complement the rich blues but perhaps are also a reference to the trans-atlantic slave trade – a topic Gavin investigated during his many visits to Bermuda, his father's birthplace. The abstraction of Gavin's wave, combined with the interplay of flatness and depth, depicts an ocean that is as much a site of beauty as it is of sorrow, as awe-inspiring as it can be terrifying. While much of the artist's work explores the underlying narratives and histories of specific natural landscapes, since 2017 he also became interested in the Purkinje effect – the way our eyes adjust to low light and in turn favour tones of blue, reversing many of our visual interpretations of colour. From waves to night skies, Gavin has explored the depths of human perceptions of the world around us.

Simon George Mpata

Untitled, 1971–73
Enamel paint on fibreboard, 61.6 × 61.6 cm / 24¼ × 24¼ in
Smithsonian National Museum of African Art, Washington DC

Water and fish, often scarce resources across much of the African continent, are celebrated in this painting by the Tanzanian artist Simon George Mpata (1942–1984). Mpata's style belongs to a movement known as Tingatinga, a reference to his half-brother Edward Tingatinga, the teacher of a group of six artists – including Mpata – based in the country's coastal capital, Dar es Salaam. Tingatinga began painting with the simple premise of creating his art using only materials that were both recyclable and readily available, such as ceramic fragments and bicycle paint, and the movement he founded caught on across much of East Africa, using a flattened style with little solid form or perspective. The Tingatinga group was known for its wildlife paintings; alongside his fish paintings, Mpata painted birds, notable for the exaggerated curve of their necks. In this painting, Mpata works with enamel paint on fibreboard and uses the trademark Tingatinga bright colours to depict two local fishermen with their haul of six colourful fishes and their trusty dhow, heightening the image of the fishing boat on the sun-baked ground. Fishing and fish have long been integral to Tanzanian life – both from the Indian Ocean and the massive inland Lake Victoria – because it is one of the world's richest fishing grounds. However, fishing in Tanzania has becoming increasingly precarious due to a dramatic decline in fish stocks and the country's refusal to outlaw blast fishing, whereby dynamite or homemade bombs are dropped into the Indian Ocean, killing hundreds of pounds of fish at a time and destroying reefs.

Edward Burtynsky

Marine Aquaculture #1, Luoyuan Bay, Fujian Province, China, 2012
Photograph, dimensions variable

For three decades, award-winning Canadian environmental photographer Edward Burtynsky (b. 1955) has captured the human impact on the natural world, from colossal mines, dams and quarries to factories, roadways and trash dumps. His determination to denounce the destructive power of human activities at a time of unprecedented crises has produced a monumental body of work that both amazes and terrifies. Burtynsky's landscapes are intended to generate awareness and educate the public about the serious threat human-caused degradation and industrial activities pose to the planet. One such industry is marine aquaculture, or the farming of aquatic animals and plants, primarily fish, for consumption: globally, more than 50 per cent of all seafood comes from aquaculture. China is at the forefront of production: roughly 70 per cent of farmed marine fish is produced there, and more than half of that comes from the aquaculture farms in Luoyuan Bay in southeastern China's Fujian Province. Miles of wooden structures support a floating city beneath which shrimp, lobster and scallops are farmed. Luoyuan Bay has been thriving since the early 1990s, where its patterned modularity and picturesque fishermen's floating homes have made it a popular tourist attraction. Farms like this are an important part of China's estimated £25 billion fish-farm industry. While such intensive farming models are lucrative, the density of so many cages ends up slowing the flow of marine water, which results in low oxygenation and high sedimentation of animal waste at the bottom of the sea. The general water-quality degradation often means that diseases spread rapidly through fish populations, causing enormous losses in both animal life and income.

John Akomfrah

Vertigo Sea, 2015
Three-channel HD video installation, 7.1 sound,
48 minutes 30 seconds, dimensions variable

Projected across three screens, this monumental and poetic work immerses the viewer in a barrage of moving images that is described by the artist as 'a meditation on the aquatic sublime'. It was created by the acclaimed British filmmaker John Akomfrah (b.1957), who rose to prominence as a founding member of the influential Black Audio Film Collective in London during the 1980s. Much of Akomfrah's work has explored issues around postcolonialism and the experiences of diaspora populations, and it typically blends excerpts from existing found archival film footage with newly shot scenes. In *Vertigo Sea*, different clips are presented concurrently on each screen – some lasting just seconds while others continue much longer – contrasting imagery relating to the modern whaling industry with awe-inspiring scenes of marine wildlife drawn from the BBC Natural History Unit. The explosion of the 1946 atomic bomb in the Bikini Atoll weapons test appears along with harrowing television news reports of migrants trying to cross oceans on overcrowded or inadequate vessels.

New material filmed on the shores of the Isle of Skye, the Faroe Islands and northern Norway features characters in eighteenth-century dress, hinting at the role of the sea in the transatlantic slave trade. The soundtrack is a similar collage of music, recorded sounds of the natural world and readings of sea-themed texts, including works by Herman Melville, Heathcote Williams and Virginia Woolf. The result is a vertiginous yet compelling vision of the multifaceted nature of the sea.

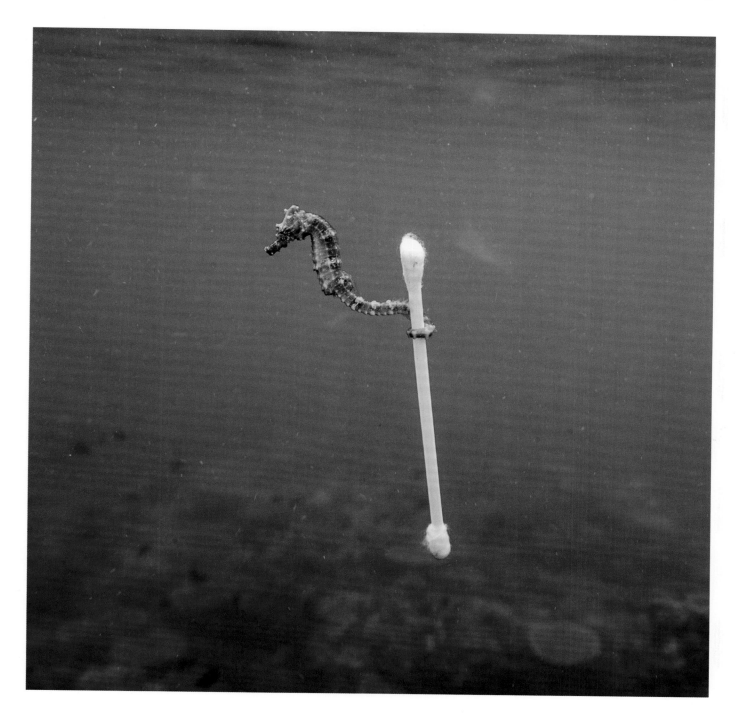

Justin Hofman

Sewage Surfer, 2016
Photograph, dimensions variable

The reality of marine pollution is laid bare in this potent image of a tiny estuary seahorse clutching a discarded cotton swab. The creature was bobbing between pieces of natural debris off the coast of Sumbawa Island in Indonesia when it caught the eye of South African wildlife photographer Justin Hofman. Seahorses are not great swimmers and rely on their small dorsal fins to propel themselves forwards. As fatigue sets in, they often catch a ride on floating objects propelled by the current, such as sea grasses, which they grasp with their slender prehensile tails. At first, Hofman was delighted by the scene before him, but his mood changed when the tide turned and the water started filling with trash. As he watched, the seahorse abandoned its seagrass and seized a shredded grocery bag before finding the more stable cotton swab. It was not the photograph Hofman had expected or wanted, but when it went viral on social media, he realized its potential for raising awareness about the state of the world's oceans, which are becoming increasingly polluted by non-biodegradable waste – it is estimated that each year at least 12 million tonnes (14 million t) of plastic are introduced. The image's power lies in its simplicity, making a stark point about the damage that human activity is causing to Earth's ecosystems by its incongruous juxtaposition of the natural and the artificial.

Julian Opie

We swam amongst the fishes, 2003
Screenprint on spray-finished block,
75 × 70 × 2.5 cm / 29½ × 27½ × 1 in

The trademark style of British artist Julian Opie (b. 1958) is almost instantly recognizable: simple portraits rendered in black line drawing, often with bold blocks of colour. In an illustrious career, Opie, who trained at London's prestigious Goldsmiths College under Michael Craig-Martin, has largely concentrated on portraits and walking figures, including his distinctive design for the cover of Britpop band Blur's seminal 2000 album *Blur: The Best Of*. Opie's body of work also includes landscapes and still lifes, as well as studies of the natural world,

such as *We swam amongst the fishes*. Inspired by a trip to Bali, Opie created a pair of large-scale paintings around the theme of swimmers and water at Chicago's Museum of Modern Art in 2003. To accompany the large works of vinyl on paint, Opie created smaller silkscreens, fixed on spray-finished MDF blocks, of a variety of monochrome fishes seen from a diver's perspective as they swim in different directions against a vivid blue background. Comprising 160 prints in total, the silkscreens were intended to fill an entire gallery wall, immersing the

viewer in an underwater world. Varying the coloured backgrounds from lilac to turquoise, Opie created the images using digital photography and computer drawing programs, illustrating over the original photographs on the computer in his inimitable style. To create a sense of depth, Opie used flat colour and painted his fishes in differing sizes with thick lines and simplified forms, which he then positioned at different angles. This series followed an earlier iteration from 2002, in which the fishes swam on a variety of different finishes from enamel to wood.

Suddenly the little blue fish was back. "Please," he said. "Could I have just one scale?"

Well, the Rainbow Fish thought. Maybe just one tiny little scale. The little blue fish was so pleased, it made the Rainbow Fish feel happy.

Marcus Pfister

Pages from *The Rainbow Fish*, published by NordSüd Verlag, 1992
Printed book, each page 15.7 × 15.7 cm / 6⅛ × 6⅛ in

The Rainbow Fish, created by Swiss artist and author Marcus Pfister (b. 1960), has sold more than thirty million copies worldwide in more than fifty languages since its publication in 1992, becoming a classic and beloved children's book. On the anniversary of its publication, Pfister wrote, 'Thirty years ago, a glittery little fish swam out into the world with a message of friendship, happiness and sharing. I'm always amazed how, as I travel the world, I come across him in the most unlikely places. It's as if he travels with me. Children from Australia to Zimbabwe have found a place in their hearts and bookshelves for my Rainbow Fish.' From his first artistic concept, Pfister wanted Rainbow Fish to stand out from all the other ocean creatures in his book. He could have made him simply more colourful, but that would have been at the expense of rendering the others lacklustre and sombre. He wanted something more, a feature that underscored just how special his glittering fins were. From his work as a graphic artist, Pfister remembered hot foil stamping, a method of applying ultra-thin differently coloured metallic foils to paper using pressure. It's that technique that gives Rainbow Fish his captivating and unique sparkle on every page. Is there a real-life contender for Rainbow Fish? While there are many seemingly iridescent fish in the ocean, the closest species is perhaps the neon tetra, which lives in small shoals in the rivers of the Amazon basin. Their beautiful iridescence comes from light bouncing off stacks of guanine platelets in their scales. As far as scientists have observed, they're apparently quite happy in each other's company. So perhaps they're sharing their scales in secret.

Anonymous

Vessel Representing a Reed Boat and Rider, AD 900–1470
Ceramic, 16 × 22 × 8.5 cm / 6¼ × 8⅝ × 3⅜ in
Dumbarton Oaks Research Library
and Collection, Washington DC

Knees bent and clenched like a jockey, a fisherman clings to his short boat, arms tensed with his head and neck raised, looking straight ahead. Even through the simplified moulding of the figure we can sense the rider's rapt concentration as he grips at the prow, attempting to steer the vessel – likely a representation of a woven reed *caballito de totora* boat. Blackware ceramic vessels of this sort are characteristic of the Chimú culture, which flourished along a stretch of around 1,000 kilometres (620 mi) of the northwest coastline of Peru between AD 900–1470, prior to the arrival of the Spanish in South America. The figure is fashioned in a typical Chimú style, wearing a banded headdress with chin strap and with long hair tied in a top knot or bun above the head. Water, the oceans and fishing were central to the Chimú culture and economy, evidenced by the proliferation of stone carvings of fish, fishing nets and waves on the walls of the 'Nik an' royal complex at the Chimú capital, Chan Chan. Thousands of small reed boats would once have plied their trade along the Peruvian coast, catching fish including catfish and skate and shellfish such as spiny oysters. Ceremonial ceramic vessels such as this one would have been used to make offerings of maize flour and red ochre to the sea deity Ni, to ward off the likelihood of drowning and to ensure nets would return full of fish.

Jean Jullien

Surf's Up, 2017
Digital illustration, dimensions variable

Prolific French graphic artist Jean Jullien (b. 1983) has produced a consistently coherent yet eclectic body of work that embraces everything from art forms such as illustration, video and photography to books, posters, clothing, mugs, installations and, more recently, dolls. Originally from Nantes, France, Jullien studied and worked in London for many years before moving to Paris. *Surf's Up*, from 2017, harks back to Hokusai's 1830 coloured woodblock *The Great Wave* (see p.127). Where Hokusai's wave is frothy, Jullien delineates his wave by painting

it in a darker shade of turquoise than the sky. A keen amateur surfer, Jullien emphasizes the thrill of a big wave, which is the holy grail for all surfers. Against the huge wave, his surfer appears tiny, and it is precisely this stark contrast in size that entices surfers to travel the world looking for big waves. For Jullien, there is much to compare between surfing and painting and much to love in both: 'I draw a lot of parallels between surfing and painting, which is maybe why I paint a lot of surf-related scenes. The elements, the wait, the trial and errors, the

progression. I started surfing when I started painting. It all coincided with a desire to slow things down a bit.' Such is his obsession with surfing that in the early 2020s he designed four surfboards: each is different, individually hand-painted and as quirky as would be expected of a Jean Jullien design, be it a shark or a seal.

Gjøde & Partnere Arkitekter

The Infinite Bridge, 2015
Wood and steel, Diam. 60 m / 197 ft
Aarhus, Denmark

A perfect circle marks the intersection of the land and the sea in this bird's-eye view of the coast near the Danish city of Aarhus. Designed by architects Gjøde & Partnere Arkitekter for the Sculpture by the Sea biennale in 2015, the *Infinite Bridge* has a diameter of 60 metres (197 ft). Visitors were invited to walk on the wooden walkway – comprising sixty pieces of wood arranged on supports 2 metres (6 ft 6 in) above the ocean floor – that took them from the soft sands of the beach out into the water, where they could admire the panorama of Aarhus

Bay before returning to the shore ... or continue around the installation again. In the words of the architects, 'The simplicity of the structure allows people to see the complexity of the surroundings'. It both forged new connections between visitors and the natural landscape and made viewing the landscape a more social activity, bringing together people on the bridge. Seen from above, it is clear that the circular structure intercepts the remains of former jetties, recalling a time in the 1800s and early 1900s when people from Aarhus caught

steamboats from the city to this beach, where the Varna Pavilion peeking from the woods on the hillside was once a popular destination with terraces, a restaurant and a dancehall. The pavilion was designed to be seen from the end of the jetty as passengers disembarked – and the Infinite Bridge has made it possible for visitors to enjoy that view once more.

Jason deCaires Taylor

Rubicon, 2016
Stainless steel, pH-neutral cement, basalt and aggregates, installation view
Museo Atlántico, Las Coloradas, Lanzarote, Atlantic Ocean

Through a hazy blue mist and across a rocky landscape, an anonymous crowd walks towards the viewer led by a woman, striding with her eyes down, staring, lost in her mobile phone. The scene is set 14 metres (46 ft) underwater off the coast of Las Coloradas beach on the island of Lanzarote, Spain, and the crowd is a grouping of sculptures by the British artist Jason deCaires Taylor (b. 1974). The whole group comprises thirty-five figures, all of which are set walking towards a 30-metre long (98-ft) wall, with a singular rectangular doorway in the centre through which they are presumably hoping to pass. The work is part of a much larger underwater sculpture park deCaires Taylor created featuring more than three hundred works in total. It is one of numerous undersea 'museums' the artist has created in seas and oceans around the world, arguing that the oceans should possess the same qualities as museums: 'conservation, education and protecting what we love'. Over time the PH-neutral marine cement sculptures will become encrusted with coral and colonized by other life forms as they are slowly reclaimed by the ecology of the sea. The title of the work refers to the idea that the crowd – and the population of the world – are blindly walking towards the point of no return as they head into a time when, as human activity causes global temperatures to rise, a climate catastrophe becomes inevitable. Through this piece and his wider practice, the artist wants to sound an alarm, compelling viewers to wake up to the dangers of climate change and begin to live in harmony with the natural world by leading more sustainable lives.

Winslow Homer

Natural Bridge, Bermuda, c.1901
Watercolour and graphite on white wove paper, 36.7 × 53.3 cm / 14½ × 21 in
Metropolitan Museum of Art, New York

The renowned American landscape artist Winslow Homer (1836–1910) could be said to have had an almost symbiotic relationship with the ocean. A great influence on subsequent generations of American artists including Edward Hopper and Andrew Wyeth, his mature works typically present classically proportioned fishermen or sailors engulfed by sublime dramatic seascapes. In the same year he painted his monumental work *The Gulf Stream* (1899), in which a lone mariner founders on a broken-masted vessel among roiling, shark-infested waters, he visited the island of Bermuda in the North Atlantic for the first time. Though he worked in oils for principal commissions – suited to capturing the tumultuous swells around the Prouts Neck peninsula in Maine, where he lived – while travelling he favoured lighter watercolours, cherishing their versatility in capturing novel sights in less formal compositions. 'I prefer every time a picture is composed and painted outdoors.' He noted 'The thing is done without your knowing it.' Still, Homer's preoccupations assert themselves in his viewpoint, which in *Natural Bridge, Bermuda* is from a vertiginous height, emphasized by the small, red-coated figure lying down to peer over the edge of the cliff at bottom right. Where other painters might have focused squarely on the picturesque, striated rock arches, Homer gives over the upper half of his composition to the deep cerulean blue band of the ocean. The North Atlantic is painted here in heavy, almost oillike washes, seemingly replete with the knife-edge potential of storm systems, which would eventually destroy the arches in the 2003 Hurricane Fabien.

Bernhard Edmaier

Shallow Sea near Eleuthera, Bahamas, 1997
Photograph, dimensions variable

Almost abstract in its composition, this aerial photograph captures the vivid variation in shades of blue of the shallow waters around Eleuthera Island in the Bahamas, where currents sweeping through the shallow waters have sculpted elongated sand banks that resemble blue mountain ridges. This image, taken in 2014, comes from the 'Blue' section of the series *Colours of the Earth*, by German geologist and landscape photographer Bernhard Edmaier (b. 1957), which was intended 'to arouse interest in the Earth's surface untouched by humans'. 'Blue' documents how the water's colour changes depending on the depth of the sea: the deeper the sea, the darker the blue of the water. Edmaier studied civil engineering and geology before becoming a photographer, and his images reflect the influence of his earlier studies. At the heart of his work is the desire to show how nature has formed Earth's surfaces, be that beneath the seas, in the deserts, up mountains or in jungles far from human interference. Colour plays a key role in how Edmaier approaches his subject: his aerial photographs capture not just the shapes of nature but also the boldness and variety of nature's palette. In a career that has spanned more than twenty-five years, award-winning Edmaier has been motivated by the power of natural phenomena, travelling to remote places to capture dramatic evidence of their influence on the planet. As such, the images he presents are precisely the ones he captures, with no retouching: this is nature as nature intended.

Brian Skerry

Last of the Tuna, 2010
Photograph, dimensions variable

This dramatic image of a shoal of Atlantic bluefin tuna (*Thunnus thynnus*) is more than simply a beautiful picture; it also carries a serious conservation message. This large, powerful fish is found in the Atlantic Ocean and Mediterranean Sea and is one of the most highly prized of all edible species, but overfishing has led to a severe reduction in its population and has resulted in it being listed as endangered. Driven partly by local markets, but also by being a highly desirable delicacy in Asia and elsewhere as a component of sushi and sashimi, the

decline of this species in parts of the Mediterranean has been almost catastrophic. As a top predator, the Atlantic bluefin tuna has a key role to play in maintaining the stability and diversity of the marine ecosystems in which it lives. In addition to being taken directly from the sea by line or net, young tuna are also transferred to pens, where they continue their growth in a process known as ranching. They are forced to live in captivity – a sad situation for a species that naturally covers long distances in the open ocean. To highlight

this practice, American photographer and film producer Brian Skerry (b. 1961) shot these tuna inside such a ranch off the coast of Spain, securing an image that shows the beauty of this streamlined fish yet is tinged with sadness at their plight. A Nikon Ambassador and National Geographic Photography Fellow, Skerry specializes in images of marine wildlife, and his work has featured regularly in *National Geographic* magazine.

Tony Wu

Aggregation of Sperm Whales, Indian Ocean, 2014
Photograph, dimensions variable

This dramatic photograph captures an unusual event off the coast of Sri Lanka when many sperm whales (*Physeter macrocephalus*) gather close together in the surface waters and tumble around one another to help slough off dead skin, leaving their usual uniform grey colouring marbled and patchy. The way the whales aid each other by rubbing and rolling their bodies together makes this a highly sociable encounter. Sperm whales are the largest of the toothed whales, making them the biggest of all predators. They can reach a length of 20 metres (65 ft), and the huge head, making up about a third of the length, contains a cavity that holds a mixture of fats and waxes known as spermaceti. This organ is thought to focus clicking sounds produced by the whale and helps to alter buoyancy when the whale dives. The image, taken by photographer Tony Wu, was winner in the mammal behaviour section of the prestigious Wildlife Photographer of the Year competition of the Natural History Museum, London, in 2017. Wu's photographs are notable for the way they capture natural animal behaviour with sensitive artistry. Indeed, he refers to himself not as a photographer but as a photo-naturalist, aiming to study his target animals with minimal disturbance in his quest to secure unique images such as this. Not simply a portrait, it provides an arresting insight into the lives of these huge marine mammals.

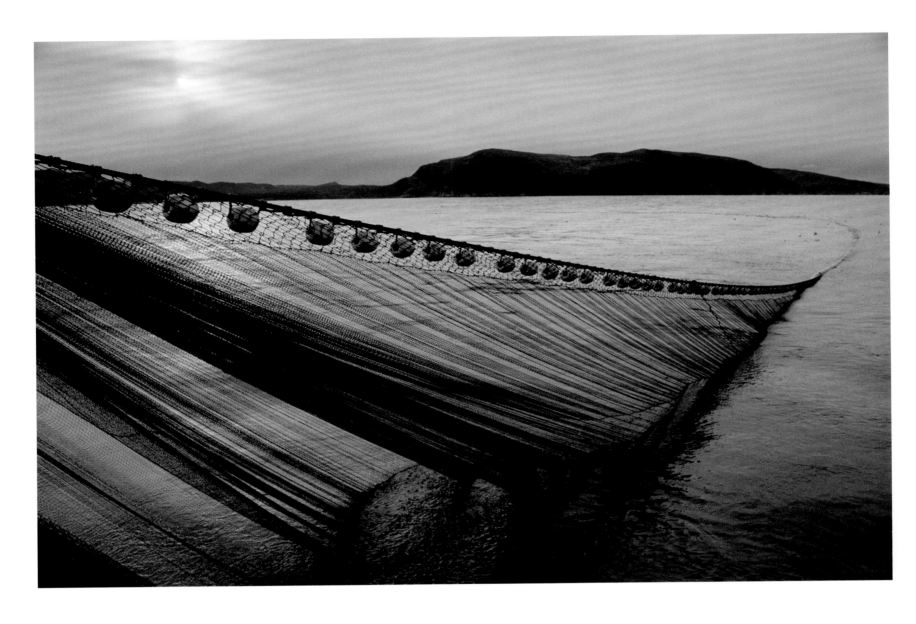

Jean Gaumy

Industrial Fishing Aboard the Einar Erlend,
Finnmark Sea, Hammerfest, 2001
Photograph, dimensions variable

Between 1984 and 1998, award-winning French documentary photographer Jean Gaumy (b. 1948) travelled the world to document the seafaring lives of commercial fishermen on windswept trawlers. His tone-rich and highly atmospheric imagery reveals the life struggle to which most people are oblivious as they pick fish from supermarket display cabinets or even local fish markets. A change from his most dramatic shots, this image captures a moment of relative calm in which a surrounding net, also known as 'purse seine', is lowered from a fishing boat. An adaptation of the older kinds of seine net used since the Stone Age by the Māori, the surrounding net encircles fish from all sides. A purse line at the bottom is pulled closed when the net is hauled in, trapping the fish. Floating buoys secured to the top edge and weights fastened to the bottom ensure the net will form a wall while in the trawl. One of the most common types of nets used in the commercial fishery, the surrounding net is extremely effective for trapping large schools of fish. However, like other kinds of nets, it also catches anything that cannot wiggle out through its mesh, including whales, dolphins, sea turtles and even seabirds. Fishery bycatch is a serious threat to marine wildlife since it causes the unnecessary deaths of many fish that are not fit for consumption. It has been estimated that every year, 38 million tonnes (42 million t) of marine creatures are unintentionally caught and killed in these circumstances.

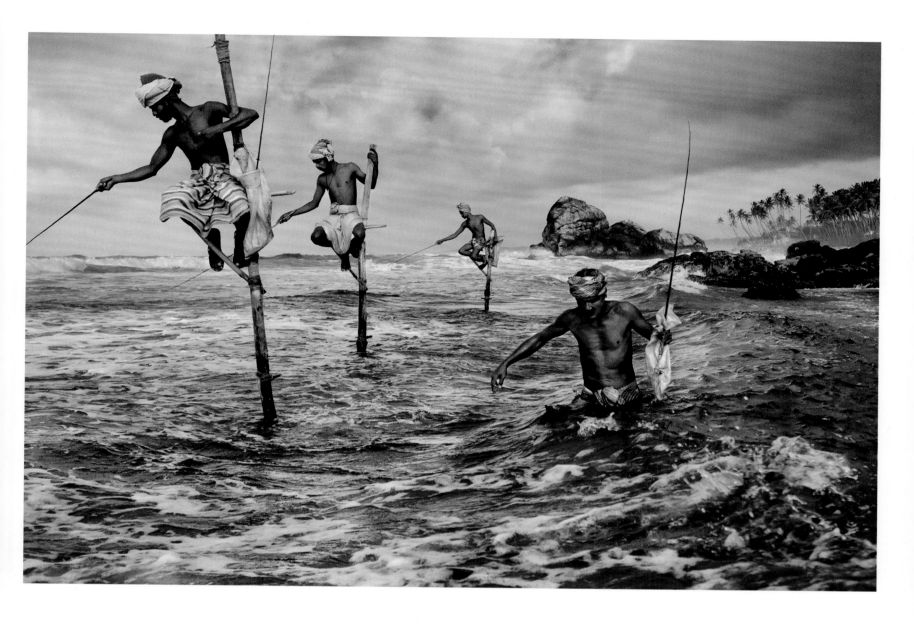

Steve McCurry

Fishermen, Weligama, South Coast, Sri Lanka, 1995
Photograph, dimensions variable

The beautiful composition of this remarkable photograph lends it the quality of a painting, but the timeless air of the scene of stilt fishing on the southern coast of Sri Lanka is deceptive. Stilt fishing – in which fishers cast their lines while they balance precariously on small crossbars attached to upright poles – is itself a relatively recent phenomenon, developed during World War II along the southern coast of the island between Unawatuna and Weligama to combat the effects of overfishing further out to sea. During monsoon seasons, it was also a more attractive proposition than taking fishing boats out onto rough seas. Fishermen remain perfectly still and silent, not even casting a shadow on the water to disturb the small fish below, and place their catch in plastic bags tied around their waists. The Indian Ocean tsunami of December 2004 destroyed the reefs along the coast, which made stilt fishing economically unviable as a way to catch food, so the practice has become less common and is usually limited only to the very poorest fishers. Today most of the stilt fishermen rely on small payments they receive from tourists, for whom they remain a popular attraction. This image was taken by celebrated American photographer Steve McCurry (b. 1950), who has made a global reputation through his ability to capture scenes that are both dramatic and that encapsulate the essence of different cultures. McCurry specializes in depicting people in unguarded moments, most famously in his image *Afghan Girl*, taken in 1984, which is widely hailed as one of the most famous photographs in the world.

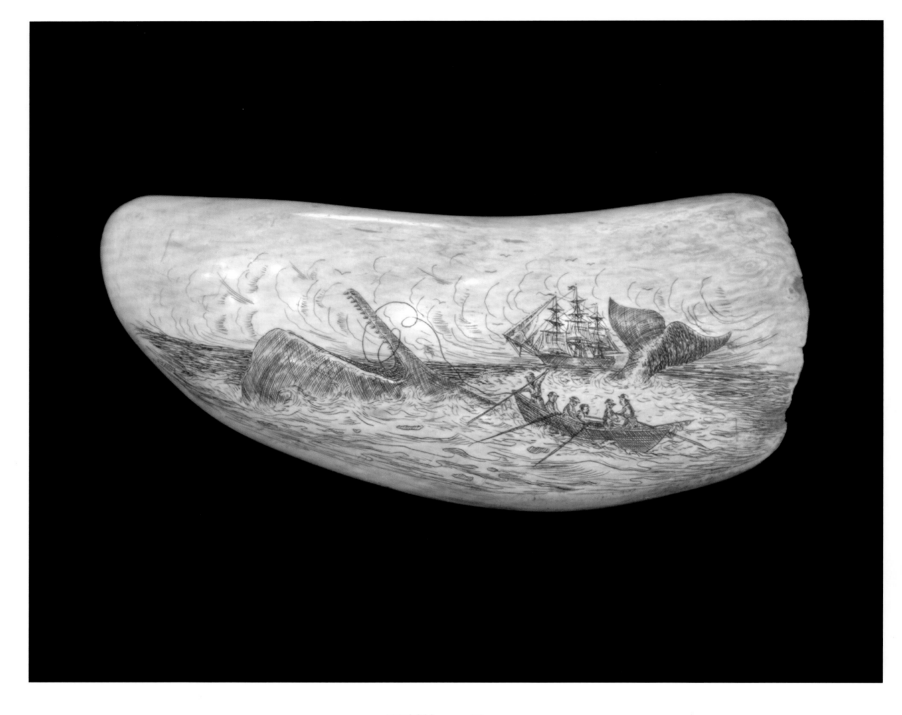

William Perry

Scrimshaw Tooth, early 20th century
Engraved sperm whale tooth, 17.8 × 7 cm / 7 × 2¾ in
Mystic Seaport Museum, Connecticut

Drawn in minute detail on the length of the tooth of a sperm whale, this whaling scene shows a huge whale on its back, its mouth open, while whalers attack it from their open boat. Scrimshawing – the engraving of maritime scenes on whale bones and teeth – was a popular leisure activity for whalers, peaking around the same time as the whaling industry between 1840 and 1860. Unable to hunt whales at night because of the inherent dangers, and with long periods to fill between whale sightings, the fishermen passed their evenings at sea scrimshawing on whale teeth, which were plentiful and which had no commercial value. The scrimshaw was often intended as a gift for the sailors' loved ones at home. Unsigned, this tooth is most likely the work of William Perry (1894–1966) who combined his love of whaling and art by carving scrimshaw. One of a new type of scrimshanders, Perry worked in a traditional style but produced work he could sell when he was back on land. Using a pointed tool with a bone handle, he engraved more than a thousand sperm whale teeth and pieces of panbone – from the back of the whale's jaw – to create highly detailed scenes of whaling life that he often traced from whaling postcards. Perry then coated the tooth with ink to accentuate the lines he had etched, and he also experimented with aging the teeth by smoking each one over a match and then rubbing in the soot to give the ivory a brown patina.

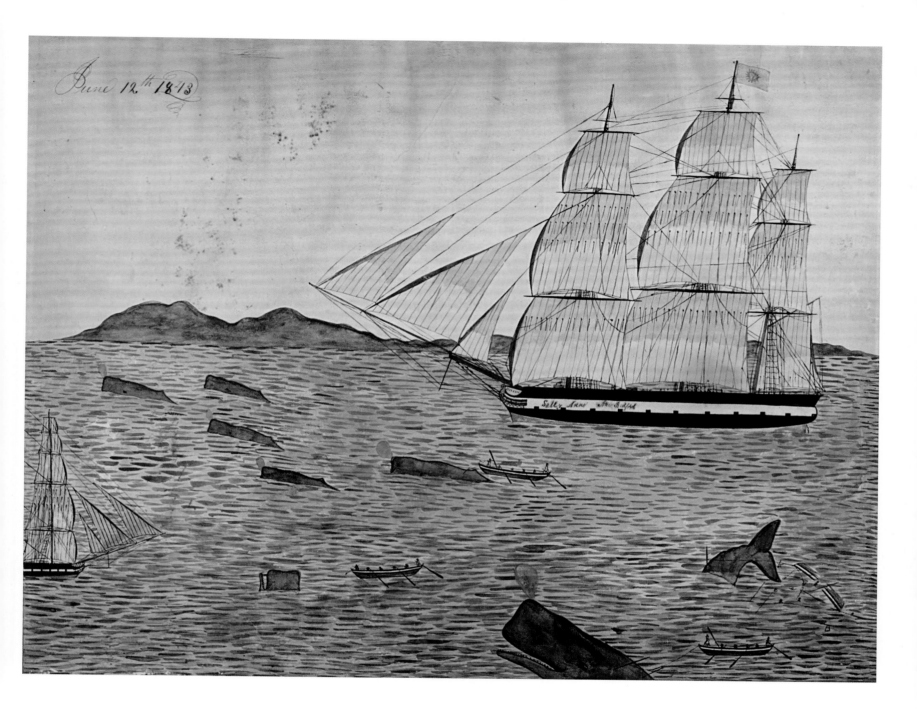

June 12.th 1843

Anonymous

Whaling Scene of the New Bedford ship 'Sally Anne', c.1843
Watercolour and ink on paper, 34.9 × 44.5 cm / 13¾ × 17½ in
Private collection

A pod of sperm whales is hunted by whaleboats dispatched from the triple-masted ship, the *Sally Anne*. Five of the creatures are beating a swift retreat towards the open sea beyond the brown hills on the horizon. The calm ocean, described in broken horizontal dashes of watercolour, is disturbed lower down by the death throes of a harpooned whale, its jaws open in an anguished cry and blood spouting from its blow hole; another whale has split a whale-boat clean in half with a violent fluke swipe, tossing passengers and equipment into the water. The *Sally Anne* was a whaling brig that operated out of New Bedford, Massachusetts – setting of Herman Melville's celebrated whaling novel *Moby-Dick* (see p.265) – during a golden era for the city. Connected by a newly opened railroad in 1840 to markets in Boston and New York, the city's economy boomed, with approximately half of the entire global fleet of whaling ships calling it home. Prior to the discovery of oil deposits in the United States, oil refined from blubber was a vital component of the industrial revolution, and spermaceti, a waxy substance found in the whale's nasal cavities, was prized for its use in smokeless and odourless candles. With long stretches of up to four years at sea, and travelling as far as Sydney, Australia, some crew members filled their time with amateur artistic pastimes, and a whole genre of folk art, including charming paintings such as this and scrimshaw carvings on whalebone (see p.188), grew up around and documented the whaling trade.

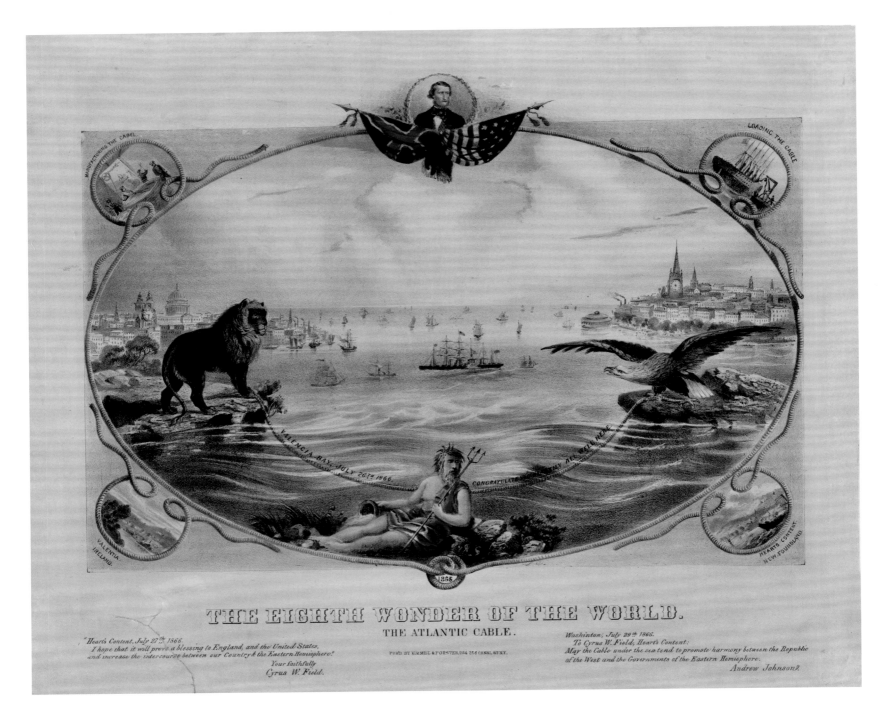

THE EIGHTH WONDER OF THE WORLD.

THE ATLANTIC CABLE.

"Heart's Content, July 27th 1866.
I hope that it will prove a blessing to England, and the United States,
and increase the intercourse between our Country & the Eastern Hemisphere."
Your faithfully
Cyrus W. Field.

PUB'D BY KIMMEL & FORSTER, 254 & 256 CANAL ST. N.Y.

Washington; July 29th 1866.
To Cyrus W. Field, Heart's Content:
May the Cable under the sea tend to promote harmony between the Republic
of the West and the Governments of the Eastern Hemisphere.
Andrew Johnson?

Kimmel & Forster

The Eighth Wonder of the World: The Atlantic Cable, 1866
Hand-coloured lithograph, 47.6 × 59.6 cm / 18¾ × 23½ in
Library of Congress, Washington DC

Transatlantic communications were revolutionized in the nineteenth century when the Atlantic cable drastically reduced the time it took messages to travel between Britain and the Americas. Previously, messages were sent by ship, which often took weeks, but telegraphic messages could be sent and responses received within hours. American businessman Cyrus West Field (1819–1892) first proposed laying a nearly 3,220-kilometre (2,000-mi) telegraph cable across the North Atlantic in 1854. Although a suitable route across the ocean's floor was discovered by oceanographer

Matthew Maury (see p.109), Field's first three attempts resulted in broken cables and a failed connection. His Atlantic Telegraph Company finally laid a permanent cable from Valentia in western Ireland to Heart's Content, Newfoundland, Canada, in July 1866. Publishers were quick to capitalize on the success, producing commemorative posters and prints for a captivated public. This hand-coloured lithograph by an unknown artist and produced by New York firm Kimmel & Forster shows the cable stretching from the paws of a lion, symbolizing Great Britain, to the

talons of an eagle, representing the United States. Neptune, god of the sea, rests in the foreground, approving the remarkable venture dubbed 'The Eighth Wonder of the World'. Field, flanked by the flags of Great Britain and the United States, appears top centre, and goodwill statements by him and US president Andrew Johnson are printed in the lower margin. A permanent cable connection between the continents has existed ever since, though subsequent generations of cables replaced the original telegraph connection with modern telecommunications technologies.

Albert Sébille

Compagnie Generale Transatlantique, 1922
Colour lithograph, 80 × 110.5 cm / 31½ × 43½ in
Private collection

This imposing ocean liner, SS *France* – nicknamed the 'Versailles of the Atlantic', a reference to its opulent interior décor – used to belong to the Compagnie Generale Transatlantique (CGT), which was established in 1855 by French brothers Émile and Isaac Péreire. Heralding the dawn of a new, faster and more efficient era of transatlantic travel, for more than a hundred years the fleet of iconic vessels owned by CGT was entrusted by the French government to transport mail to North America. This Art Deco poster by French artist Albert Sébille

(1874–1953) immortalizes the monumental stature of one of its freight ships in an attempt to relaunch the firm after the major setbacks caused by the outbreak of World War I in 1914. When war began that August, the activities of CGT were abruptly interrupted by a sailing curfew imposed by the French government due to safety concerns. However, due to strong public demand, for a brief period CGT operated a reduced service across the Atlantic Ocean to repatriate Americans who were eager to return home from Europe. Soon after, thirty-seven

of CGT's fleet were requisitioned by the French government to serve as auxiliary cruisers during the conflict. Most notably, part of the fleet was converted to floating hospitals that provided essential additional capacity to care for the wounded, while those that still crossed the Atlantic to deliver mail also brought food and, later, troops from the United States. In all, thirty of CGT's ships were lost in the conflict, leaving the firm to grapple with a dire need to rebuild as well as to relaunch its luxury image.

Nicholas Pocock

Entries 11–13 August 1774, from the *Logbook of the* Snow Minerva, 1772–76
Ink on paper, 32.5 × 37.5 cm / 12¾ × 14¾ in
Mariners' Museum, Newport News, Virginia

This logbook travelled the high seas aboard the merchant ship *Minerva*, which on 16 November 1772 set sail from Bristol, England, and travelled to Ireland, the Madeira Islands and Dominica in the Caribbean before returning to Bristol on 11 February 1776. The captain, Nicholas Pocock (1740–1821), not only recorded key daily information, such as speed, air pressure, wind and compass direction, but also made pen, ink and wash drawings of the ship each day, showing the weather conditions in which it sailed. Pocock, the son of a Bristol mariner, sailed

the ocean from an early age and was apprenticed to his father as a teenager, becoming a captain by the age of twenty-six. His other great passion was drawing, a talent he nurtured while at sea. As captain, he led twelve lucrative voyages to America and the West Indies for the Quaker merchant Richard Champion, but his employment ended when the American Revolution and subsequent trade ban led to Champion's insolvency. Pocock consequently turned to painting full-time, becoming recognized as the finest marine artist in Britain, celebrated

for the exquisite detail of his pictures. Thanks to the rigorous attention to detail of Pocock and others, logbooks such as this are important for historians and scientists alike: climatologists have studied historical data recorded in them to learn about changes in weather patterns and to calibrate climate models, which predict how climates might change as global temperatures rise.

Gustave Le Gray

Brig on the Water, 1856
Albumen silver print from glass negative, 32.1 × 40.5 cm / 12⅝ × 16 in
Metropolitan Museum of Art, New York

This picturesque image of a placid sea was among the most famous and widely distributed photographs of the nineteenth century. Gustave Le Gray (1820–1884) was a French photographic pioneer who embraced the medium in 1847, soon after it was launched in Paris to great sensation. A staunch supporter of paper-based photographic printing techniques, which at the time were not particularly popular in France, Le Gray brought important technical innovations to the field. It was during the 1850s that, adamant that photography possessed true artistic worth, he embarked on the production of a series of dramatic and poetic seascapes that brought him international acclaim. While landscape photography had by that time asserted itself as one of the most popular genres in the early history of the art form, well-lit images of the sea eluded even the most technically dexterous of professionals. The issue was caused by the difficulty to balance the contrast between sea and clouds so that both could look correctly balanced in the same image. Many photographers learned to circumnavigate the issue by sandwiching together two negatives, one focusing on accurately capturing the reflectiveness of the sea and the other grasping the volumetric softness of clouds. The two were merged and printed as one, yielding a harmonized and yet often odd-looking image. *Brig on the Water* was the first image representing the sea and clouds to be made using a single negative. Le Gray capitalized on the cloud cover, which reduced the brightness of the sun enough to suggest the effects of twilight or moonlight, thus creating a highly poetic and subtly atmospheric image.

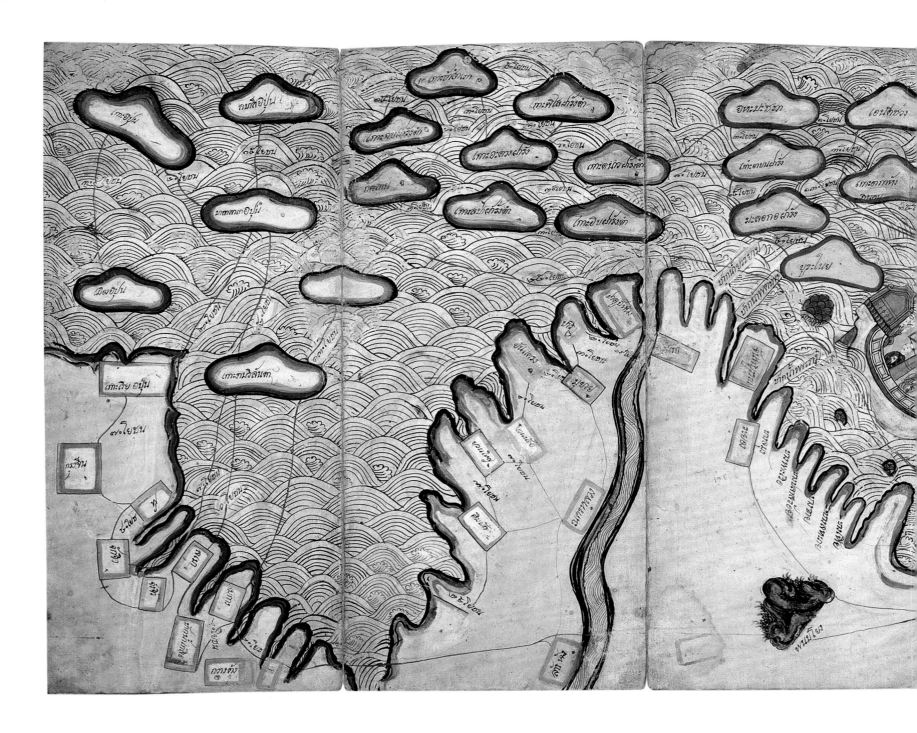

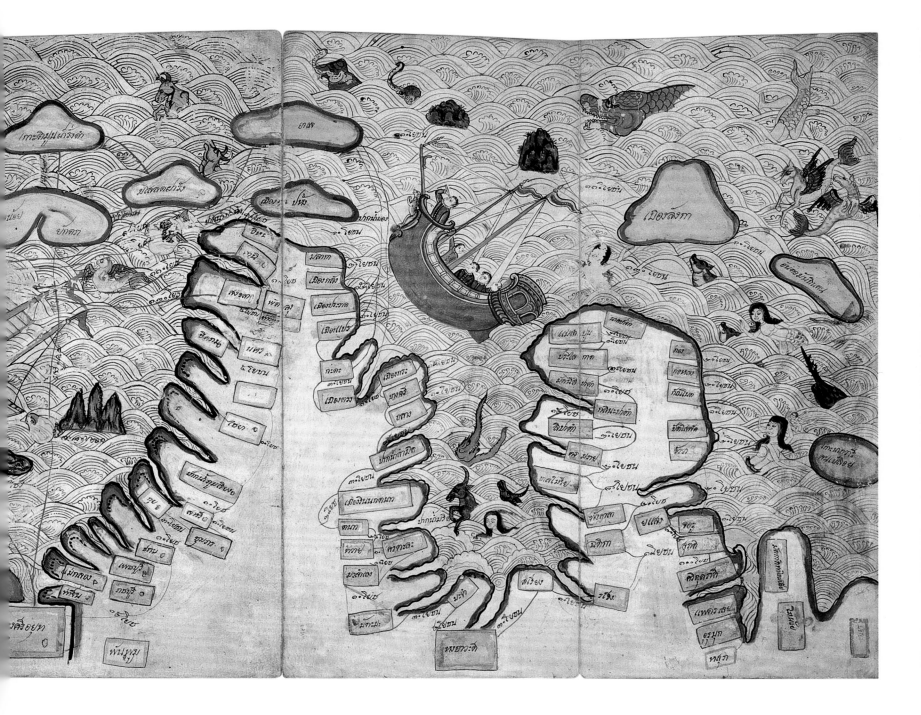

Anonymous

Map of the Indian Ocean, 1776
Manuscript on paper, 51.8 × 320 cm / 20⅜ in × 10 ft 6 in
Museum für Islamische Kunst, Berlin

This beautiful map covers six panels of the *Trai phum* (Story of Three Worlds), a Thai treatise on the shape of the universe, originally published in the fourteenth century. The billowing shapes with blue-green outlines that rise from the bottom of the map are the peninsulas of Asia – the map is orientated broadly with south at the top and east to the right, although the orientation varies in different places – from India on the right and Korea on the left. Above and to the left are the island groups of the Indian Ocean and South China Sea. While the mainland has

some detail – cities and provinces are named along the coasts and within Thailand – many of the islands are identical. They are also coloured yellow, reflecting the fact that the islands of Southeast Asia were known in ancient India as the islands of gold. Although the map shows places linked by thin ochre lines marked with distances, there is no suggestion that it was actually intended for navigation (its size alone would make it impractical). Instead, it probably reflects a Chinese or other Asian original, although the appearance of a European sailing ship

and a Chinese junk – the map is also decorated with mermaids and sea creatures – is a symbolic representation of the contacts with both East and West that were altering Thai views of the world at the time.

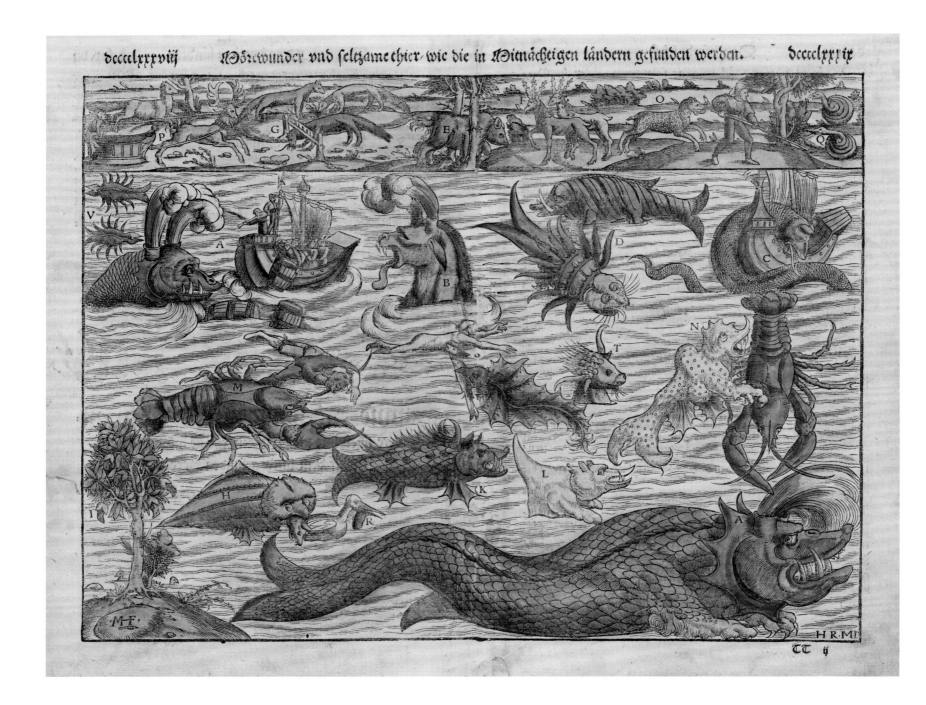

Sebastian Münster

Sea Wonders and Strange Animals such as Are Found in the Midnight Lands, from *Cosmographiae Universalis*, 1570
Hand-coloured woodcut, 34.3 × 26.7 cm / 13½ × 10½ in
Private collection

An ancient mariner's worst nightmares writhe, lurk and kill beneath the waves in this menagerie of terrifying sea monsters. In the top right of the chart, a leviathan coils around and crushes a defenseless vessel, while on the left, horned, doglike beasts chase down another ship. Artist Sebastian Münster (1488–1552), a German scholar of Hebrew specializing in mathematical geography and cartography, uses the full force of his imagination to dream up some creatures that are recognizable, such as giant lobsters; some that are inspired by other land animals, such as leopard-spotted webbed fish monsters; and others that are pure fantasy but reflect the innate fear of the unknown and unexplored oceans. Appearing in Münster's *Cosmographia Universalis*, published in 1544 – the earliest description of the world produced in German – the illustration drew heavy inspiration from the 1539 *Carta Marina*, an early map of the Nordic countries, which depicts the sea as similarly full of an assortment of monstrous creatures (see p.302). Prior to *Cosmographia*, Münster had gained a reputation for his translations and lexicography of Hebrew, as well as a treatise on sundials and a Latin edition of Ptolemy's famous *Geographia* (1540). Münster's inclusion of woodcuts such as this, as well as the innovation of using one distinct map for each continent, made *Cosmographia* one of the most successful publications of the sixteenth century and a key influence on early atlas makers.

Text embroidered on image: Η ΘΕΆ.ΤΗΣ ΓΟΡΓΌΝΑ ΘΑΛΆΣΣΗΣ

Anonymous

Mermaid Godess of the Sea, early 20th century
Embroidered silk, 68 × 90 cm / 26¾ × 35½ in
Historical Museum of Crete, Heraklion

On this silk embroidery from Koustogerako, a village in the mountains of southwestern Crete, a richly bejewelled and crowned mermaid holds the anchor of a steamship in one hand and a fish in the other; more fish swim in the sea beneath the ship, which flies the Greek flag. Her title is embroidered above her – Mermaid, Goddess of the Sea – and she seems to look askance at the captain in the ship's bow and the row of sailors along the gunwale. In ancient Greek mythology, mermaids were derived from the malevolent Sirens (see p.31), half-bird, half-female

creatures whose song lured sailors onto the rocks. By the Christian period, they had morphed into half-female, half-fish mermaids. According to modern Greek folklore, Thessalonike, sister of Alexander the Great, became a mermaid (*gorgona*) after her death, living in the waters of the Aegean. She would question the sailors of any ship she encountered, asking if her brother was dead or alive – to which the correct answer was, 'He lives and reigns and conquers the world.' If the right answer was supplied, Thessalonike would calm the seas and send the ship safely on its

way. Any other answer enraged her and drove her to whip up wind and waves into a fierce storm that would sink the ship and drown everyone on board. The legend derives from a seventeenth-century Alexander romance (largely fictional accounts of the exploits of Alexander the Great, see p.44) that circulated in Ottoman Greece.

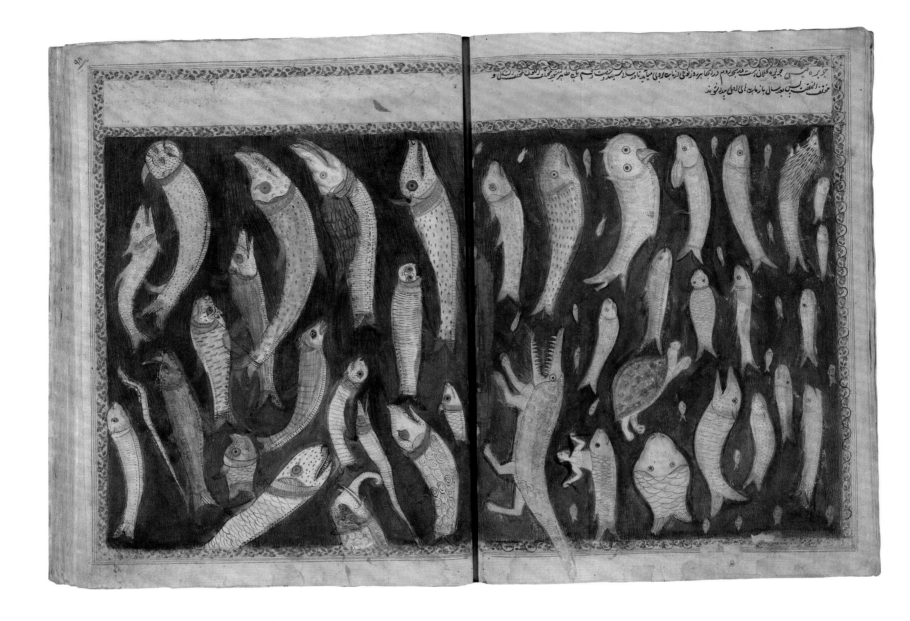

al-Qazwini

Pages from a manuscript copy of *Marvels of Things Created and Miraculous Aspects of Things Existing*, 17th or 18th century
Pigments on paper, each page 42 × 30.5 cm / 16½ × 12 in
University of St Andrews Libraries and Museums, Scotland

This slightly bizarre image features some surprising denizens of the deep, including a fish with the head of a horned, moustached man; various others with the heads of dogs, cats and a tusked elephant; a crocodile, a turtle and a fish with an owl's head; a hedgehog-fish and a mermaid-fish. The painting is a double-page illustration from the 'Wonders of the Seven Seas' section of an Arabic work (here translated into Persian in the eighteenth century) called *Marvels of Things Created and Miraculous Aspects of Things Existing*, by Abu Yahya Zakariya ibn Muhammad ibn

Mahmud-al-Qazwini (*c*.1203–1283), known as al-Qazwini. Originally composed in Iran, al-Qazwini's encyclopaedia begins with a description of the heavens, constellations and angels; the second part then discusses the earthly world, including the land and seas and the animals and plants that inhabit them, ending with a section on fantastic creatures. The author's declared aim was to inspire the reader to appreciate the omnipotence of God by marvelling at the variety and perfection of his creations. The book is a compendium of medieval knowledge,

drawn from Greek, Roman and Islamic scholarship with very little original material, and was very popular during al-Qazwini's lifetime and after. The section preserved in this manuscript concerns the seas of China and India, and features dragons, giant birds and hybrid creatures such as the fish seen here. The animal-headed creatures may represent demons who were believed to live in remote seas and along their coasts.

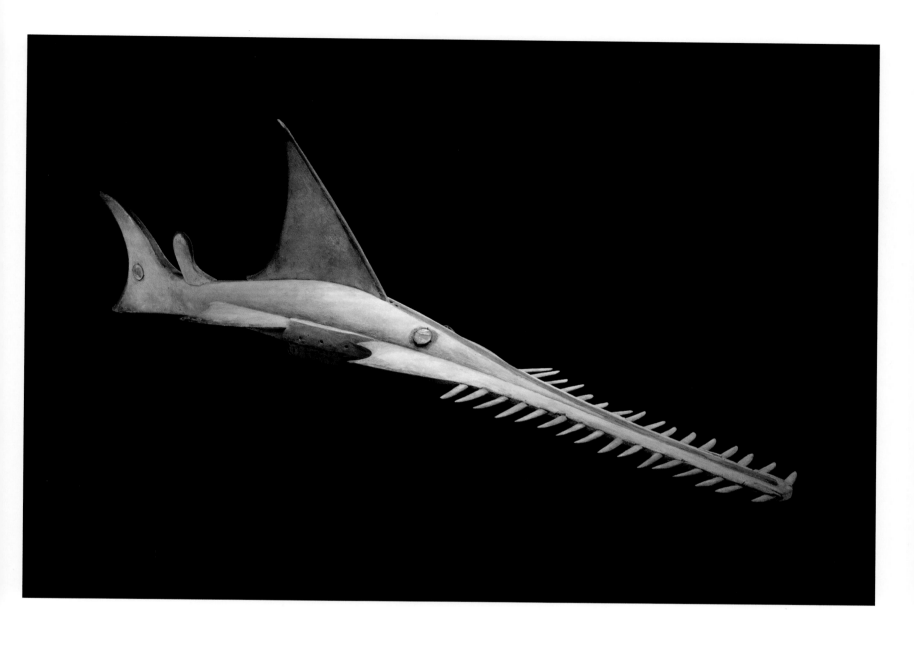

Anonymous

Sawfish (*Oki*) Helmet Mask, early-mid 20th century
Mixed media, wood, mirrors, nails and paint, 62.2 × 227 × 47.6 cm / 24½ × 89⅜ × 18¾ in
North Carolina Museum of Art, Raleigh

Created for a ritual masquerade in the Niger Delta, probably by a member of the Ijo people, this sawfish headdress combines the two most prominent elements of traditional Delta culture: water and warrior. Throughout the Niger Delta, water and water spirits are associated with fertility and prosperity; at the same time, a warrior ethos is displayed in images and activities that emphasize male strength and forcefulness. The Ijo people are fishermen in the coastal region of Nigeria, and in the Ijaw language the sawfish is called *oki*. The fish's large size, toothed snout and perceived aggression make it particularly popular for ceremonial masquerades: it is considered extremely dangerous, with powers that, properly directed, can counter evil. The sculptor of this headdress combined separately carved wooden teeth, fins and other elements, creating an artificially streamlined body and exaggerating the length of the toothed rostrum, adding to its fierceness; mirrors form the eyes and decorate the tail. Sawfish (*Pristidae*) are an endangered family of rays living in tropical and subtropical waters from oceans and brackish estuaries to freshwater lakes and rivers. They have a strong, sharklike body and are among the largest fish, with some species reaching more than 7 metres (25 ft) in length. Archaeological remains of sawfish survive across the globe, but today it has been hunted to extinction along most of the west coast of Africa and is one of the most endangered marine fishes in the world.

Boney plates.

scales hard forming an armour
almost case like:

Teeth small and sparing
scattered on hard palate.

caudal fin

Colour Dark grey black. (uniform)

Length. 4.½ ft.

depth of Body 18 inches

depth of tail 12 inches.

length of fins. spinous Dorsal. 8"
 Soft Dorsal 9"
 Pectoral = 12"
 Pelvics = 8"
 ANAL = 12"

Marjorie Courtenay-Latimer

Note to Dr J.L.B. Smith on the Discovery of the Coelacanth, 1938
Ink on paper, 21.6 × 24.7 cm / 8½ × 9¾ in
South African Institute for Aquatic Biodiversity, Grahamstown

It is almost impossible to overstate the scientific significance of this rather simplistic sketch of an unusual-looking animal. On 22 December 1938 Marjorie Courtenay-Latimer (1907–2004), a young curator at the East London Museum in South Africa, was called to examine a strange marine fish that had been caught by the fishing boat *Nerine*, owned by Captain Hendrik Goosen. She recognized at once that the discovery was hugely significant, and her rough sketch surrounded by notes and measurements marks what would prove to be the greatest zoological discovery of the twentieth century. Courtenay-Latimer's sketch shows a coelacanth (*Latimeria chalumnae*), a lobe-finned fish similar to animals only previously known from ancient fossils. Coelacanths had swum the seas for more than 350 million years until they were presumed to have become extinct around 65 million years ago. The discovery of a living specimen was momentous. All four-limbed vertebrates – amphibians, reptiles, mammals and birds – evolved from an ancestor that was a lobe-finned fish, so the living coelacanth provided a window on our own ancient origins. The coelacanth is not small – this first specimen was nearly 1.5 metres (5 ft) long and weighed nearly 58 kilograms (127 lbs). That it went undetected for so long shows us how little we know of life in the oceans. Following this discovery, it was fourteen years until the next specimen was caught, off the Comoros Islands. In 1999 a second living species of coelacanth was described from Manado, North Sulawesi, Indonesia. *Latimeria*, the generic name of the living coelacanths, honours Courtenay-Latimer.

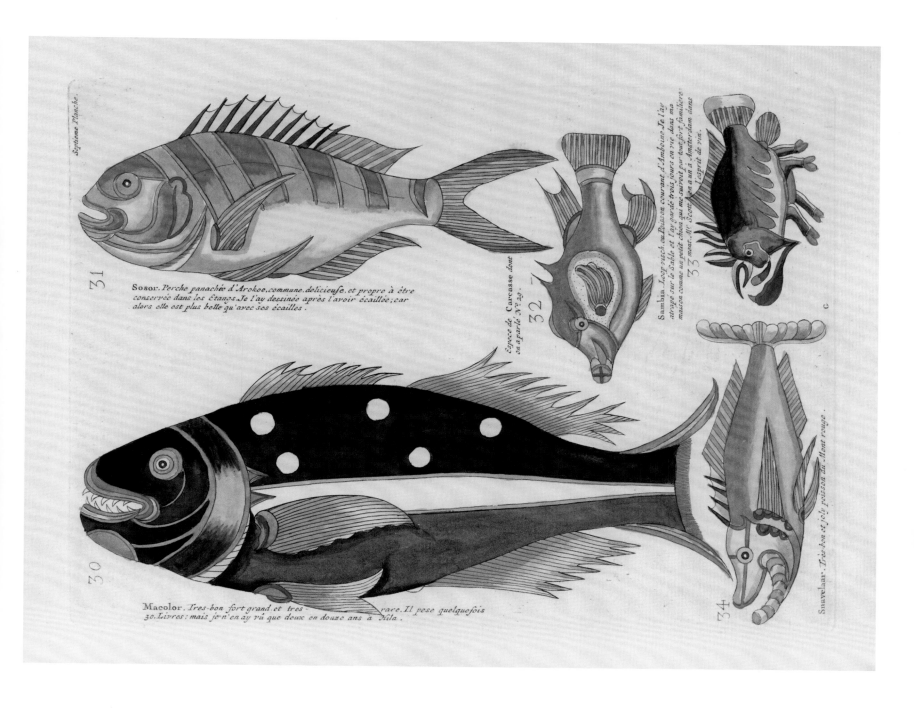

Louis Renard

Plate VII, from *Poissons, ecrevisses et crabes*, 1754
Hand-coloured engraving, 40.5 × 26 cm / 16 × 10¼ in
Ernst Mayr Library of the Museum of Comparative Zoology, Harvard University, Cambridge, Massachusetts

This colourful illustration of a variety of different fish species is a landmark in the study of marine zoology. A hand-coloured engraving originally published in 1719 as part of two volumes titled *Poissons, Ecrevisses et Crabes*, by French publisher and bookseller Louis Renard (c.1678–1746), this plate is one of a hundred images depicting 415 fishes, 41 crustaceans, 2 stick insects, a dugong and, on a double spread, a mermaid. The drawings were based on studies made by a former soldier and clerical assistant in the East Indies, Samuel Fallours, who drew and coloured them from life, but

their scientific value is somewhat limited. Not only are the anatomical details of some marine creatures grossly approximated, but the colouration seems to be very often wholly arbitrary and likely more concerned with entertaining the general reader than scientific study. Drawing fish has always presented artists with specific challenges: near impossible to observe with the naked eye as they swim, the iridescent colours of fish rapidly fade when the animals are removed from water for observation. In more than one way, Renard's volume is a product of its time – a reflection of the

growing importance of natural history as a noble pursuit during the eighteenth century and an attempt to record and organize the many new species naturalists encountered as Europeans sailed the globe. The persistent inclusion of inaccurate reproductions or fantastical creatures is the telling sign of how difficult it initially was for natural historians to demonstrate the existence of individual species.

Anonymous

Horseshoe Crab Effigy, c.AD 450–900
Gold, 2.2 × 1.7 cm / 1 × ¾ in
Museum of Fine Arts, Boston

This tiny gold effigy of a horseshoe crab would have been worn as a pendant; a wire suspension ring was cast on the back, behind the junction between tail and body. It probably came from the Sitio Conte necropolis, in modern Coclé Province, Panama, where the Coclé people buried the upper echelons of their society between the fifth and tenth centuries, along with painted pottery, gold and other precious objects. The Coclé used an array of gold-working techniques, including open-back casting (as here), lost-wax casting, hammering, depletion gilding, sheathing and annealing. Images of animals from maritime, coastal and terrestrial habitats are common, including crabs, stingrays, sharks and other fish, crocodiles, marine and freshwater turtles, and species of birds, bats, dogs and deer. In addition to providing food in some cases, these animals functioned as symbols and totems in a supernatural environment, perhaps in shamanic rituals. It has been proposed that the presence in art of stinging or biting animals, such as crabs, speaks to competitive qualities that would have been highly valued. Some images are realistic enough to identify the species, while others are unrealistic, but all were clearly meant to represent actual animals. This appears to be a male crab, if the suggestion of one larger claw is accepted. The horseshoe crab (family *Limulidae*) lives primarily in brackish coastal waters and is not actually a crab at all, but a member of the subphyllum *Chelicerata*, along with sea spiders and arachnids.

Anatomie de la Limule, from Recherches sur l'anatomie des Limules, 1873
Coloured engraving, 24 × 16.8 cm / 9½ × 6⅝ in
Marine Biological Laboratory, Woods Hole Oceanographic Institution Library, Massachusetts

Alphonse Milne-Edwards

This strikingly detailed illustration of the vascular system of a horseshoe crab (*Limulus polyphemus*) is the work of French zoologist Alphonse Milne-Edwards (1835–1900), the son of renowned zoologist Henri Milne-Edwards. True living fossils, horseshoe crabs have been around for 450 million years, surviving many ice ages and waves of mass extinction. This pioneering study shows the intricate network of veins in all its parts: the two large longitudinal vessels collect blood from the periphery of the animal body and transport it to the gills visible in the lower part,

by the base of the tail. Enriched with oxygen, the blood is then returned to the heart, where its cycle begins again. As evidenced in this illustration, the horseshoe crab's blood is not red like that of most animals but an intense blue. Very few animals show this type of colouration, which is mainly due to the presence of copper in the blood. Horseshoe crabs' blood has been used in medical research since the 1970s, when scientists discovered its remarkable antibody properties. The blood contains immune cells that detect and isolate toxic bacteria, making

it an essential agent in the development of vaccines, drug testing and other medical practices. There is no other way to harvest the animal's blood but to cause its death. However, a synthetic alternative produced in the late 1990s by the biologists at the University of Singapore is most likely to prevent a human-caused extinction of this species.

Eileen Agar

Hat For Eating Bouillabaisse, 1937
Cork, coral, seashells, fishbone and sea urchin, 33 × 49 × 23 cm / 13 × 19¼ × 9 in
Victoria and Albert Museum, London

A collection of shells, corals, a spiked urchin and starfish perch jauntily atop a blue and ochre cracked cork mound, accompanied by a towering shard of bark and the fishbones of a common sole. What at first glance appears to be a museum's undersea diorama is, in fact, a fashion accessory: a hat conjured from an upturned fruit bowl by Argentine-British Surrealist Eileen Agar (1899–1991). Agar's works are infused with her belief in the spiritual interconnectedness of humans and the natural world, and she sought to incorporate animals and plants into her creations

whenever possible. In two-dimensional works from this period, the same *Ophioderma* brittle star Agar had likely collected while holidaying in southern France recur, along with tree leaves or Matisse-like cut paper seaweed (see p.219), often surrounding human figures in whirling collaged confusion. With *Hat for Eating Bouillabaisse*, Agar bursts her mystical conjunctions from the page, as nature becomes a three-dimensional object to be worn during the reverent consumption of the titular French fish stew. Agar's hat couldn't be said to represent a particular

spot in the world's oceans, with items clearly gathered throughout the artist's abundant travels, including Neptune's whelk from the Arctic seas, and cerith shells and smooth clams from the Mediterranean. This complex, performative piece encapsulates Agar's artistic confidence just one year after she was chosen for the renowned International Surrealist Exhibition in London, among only a select few women artists.

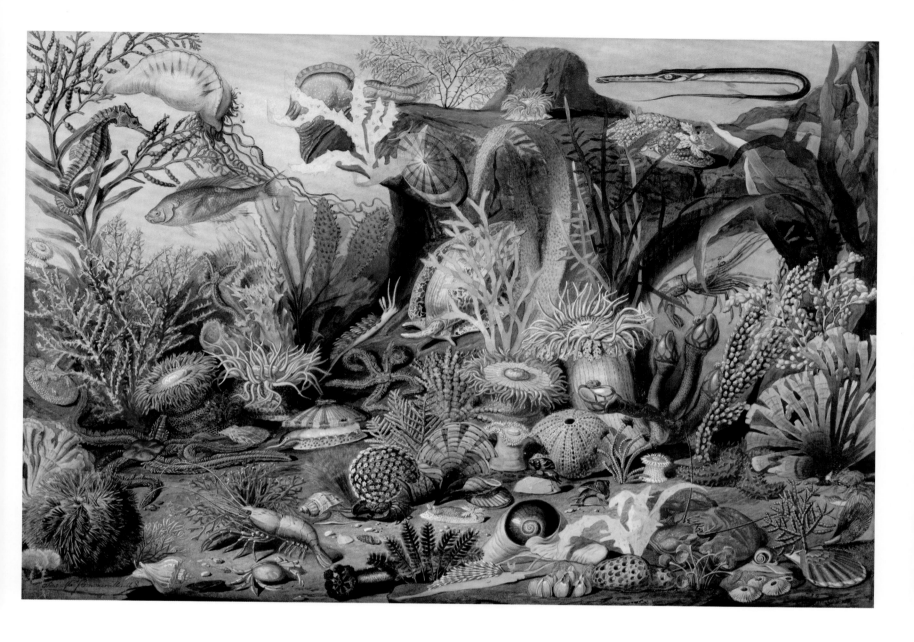

Christian Schussele and James M. Sommerville

Ocean Life, c.1859
Watercolour, gouache, graphite and gum arabic on
off-white wove paper, 48.3 × 69.7 cm / 19 × 27½ in
Metropolitan Museum of Art, New York

A colourful panoply of ocean flora and fauna is arranged across every inch of this watercolour by artist Christian Schussele (1824–1879) and naturalist and physician James M. Sommerville (1825–1899). The image presents an imagined grouping of seventy-five distinct specimens, collected for study by Sommerville, and described in rich detail in his pamphlet *Ocean Life* (1859), part of a wave of new scientific research into the subaquatic realm in the mid-nineteenth century that also catered to a mass audience eager to learn about the otherworldly

residents of the deep. Sommerville, a member of the Academy of Natural Sciences, commissioned Schussele, professor of the Pennsylvania Academy of the Fine Arts, to paint the original work. Sommerville then transposed it as a lithographic print for his publication, with a numbered key identifying each species shown. The white, gas-filled bladder of a Portuguese man-of-war carries it towards the top left of the scene and the tail of a tobacco trumpetfish describes its sharp turn at top right, below which, in delightfully orchestrated

composition, cascades a waving diagonal of algaes, anemones, barnacles and crustaceans, culminating in the round, spiked sea urchin at bottom left. Based on both painstaking drawings of Sommerville's specimens and on direct observations of the seafloor from a boat, the scene is suffused with a vitality that might have been lacking in a still life; a hybrid that Sommerville termed 'a mental oasis of the sea'.

David Hall

Soft Coral Colony with Commensal Goby, 2006
Archival digital print, 55.8 × 76.2 cm / 22 × 30 in

This remarkable image taken in Pantar, Indonesia, in 2006 by American underwater photographer and scientist David Hall (b. 1943) captures the mutually beneficial relationship between the notoriously shy goby fish (*Pleurosicya boldinghi*) and fragile soft coral (*Dendronephthya* sp.). Hall was photographing a coral colony he noted as being particularly colourful when he noticed the tiny goby living in its midst and made the fish the focus of his composition. The image encapsulates the goby and coral's commensal relationship: the bicoloured soft corals provide the goby with shelter,

protection and food. In return, the goby keeps the coral algae-free, deters predators and reduces the coral's susceptibility to bleaching. As algae forms, the coral sends a chemical message to the goby to remove it. In the same way, if a predator, such as a damselfish, tries to eat the coral, the goby releases a toxin that sends the damselfish scurrying away. For its part, the coral provides a protective shelter where the goby can easily hide from predators. Also hidden in this scene are a well-camouflaged transparent commensal shrimp – resting on the purple branch of coral to the upper right

of the goby – and several transparent comb-jellies. Hall started scuba-diving in the 1960s and then began to photograph the species he saw underwater as a means of recording them. A scientific quest soon aligned with artistic expression. He turned professional in 1980 with the goal of presenting the beauty of marine life to as many people as possible. His award-winning images – he has twice been named Wildlife Photographer of the Year – have appeared in countless publications as well as in the children's books he has written to introduce the younger generations to the beauty of marine life.

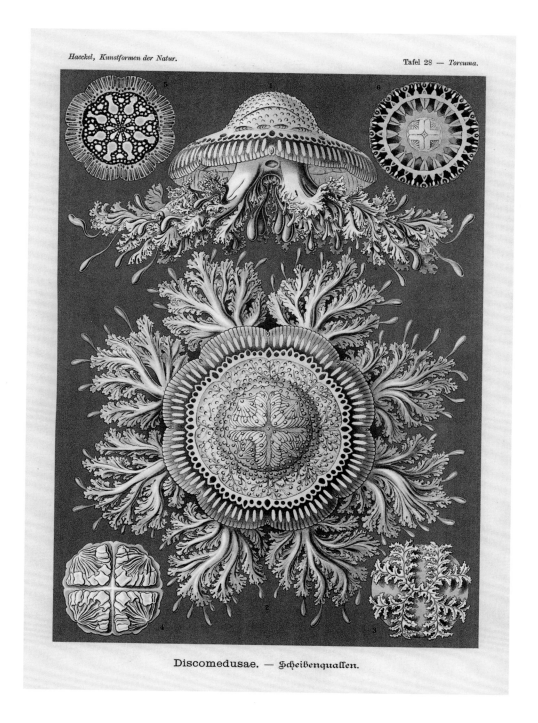

Discomedusae. — Scheibenquaffen.

Ernst Haeckel

Discomedusae, from *Kunstformen der Natur* (*Art Forms in Nature*), 1904
Colour lithograph, 36 × 26 cm / 13¾ × 10¼ in
Private collection

These otherworldly, fantastical forms, seemingly lifted from a world of science fiction, are the masterful work of nineteenth-century German scientist and artist Ernst Haeckel (1834–1919). Ornate renderings of geometric patterns, architectural structures, and organic shapes show six views of *Discomedusae*, a subclass of jellyfish. The gelatinous organisms are among the many natural wonders collected in Haeckel's landmark publication *Kunstformen der Natur* (*Art Forms in Nature*). The portfolio of one hundred prints was published in ten instalments from 1899 to 1904, and also in a two-

volume edition. To create the vibrant plates, Haeckel collaborated with artist Adolf Giltsch, who translated his drawings and watercolours into exquisite lithographs. The marriage of art and science had long been established by Haeckel's time, but his contribution was groundbreaking. He devoted his life to discovering, naming, classifying, describing and depicting thousands of species of flora and fauna. A contemporary of Charles Darwin, he helped popularize Darwin's theory of evolution – and, despite his contributions to science, Haeckel himself advanced the racist theory that

evolution favoured white European males. However, his mesmerizing illustrations – he created more than one thousand over his lifetime – captured the imagination of the public, making biology not only approachable but fashionable. Haeckel's work also influenced the arts, including Art Nouveau and the designs of Louis Comfort Tiffany, among others. René Binet modelled the elaborate entrance gate to the 1900 Paris World Exposition on his illustration of a radiolarian, and Haeckel himself decorated the ceilings of his home with frescoes of jellyfish.

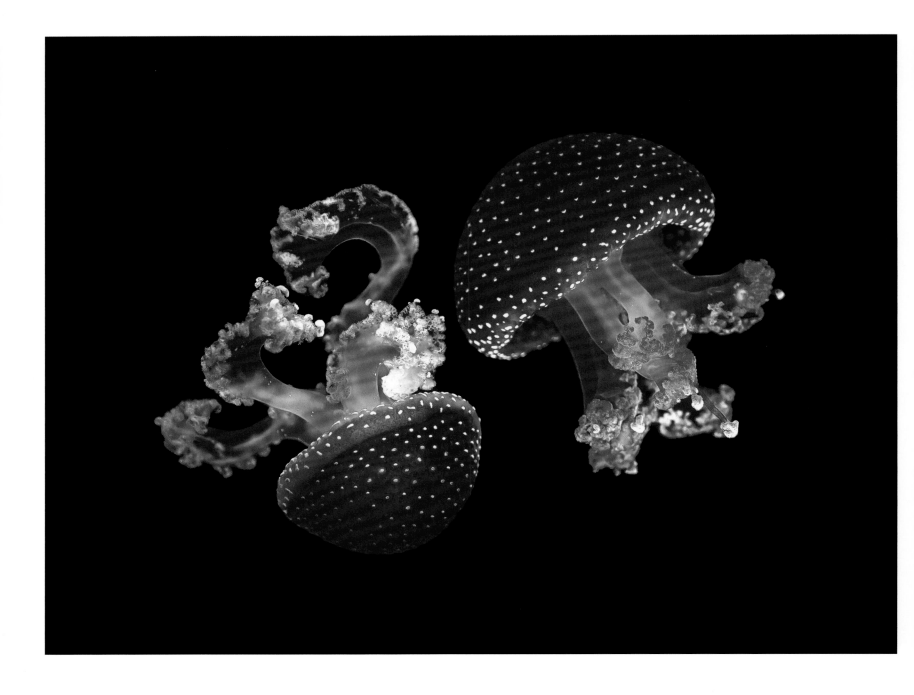

Pedro Jarque Krebs

Jellyfish Ballet, 2019
Digital photograph, dimensions variable
Private collection

This striking photograph of two white-spotted jellyfish (*Phyllorhiza punctata*) is the work of award-winning Peruvian wildlife photographer Pedro Jarque Krebs (b. 1963). Often photographing animals in natural reserves, Krebs has developed a distinctive style that allows him to emphasize the individual uniqueness of each animal he photographs. White-spotted jellies thrive in the warm tropical waters of the western Pacific Ocean, from Oceania through East Asia. Like sponges and oysters, this species feeds on microscopic zooplankton while floating across currents, but unlike them, this species tends to navigate marine waters in swarms. These swarms have been known to often cause temporary ecological unbalances because of the species' voracity – each jellyfish can filter 50 cubic metres (1,766 cubic ft) of plankton-rich seawater in a single day. Capable of attaching themselves to the hull of boats, white-spotted jellies can colonize new marine territories and reproduce quickly, and have thus become an invasive species in non-native areas, such as the Gulf of California, the Gulf of Mexico and the Caribbean Sea. The white-spotted jellyfish can multiply sexually by releasing sperm and eggs into the water – a phenomenon called spawning – or asexually by cloning itself. The eggs of this species hatch into microscopic flatwormlike creatures covered in hairlike cilia that allow them to swim. The planula (the first stage in a newborn jellyfish) eventually anchors itself to the seabed, where it can spend years as a tiny polyp until, when optimal conditions manifest, its body segments into a multitude of individuals that will detach and swim away to become many adult jellyfish.

ManBd

Rainbow Goby, 2018
Photograph, dimensions variable

With its brilliant yellow body and seemingly iridescent turquoise spots, a minuscule hairy goby peers out from its hiding spot nestled among fluorescent rainbow-coloured coral. This notoriously shy goby was shot in Lembeh, Indonesia, by Malaysian photographer ManBd, earning him a runner-up award in the Compact category of the 2021 Underwater Photographer of the Year competition. The image is all the more spectacular because the goby measures just over 3 centimetres (1 in) and hides deep in the branches of the hard coral where it lives. ManBd used coloured torches to illuminate the coral and a separate white light for the goby in order to accurately capture the fish's body with its distinctive hairs against the coral. *Goby* is a catch-all name for the more than 2,200 species of fish worldwide that belong to the suborder Gobioidei. The majority typically grow to be no more than 10 centimetres (4 in) long and are found in tropical or temperate waters. Indonesia has the highest diversity of coral reef fish in the world – more than 2,000 species – and is home to more than 480 species of hard coral, nearly 60 per cent of the world's recorded species. The waters surrounding the country are at the heart of the Coral Triangle, the global epicentre for marine biodiversity. Spanning to Timor Leste, Malaysia, the Philippines, Papua New Guinea and the Solomon Islands, it covers 5.7 million square kilometres (2.2 million sq mi) of the ocean.

Sayaka Ichinoseki

Baby Anglerfish, Shakotangun, Hokkaido, Japan, 2020
Photograph, dimensions variable

These tiny, translucent creatures look almost alien but are in fact anglerfish embryos still trapped in eggs shortly before they hatch. Each egg is only about 2 millimetres (0.08 in) in size and was part of a huge sheet of eggs nearly 2 metres (6.5 ft) square discovered by photographer Sayaka Ichinoseki on the northern-most Japanese island of Hokkaido. The stillness of the quiet, delicate moment filled with promise is something of an illusion. The embryos were active and aware, so the whole sheet of eggs was in constant motion, as well as rising and falling with the swell of the ocean. Attempting to photograph such minute detail requires not just great skill but also remarkable patience. This image was captured only after four hours of hard work. Anglerfish live in oceans worldwide – there are some sixteen families – including at the bottom of the deep sea, but are all distinguished by the luminescent lure they use to attract prey towards their sharp-toothed mouths. Some of the deep-sea species are strikingly unattractive in appearance, and although various species are eaten, in European markets anglerfish is marketed as monkfish, reputedly so as not to put off customers. The image is actually one of four Ichinoseki took of anglerfish eggs at different stages of development – this is the last in the sequence – as part of her quest to photograph unusual images of the undersea realm, not just in Japan but also around the world. This image won her first place in the Faces of the Sea category at the eighth United Nations World Oceans Day Photo Contest. Bringing the small, subtle and silent into sharp focus is crucial for our understanding of the delicate connections of life that are spread across the oceans.

Studio Ghibli

Still from *Ponyo*, 2008
Animated film, dimensions variable

Ponyo, a fishlike character with a human face, strikes out from her many siblings at the start of an adventure with disastrous consequences. Eventually trapped in a jam jar, she drifts ashore and is rescued by a five-year-old boy named Sōsuke. Although Ponyo is reclaimed to the sea by wave spirits summoned by her wizard father, she declares her desire to become human, using her father's magic to begin the transformation as she returns to live with Sōsuke in his fishing village. Immediately, however, the natural world shows signs of upheaval, with a tsunami sweeping

over the coast and the moon falling out of its orbit, before the love between Sōsuke and Ponyo – plus some benevolent magic – returns the balance of nature. The story, which combines a thoroughly modern message about protecting the seas with ancient folktales about the interaction between humans and the creatures of the sea, was written and directed by renowned animator Hayao Miyazaki (b. 1941) for Studio Ghibli, the production company he cofounded in 1985. Few artists achieve the cult following of Miyazaki, fewer still can rightfully claim to have started a revolution

in their own industry. Released in 2008, *Ponyo* quickly garnered the praise of critics worldwide and won the 2009 Japan Academy Prize for Animation of the Year. The film took Miyazaki's own inimitable style, which often features the outlandish and bizarre, and allowed it yet more freedom by dissolving it into the oceans. Rich colours, seamless animation and huge set pieces flow perfectly into intricate moments of high detail or subtle emotion. For a lover of the beauty of the oceans, Miyazaki creates a masterpiece of the marine that stands out above all others.

Nouveau Larousse illustré.

Adolphe Millot and Claude Augé

Ocean, from *Nouveau Larousse illustré:*
dictionnaire universel encyclopédique, vol. 6, 1897
Lithograph, 32 × 24 cm / 12½ × 9½ in
John P. Robarts Research Library, University of Toronto

This imaginary underwater scene is teeming with marine creatures that in reality would never be found all together in one location. Among the forty-three animals and plants illustrated in great detail by Adolphe Millot (1857–1921) for the French encyclopaedia *Nouveau Larousse illustré* are shrimps, sponges, crabs, sea spiders, dragonfish, knifefish and tripodfish. Each one is numbered, and a corresponding key beneath the image shows its name in French and the depth at which it lives. At the top of the illustration, a graceful jellyfish with stringy tentacles ascends near a fierce black seadevil, whose gaping mouth reveals razor-sharp teeth as it pursues a terrified shrimp. Below these, a large green-eyed gulper shark glides past the black, sinuous form of a rarely seen pelican eel, while on the ocean floor are various sea stars, urchins, corals and sea cucumbers. The scene is one of two full-colour plates illustrating ocean life that were included in the comprehensive seven-volume publication. Millot, an entomologist and senior illustrator at the National Museum of Natural History in Paris, painted many of the creatures from real-life specimens, though others are based on existing illustrations he found in books. Millot was responsible for a great many of the natural history plates in the *Nouveau Larousse illustré* (see p.95). Edited by Claude Augé (1854–1924), it resembles a scaled-down version of Pierre Larousse's fifteen-volume *Grand dictionnaire universel du XIXe siècle* (1866–76) and features 49,000 black-and-white illustrations and 89 colour plates across its 7,600 pages.

Paul Klee

Fish Image, 1925
Oil, watercolour and ink on cardboard primed
with gypsum, 62 × 43 cm / 24½ × 17 in
Museum Sammlung Rosengart, Lucerne

Paul Klee (1879–1940) was arguably one of the most original twentieth-century artists. He is widely celebrated for his ability to abstract reality into geometric compositions that evoke a sense of ethereal harmony. Fish became a recurring theme in his work during the 1920s, when he also kept a large aquarium in his home. The movement of fish in water fascinated him so much that he often asked his students to copy them in order to grasp the essence of their otherworldly weightlessness and elegance – how they can be so entirely at one with the world that surrounds them. Water, and seawater especially, held for the artist a particular meaning linked to a primordial kind of spirituality. His drawings and paintings of fish, often washed in a deep, azure hue, thus represent a mystical continuity between the sky and the water. For this reason, his fish never resemble those we see in natural history illustrations but instead appear as abstracted forms designed to summon the imperturbability of ichthyic life. Klee believed that seeing the world through the wonderment of a child's eye could allow artists to represent the essence of reality, pure from corruptive forces. It is in this context that his paintings of fish represent a positive state of meditative bliss that the human mind can master through the union of art and nature.

Rachel Carson and R. M. Sax

Cover of *The Sea Around Us*, 1951
Printed book, 22 × 14.5 cm / 8¾ × 5¾ in
Private collection

A ship sails against a sea-green background as a winged god of wind blows gusts and seagulls fly above. An anchor and a lighthouse flank the ship and give way to a wreath of ocean motifs: a lobster, fish, eel, shell, crab, starfish, jellyfish, seahorse, snake and seaweed. A graphic of a nautical map anchors the entire scene. Illustrated by the German-born artist R. M. Sax (1897–1969), this is the cover of the Staples Press UK edition of *The Sea Around Us*, by American marine biologist and pioneering environmentalist Rachel Carson (1907–1964), chapters of which first appeared in the *New Yorker* magazine. The American edition, published by Oxford University Press, was released in July 1951, and this UK edition followed a few months later. *The Sea Around Us* – the second of three popular books Carson wrote about the ocean – was part poetic meditation and part rigorous scientific survey of the life and history of the sea. It remained on the *New York Times* bestseller list for eighty-six weeks, won the National Book Award for nonfiction in 1952 and cemented Carson's standing as one of the finest writers of the twentieth century. 'It is a curious situation that the sea, from which life first arose, should now be threatened by the activities of one form of that life,' Carson wrote. 'But the sea, though changed in a sinister way, will continue to exist; the threat is rather to life itself.' In 1962, Carson went on to publish her fourth and final book, *Silent Spring*, a rallying cry against the use of pesticides that inspired the modern environmental movement.

Charles Frederick Tunnicliffe

Illustration of a Rock Pool and Marine Life, from *What to Look for in Summer*
by Elliot Lovegood Grant Watson, 1960
Colour lithograph, 18 × 12 cm / 7 × 4¾ in
Private collection

In muted tones of blue, grey, orange, green and brown that seem wholly appropriate to the cold British tidal waters, a lobster, prawn, shrimp and two crabs rest peacefully on parallel bands of seaweed and rock. Such close conjunction would seem almost impossible in the wild, but here the famed wildlife artist Charles Frederick Tunnicliffe (1901–1979) presents marine animals native to the waters around his home on the island of Anglesey in Wales as though helpfully arranged on a set of supermarket shelves, enlivened by a diagonal tilt from right to left. *What to Look for in Summer* is one of four Ladybird 'Seasons' books published between 1959 and 1961 and part of the publisher's famous series of small didactic books for children. Tunnicliffe, who gained renown with his illustrations for Henry Williamson's *Tarka the Otter* (first published in 1927), had a gift for presenting complex natural subjects in accessible fashion and was the perfect fit for Ladybird's nature books. His carefully considered compositions were distilled from a jumble of preparatory ideas sketched on whatever fragment of paper came to hand, but his rendering of each specimen was based on meticulous observation: photographs of the artist at work in his studio show him measuring a bird with callipers as he works up a sketch of it. The accompanying text, by naturalist Elliot Lovegood Grant Watson, gently urges readers to get outdoors and to scrutinize and celebrate nature themselves, chiming like all Ladybird's mid-century nature books with a climate of popular concern for the preservation of the natural world in Britain following the 1947 Town and Country Act, which encouraged the control of urban development into the countryside.

Anonymous

Plate from *Album de coquillages et poissons provenant des collections du cardinal de Mazarin*, late 16th or early 17th century
Watercolour, 17.8 × 22.9 cm / 7 × 9 in
Bibliothèque nationale de France, Paris

With its intricately detailed scientific drawings of various shells, molluscs and invertebrates, of all shapes and sizes, this illustration by an unknown artist is close in style to the zoological plates that were collected by Italian naturalists and scholars in the sixteenth century, such as Ulisse Aldrovandi and Cassiano dal Pozzo. For many years, the work was incorrectly attributed to Claude Aubriet, the renowned and prolific French natural history illustrator and painter. In fact, the work is part of an album of shells and fish from the private collection of Cardinal Jules Mazarin – the chief minister to the kings of France from 1642 until his death in 1661 – which was probably bought in Italy by Mazarin's librarian Gabriel Naudé on behalf of the cardinal. When civil unrest broke out in France during the Fronde (1648–53), much of the cardinal's first library – with some forty thousand volumes – was lost, but Naudé was able to save a number of the most valuable works and later recover many of the books upon Mazarin's return to power in 1653. During his de facto reign, Mazarin was recognized as one of France's greatest patrons of the arts in the seventeenth century, second only to Louis XIV. Mazarin allowed scholars open access to his library – making it the first public library in France – and by the time of his death he had rebuilt his collections back up to nearly thirty thousand volumes, covering an encyclopaedic range of topics from theology, literature and geography to science, medicine and natural history. In 1661 the books, along with the original bookcases, were bestowed to the Collège des Quatre-Nations, which Mazarin had founded as part of the Sorbonne. Since then, the Bibliothèque Mazarine has grown to house more than 600,000 volumes.

Jean Schlumberger for Tiffany & Co.

Coquillage Clip, c.1957
Diamonds, sapphires, gold and platinum, L. 7.3 cm / 2⅞ in
Private collection

Designed by the leading jeweller of the day for one of the world's richest women, this Tiffany & Co. sapphire, diamond, gold and platinum shell brooch captures nature's wonder in spectacular fashion. It is the work of French jeweller Jean Schlumberger (1907–1987), who designed it and a companion shell bracelet for Peggy Rockefeller in 1957. Known for his love of sapphires and displaying an understanding for the jeweller's originality and wit, banker David Rockefeller commissioned the pieces for his wife. New York jewellers Tiffany & Co. had hired

Schlumberger the previous year, and such was his reputation that they allowed him to decorate his own design studio and salon and gave him an almost limitless supply of the finest stones to work with, allowing him to create stunning designs for, among others, Elizabeth Taylor, Wallis Simpson, Greta Garbo and Audrey Hepburn. A frequent traveller, Schlumberger often visited Bali, India and Thailand for inspiration, and the energy and dynamism of these countries translated into his jewellery. Each design began with a drawing to discover the natural

forms that caught his eye because, he explained, he wanted his finished pieces to radiate a random, organic quality. In this shell brooch, the carefully placed sapphires give the shell its body while the many diamonds, finished with gold, radiate away to give a depth to the magnificent piece. The ability to bring a shell to life with precious stones suggests why Schlumberger's gem-encrusted shells were among his most coveted designs, alongside others drawn from nature, such as his birds, plants and sea creatures.

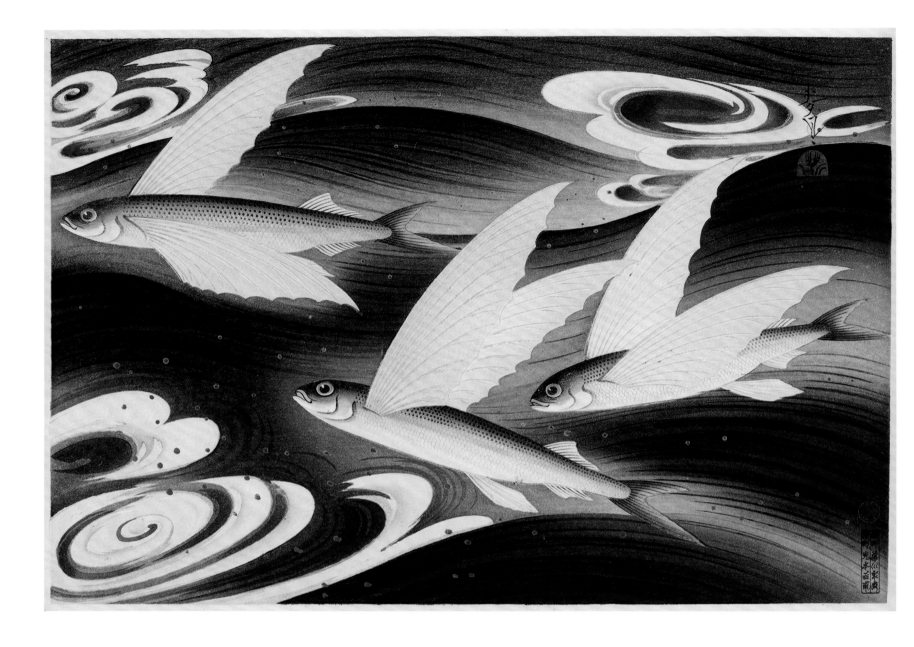

Ono Bakufu

Flying Fish, from *Great Japanese Fish Picture
Collection* (*Dai Nihon gyorui gashu*), vol. 1, 1937–38
Woodblock print, 42 × 28.2 cm / 16½ × 11 in
Private collection

Three flying fish glide above undulating and swirling waves in this beautifully designed print. The subtle use of mica allows Japanese artist Ono Bakufu (1888–1976) to capture the shimmering quality of the 'wings' and the reflective undersides of these remarkable creatures. Ono Bakufu was a painter and printer based in Tokyo who was well-known for his depictions of landscapes, and especially for his studies of fish. He moved south from Tokyo to the Kansai region after the 1923 Kanto earthquake devastated much of the city and surrounding area. This illustration is from a series of twelve woodblock prints in the first volume of a limited-edition five-volume set illustrating local fish species of culinary or cultural importance, and published under the title *Dai Nihon gyorui gashu*, *Great Japanese Fish Picture Collection* (1937–41). Each plate was accompanied by a separate leaflet with detailed information about the species depicted. The portraits were based on detailed study of dead specimens combined with sketches of living fish, and combine a high degree of accuracy with great artistic beauty. The species pictured here is probably the Japanese flying fish (*Cheilopogon agoo*), which is commonly eaten in sushi and other local dishes. Flying fish live mainly in the surface waters of tropical and subtropical oceans. Though incapable of true powered flight, they can launch themselves from the water and glide above the waves, aided by their winglike modified pectoral fins, a behaviour that may enable them to escape chasing predators such as tuna, marlin or mackerel.

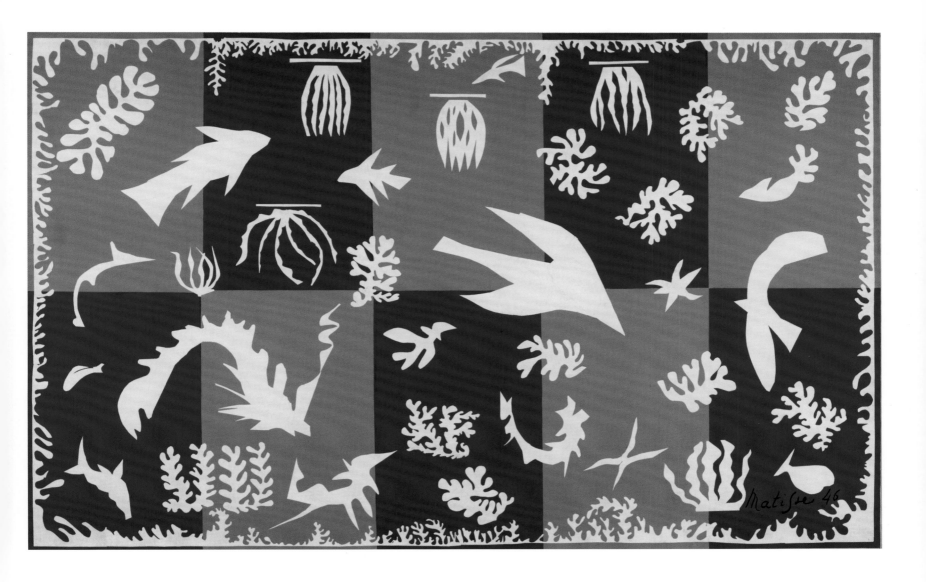

Henri Matisse

Polynesia, The Sea, 1946
Gouache on paper, cut and pasted, mounted
on canvas, 1.9 × 3.1 m / 6 ft 5 in × 10 ft 4 in
Musée National d'Art Moderne, Paris

An abundance of aquatic lifeforms fills this lively interpretation of the seas that surround Polynesia, famed for its more than one thousand islands scattered over the central and southern Pacific Ocean. French artist Henri Matisse (1869–1954) visited the islands, including the largest, Tahiti, in 1930 while searching for new inspiration. He spent time exploring coral atolls such as Fakarava in the Tuamotu Archipelago, swimming in lagoons and expressing his wonder at the numerous sea creatures living beneath the surface. Translating these experiences into paper,

Matisse depicts his interpretation of the myriad sea life and forms, which include fishlike shapes, jellyfish and various types of coral or sponges, wrapping the whole scene in a frame of delicate seaweed. It is this border, with no sense of top or bottom, that gives the picture a sense of weightlessness, expressing what it might have been like to float among the fish. The largest, central white shape also evokes the form of a bird, imparting a different perspective: either looking down into the watery world or looking up at the life above

as the artist floated in the water. *Polynesia, The Sea* was created during the final decade of Matisse's life, during which poor health left him without the strength to paint. Matisse turned to creating paper cut-outs, which in this case closely recall the traditional Tahitian fabric, or *tapa*, decorated with appliqued geometric plant and animal motifs.

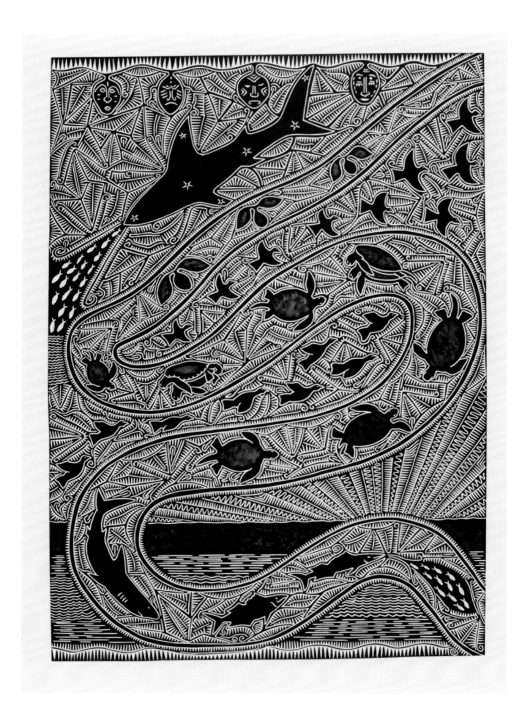

Billy Missi

Zagan Gud Aladhi (*Star Constellation*), 2007
Hand-coloured linocut, 100 × 70 cm / 39⅜ in × 27½ in
Australian National Maritime Museum, Sydney

Known for his bold and detailed linocuts, which illustrate the knowledge that passes from one generation to the next, Torres Strait Islander Billy Missi (1970–2012) was brought up in the storytelling, song and dance traditions of the Wagedagam part of Mabuiag Island, northeast of Australia. As the artist once observed, 'In our culture, the stories and other knowledge of our world have always been handed down orally from generation to generation since time immemorial. It is this knowledge that provides guidance.' With minimal formal art training on Moa Island under Dennis Nona, Missi became a full-time artist in 1999. Skilfully combining traditional carving techniques, iconography and his distinctive fish-bone patterns with the Western medium of the linocut, he forged a new aesthetic and print movement based on traditional Torres Strait Islander principles, as illustrated in this linocut, *Zagan Gud Aladhi*, or *Star Constellation*, from 2007. Here Missi highlights the significance of star constellations, animal migratory patterns and breeding cycles in the ontological belief systems of the Torres Strait Islanders. Natural lore tells of how, at a certain time of year (August), the turtle breeding season is heralded by the appearance of small fish – *zagal* – as the tides and the night sky change and the first migratory birds appear from neighbouring Papua New Guinea. Missi's work, he argued, was based on the need of the islanders to survive: the livelihood of the islanders is inextricably linked to the ecosystems of the Pacific islands – should events like this fail to occur, it would spell disaster for the islands.

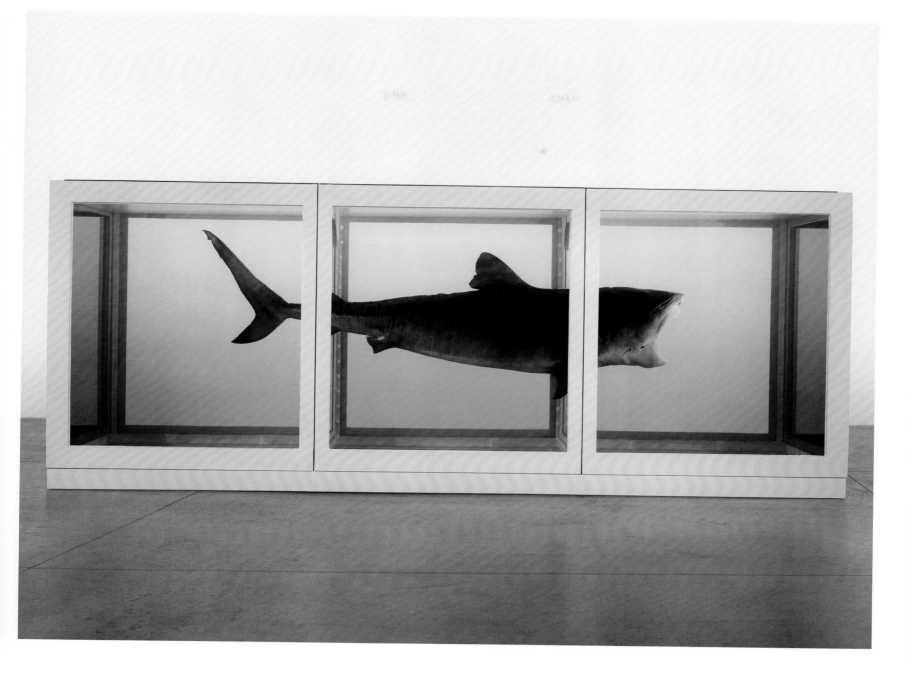

Damien Hirst

The Physical Impossibility of Death in the Mind of Someone Living, 1991
Glass, painted steel, silicone, monofilament, shark and formaldehyde solution,
2.2 × 5.4 × 1.8 m / 7 ft 1¼ in × 17 ft 9¼ in × 5 ft 10¾ in
Private collection

Artificially suspended in time and space, a tiger shark preserved in a formaldehyde solution within a glass-panelled tank confronts viewers with its jaws open, teeth bared. Originally exhibited on the occasion of the renowned 'Young British Artists' show at the Saatchi Gallery in London in 1991, *The Physical Impossibility of Death in the Mind of Someone Living* is one of the most iconic and controversial pieces created by British artist Damien Hirst (b. 1965). In order to secure a shark of the right magnitude – Hirst wanted one 'big enough to eat you' – he placed an order on the bulletin boards of a string of fishing villages on the Queensland coast of Australia. Due to the time difference with London, Hirst and his dealer, Jay Jopling, had to spend many long nights fielding calls from anglers before settling on a price of £6,000 for this shark, which was caught off Hervey Bay and shipped to London. Frozen and stripped of its surroundings, the animal is safely visible through the glass, giving an opportunity to appreciate its anatomy and seemingly ferocious nature. Vitrines, as Hirst learned from American artist Jeff Koons, command institutional merit. In this context, the fish is positioned as the ultimate representation of the dangers that can be found in a marine setting – despite the relatively harmless demeanour of sharks – raising existential questions about fear, pain and death. Hirst's sensational work became a centrepiece of the British art movement in the 1990s, despite its sound denouncement by marine conservationists.

Karim Iliya

Striped Marlin, 2020
Photograph, dimensions variable

In a dramatic event close to the surface of the open sea off the Pacific coast of Mexico, a striped marlin (*Tetrapturus audax*), one of the fastest and most aggressive fish of the ocean, hunts among a shoal of terrified Pacific chub mackerel (*Scomber japonicus*). This muscular predator uses its elongated snout – the source of its name, because of its resemblance to the long marlinspike sailors used to knot ropes on sailing ships – to thrash and stun its prey as it swims at high speed through a dense shoal of fish, causing confusion among its prey. The cloud of bubbles rising from the marlin's bill accentuates the energy involved in this frantic encounter as the frightened mackerel scatter from the threat. Among the fastest swimmers in the sea, marlin can reach top speeds of around 110 kilometres per hour (68 mph) in short bursts as they hunt their prey, which is usually shoaling fish such as sardines and mackerel. There are around ten living species of marlin, which all live in the open ocean, travelling hundreds and even thousands of miles along currents. The marlin's speed, size – they can grow up to 4.2 metres (13.8 ft) long and can weigh more than 200 kilograms (440 lbs) – and aggression make it a prized fish among game fishers. Ernest Hemingway's renowned 1952 novel *The Old Man and the Sea* tells the story of an epic struggle between an old Cuban fisherman and the marlin he hooks after months of unsuccessful fishing trips in his open boat. This photograph earned photographer Karim Iliya (b. 1989) an award in the Underwater category of the Nature Photographer of the Year competition in 2020.

Larry Fuente

Game Fish, 1988

Fibreglass, black auto-body type epoxy resin, polyurethane resin, plywood, plastic found objects including beads, buttons, poker chips, badminton birdies, Ping-Pong balls, rhinestones, coins, dice, plastic figurines, combs, miniature pinball games, 1.3 × 2.9 × 0.3 m / 4 ft 4 in × 9 ft 5 in × 11 in

Smithsonian American Art Museum, Washington DC

Fabulously kitsch, *Game Fish* by Chicago-born artist Larry Fuente (b. 1947) reflects the artist's love of surface ornamentation and three-dimensional assemblage. Transforming the ordinary into the extraordinary, Fuente took mass-produced, brightly coloured plastic found objects with little intrinsic value – such as beads, buttons and plastic baubles – mixed them with rhinestones, coins, poker chips, Ping-Pong balls, figurines, combs and miniature pinball games and then used them to cover a nearly 3-metre (10 ft) long fibreglass fish. For more than five decades, Fuente has focused on producing a body of work obsessed with using surface and ornamentation to transform everyday objects. He spent five years covering a 1960 Cadillac with one million coloured beads, sequins, buttons and lawn ornaments, decorating its side panels with the soles of shoes to create a trail of walking feet, which he characterized as 'lost soles'. Fuente's obsessive attention to detail in *Game Fish* gives the fish texture and form, forcing the viewer to take a closer look and examine not only how it is constructed but also just how much potential waste has been used to create it. With its pointed bill and arched dorsal fin, Fuentes's fish is modelled after a sailfish, one of the most popular species for recreational sport fishing worldwide. Considered one of the fastest fish in the ocean, sailfish can reach speeds of 112 kilometres per hour (70 mph) and adults can weigh more than 100 kilograms (220 lbs).

Mary Anning (discovered by)

Plesiosaurus macrocephalus Fossil, 1830
Fossil, installation view
Natural History Museum, London

When this fossil of a plesiosaur dinosaur was unearthed by Mary Anning (1799–1847) on a Dorset beach in 1830, it was the first of its species to be found. After fossil hunting in her childhood with her father, Anning had become an accomplished naturalist; she had also found the first complete ichthyosaur at age twelve, and the first whole plesiosaur (of any species) in 1823. Anning described the new specimen in a letter to geologist William Buckland as '... without exception the most Beautiful [sic] fossil I have ever seen'. When this specimen lived, 190 million years ago in the early

Jurassic period, plesiosaurs dominated the shallow seas of what is now Europe, as well as areas of the Pacific Ocean near Australia, North America and Asia. Features including a stocky torso, flippers, a long neck and many small teeth would have enabled them to catch fast-moving prey, such as fish and squid, with relative ease. However, as Anning noted in her letter, this individual had met its end while still a juvenile. The fossil was bought by William Willoughby Cole and later named as *Plesiosaurus macrocephalus* (large-headed) by Buckland in 1836. Despite being

a poor, working-class woman within the male-dominated society of the nineteenth century, Anning was described in her day as the 'celebrated Miss Mary Anning', a 'persevering and successful collectress of extraneous fossils'. She confidently corresponded with some of the leading scientists in Europe, and today her legacy lives on in books, films and the fossils she unearthed, which feature in museum collections around the world, including this specimen in London's Natural History Museum.

Masato Hattori

Ordovician Sea, 2014
Digital illustration, dimensions variable

This fascinating modern rendering brings to life the long-lost prehistoric ocean world of the Ordovician period, between about 488 and 443 million years ago. During this period, primitive early life forms such as arthropod trilobites gradually diversified, and by its end the ancestors of most common invertebrate groups had appeared. Two cephalopod molluscs (*Cameroceras*) drift across the scene, their eyes and tentacles visible at the front of their tapering protective shells. Rising from the seafloor like a grove of miniature trees is a group of stalked echinoderms

(*Pycnocrinus*), with frilled arms spread out to trap edible particles suspended in the water. On the right, trilobites of the genus *Isotelus* trundle across the seabed in front of a lurking eurypterid sea scorpion (*Megalograptus*), an active predator. Also featured are several early forms of fish, including the tadpole-shaped *Arandaspis* and the bottom-feeding *Sacabambaspis*. Unlike most modern fish, these primitive vertebrates were jawless. Swimming at top right is another jawless early vertebrate, an eellike conodont with a long, sinuous body. The creation

of Masato Hattori (b. 1966), this digital illustration is a prime example of the Japanese artist's work focusing on prehistoric life, especially in depicting such creatures in lifelike panoramas of imagined habitats. Working with palaeontologists, Hattori has helped foster a deeper understanding of the lives of some of the earliest animals, including dinosaurs and these extinct marine creatures.

Anonymous

Dolphin Fresco (detail), c. early 14th century BC
Pigments on plaster
Archaeological Museum, Heraklion, Crete

This delightful wall painting of dolphins, jack fish and herrings is not at all what it seems. The actual panel in the Heraklion Archaeological Museum is comprised of fragments of two dolphins and thirteen smaller fish, reconstructed in a manner that Sir Arthur Evans, the excavator of the Minoan palace at Knossos, admitted was a 'spirited amplification of the existing remains'. The reconstruction installed above the doors of the so-called Queen's Megaron was created by Émile Gilliéron, the younger of a father-son team of restorers. In reality, the painting has been convincingly shown to have been a floor decoration that had fallen from a room above. Moreover, the 'domestic quarters' in which it was discovered are much more likely to have been a centre of a religious cult than a residential wing. The idea of a marine floor painting may have come from Egypt, or may have developed from the Minoan habit of covering the floors of domestic shrines with seashells and pebbles. There is clear evidence for a Minoan cult associated with nature and fertility, including marine life and the sea (see p.301). Dolphins attend the sea god Poseidon in later Greek art, and tablets written in Mycenaean Greek script (Linear B) record the god's name in the Bronze Age. On Minoan seals the animal appears alongside priests and goddesses and has been interpreted as the marine equivalent to a lion. Far from being a playful mammal, this painting more likely emphasized the predatory power of a sacred creature.

Anonymous

Tetradrachm coin, c.450 BC
Silver, Diam. 2.3 cm / 1 in
Ashmolean Museum, Oxford

A dolphin leaps over waves, represented by a triple zigzag line, below which lies the shell of a murex sea snail on the obverse of this silver coin from Tyre, a Phoenician city on the coast of modern Lebanon. It is a fairly high-value tetradrachm (four drachmas), worth about four days' pay for a soldier or skilled labourer. On the reverse of the coin is an owl with crook and flail – symbols of the Egyptian god Osiris – testifying to the international society of the Phoenicians, who were a trading people active throughout the Mediterranean. On the obverse,

the dolphin was associated with Astarte, Phoenician goddess of fertility; her classical Greek equivalent, Aphrodite, is often shown accompanied by the animal. In a society of sailors, dolphins were important omens, warning of changing conditions and impending storms. Tyre began to produce its own coinage in the mid-fifth century BC, and the murex shell symbolizes the city's source of wealth. A purple dye was manufactured from secretions produced by species of predatory sea snails (*Muricidae*) in a process that was highly labour-intensive and thus extremely expensive; in the

Roman Empire, 'imperial purple' was reserved for the clothing of emperors. The dye was particularly prized because, rather than fading over time, the colour was said to grow more vivid. Indeed, the name 'Phoenician' may be rooted in the Greek *phoenix*, signifying the colour purple-red. Huge mountains of shells still lie on the outskirts of the modern city – the remains of the vast Tyrian dyeing industry based on this tiny sea creature.

Alfred Brehm

Lobster and Crayfish, from *Brehms Tierleben*, vol. 10, third edition, 1893
Colour lithograph, 17.8 × 25.4 cm / 7 × 10 in
Private collection

Two lobsters clash in a tangle of claws and antennae, fighting over their latest prey on the seafloor. This vividly coloured engraving is one of many from *Brehms Tierleben* (*Brehm's Life of Animals*) by German zoologist Alfred Brehm (1829–1884), published in six volumes from 1864 to 1869 and expanded to ten volumes in 1876 to 1879. The illustration shows a clawed lobster from the genus *Homarus* on the left and a common spiny lobster or crayfish (*Palinurus vulgaris*, now *P. elephas*) on the right. The latter is common in the Mediterranean but also on the west and south coasts of Ireland and England. Indeed, Brehm noted in 1883 that when he first published the book the spiny lobster was found in such huge quantities in Ireland and England that it was a popular item in the fish markets of London. Brehm's meticulous descriptions of these marine creatures helped readers gain new knowledge about realms that otherwise remained unknown and out of reach. He also described the difference between the lobster and the spiny lobster: spiny lobsters lack frontal claws and have longer, thicker spiny antennae. Writing in an accessible way, Brehm described the nature and peculiarities of the spiny lobsters, distilling scientific knowledge for the common reader. By opening up such information to a wide audience, Brehm's encyclopaedia became an important publication for the general public in German-speaking countries from the late nineteenth century until the second half of the twentieth century, and is considered the first modern popular zoological treatise.

Pascal Kobeh

Aggregation of Spider Crabs, South Australia Basin, 2008
Digital photograph, dimensions variable

An extraordinary natural spectacle occurs during the Southern Hemisphere's winter each year: spider crabs (*Leptomithrax gaimardii*) appear out of the deep to aggregate in masses that can exceed 50,000 individuals. In 2010, renowned French underwater photographer Pascal Kobeh (b. 1960) captured this phenomenon in the shallow waters of South Australia. Related to lunar cycles, this great gathering occurs between late May and June, when the water temperature is a cool 11–15° Celsius (51.8–59° F). When coming together in such large numbers during their annual pilgrimage,

the crabs leave barren surfaces in their wake. Once in the shallow water, the crabs shed or moult out of their exoskeleton shells, emerging with new soft ones. Despite the size of an assembled horde, the individual creatures are comparatively small, measuring only 15 centimetres (6 in). Their usual inconspicuous colour, and a shell that is covered in knobs, hairs and living things such as sponges and algae, allow the crabs to blend into the ocean floor. However, after moulting it takes a few days for the shell to harden and become an effective deterrent to predators – and a soft crab is

irresistible to predators such as stingrays. By coming together in the thousands, it is thought the crabs increase their chance of survival and reduce the possibility of being eaten during their most vulnerable time. A theory that the annual aggregation is related to reproduction has been mostly disproven. The males cannot mate while their shells are soft, and mating has only been observed occasionally among the tens of thousands of moulting crabs. What happens when the crabs disperse back into deep water remains a mystery, much like the reason for their great migration.

Warren Baverstock

Crinoid Commensal Shrimp Pair, Lembeh Straits, 2016
Photograph, dimensions variable

The pair of male and female shrimps nestled among the velvet cushionlike tentacles of this crinoid feather star are almost invisible thanks to their duplication of the exact colour variations of their host – down to the orange flashes – as a way to avoid potential predators. This image by Saudi Arabia-based underwater photographer Warren Baverstock (b. 1968) shows a remarkable example of the way different species in the ocean have relationships that cover a spectrum from outright freeloaders to mutually beneficial coworkers. At one end of the spectrum are parasites, such as lampreys, which live at the expense of their hosts' health. Lampreys attach themselves to the skin of other fishes using their suction-disk mouths, which are filled with small, rasping teeth that puncture the skin and drain the fishes' body fluids. Symbionts share a close, prolonged association, with advantages to both species. Boxer crabs hold sea anemones in their claws, for example, using the stinging tentacles as a defense to fend off predators, while the anemones gain the opportunity to feed on particles from the crabs' meals. Commensalism (literally 'sharing a table') is a halfway house, where one species benefits but the other is unaffected: like these shrimps. Imperial shrimps ride on the back of slow-moving sea cucumbers and nudibranchs. Should potential predators appear, the shrimp will hide, sheltering between the feathery naked gills on the back of a nudibranch, or slipping beneath the cucumber's body. The shrimp hangs on while the pair moves through the water until they reach somewhere rich in food. The crustacean leaves its carrier, feeds, then finds another ride to carry it to a new part of the reef.

Aki Inomata

Think Evolution #1: Kiku-ishi (Ammonite), 2016–17
HD video still, dimensions variable;
Sculpture: ammonite fossil and resin, 12 × 15 × 7 cm / 4¾ × 5⅞ × 2¾

A curious baby octopus explores the cavity of a glistening ammonite shell, though not one that could ever be found in nature. This is instead the work of Aki Inomata (b. 1983), a contemporary Japanese artist interested in the versatility of technological innovation and its ability to enrich our perspectives on the natural world. Inomata's life-size, see-through shell was cast from ammonite fossils, 3D printed in resin and then presented to her pet octopus to explore. A species known for its intelligence and inquisitiveness, the octopus proceeded to make itself comfortable within the shell's cavity. Similar to a nautilus, ammonites became extinct at the end of the Cretaceous period, about 66 million years ago. According to the fossil record, they were the less agile and considerably slower ancestors of octopuses and squid. It is believed that evolutionary pressures led octopuses to lose their shell to become faster and nimbler. The loss of the shell is specifically linked to the development of the octopus's brain, which, unlike that of other vertebrate animals, is not centralized but distributed across the animal's body. This still from Inomata's video captures the moment the octopus inhabits the shell in the same way its ancestors would have, thus visually evidencing the present and past of a complex evolutionary journey.

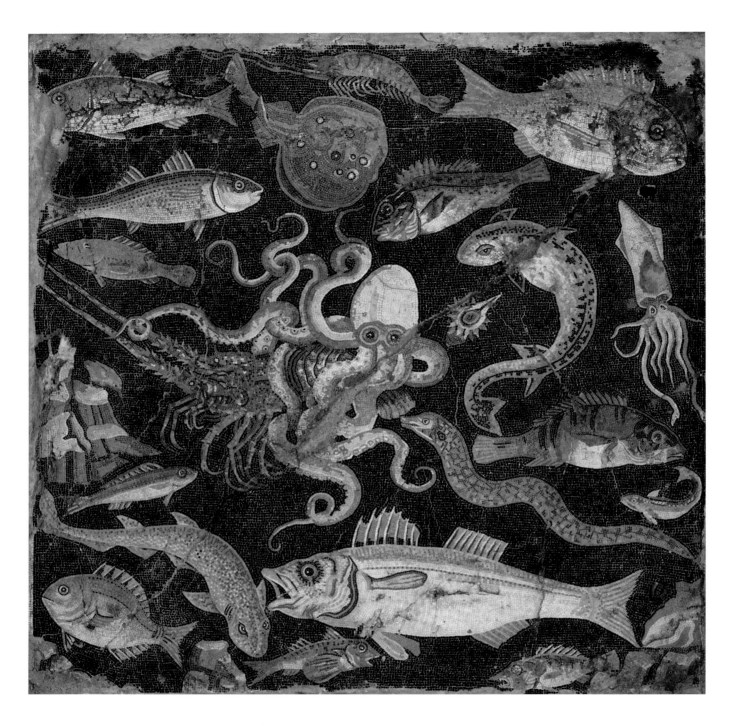

Anonymous

Marine Fauna, 100 BC
Mosaic, from the House of Lucius Aelius Magnus, Pompeii
Museo Archeologico Nazionale di Napoli

This highly detailed Roman mosaic dating back to 100 BC by an unknown artist is from the Casa di Lucius Aelius Magnus (House of Lucius Aelius Magnus) at Pompeii, now on display at the Naples National Archaeological Museum. Based on discoveries at the impeccably preserved site, Pompeiians loved decorating their houses with wall paintings and mosaics depicting natural scenes, but the heightened realism in this example is remarkable for a mosaic of this period. In total, the image depicts twenty-one creatures, including various fish and shellfish, an eel, an octopus and even a small bird, in such an accurate representation that it can only have been achieved through a careful study of each animal's anatomy. Even more striking is the sense of naturalism and motion each animal conveys. In the lower right corner, a moray eel snakes upwards towards a climactic scene: a fight between an octopus and a spiny lobster. The octopus's limbs wriggle around the body of the crustacean, both weightlessly suspended in their struggle. All around them, other fish, shrimp and a squid swim unperturbed. This representation of true natural behaviour could only come from observing live animals, but the rudimentary diving equipment of the time would have prevented such observations from taking place in the sea itself. It is known that wealthy Romans kept 'holding fish tanks' beside their villas so they could eat fresh fish whenever they wished. These tanks also provided artists with the opportunity to study marine life in the shallow waters of a contained environment.

Anonymous

Octopus, c.1550–1600
Bronze, 10.1 × 16.4 cm / 4 × 6½ in
Victoria and Albert Museum, London

At first glance, the somewhat abstract form of this sculpture of an octopus might pass itself for the work of modern masters such as Henri Matisse or Henry Moore – so it might come as a surprise that it is some five hundred years old, cast in bronze by an unknown metalworker, possibly in Flanders in northern Europe, in the later part of the sixteenth century. Standing at about 10 centimetres (4 in) tall, the sculpture likely portrays a young octopus, and the number and shape of the tentacles and most of the body features have been represented in a highly realistic way. Notably, the underside of each tentacle shows two rows of suckers decreasing in size towards the tips. The sculpture also captures a sense of liveliness and motion in the curling of each tentacle, suggesting that the artist was likely working from a living model. That would explain the upright position of the animal's head, which is the right shape but in an unnatural position, as if propped up. The positioning of the eyes and the addition of a mouth owe more to the human face than to a real octopus, giving the finished statuette a curious and oddly unsettling anthropomorphic quality. The expressionless stare and downwards corners of the animal's mouth suggest an uncanny emotional depth or some kind of pensive mood. The octopus captured the Renaissance imagination because of its distinctively complex range of observable behaviours, and it was thought to induce hallucinations if ingested raw.

魚角 Kogu

Uranoscopus asper tac.

Anonymous

Uranoscopus asper, 1843
Watercolour on paper, 18 × 22.5 cm / 7 × 9 in
University of Groningen Library, the Netherlands

This Chinese watercolour of a stargazer fish (*Uranoscopus asper*) belongs to an extensive collection of illustrations that includes more than three hundred fishes, as well as reptiles, cephalopods and crustaceans. Painted by an unknown artist or artists in the first half of the nineteenth century, the collection records fish that were found not just in China's seas and rivers but across the world, from Japan, Australasia and the Indian archipelago to the Americas and Europe. Highly detailed, each illustration is accompanied by the species' name in Chinese characters with a translation in Latin. The stargazer fish in this plate is found in the waters of the north-western Pacific Ocean around Japan. Considered a delicacy in some countries, the stargazer is notable for its venom and, in the case of the *unranoscopus*, for its electric shocks. Its distinctive appearance is the result of its method of hunting: its top-mounted eyes enable it to bury itself in the sand and wait for its prey to swim overhead, when it catches it in its sizeable upwards-facing mouth. The collection of illustrations belongs to the University of Groningen in the Netherlands, which acquired them from the merchant Magdalenus Jacobus Senn van Basel, who in 1838 became the first commercial agent sent by the Dutch to the Chinese city of Guangzhou. Van Basel's posting marked a step towards normal trading relations between the Netherlands and China following the Dutch government's decision to disband the once-powerful Dutch East India Company, which had controlled much of trade in Asia since its creation in 1602.

Anonymous

Ewer in the Form of a Fish and Shrimp, 14th–15th century
Stoneware with yellow-green glaze, moulded, incised and
painted decoration, 19.4 × 17 × 5.5 cm / 7⅝ × 6⅝ × 2⅛ in
Museum of Fine Arts, Boston

Made by an unknown ceramicist during Vietnam's Tran-Le dynasty, this ewer most likely dates from the fourteenth or fifteenth century. Typically used to carry water, ewers are large vessels with a wide mouth, and in this iteration the ceramicist has fashioned the receptacle from a shrimp perched atop a fish, its mouth wide open to pour from. Made from stone with a yellow-green glaze, the fish's scales are beautifully incised, and some detail of the original painted decoration on its fins still remains. Highly fanciful, the work represents a high point in Vietnamese culture as the Tran dynasty (1225–1400) was laying the foundations of modern-day Vietnam. They introduced the Vietnamese language, which was spoken in the royal court alongside Chinese, and a written literature, and expanded Vietnam southwards through military conquest. Against this backdrop, the arts were actively encouraged as the Tran sought to give themselves an independent cultural identity. Now housed in Boston's Museum of Fine Arts, the ewer links this history with a more recent episode in Vietnam's past. It was donated to the museum by the plastic surgeon John Davidson Constable, along with other Vietnamese ceramics. Constable's father had emigrated from London, England, to be the museum's curator, and his son, who became an expert in Asian arts, served as a volunteer physician in Saigon during the Vietnam War (1955–75). Constable's time in Vietnam left an indelible impression and a desire to showcase to the United States the skill and talent of Vietnamese craftspeople.

Aka Høegh

They Came, from *Stone and Man*, 1994
Carved stone, dimensions variable
Qaqortoq, Greenland

One of Greenland's best-known artists, Aka Høegh (b. 1947) has, over many years, turned her hometown of Qaqortoq, the largest settlement in southern Greenland, into a permanent open-air art gallery. In an ongoing project, *Stone and Man*, which started in the early 1990s, Høegh asked more than a dozen artists from across the Nordic region, including Norway, Iceland, Finland and Sweden, to help her create twenty-four separate carvings and sculptures. While some of the work turned into fully realized sculptures made from local boulders, others looked more like reproductions of ancient indigenous works: carved into the faces of lichen-covered boulders are whales and fishes and human faces. Over time, more sculptures have been added until they now number around forty. While most are clustered together, some have appeared as carvings in the town of Qaqortoq itself. In this image, a shoal of fish swimming in the same direction are carved directly into the rock face. Behind them, on another rock, lurks a predator in the shape of a whale. Fish – principally cod, halibut and salmon – are central to Greenland's culture and economy, with more than 10 per cent of the population involved today in the fishing industry. Høegh's interest in creating *Stone and Man* is to create an art of national expression that not only reflects local myths and legends but also brings together Greenland's heritage and its dependence on the natural world. In a nation where nearly 90 per cent of its population are native Greenlanders (Inuit), Høegh's work is at the forefront of preserving indigenous culture and creating Greenland's artistic identity.

Anonymous

Barramundi, after 2000 BC
Ochre pigments on rock
Mt Borradaile, Arnhem Land, Northern Territory, Australia

This image of what is thought to be a barramundi (*Lates calcarifer*), also known as the Asian seabass, is painted with natural ochre pigments on a rock escarpment at Mt Borradaile, an Aboriginal sacred site in western Arnhem Land. It is painted in the X-ray style, indigenous to this area, which is believed to have appeared around the beginning of the second millennium BC. The artist first painted the silhouette of the fish in white, then added internal details in red, making visible the backbone, swim bladder, liver and stomach. X-ray paintings are among the most significant of *Garre wakwami*, or 'Dreaming' paintings, made by the people of western Arnhem Land. Fish such as the barramundi are associated with the Rainbow Serpent, which is said to have originated here and to have created mountains, rivers, lakes, valleys and plains as it travelled the land. From the Rainbow Serpent emerged spirit people; it is said that spirit children take the form of small fish in ancestral clan wells. As such, the barramundi (meaning 'large-scaled river fish') is a creation ancestor as well as an important food source. Most barramundi inhabit freshwater rivers, but some live their entire lives in the sea; even the river fish must return to saltwater estuaries to spawn. The fish is hermaphroditic: virtually all are born male, becoming female after at least one spawning season.

Ray Eames

Sea Things, 1945
Cotton twill, screen and hand-printed,
1.4 × 1.2 m / 4 ft 6 in × 4 ft 1 in
Los Angeles County Museum of Art

This hand-drawn textile design is teeming with starfish, urchins, snails, crustaceans, seaweed and whimsical sea creatures plucked from the creative imagination of American artist and designer Ray Eames (1912–1988). The lively pattern was designed in 1945 and submitted to the Competition for Printed Fabrics at New York's Museum of Modern Art in 1947. Although it did not win any awards, it did merit an Honourable Mention and was included in the Museum's exhibition 'Printed Textiles for the Home' later that year. While Eames often worked in creative partnership with her husband, Charles – their creations included furniture such as the celebrated Eames Chair – *Sea Things* is one of a few examples where she took sole credit. The design reflects her curiosity about nature, which both Eameses loved to explore. When the couple settled in Los Angeles in the early 1940s, they spent much of their free time among the sand dunes of the Pacific coast, collecting stones, shells and other objects that inspired them. Their long-running interest in marine life appears in several projects, including an unbuilt design for a national aquarium and an associated 1970 film about a jellyfish titled *Polyorchis Haplus*. The *Sea Things* design, which can be repeated horizontally or vertically for different applications, was manufactured commercially in 1950 by Schiffer Prints, a textile division of Mil-Art Company for their 'Stimulus' collection. Today, the timeless design is produced as a table runner by Vitra, a Swiss furniture company that continues the Eames's vision of bringing affordable, high quality modern design to the general public.

William Kilburn

Design from an Album of Designs for Printed Textiles, c.1788–92
Watercolour on paper, 22.7 × 18.8 cm / 7½ × 9 in
Victoria and Albert Museum, London

Best known for his naturalistic floral motifs, Irish artist William Kilburn (1745–1818) designed some of the eighteenth century's most original and successful cloth prints, featuring wispy pastel plants from land and sea. Against a neutral background, these delicately detailed pink, brown, green and blue seaweeds flutter alongside corals, mosses and skeleton leaves. So successful was the pattern that the Dublin-born designer presented a muslin chintz featuring it to Queen Charlotte, wife of King George III. Following his youthful apprenticeship to a cotton and linen printer near Dublin, Kilburn later moved to London, where he sold his designs to calico printers and his drawings and engravings to print shops. He was sufficiently skilled for the botanist William Curtis to hire him to produce plates for his *Flora Londinensis*, published in the late 1770s. Kilburn's success led him to purchase his own calico-printing factory, and in order to ensure the quality of reproduction of his delicate floral and seaweed patterns, he led a group of fellow manufacturers to successfully lobby the British Parliament to protect their copyright. In May 1787, Parliament passed a bill preventing Kilburn's rivals from producing inferior reproductions on cheap cloth, which they had been selling at two-thirds of the original price. His seaweed pattern perfectly suited the diaphanous quality of muslin chintz and was accordingly expensive at what was then an exorbitant price of a guinea per yard. Widely regarded by his peers as the standout calico printer of the age, Kilburn designed patterns that were seen as the closest drawings to nature, mixing identifiable species alongside more imaginary plants.

NNtonio Rod (Antonio Rodríguez Canto)

Trachyphyllia, from *Coral Colors*, 2016
Film still, dimensions variable

This dazzling image of a coral comes from *Coral Colors*, an award-winning time-lapse film by NNtonio Rod (Antonio Rodríguez Canto, b. 1966). Capturing extremely vibrant and incredibly sharp images of minute creatures such as corals was not a simple feat, as corals move slowly and live at depths that pose challenges to lighting and equipment. But after a year of work and twenty-five thousand photographs, Rod created *Coral Colors* and garnered a string of accolades, both for the quality and originality of his filmmaking and for revealing the intricacies of these marine invertebrates. Corals typically live in compact colonies of minuscule polyps. Over time, each individual excretes an exoskeleton: the structural part of coral that we commonly see in natural history museums or used in jewellery making. The polyps often have a set of tentacles surrounding a central mouth that they use to feed on plankton, but most of their nutrients are produced directly inside their own bodies through a symbiotic relationship with *dinoflagellates*, microscopic algae that also give corals their vivid colouration. The climate-change-related phenomenon of coral bleaching, in which pigmentation is lost, occurs when corals expel the algae from their tissues due to a stressful stimulus, such as warmer water temperatures or increasingly low tides. Bleached corals become more vulnerable to predators and other environmental factors that might ultimately lead to death. As Rod explains, *Coral Colors* was expressly made to build awareness and interest for these wonderful marine animals as they become more vulnerable to human-caused environmental degradation.

Franco Banfi

*Three False Clownfish in Sea Anemone, Lighthouse Reef,
Cabilao Island, Bohol, Central Visayas, Phillippines*, 2007
Digital photograph, dimensions variable

An impossibly vibrant purple sea anemone (*Heteractis magnifica*) provides not just a colourful backdrop but also a secure resting place for three equally colourful orange-and-white False clownfish (*Amphiprion ocellaris*). This image is the work of award-winning Swiss underwater and wildlife photographer and free-diver Franco Banfi (b. 1958), who has been photographing ocean life around the planet for nearly forty years. Best known for his striking photographs of whales, Banfi is a passionate environmentalist and conservationist who uses his pictures to raise

awareness of the ocean's unique biodiversity, which, he argues, is little explored or understood but increasingly in peril. This image of the clownfish and sea anemone exemplifies this approach. More than one thousand anemone species live in the ocean, but only ten of those species coexist with the twenty-six species of tropical clownfish – and only select pairs of anemone and clownfish are dependent on each other for survival. The two species have evolved not only to protect each other from predators but also to exchange nutrients, a relationship known as obligatory

symbiosis. In a further sign of their mutual dependence, the clownfish can protect themselves from the harpoonlike stingers the anemones use to catch food and defend themselves. The clownfish is covered by a layer of mucus that is three to four times thicker than that of the average fish, which protects it in the event that it is struck by an anemone's tentacle. While the anemone provides the clownfish with a safe home, the clownfish returns the favour by cleaning the anemone, scaring away predatory fish and feeding it with their waste.

Vittorio Accornero de Testa for Gucci

Scarf, 1970–79
Printed silk twill, 87 × 86 cm / 34¼ × 33⅞ in
Cooper-Hewitt, Smithsonian Design Museum, New York

A gorgeous silk scarf from Gucci, one of the world's leading fashion houses, remains as highly desirable today as when the first was created in the 1960s. This example is the work of Italian artist Vittorio Accornero de Testa (1896–1982), who designed for Gucci between 1960 and 1981. Legend has it that Accornero's first Gucci scarf – the classic floral design – was created for Grace Kelly when she visited the Milan Gucci store in 1966 with her husband, Prince Ranieri of Monaco. Rodolfo Gucci wanted to present the princess with a gift and asked Accornero for a floral design featuring flowers on silk rather than in a bouquet. Accornero's design revolutionized fashion accessories at a stroke. Accornero was the perfect choice to design such a prestigious item, having come to Gucci as an established costume and set designer who for many years had also illustrated fairy tales and children's books. The influence of this background is clearly seen in this silk scarf. Within the border – the scarf was produced with a range of different-coloured borders, including turquoise, yellow and navy – is a veritable fantasy of the perfect underwater ocean garden. There are vibrant pink corals and multicoloured seaweeds, among which seahorses move and brightly hued fish swim along. Tiny shells sit on the seabed, and there is even a pearl in an oyster. Because the scarf is for Gucci, a byword for luxury, strands of pearls also decorate the seabed. Produced in the 1970s, the underwater seascape is a vibrant addition to the defining floral scarf, but unlike many of Accornero's nearly eighty other scarf designs, this one is not signed by its creator.

Captain Jared Wentworth Tracy

Sailor's Valentine, 1839–40
Shells, wood and glass, open 22.2 × 45.7 × 3.8 cm / 8¾ × 18 × 1½ in
Nantucket Historical Association, Massachusetts

Cheerful arrangements of pastel-coloured shells are artfully gathered into geometric and floral forms and displayed in a hinged octagonal wooden box, each side glazed with glass. On the left, an anchor, a symbol of stability, grounds the design; on the bottom right, a loose depiction of a basket 'holds' the various shell-shaped blooms. Known as 'sailors' valentines', crafted mosaics like this were a popular folk art form in the late eighteenth and early nineteenth centuries – whalers and merchant seamen would give them as mementos to loved ones when

they returned home after months, or even years, at sea. The designs commonly incorporated hearts, roses, nautical symbols and sentimental phrases, and it was long assumed that sailors created these valentines themselves, collecting shells from beaches and painstakingly fitting them together during tedious stretches of downtime aboard ships – but that romantic image seems to be not entirely accurate. A uniformity of design indicates that the valentines were not always unique, and more recent research has revealed that many sailors

purchased these works from shops, primarily in Barbados, a port where they often stopped before the final leg of their voyage to North America. This mosaic, however, was not just another run-of-the-mill purchase. Jared Wentworth Tracy (1797–1864) is believed to have made it for his wife, Mary. He was the captain of the *Harmony of Nantucket*, a schooner shipwrecked in 1839 on a reef in the Mozambique Channel. When Tracy finally made it back to Nantucket later that year, he brought this sailor's valentine with him.

Maggi Hambling

Scallop: A Conversation with the Sea, 2003
Steel, H. 3.7 m / 12 ft
Aldeburgh, Suffolk, UK

'I hear those voices that will not be drowned' reads the inscription around the rim of this upright stainless-steel scallop shell that rises almost 4 metres (13 ft) above the shingle beach at Aldeburgh on the Suffolk coast in the east of England. The words come from Benjamin Britten's opera *Peter Grimes*, which tells the story of a doomed fisherman living in a town with many resemblances to the fishing port. British artist Maggi Hambling (b. 1945), known widely for her paintings, particularly of ocean waves, turned to the common scallop (*Pectinidae*), a family of edible marine bivalves and a local delicacy in Suffolk, for the form of this towering sculpture. One half of the shell stands upright, its sea-facing surface polished to catch the light, while the other is horizontal, both anchoring the upright steel and forming a seat where visitors can rest and watch the sea (the work's full title is *Scallop: A Conversation with the Sea*). The sculpture was Hambling's tribute to Britten, one of her favourite composers, who lived and worked in Aldeburgh and walked on the beach nearly every day. She raised funds to pay for its creation and donated it to the town for free. Although much admired, the sculpture has also attracted some criticism as an unwanted intrusion on an otherwise unspoilt beach. Born in nearby Sudbury, Suffolk, Hambling studied art in Ipswich and Camberwell and at the Slade School of Fine Art and was also artist in residence at the National Gallery in London from 1980 to 1981. Oceans have inspired much of her work.

SINGLE-CELLED ANIMALS

The simplest animals are the *Protozoa*, whose bodies consist only of one solitary cell, a microscopic blob of living matter. Abundant though they are, they are too small for most of us to notice. One, however, has a shell visible as a tiny brown ball about a twelfth of an inch in diameter, attached to seaweed holdfasts or stones : this is *Gromia oviformis*, a shore protozoan.

Many protozoans live in the plankton, along with those tiny plants the flagellates. One of the latter, *Noctiluca scintillans* (Plate **21**, *1*), feeds like an animal and so is included here ; it is best known by its effects, for it is mainly responsible for night-time phosphorescence on the surface of the sea.

MANY-CELLED ANIMALS

The vast majority of living creatures consist of multitudinous cells, specialized to carry out various functions but all co-operating to form one plant or animal body. Every creature, however, no matter how complex or numerous its cells, began life as one cell and grew to maturity through a process of repeated subdivision.

Sponges

Among the simplest many-celled animals are the sponges, the *Porifera* ('cavity bearers'), whose body walls have a number of openings leading into channels which extend throughout

117

Plate 26 LAVER, CORALLINES AND LICHENS
(pp. 113–115)

1. Purple laver, *Porphyra umbilicalis* : to 10 in. 2. *Delesseria sanguinea* : to 8 in. 3. Coralline, *Corallina officinalis* : to 6 in. 4. *Lithophyllum incrustans* : variable patches. 5. *Ramalina* : 1½ in. 6. *Lichina pygmaea* : to 1 in. 7. *Xanthoria parietina* : 4 in. across. 8. *Lecanora* : variable patches.

I. O. Evans

Pages from *The Observer's Book of Sea and Seashore*,
published by Frederick Warne & Co., London, 1962
Printed book, 14 × 8.6 cm / 5½ × 3⅜ in
Private collection

For many British children and adults curious about the natural world in the mid-1900s, the small pocket-sized volumes of the *Observer's Books* series were an ideal introduction. These pages are from *The Observer's Book of Sea and Seashore*, edited by South African author I. O. (Idrisyn Oliver) Evans (1894–1977), which was published in 1962. The book includes the clear illustrations and equally accessible text that made the books so popular, accompanying those exploring beaches and rockpools along the coast. The drawings of 'Laver, Corallines and Lichens' in pastel include the purple laver (1, *Porphyra umbilicalis*), an edible type of common seaweed found on rocky coasts that is used in Wales to make traditional laverbread. To the right of the laver is Coralline or coral weed (3, *Corallina officinalis*), a red algae with branching fronds that can vary from pink to red to purple to yellow depending on the available light: the more light, the paler the hues. At top right is *Lecanora* (8) a grey lichen composed of fungus and algae that often forms rounded colonies. The *Observer's Books* were published from 1937 to 2003 and edited and illustrated by a roster of names. *Sea and Seashore*, number thirty-one in the series, was the second visit to the oceans following number twenty-eight, *Sea Fishes*. Eventually a hundred of these now collectible books were published on subjects ranging from the general (nature, sports, architecture) to the highly specific (larger British moths, flags, kitchen antiques) with the shared goal of imparting knowledge concisely without burdening the 'observer' with technical terminology.

Paula do Prado

Kalunga, 2019–20
Mixed media fibre, 90 × 120 × 5 cm / 35 × 47¼ × 2 in
Collection of the artist, Australia

As a means of exploring ancestral connections, the tension that exists between fear and curiosity and an imaginary ocean boundary known as the Kalunga line, Uruguayan-born artist Paula do Prado (b. 1979) created *Kalunga* working with her then-six-year-old son, Tomas. Using crocheted and coiled yarns, she decorated paper-covered wire and finished her sculpture with repurposed plastic fruit netting and plastic beads to create the sea as imagined by Tomas. To him, the sea was a magical place full of wondrous beings; to her, as a non-swimmer, it was a place of

fear and wonderment in equal measure. The word *Kalunga* comes from KiKongo, a Bantu language spoken in many parts of Africa. It can mean both 'the ocean' and 'the divine' and is used to reference 'the threshold between two worlds' – particularly a notional line somewhere in the middle of the Atlantic Ocean, and an imaginary line between living and death where one crosses into the other. For do Prado, who made the journey from Uruguay to Australia as a child, the spiritual connection her ancestors have with the sea and how that connection affects her and

her son's lives today is something on which she continually reflects. In creating *Kalunga*, she hoped to convey some of these reflections while embracing the opportunity to work with her young son. Their collaboration reveals a playfulness and thoughtfulness that shows not just their readiness to experiment but also to work through complex ideas, such as the tension between the fear and curiosity that the ocean evokes in mother and son.

Christo and Jeanne-Claude

Surrounded Islands, Biscayne Bay, Greater Miami, Florida, 1980–83
Installation, dimensions variable

The extraordinary sight of a flotilla of fuchsia pink halos surrounding these three islands dazzled anyone who came across them. Yet this remarkable site-specific installation lasted only two weeks, representing an enormous undertaking for such a short-lived artwork, and included a total of eleven surrounding islands from the city of Miami to North Miami, the Village of Miami Shores and Miami Beach, all in the shallow waters of Biscayne Bay off the Florida coast. Ultimately some 604,000 square metres (6.5 million sq ft) of pink polypropylene

fabric floated on the water, roughly sketching out the contours of each island, all orchestrated by the artists Christo (1935–2020) and Jeanne-Claude (1935–2009). They chose pink because it fit well not just with the tropical vegetation of the uninhabited islands, all of which were extensively cleaned up as part of the preparation for the spectacle, but also with the Miami sky and the colour of the shallow waters of the bay. Tended constantly by a team of 120 monitors in pink T-shirts in inflatable boats, the cloth became an extension of the islands, rising and

falling with the tide and highlighting the way in which Miami and its inhabitants live between land and water. The artists, who were also a married couple, were particularly noted for large-scale site-specific works using fabric, including 'wrapping' structures such as the Pont Neuf in Paris and the Reichstag in Berlin, and building 'floating piers' that allowed visitors to walk out on the surface of a lake in northern Italy.

Georgia O'Keeffe

Sun Water Maine, 1922
Pastel on paper laid down on board,
48.3 × 64.1 cm / 19 × 25¼ in
Private collection

A lower band of dark green alludes to the lush and dramatically nonlinear coastline of the northeastern US state of Maine, above which the ocean is represented by a single unbroken band of teal blue that communicates a sense of unperturbed peace, while the sky appears washed out by the intense glare of a rising sun. Celebrated American artist Georgia O'Keeffe (1887–1986) worked on this pastel illustration while staying by the Atlantic Ocean at York Beach in Maine, where she explored the expressive potential of horizontal compositions and flat colour fields. O'Keeffe's landscapes are imbued with an almost primordial aesthetic simplicity that brims with spiritual serenity, and *Sun Water Maine* reconfigures the classical iconography of Western landscape painting into a thoroughly modern, synthetic language that prioritizes colour over detail. While characterized by a sense of otherworldly stillness, many of O'Keeffe's landscapes allude to the passing of time – a reference to the ineluctable natural rhythm that defines human existence. The artist's distinctive painting style effortlessly combines Zen Buddhism and the crispness of Japanese art. Capitalizing on the emotive quality of colour, O'Keeffe devised an essentialist artistic language to immortalize the sublime vitality and energy of the natural spaces she loved. In contrast to nineteenth-century paintings of stormy and treacherous seas, the placidity of O'Keeffe's ocean invites the viewer to harmoniously engage with nature through a deeper, more contemplative state.

Subhankar Banerjee

Kasegaluk Lagoon and Chukchi Sea, 2006
Photograph, 1.7 × 2.2 m / 5 ft 8 in × 7 ft 2 in

This image is reminiscent of colour field paintings of the 1940s and 1950s: the left part is covered by a huge field of brown-beige draining into a field of clear blue on the right-hand side of the photograph, while the horizon is covered by a line of dark blue beneath a white-grey field representing the sky. Despite its abstract appearance, this photograph by Indian-born American photographer, writer and activist Subhankar Banerjee (b. 1967) shows an aerial view of the boundary between the Kasegaluk Lagoon and the Chukchi Sea in the American Arctic, where brown-beige fresh water from several rivers,

carrying myriad nutrients, meets the blue sea. Winds push the fresh water from the lagoon into the sea, and vice versa, creating a band of natural water movement that creates an abundant ecological environment, pivotal for migratory birds such as Pacific black brant – around half the world's population of the birds gather at Kasegaluk before flying south to Mexico for the winter – and other marine creatures, including beluga whales, spotted seals and polar bears. Banerjee has photographed widely in the Arctic National Wildlife Refuge in Alaska and other important ecological and

cultural sites in the American Arctic and is a leading activist for their conservation. He was an outspoken defender of the need to protect Kasegaluk Lagoon from the effects of oil drilling that was planned for the region before the plans were finally abandoned in 2015. Banerjee's photographs of the Arctic have been exhibited extensively in museums and galleries and were shown at the 18th Biennale of Sydney. Banerjee's work has been instrumental in the efforts to preserve critically important eco-cultural areas of the American Arctic, including the Arctic National Wildlife Refuge.

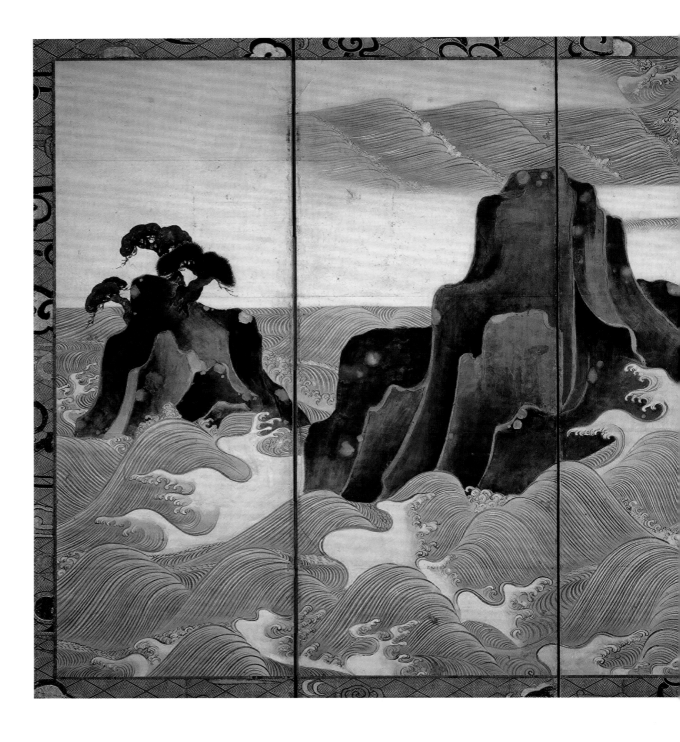

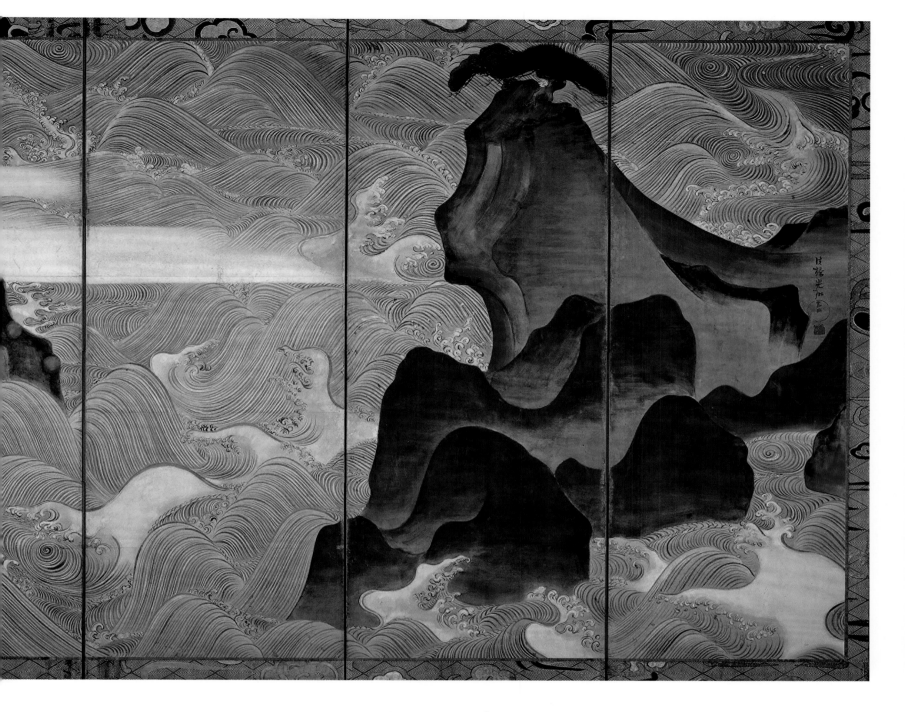

Ogata Kōrin

Waves at Matsushima, early 18th century
Six-panel folding screen; ink, colour and gold on paper,
overall: 1.5 × 3.7 m / 9 ft 11 in × 12 ft 1 in
Museum of Fine Arts, Boston

Tumbling waves break around pine-topped islets, and the bright horizon beyond is partially occluded by clouds that mirror the waves below. Though traditional in structure, the treatment of this six-panelled screen painting is stylized rather than naturalistic, and lends impressive prominence to the rocky outcrops that stand proudly amid the angry sea, as the white tips of the breaking waves seem to grasp angrily towards the rocks. The Japanese painter and designer Ogata Kōrin (1658–1716) worked in a style of art that came to be known as the Rinpa School of painting,

and which was prominent in the Edo period (1603–1867). This style featured the use of vibrant colours deployed in a decorative manner, often to depict subjects inspired by the natural world and changing seasons. A bay on the eastern coast of Honshu, Japan's largest island, Matsushima is a scenic spot famous for its many wooded islands. (Confusingly, though, this work is not in fact based on Matsushima, but is a portrayal of the coast near Sumiyoshi in Osaka – the painter Sakai Hōitsu, Kōrin's disciple, is responsible for the misattribution.) Although

Kōrin was inspired by a work of the same title by the famous early seventeenth-century designer and artist Tawaraya Sōtatsu, another possible influence for the subject is the Daoist mythical island, known as Mount Penglai in China and Mount Hōrai in Japan, which is associated with longevity and immortality. Much of Kōrin's finest work was produced towards the end of his career, and in 1701 he was awarded the honorific artistic title of hokkyō, meaning 'bridge of Buddhist law'.

Benvenuto Cellini

Saliera (Salt Cellar), 1540–43
Gold, enamel, ebony and ivory, 26.3 × 28.5 × 21.5 cm / 10¼ × 11¼ × 8½ in
Kunsthistorisches Museum, Vienna

The main theme of this unique salt cellar by renowned Italian goldsmith and sculptor Benvenuto Cellini (1500–1571) is the interlinking of the sea and land, but overall it presents an allegory of the entire cosmos, including personifications of the winds, the times of day and the human world. A nude Neptune, god of the sea, entwines his legs with those of Tellus, personification of the land, in a pose the Renaissance viewer would have recognized as sexual. At the time, salt was believed to be produced by the melding of elements from land and sea. Neptune holds a trident and uses

reins to control the hippocamps (fish-tailed seahorses, symbolizing the tides) rising from the waves on either side of him, accompanied by fish and other sea creatures. Beside Neptune is a small bowl for salt, in the form of a ship. The right hand of Tellus rests on a cornucopia, or horn of plenty, while the left squeezes her breast, a sixteenth-century gesture referencing fertility and abundance. The temple next to her would have held peppercorns, their exotic origins suggested by the Indian elephant on which she sits. Originally commissioned by Cardinal

Ippolito d'Este, the salt cellar was eventually made for Francis I, king of France. Salt taxes were the highest source of royal revenue, and Francis was the first French monarch to initiate trade with India in spices such as pepper. In addition to its beauty, the king must have appreciated the political and economic symbolism of the piece.

John Samuel Pughe

Another Party Heard From, from *Puck*, vol. 43, no. 1117, 1898
Chromolithograph, 34.3 × 25.4 cm / 13½ × 10 in
Library of Congress, Washington DC

'Great whales!' exclaims a flustered Neptune, who cowers beneath the Caribbean Sea amid the wrecks of Spanish warships during the Spanish-American War (1898). 'If those Yankees keep this up much longer I'll have to move!' This cartoon by Welsh-born John Samuel Pughe (1870–1909) was commissioned for the cover of the American satirical magazine *Puck*, famed for its colourful illustrations lampooning the political issues of the day. Fought between May and August 1898, the Spanish-American War began as a conflict over Cuban independence but soon turned into a campaign to strip Spain of its remaining overseas colonies. Referenced here is the Battle of Santiago de Cuba, which was fought on 3 July 1898, and which sealed the US victory over the Spaniards in the four-month-long conflict. The pivotal day of action saw four American battleships and two armoured cruisers decisively defeat a Spanish squadron. Although in reality six ships were sunk, Pughe shows nine lying on the seabed with at least another four starting to sink above. In Roman mythology, Neptune is the mighty god of the sea; identified by his long beard and signature trident, he governs the waters and summons storms to sink ships and send sailors to their graves. Pughe's illustration, which underscores the emergence of the United States as a major naval power, shows Neptune rendered impotent by the might of the US Navy. The hostilities were a turning point in the history of the United States, establishing it for the first time as a power with a global presence.

PEARL OYSTER.

1. 2. The young brood or spat.
5. Four months old.
4. Six months old.

5. One year old.
6. Two years old.

THE PEARL OYSTER.

Full Growth.

George Brettingham Sowerby

Pearl Oyster, from *Sketches of the Natural History of Ceylon* by J. Emerson Tennent, 1861
Engraving, each page 19 × 12.5 cm / 7½ × 5 in
Cornell University Library, Ithaca, New York

In theory, almost any mollusc can create a pearl, but those that are most valued for their nacre or mother of pearl – a hard, resilient substance that is iridescent, appearing to change colour in different conditions – come from the *Pinctada* genus, a group of saltwater molluscs also known as pearl oysters. These detailed drawings by British naturalist George Brettingham Sowerby (1788–1854), a leading expert on molluscs, show the life cycle of the oyster alongside an external and internal close-up of a *Pinctada* with its pearls. Pearls have been valued as gemstones for millennia,

their first recorded mention dating back to 2206 BC in China. In early Hindu texts from India, pearls were said to be created by lightning hitting the water, making them the symbol of a powerful union of heaven and earth. In Western art, meanwhile, pearls often appear as symbols of power and sophistication. Predominantly associated with femininity, the soft white lustrous orbs were often symbolically associated with the moon, purity and the otherworldly. Natural pearls are produced within the soft tissue of the *Pinctada*, which came originally from the

central Indo-Pacific region, and are made of layers of calcium produced by a natural response to an irritant object, such as a grain of sand, that has infiltrated the mollusc's body. It takes between three months to two years for an oyster to produce a pearl large enough to be used for jewellery. From the thirteenth century, the demand for pearls by wealthy individuals seeking status symbols was such that pearls were deliberately cultured by introducing fragments of molluscs' inner shells into pearl oysters.

Fosco Maraini

Ama Woman Pearl Fisher from the Island of Hekura, Japan, 1954
Photograph, dimensions variable

Wearing only a loincloth and bandanna, a female free diver harvests molluscs from the seabed off the coast of the Japanese island of Hegura-jima, also called Hekura. A rope tied to her waist and attached to a boat some 30 metres (98 ft) above waits to be tugged to signal that she is ready to resurface. The woman was one of the many skilled Ama – Japanese for 'sea women' – Italian anthropologist and ethnographer Fosco Maraini (1912–2004) photographed in 1954 while documenting the community of women who made their living by diving for oysters, sea snails

and other shellfish. Maraini's photographs were the first to record the women's remarkable exploits, showing them deep under the water as well as above in the island's rocky landscape. Ama were recorded as early as AD 750, and this ancient tradition of female sea foraging was once common along Japan's central and southern coasts. Since 1893, when cultured pearls were introduced, the Ama have been particularly associated with their cultivation, diving to insert a nucleus into an oyster and then years later diving again to retrieve the pearl.

Despite this, the Ama are in decline, from around six thousand shortly before Maraini visited to only around two thousand today. Traditions have also evolved to wearing wetsuits and goggles, although modern Ama still do not use breathing equipment, and they visit a shrine after every shift to thank the gods for their safe return.

Jeannette Klute

Marine Life, c.1950s
Dye transfer print, approx. 34.6 × 27 cm / 13⅝ × 10⅝ in
Dallas Museum of Art, Texas

This remarkably detailed and intimate image of marine life at low tide is part of a series in which pioneering American photographer Jeannette Klute (1918–2009) explores the tension between realism and abstraction in the representation of natural subjects. Key to rocky intertidal shores, tide pools often brim with an incredible variety of marine life, as is demonstrated here. Mussels, snails and barnacles emerge from the shallow waters in which they find food and shelter, clinging to the surface of rocks and pebbles covered with algae and seaweed.

A small crab scavenges the areas between stones, taking advantage of a semi-enclosed environment where predators are scarce and hiding places abound. In her photograph, Klute captures the magical complexity of these tidal ecosystems and the many marine creatures that thrive there by framing the subject from above, thus reducing its tridimensionality to a painterly flatness – an interest in form and colour that in the 1950s led the photographer to become a painter. But before this professional transition took place, Klute also substantially

contributed to the development of the dye imbibition print – a process that superimposes images in different colours – which enabled artists to capture the natural world with higher definition and truthfulness to realistic colouration. Her talent and innovation led to her being hired by Kodak as a lab assistant and, in 1945, rising to direct the company's colour printing group.

Anonymous

Flask with Fish and Scroll Design, late 15th century
Buncheong stoneware with incised and *sgraffito* decoration,
H. 22.8 cm / 9 in, diam. of body: 18.3 × 13.9 cm / 7⅛ × 5½ in
Museum of Fine Arts, Boston

In sixteenth-century Japan, a type of Korean pottery known as *buncheong* became highly prized. It originated under Korea's last and longest-lasting dynasty, the Joseon Dynasty (1392–1897), but its roots lay in the celadon of the preceding Goryeo Dynasty (918–1392). The term *buncheong* is an abbreviation of *bunjang hoecheong sagi*, a phrase coined in the 1930s by South Korea's first art historian, Go Yuseop, which translates as 'grey-green ceramics decorated with powder'. The style's popularity lay in its unassuming appearance, which gave it a sense of being both practical and without pretension. Its decoration comes from the application of white slip under the glaze. The slip was then combined with a number of different decorative techniques, including an incised or *sgraffito* design, as shown here. Experimental and playful, it contrasted greatly with the formality of celadon pottery. This flask is typical of work from the Jeolla Province. *Buncheong* all but disappeared from Korea at the end of the sixteenth century as Joseon white porcelain took over, but Japan's invasion of Korea in 1592 saw villages of potters forced to relocate to Japan, where *buncheong*, known there as Mishima pottery, became highly influential. Against this backdrop, the flask was eventually acquired by American physician William Sturgis Bigelow while living in Japan from 1882 to 1889. During a time when most of the country was closed to foreigners, Bigelow amassed a huge collection of Asian ceramics and art. On his return to the United States, he donated around seventy-five thousand objects of Japanese art, including this flask, to Boston's Museum of Fine Arts, where it remains.

Anna Atkins

Ptilota plumosa, from *Photographs of British Algae:*
Cyanotype Impressions, vol. III, 1843–53
Cyanotype, 25.3 × 20 cm / 10 × 7¾ in
New York Public Library

A landmark work in the history of photography and scientific illustration, *Photographs of British Algae: Cyanotype Impressions* (1843–53) by artist and botanist Anna Atkins (1799–1871), catalogues hundreds of species of algae native to Great Britain using a technique invented only a year before its first volume appeared. The original works, including this feathery *Ptilota plumosa,* were made by Atkins using a photographic process called a cyanotype. The cyanotype was developed in 1842 by Sir John Herschel, a colleague of Atkins's father, John George

Children, himself a prominent chemist and a Fellow and Secretary of the Royal Society. To make her cyanotypes, Anna Atkins laid each algae specimen on a chemically sensitized sheet of paper under a pane of glass and exposed it to sunlight for up to fifteen minutes. After it was washed with water, the exposed paper turned blue and the covered areas white. Atkins then meticulously wrote the botanical name of the plant at the bottom of each sheet. She collected the majority of the specimens for *British Algae* herself, with some help from friends, and

ultimately produced approximately thirteen editions of the book, each with more than four hundred plates. Atkins originally meant her work to accompany the 1841 *Manual of British Algae* by naturalist William Harvey, which contained only written descriptions, but her own book is now recognized as the first published work illustrated with a photographic process. Despite that landmark, as a woman in Victorian England, Atkins received little to no public recognition until the 1970s.

Edward Weston

Starfish, 1929
Gelatin silver print, 24.1 × 19.4 cm / 9½ × 7⅝ in
Museum of Fine Arts, Boston

While American photographer Edward Weston (1886–1958) is better known for his celebrated portraits of personalities such as Albert Einstein and Marilyn Monroe, much of his body of work captured the elusive beauty of the animals and plants around his home in Carmel on the California coast in original and evocative ways. His tonally rich and detailed black-and-white photographs foregrounded an iconic quality in their subjects, elevating them from their mundane reality and the banality of documentary imagery in order to highlight the sculptural qualities and overlooked beauty of their form. This is certainly the case with this little-known portrait of a starfish Weston took in a marine aquarium. In the wild, starfish spend their lives crawling on stones and sand at the bottom of the sea, but Weston's picture, which shows the animal crawling on the glass of a fish tank, offers a new perspective. The image gives us a rare glimpse of the underside of the animal's body, with its mouth positioned at the centre. A scavenger and opportunistic feeder, the starfish never displays the vulnerable underside of its body. Unconcerned with representing the reality of the animal's behaviours in the wild, Weston opted instead for an interpretative approach inspired by the interest Surrealism nurtured for alien and enigmatic life forms. In this image, the starfish appears animated, as if caught in a dance suspended in water – something impossible to see in the wild.

William R. Current

Seaweed, Point Lobos, 1969
Gelatin silver print, 21 × 21 cm / 8¼ × 8¼ in
Museum of Fine Arts, Boston

This vivid black-and-white photograph of kelp that has washed ashore on the coast of California – closely cropped in order to emphasize the formal beauty of lines and volumes, the textures of the kelp standing out starkly against grains of sand – imbues the dying seaweed with a vitality that transcends the precarity of organic matter. The image is the work of American photographer William R. Current (1923–1986), who immortalized the raw and sublime beauty of the western and southwestern United States, strongly inspired by the work of landscape photographer Ansel Adams (see p.261). Of the order Laminariales, kelp, despite its appearance, is not a plant but a *heterokont*: an organism made of one tissue. The leaflike structures, known as blades, are in fact elongated stems. The gas-filled bladders visible in the photograph (typical of American species) are designed to lift the organism towards the ocean's surface. A fast grower, kelp can reach 30 to 80 metres (100–260 ft) in length, and grows in thick forests. Today, the kelp forests off the coast of California have almost entirely disappeared due to extreme ocean warming that began in 2014. It has been claimed that urchins might also be to blame: they are voracious kelp eaters, and the absence of predators in the area has enabled an unprecedented expansion of existing colonies. Experts report that 95 per cent of kelp forests have so far vanished.

Ansel Adams

Stream, Sea, Clouds, Rodeo Lagoon, California, 1962
Gelatin silver print, 49.2 × 37.5 cm / 19⅜ × 14¾ in
Private collection

Rodeo Lagoon, north of San Francisco in the Marin Headlands, empties into the Pacific whenever the water level rises over a sandbar that separates ocean and brackish wetlands. In this photograph, renowned American photographer Ansel Adams (1902–1984) catches the simultaneous exhale of the lagoon into the sea and the glittering response of the surf as it beats back the advancing stream. Above, clouds build with more moisture. The most important landscape photographer of the twentieth century, Adams was drawn to water in all its forms. He was a founder in 1932 of Group f/64, whose members rejected the prevailing pictorial style of photography and its borrowed techniques of painting. The group's name came from the smallest aperture then available on cameras, which resulted in great depth of field and sharpness, and the clarity of this photograph is such that one can distinguish each ripple of the stream as it flows towards the sea, and almost each grain of sand. Photographing surf was difficult, according to Adams – the waves were unpredictable and constantly changing – and he said the photographer must try to anticipate and press the shutter a fraction of a second before the ideal moment. The technical precision of this image conjures up in the viewer the smell and sound of the sea spray and the surge of the waves. Adams began his career as a musician and composer, and he sometimes compared printing images to playing music: a sense of timing and of tone – visual or aural – was crucial to the best performance.

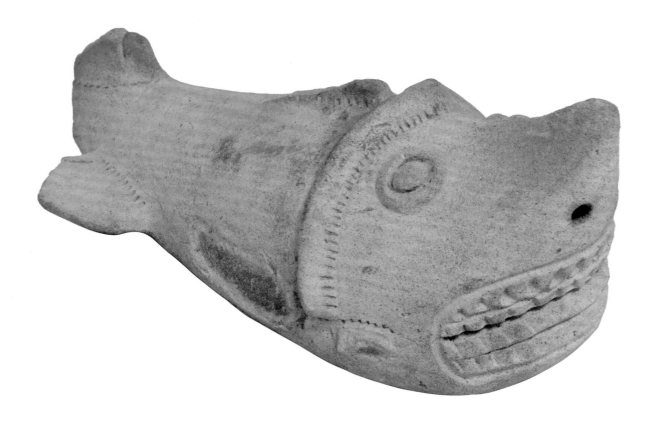

Anonymous

Shark, 1st–5th century AD
Terracotta, L. 21.6 cm / 8½ in
Metropolitan Museum of Art, New York

The La Tolita-Tumaco culture of coastal northern Ecuador and southern Colombia is well-known for its terracotta figurines, which are so realistically detailed that they have been called portraits. This rendition of a shark, in contrast, is more symbolic than accurate, with an emphasis on the fearsome teeth and large head of the fish. The object may have had a ritual, shamanic purpose – the shark has psychological and symbolic meaning in many cultures, beyond its use as a food source – but centuries of looting means that there is no archaeological context for the vast majority of La Tolita works in museums around the world. Some pieces, such as jaguar-toothed masks, are almost certainly religious, and it is easy to imagine the shark – the consummate marine aggressor – as part of shamanic paraphernalia. It is assumed that most sculptures came from graves, where they were deposited as gifts for the dead. The La Tolita-Tumaco region covered the coast and inland alluvial plain, an area of mangrove swamps and thick rainforest. The culture was at its height between around 200 BC and AD 400 and had, in addition to a tradition of sculpting in clay, a highly sophisticated metalworking practice using gold, platinum and lead. The society was complex and hierarchical, with evidence for elite chiefs and priests living alongside fishers, farmers and craftspeople. Such archaeological evidence as exists suggests that the people were also expert navigators and traded up and down the coast.

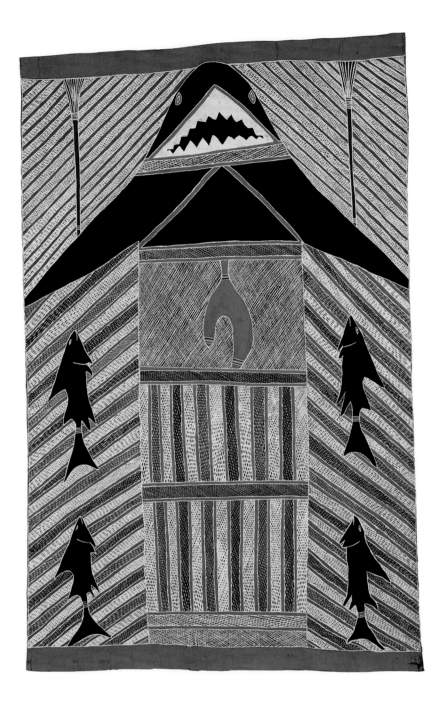

Bunbatjiwuy Dhamarrandji

Bul'manydji at Gurala, 1998
Natural pigments on bark, 166 × 99 cm / 65⅜ × 39 in
Australian National Maritime Museum, Sydney

The Djambarrpuynu clan's ancestral shark, Bul'manydji, lies butchered, only its head and liver still undamaged. The intact liver represents future clan generations, while on either side of the head, the many-pronged spears refer to the ritual dance associated with the shark's death. The artist incorporates the *miny'tji* (the sacred clan design of cross-hatching) to indicate clear saltwater above the fins, while heavier lines below represent water mixed with the entrails of the fish. Bunbatjiwuy Dhamarrandji (1948–2016) was a member of the Dhuwa moiety of the Djambarrpuynu clan, and this bark painting was created for the Saltwater Project, established by the Yolnu people of East Arnhem Land in northwest Australia in 1996 to educate outsiders about the history, geography, laws and codes of behaviour of that landscape and its sacred places. The details of the painting underline the Djambarrpuynu clan's spiritual relationship to the coastal areas adjoining their lands. This and the seventy-nine other Saltwater Project bark paintings were instrumental in a ruling handed down in 2008 by the Australian High Court that recognized Yolnu ownership of the intertidal zone along the coasts of their ancestral lands, reinforcing the legal argument that the region between the low and high tide limits included both physical and spiritual space sacred to the clan. The ruling was pioneering in its recognition of native peoples' title to intercoastal waters, including primacy over fishing or commercial interests.

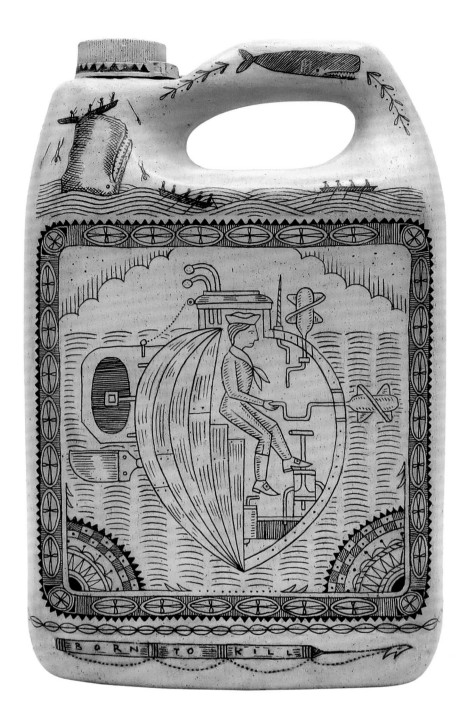

Duke Riley

#34 of the Poly S. Tyrene Maritime Collection, 2019
Salvaged, painted plastic bottle, 30.5 × 18.4 × 7.6 cm / 12 × 7¼ × 3 in
Private collection

An underwater view reveals a one-man submarine making its way through the ocean. Above, on the choppy sea, a whale breaches the water, upending a vessel and sending two whalers overboard while harpoons fly through the air. Other whaling boats ride waves nearby, and a second whale floats above the scene out of harm's way – at least for the moment. Brooklyn-based visual, performance and tattoo artist Duke Riley (b. 1972) painted this scene on a cream-coloured surface applied to an antifreeze bottle found on the Brooklyn waterfront. *#34 of the Poly S. Tyrene*

Maritime Collection is part of a series fashioned out of plastic debris littering our shorelines. Here, Riley reimagines scrimshaw, the shipboard art that gained popularity in the nineteenth century – on voyages, whalers would spend free time carving scenes onto ivory or bone for loved ones back on land (see p.188). He recontexualizes the traditional seafaring vignettes, replacing portraits of sea captains and ship owners with those of lobbyists and CEOs from the plastic and petroleum industries. The vessel depicted here is the world's first combat submarine, the Turtle. Designed

by American inventor David Bushnell, it was used to attack a British flagship in New York Harbor in September 1776. Although unsuccessful, it was a courageous act against an occupying force in defense of liberty. (In 2007, Riley reenacted the Turtle's mission, building and launching a similar wooden vessel and navigating it within a few yards of the *Queen Mary 2* before being arrested.) Below the Turtle a harpoon painted with the words BORN TO KILL links the violence inflicted on nature by the whaling industry with the destruction now exacted by the oil industry.

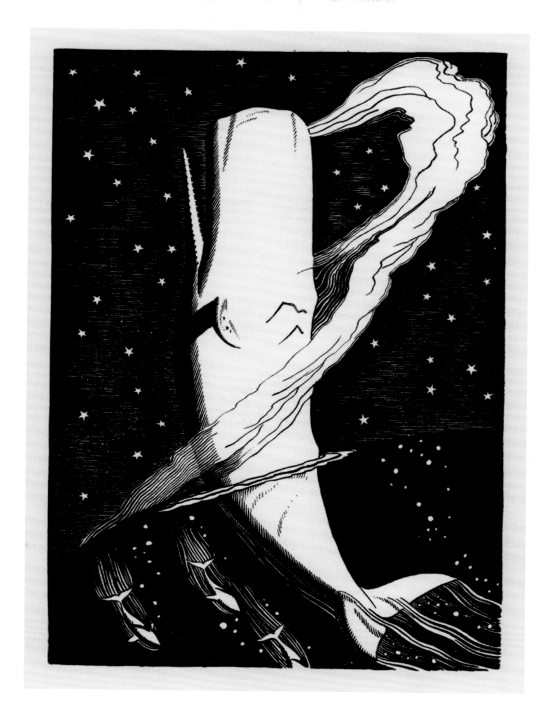

Rockwell Kent

Illustration from *Moby-Dick; or, The Whale* by Herman Melville, 1930
Lithograph, 26.7 × 19.1 cm / 10½ × 7½ in
Beinecke Rare Book and Manuscript Library, Yale University, New Haven, Connecticut

As the gargantuan sperm whale surfaces, it propels a billowing jet of water from the blowhole near the top of its skull that falls away in a sweeping diagonal, bisecting the composition and emphasizing the great height to which the whale's evident speed has carried it. The woodcutlike print, by American artist Rockwell Kent (1882–1971) is the first sight of the titular creature within the celebrated 1930 Lakeside Press edition of Herman Melville's 1851 novel *Moby-Dick; or, The Whale*. Kent's illustrations adorned many famous literary works in the first half of the twentieth century, but those he created for *Moby-Dick* are among his finest – their stark, expressive Art Deco style capturing the novel's grand scale and brooding atmospherics. Kent's towering whale is pictured against a stylized starry night sky, foregrounding the white and monstrous essence described in Melville's prose. The book tells the story of Captain Ahab's fanatical pursuit of revenge, aboard his ship the *Pequod*, against a threatening giant white sperm whale. The novel was poorly received upon its original publication, particularly in the United States, but began to be reassessed by literary critics in the 1920s, among them D.H. Lawrence, who called it 'the greatest book of the sea ever written'. It was arguably Kent's visual imagining of the story, however, and the several hundred of his illustrations that accompanied the limited edition three-volume set, that helped to revive and popularize *Moby-Dick* as a literary masterpiece.

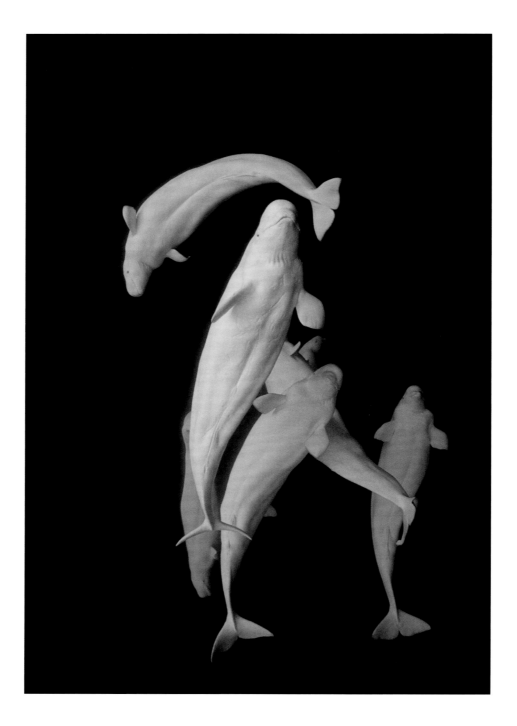

Doug Allan

Belugas – White Ghosts of the Arctic, 1997
Digital photograph, dimensions variable

Arctic belugas (*Delphinapterus leucas*) can be heard underwater long before they're seen. These whales chirp and whistle to each other; they can sound so similar to a flock of birds that they were called sea canaries by the early whalers who first encountered them. Their vocalizations were loud enough to penetrate the hulls of the wooden ships, and were audible to all sailors below decks. Belugas use their sounds as underwater sonar to detect holes in the ice where they can surface to breathe, or find their fish prey in the dark water of winter deep under the ice. They also use it for social communication, but exactly what they're saying to each other remains a mystery. Over many dives, Scottish photographer Doug Allan (b. 1951) found that the secret to bringing belugas close is to make sounds yourself – singing 'Happy Birthday' down his snorkel did the trick for this image. Floating on the surface, Allan looked straight down into the black waters and, when the belugas came in for a look, they rolled on their backs directly underneath for a better view up at the photographer's silhouette. Belugas are unusual among whales in that the vertebrae in their necks are flexible, while with most whales, they are fused. This means that belugas can twist and turn their heads as they swim around – and Allan has received more than one over-the-flipper glance from a beluga as it passes, an odd feeling when swimming with a marine mammal that can reach up to 6 metres (20 ft) long.

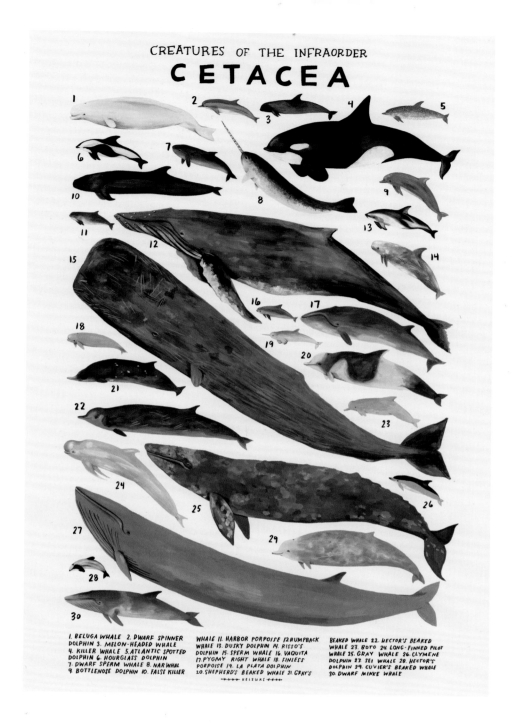

CREATURES OF THE INFRAORDER
CETACEA

1. BELUGA WHALE 2. DWARF SPINNER DOLPHIN 3. MELON-HEADED WHALE 4. KILLER WHALE 5. ATLANTIC SPOTTED DOLPHIN 6. HOURGLASS DOLPHIN 7. DWARF SPERM WHALE 8. NARWHAL 9. BOTTLENOSE DOLPHIN 10. FALSE KILLER WHALE 11. HARBOR PORPOISE 12. HUMPBACK WHALE 13. DUSKY DOLPHIN 14. RISSO'S DOLPHIN 15. SPERM WHALE 16. VAQUITA 17. PYGMY RIGHT WHALE 18. FINLESS PORPOISE 19. LA PLATA DOLPHIN 20. SHEPHERD'S BEAKED WHALE 21. GRAY'S BEAKED WHALE 22. HECTOR'S BEAKED WHALE 23. BOTO 24. LONG-FINNED PILOT WHALE 25. GRAY WHALE 26. CLYMENE DOLPHIN 27. SEI WHALE 28. HECTOR'S DOLPHIN 29. CUVIER'S BEAKED WHALE 30. DWARF MINKE WHALE
→→→→ KELSEY ←←←←

Kelsey Oseid

Cetacea, 2016
Print from gouache painting, 51 × 76 cm / 20 × 30 in
Private collection

Three huge whales dominate this illustration of thirty species from the taxonomic order Cetacea – the humpback whale (12), the sperm whale (15) and the Sei whale (27) – but there are reminders that the whole order is not on the same scale, including the vaquita (16) of the northern Gulf of California, the smallest of all cetaceans, reaching just 1.5 metres (4.9 ft) in length. Another small species is Hector's dolphin (28), which is endemic to New Zealand. Other notable inclusions are the narwhal (8), with its long tusk, which hunts its prey beneath the sheet ice in the Arctic and Russian seas. The exact purpose of the tusk – an outgrown wisdom tooth – is unclear, but it might be used in signalling information to other narwhals about sea conditions (it contains millions of nerve endings to sense the water) or to stun smaller fish. Another Arctic resident from the same family as the narwhal, the beluga whale (1), sometimes known as the white whale, has provided an important food source for indigenous peoples inside the Arctic Circle for centuries and is still hunted today. Humans have long had a close relationship with cetaceans – aquatic mammals such as whales, dolphins and porpoises – of which more than ninety species inhabit the world's oceans, lakes and rivers. Known for their high intelligence and complex social behaviour, cetaceans live in tight-knit social groups, develop close relationships, communicate with each other and spend a good deal of time at play. Resembling the illustrated encyclopaedias that appeared in the late 1800s, this plate brings together separate gouache images by contemporary American artist Kelsey Oseid (b. 1989), who specializes in natural history subjects.

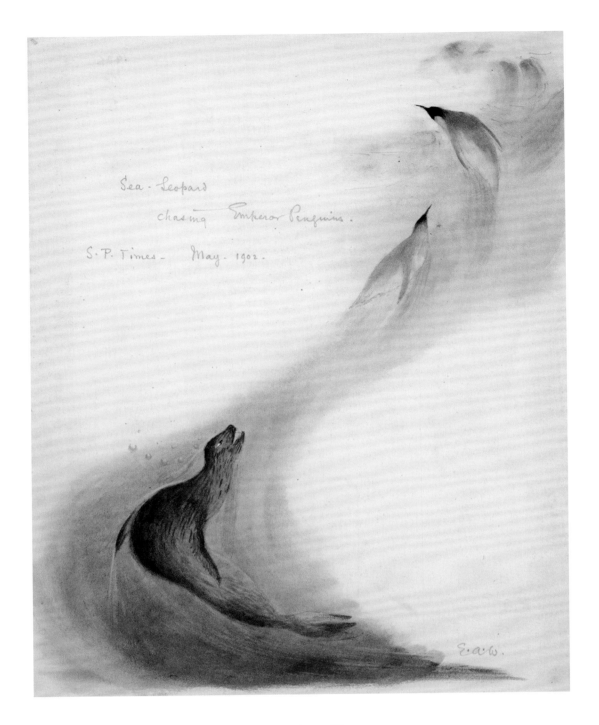

Sea-Leopard
chasing Emperor Penguins.
S.P. Times - May. 1902.

E.a.W.

Edward Wilson

Sea-Leopard Chasing Emperor Penguins, 1902
Watercolour, 25.2 × 20.2 cm / 10 × 8 in
Scott Polar Research Institute, University of Cambridge

This painting of a seal hunting its supper in May 1902, in the depths of the Antarctic winter, is a souvenir of Robert Scott's 1901–4 expedition to explore the southern continent. Painted by the vertebrate zoologist and expedition artist Edward Wilson (1872–1912), the image was one of many by Wilson that appeared in the *South Polar Times*, a magazine published by the expedition's members when their ship, *Discovery*, was icebound in McMurdo Sound, an extension of the Ross Sea that forms a deep bay of the Southern Ocean. At a time when more was known about Mars than the frozen south, Wilson illustrated stories and anecdotes that the explorers wrote about their environment, scientific work and leisure pursuits. Despite temperatures dipping to -50° Celsius (-58° F) and having to sketch in fur mittens, Wilson accurately rendered skuas, albatross, seals, penguins and other wildlife, along with events such as the first Antarctic flight (by balloon) and toboggan races. A story recounted by Reginald Skelton, chief engineer, sheds some light on the difficulties that painting the sea-leopard – also known as a leopard seal (*Hydrurga leptonyx*) – must have presented: 'This beast had an extremely fierce-looking head, with large mouth and a most dangerous looking set of teeth – I should not like to get very near one, on opening his stomach, an Emperor penguin was found, which must have been swallowed pretty nearly whole.' Wilson's enduring fascination with Antarctica drew him back nearly a decade later, when he died along with Scott and four others after an attempt to be the first people to reach the South Pole – only to be beaten to the prize by Norwegian Roald Amundsen.

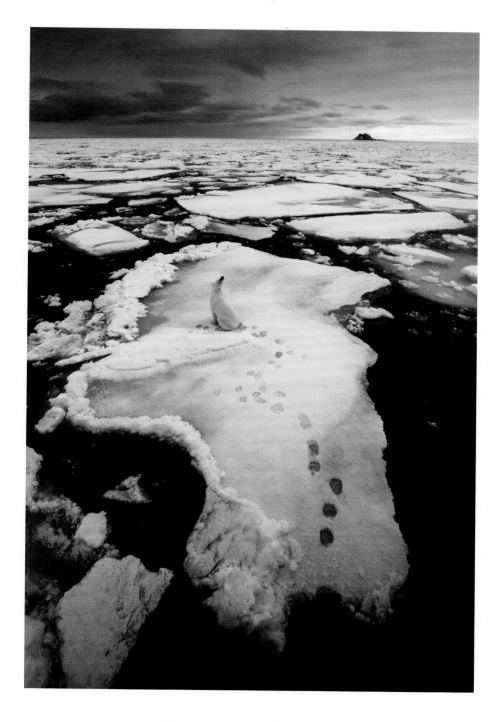

Ole Jørgen Liodden

*Polar Bear Sitting on Floe in Vast Thawing Sea-ice
Landscape, Spitsbergen, Svalbard*, 2011
Digital photograph, dimensions variable

Whales, seals and polar bears are classed as marine mammals by Arctic ecologists – all depend on the sea for their survival, the crucial difference being that whales and seals live *in* the water, while polar bears live *on* it. The frozen sea ice is the bears' natural preferred habitat, and variances in the distribution and kind of ice on the Arctic Ocean due to climate change is dramatically affecting polar bears. The Arctic is warming faster overall than any other part of the planet. The white, frozen ocean of winter is melting earlier each spring. Without the ice on top,

the dark waters then warm more during the summer, which in turn causes ice to re-form later in the autumn. Because of these changes, pregnant female bears are getting less time to hunt seals and build up their fat reserves before denning in November to give birth to their cubs. And since they are not as healthy as they used to be, they give birth to fewer cubs. Come March, when the bears emerge from their dens, that spring sea ice is liable to break up sooner, depriving them and their cubs of time and territory for seal hunting before the lean months of summer.

In this image by Norwegian photographer and conservationist Ole Jørgen Liodden the sombre lighting, the grey slushy ice pawprints and the bear looking heavenwards – as if it too is wondering just what is happening to its habitat – create an air of wistful premonition in a powerful evocation of the threat climate change poses to the survival of the Arctic's most charismatic animal.

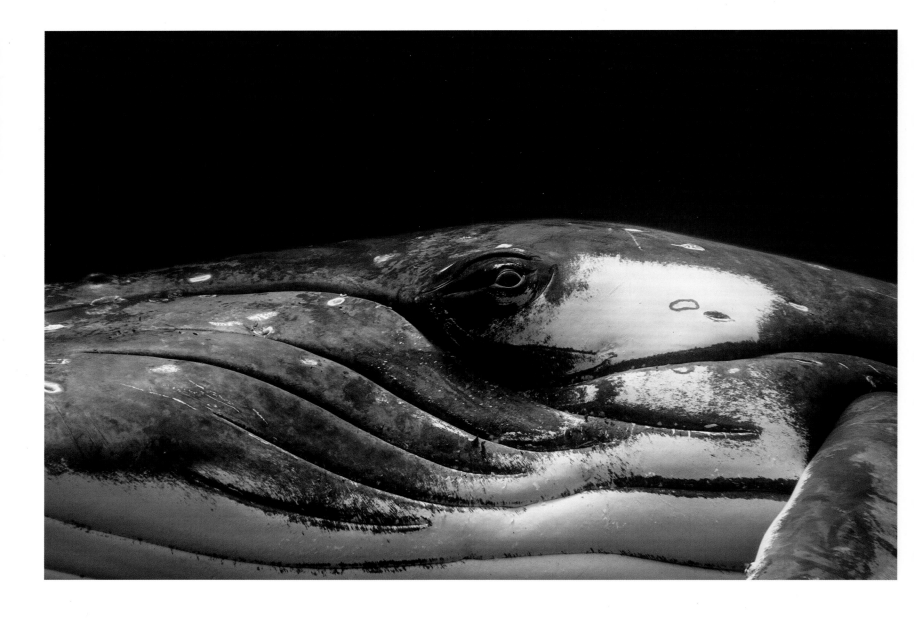

Wade Hughes

Look of a Whale, Female Humpback Whale, 2017
Photograph, dimensions variable

An intimate portrait such as this is both startling and revealing. Watching whales from a boat, the experience is overwhelmingly one of size and power: the beating of mighty tail flukes that leave footprints of roiling water at the surface as the whales swim at an effortless 12 knots or more, the explosive blow when they breathe, a spyhopping head standing tall against the sky. When a whale breaches completely, a 50-tonne (55-t) creature leaves the water in a remarkable display of power. Australian photographer Wade Hughes, who has made a reputation for his monochrome images of whales taken underwater, is less interested in whales' size and power than he is in capturing the marine mammal's apparently inherent interest and emotional engagement with another species – him. This image shows a female whale as she looks at Hughes. After females give birth to their calves, they are difficult to approach; they become very protective, turning away and keeping themselves between the photographer and their calves. But as the youngsters grow older, the female's curiosity begins to overcome her wariness. The result is an encounter like this. The photographer underwater cannot hide from his or her subject: when they see the animal, the animal sees them. They always have the privilege of simply swimming away. The success of a shot like this is that the whale has chosen to spend time in Hughes's presence: the photographer has waited patiently until the female has approached him, and the respect he has shown her seems to be reflected in the whale's eye.

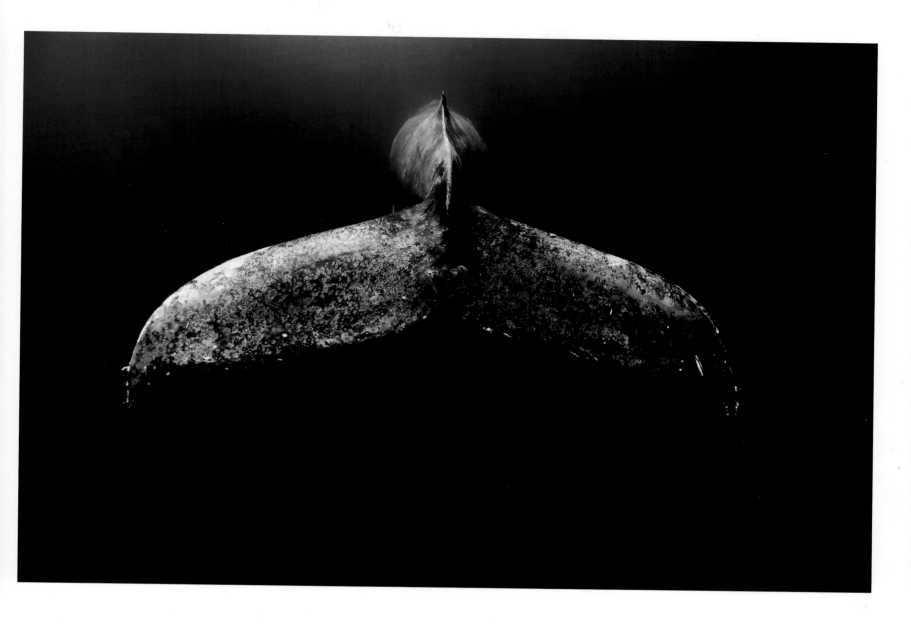

Jorge Hauser

Whale Tail, 2018
Digital photograph, dimensions variable

In the deep blue of the ocean, the barnacled tail of a solitary whale disappears from view as it moves through the vast emptiness on its long journey through the open waters. The image possesses a dreamlike quality amplified by the gloom of the water and scant traces of sunlight filtering from far above, evoking a feeling of loneliness and capturing the mystery of life in the ocean – a touching tribute to the fragility and beauty of our natural world. This photograph was taken by Mexican photographer Jorge Hauser (b. 1984) while diving off the coast of Baja California, located in

Mexico's northwestern region. Hauser noticed a whale swimming 15 metres (45 ft) below and dove down to capture the image, barely making it in time to catch the last glimpse of the creature disappearing into the deep. The waters of Baja California are the site for remarkable convergences of whales. In the winter months, almost the entire world's population of grey whales, humpbacks and blue whales migrates to the shallow lagoons of the peninsula's traditional breeding and birthing grounds. Their journey – in some cases more than 22,500 kilometres (13,980 mi) – from the

Bering Sea to these warm waters is considered the longest mammal migration on Earth. A passionate conservationist and underwater photographer, Hauser captures images full of movement and vibrancy, enhanced by his practice of shooting only with natural light while underwater.

Keith Shackleton

High Arctic, 2005
Oil on board, 61 × 111.7 cm / 24 × 44 in
Private collection

A small flock of guillemots flies past a majestic iceberg in the freezing waters of the Arctic Ocean. The turbulent grey-blue waves, which dominate two-thirds of this oil painting, are built up with subtle layers of colour, creating a remarkable sense of depth. Flecks of white paint map the play of light on the ocean's surface, contrasting the energy of the choppy water with the slow-drifting iceberg, which has most likely originated from the glaciers of the Greenland Ice Sheet. At the top right of the composition, a patch of blue sky appears through a break in the clouds,

suggesting that the sea will soon be calm. The British marine and wildlife painter Keith Hope Shackleton (1923–2015) was celebrated for his closely observed depictions of the Arctic and Antarctica. Painting in a Realist style, Shackleton often included seabirds in his compositions, which he observed while working as a boatman and naturalist in the polar regions. For many years he worked on board the MS *Lindblad Explorer*, which was designed, built and operated by the Swedish explorer and environmentalist Lars-Eric Lindblad, who pioneered ecotourism in Antarctica.

Shackleton also travelled and studied in the Atlantic, Pacific, Indian and Arctic Oceans. His interest in such expeditions was sparked at an early age after learning of the exploits of his relative, the famous explorer Ernest Shackleton, who led three expeditions to the Antarctic in the early twentieth century.

John James Audubon and Robert Havell

Fork-tailed Petrel, from *The Birds of America*, double elephant folio edition, 1838
Hand-coloured etching and aquatint, 97 × 65 cm / 38¼ × 25⅝ in
Private collection

Swooping low over the ocean, two fork-tailed petrels scan the water for food. Choppy waves and an overcast sky add to the drama of the scene, which shows the birds from above and below, highlighting their distinctive tails, bluish-grey plumage and webbed feet. The renowned American naturalist and painter John James Audubon (1785–1851) created the image for his magnum opus *The Birds of America*, the most important and spectacular ornithological book ever produced. Containing 435 hand-coloured plates and depicting 1,065 life-size birds, the book fulfilled Audubon's dream of travelling the United States and recording every native species of bird then known, including many seabirds and shore-birds. The plates were engraved by Robert Havell (1793–1878) after Audubon's original drawings, most of which were made from specimens that he had captured himself. These petrels were no exception, having been shot by Audubon from a small rowing boat in the North Atlantic Ocean off the coast of Newfoundland in August 1831. Audubon had carefully observed the petrels while alive, watching them fly over the water and occasionally diving to seize small fishes and crustaceans from floating seaweed. Between violent bouts of seasickness, he killed around thirty of the birds over the course of an hour and brought them back to the American packet ship *Columbia*, where he studied and sketched them. His seasickness got the better of him, however, and he was unable to complete the drawings until he returned to dry land.

Gustave Doré

Plate from *Der alte Matrose* by Ferdinand Freiligrath, translated from
The Rime of the Ancient Mariner by Samuel Taylor Coleridge, 1877
Engraving, 45.5 × 35 cm / 18 × 13¾ in
British Library, London

Paul Gustave Louis Christophe Doré (1832–1883) was a highly successful French artist who is best known for his wood engravings and illustrations of the Bible and several famous literary works, including *Don Quixote* by Miguel de Cervantes (1863), *Paradise Lost* by John Milton (1866) and *The Rime of the Ancient Mariner* by the English poet Samuel Taylor Coleridge (1875). First published in 1798, and Coleridge's longest poem, it recounts the tale of an old sailor who holds the attention of a wedding guest by relating the story of a long and arduous sea voyage the mariner claims to have experienced in his past. Highly romantic, and dealing with the powers of nature, fate and the supernatural, Coleridge's poem found great appeal during the Victorian period. It also became widely popular in European literature. This illustration from a German edition of Coleridge's famous epic (*Der alte Matrose* by Ferdinand Freiligrath, published in Leipzig in 1877) depicts an episode early in the poem, when the mariner's ship is driven steadily southwards into the icy polar seas. The helpless vessel is tossed by huge waves in a raging storm, while in the background giant waterspouts rise into the freezing air. Doré's detailed depiction of this inhospitable and frightening scene is the perfect accompaniment to the sombre, portentous text of the poem.

Gorham Manufacturing Company

Pitcher, 1882
Silver, 22.9 × 21 × 17.5 cm / 9 × 8¼ × 6⅞ in
Metropolitan Museum of Art, New York

Tumultuous waves crash and foam as agitated fish dart to and fro in this dynamic scene decorating a silver pitcher. The sinuous imagery is echoed by the vessel's elegant curves, in particular its cast serpentine handle, which takes the form of a Mizuchi, a legendary Japanese water dragon and deity. The aquatic motifs are closely inspired by Japanese prints – the curling wave crests closely resemble those of Katsushika Hokusai's iconic *The Great Wave* (see p.127) from his *Thirty-Six Views of Mount Fuji* – and have been applied by repoussé, a technique in

which metal is shaped by hammering to create a low relief. This exquisite piece of tableware was produced by Gorham, one of the world's leading nineteenth-century silver manufacturers and the first American company to incorporate Japanese-inspired designs into its products, ahead of competitors such as Tiffany & Co. John Gorham, who inherited the firm from his father in 1848, spearheaded the trend, recruiting craftsmen from Britain who were already working in the Japanese style, and assembling a large reference library about East Asian ornament.

By the 1870s, *Japonisme*, the enthusiasm for things Japanese, was flourishing in the United States even more vigorously than in Europe, where Japanese influence on the decorative arts had been growing since Japan opened its borders in 1853 after centuries of isolation. While the island nation's complex relationship with the sea is reflected in numerous items of silverware from the period, few portray the ocean's threatening power as vividly as this pitcher.

Ran Ortner

Deep Water No. 1, 2011
Oil on canvas, triptych, 1.8 × 7.3 m / 6 ft × 24 ft
Le Bernardin, New York

Holding moments in time has always been the ambition of classical painting, and the very gesture of framing a second in the life of this planet has a deep existentialist root. It is part of a confrontation with the inexorable passing of time that manifests in everything around us that moves, from the passing of seasons to the growth of plants or the wilting of flowers. Acclaimed American artist Ran Ortner (b. 1959) has pushed this concept to the limit of the representable. His enormous canvases portray vast and simmering swaths of oceanic waters. Inspired by the emotional complexity found in the paintings of Old Masters, the meticulous attention with which he reproduces the refraction through and across the dappled waves evokes a palpable tension, heightened by the intensity of innumerable layers of oil paint. Sublime in essence and irremediably timeless, Ortner's paintings abandon artistic tradition to capture the sea at its most elemental – neither the backdrop of naval victories nor the setting of miraculous events. His close cropping invites intimacy, decontextualizing the subject while simultaneously rendering it enchanting and terrifying. Viewers are literally lost at sea: no shore in view, experiencing an impossible sight of shattering beauty, engulfed in its uncontainable forces. What simmers beneath the ruffled waters? Ortner has no doubt that his paintings are a kind of abstract self-portrait: representations of transcendental connections between the human and natural worlds that words can never fully express.

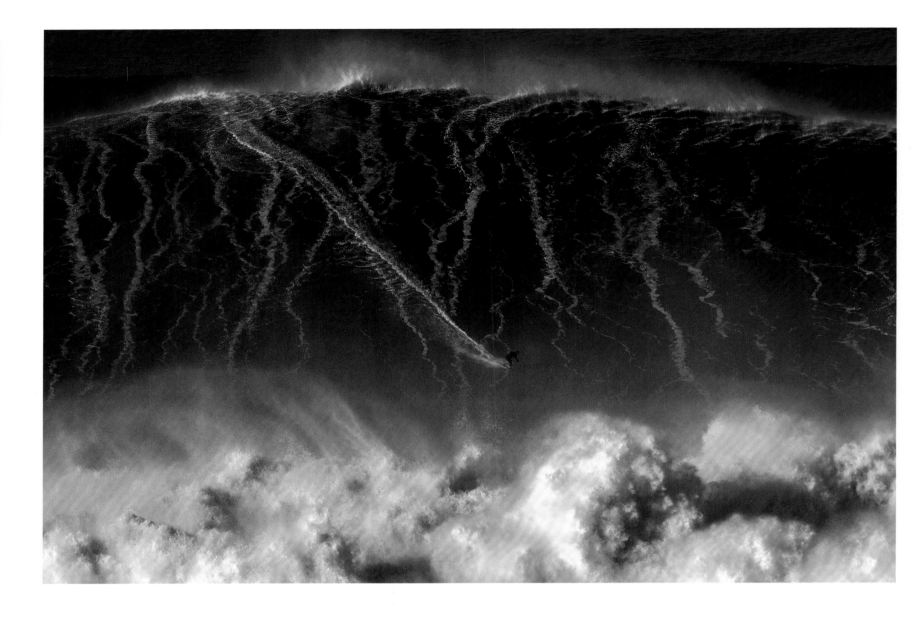

Octavio Passos

Sebastian Steudtner, Praia do Norte, Nazaré, Portugal, 2018
Photograph, dimensions variable

German surfer Sebastian Steudtner cuts a diagonal line across a huge wave as it crests above foaming surf at Praia do Norte on the Portuguese coast. For any surfer, the holy grail is to ride a 30-metre (100-ft) wave, but those waves are not easy to find. To date, despite occasional claims to the contrary, the highest wave recorded is a mere 24.3 metres (80 ft), so the quest continues. When the wave will come is uncertain, but where it will come is more predictable: Nazaré, a fishing hamlet in the far west of Portugal, north of Lisbon. Most of the world's best surfing happens in remote islands in the middle of the ocean, such as Hawaii and Tahiti, where the sea goes from very deep to very shallow in a short distance. That was why in the mid-1900s surfers flocked to Hawaii and photographers followed. Today they flock to Nazaré, which was almost completely unknown until 2010 but is where the underwater topography generates huge waves thanks to an anomaly dating from the formation of the Atlantic Ocean during the Jurassic period around 150 million years ago. Off Nazaré is a huge underwater canyon three times larger than the Grand Canyon and up to 4.8 kilometres (3 mi) deep that funnels monster waves towards Nazaré's photogenic Praia do Norte, overlooked by the sixteenth-century fort of São Miguel Arcanjo and its red lighthouse. Advances in surf technology and the advent of tow-in surfing have allowed surfers not only to access Nazaré's monster waves but to ride them as well; this photograph by Portuguese photographer Octavio Passos (b. 1987) taken in January 2018 expertly captures the thrill.

Anonymous

Artwork for *The Poseidon Adventure* film poster, 1972
Private collection

The Poseidon Adventure was originally released more than fifty years ago, in 1972, but remains one of the most popular disaster movies of all time, telling the story of passengers surviving in an overturned ocean liner. The iconic poster art depicts the moment a fictional freak wave caused by an undersea earthquake in the Atlantic Ocean engulfs the SS *Poseidon*. The movie, directed by Ronald Neame, is based on the 1969 novel of the same name by Paul Gallico, and was inspired by an incident during World War II when the SS *Queen Mary*, laden with US troops bound for Europe, was sunk by a giant wave. In the movie, the *Poseidon* – named after the Greek god of the sea and the bringer of storms and floods – is sailing from New York City to Greece on New Year's Eve when a huge wave flips it upside down, killing all but ten of its passengers. In true disaster-movie style, the survivors battle fires, flooding, the ship's malfunctions and in-fighting in a desperate attempt to escape a watery grave. The poster art captures the terror the glamorous passengers must have felt as – dressed in evening wear – they were caught completely unprepared for the desperate journey they would have to make up to the bottom of the liner's hull before it sank.

Zaria Forman

Whale Bay, Antarctica No. 2, 2016
Soft pastel on paper, 1.3 × 1.9 m / 4 ft 2 in × 6 ft 3 in

From Greenland's ice sheet in the Arctic Ocean to the Maldive Islands in the Indian Ocean, American artist Zaria Forman (b. 1982) has travelled the globe in her quest to document landscapes at the forefront of climate change. This large-scale pastel drawing captures the grandeur of a towering glacier in Antarctica, the ethereal majesty of which was unlike anything the artist had seen before. Intense turquoise and gradations of blue and grey delineate the fissures, folds and textures of the snowy ice, which are reflected in the shimmering water below.

The drawing's realism and scale capture something of the overwhelming experience of witnessing a glacier up close. Wherever she travels, Forman's process begins with taking thousands of photographs on location, which, along with her memories, inform the enormous drawings she makes in her New York studio. Beginning with pencil outlines, she builds her images up slowly, manipulating and blending the powdery pigment with her palms and fingertips to achieve striking photorealistic results. Taking upwards of two hundred hours to complete,

her drawings capture moments of transition, instability and tranquillity, highlighting the fragility of these imperilled locations. Melting glaciers are a major factor in global sea level rise, which has already begun submerging some of the world's lowest lying islands. As records of sublime landscapes in flux, Forman's glacier drawings celebrate the beauty of what we all stand to lose. She hopes that viewers will grasp the urgency of the climate crisis and be inspired to take action so that these locations are protected and preserved.

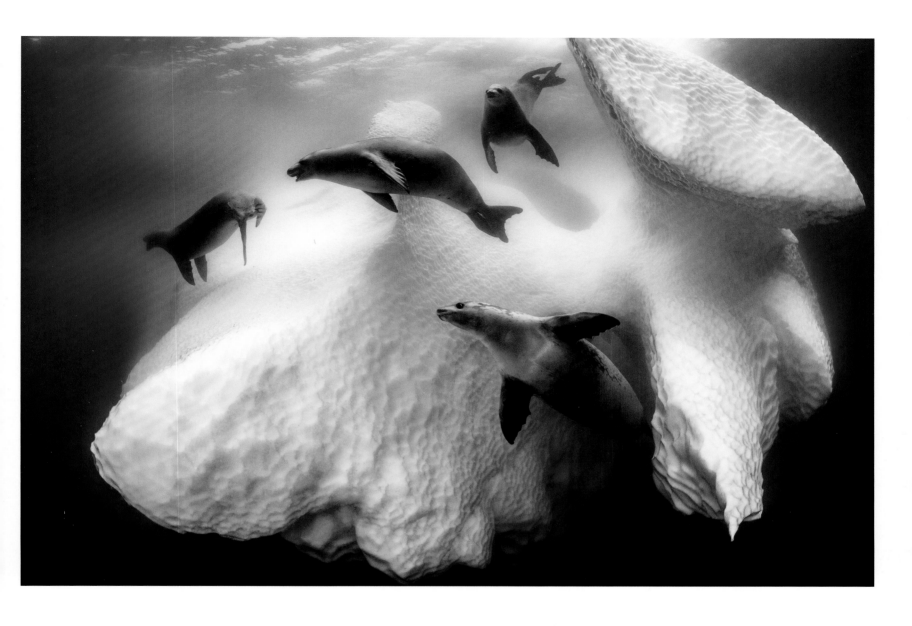

Greg Lecoeur

Crabeater Seals Swimming among Iceberg, Antarctica, 2019
Photograph, dimensions variable

Beneath the muted light of a cloudy sky, with a hint of ripples to define the surface of the sea above, four crabeater seals swim as if choreographed around the dimpled faces, darkly enigmatic passages and semi-caves of a sculpted iceberg. Crabeaters are the most numerous seals on the planet, with estimates of their population ranging from ten to fifty million, although they are hard to count because of where they live, scattered in the Antarctic pack ice. Despite their name, they don't eat crabs; krill is their main diet, which are captured by special tricuspid teeth

that let water pass between them when they close their mouths, trapping the krill inside. The Norwegian word for krill is *krip*, which the English turned into *crab* … and the name stuck. Crabeaters are not as vocal as Weddell seals, with whom they share the pack ice. Instead of deep grunts and long whistles, they make a kind of broken and guttural 'benevolent growling', like a heavy old door being opened slowly on unoiled hinges. It's the only element missing from this striking image by renowned French underwater photographer Greg

Lecoeur (b. 1977). The perfect composition of the seals – showing just how relaxed they are in the company of the photographer – and the dramatic lighting, in which the iceberg fades into the blue-grey distance, won Lecoeur the Underwater Photographer of the Year award in 2020. Originally from Nice, Lecoeur trained as a diver before taking up underwater photography, which he uses to highlight the fragility of environments such as the Antarctic, the subject of his 2020 book *Antarctica*.

Eugene Hunt

Sea Lion Rock, 2001
Serigraph print on paper, 44 × 38 cm / 17⅜ × 15 in
University of Victoria Legacy Art Galleries, British Columbia, Canada

Groups of sea lions huddling together on small islands of rock are a common sight along Canada's west coast. Found in every ocean on Earth except the Atlantic Ocean, the sea lion, like its relatives the seal and walrus, has for centuries provided sustenance – both literal and metaphysical – for indigenous cultures of the Pacific Northwest. Eugene Hunt (1946–2002), a member of the Fort Rupert Band of the Kwakiutl or Kwakwaka'wakw people, belonged to a tradition that both depended upon and revered the sea mammals, whose whiskers were used in their ceremonial

headpieces. Born in Albert Bay, British Columbia, Hunt spent four years in the early 1960s as a wood-carver, following the dominant artistic medium among Pacific Northwest cultures before abandoning his art career entirely to work as a commercial fisherman for the next twenty-five years. He only returned to his art in 1987, when he began to paint. Working alongside other notable Kwakwaka'wakw artists, including his relatives Calvin Hunt and George Hunt Jr, Hunt explored his fascination with blending traditional Kwakiutl art and a graphic landscape style.

In this image, which was originally painted on a hide covering a drum, the artist uses the angular lines and shapes of traditional indigenous art to show the dorsal fins of three orca whales breaking above the waterline, while two cormorants share the rocky outcrop with the sea lions. The sky is an almost bleached yellow, a colour often used by Kwakwaka'wakw artists, and Hunt's Pacific Ocean is a dark, foreboding blue.

Enzo Mari

16 Pesci, 1974
Expandable resin with wood grain in a silk-screened case,
34 × 25 × 3 cm / 13½ × 9⅞ × 1¼ in
Private collection

This puzzle is deceptively simple. Created for the manufacturer Danese Milano in 1974 by visionary artist and designer Enzo Mari (1932–2020), the sixteen fish are hand-jigsawed out of resin in one continuous cut. Interlocked, the three mammals, one mollusc and twelve fish fit neatly into the silkscreened case, but remove them from their snug home and all sorts of compositions and compact sculptures become possible. Each aquatic creature is designed to stand upright, allowing them to balance on each other in limitless configurations.

Once the figures are set free from the confines of the case, it takes clever problem-solving to fit them back together again. Mari collaborated with various companies over his sixty-year career to create innovative games, chairs, tables, plates, vases, tiles, books and more. (In 1957, Mari designed the predecessor to *16 Pesci*: *16 Animali*.) His politics were built into his creations: in an era of rampant consumerism, he rejected the idea of disposable objects and championed design that was elegant, affordable, useful and built to last. He prioritized

beautiful lines not only to create an inspired experience for the user but also for the sake of the factory workers – to relieve them from what Karl Marx termed 'alienated labour'. Danese Milano continues to release *16 Pesci* – now cut from a single block of oak – as a limited edition of two hundred each year. Manufacturing this delightful puzzle in one masterful cut must be a satisfying endeavour – just as Mari intended.

Eye of Science

Spiny Dogfish Skin, 2004
Coloured scanning electron micrograph, dimensions variable

The mechanical appearance of this electron micrograph belies the natural origin of the specimen and displays the wonder and scientific value of portraying biological structures at high magnification. The array of flexible, overlapping scales forms the outer surface of the skin of a dogfish, a small relative of sharks. The reflective surfaces of the scales lend a metallic effect that suggests the skin is reminiscent of part of a medieval suit of armour. In common with many other sharks and dogfish, the pointed scales of the outer skin layer feel rough to the touch, like sandpaper. Each scale consists of dentine and dental enamel and is attached at the base by a bony anchor. In life, this tough outer skin layer, rough in one direction yet smooth in the opposite, gives the dogfish a degree of protection against attack while also allowing the water to flow smoothly over its body. The fluted shapes of the scales create a hydrodynamic effect, lowering turbulence and reducing the drag on the fish as it swims through the water, thus saving energy. The spiny dogfish (*Squalus acanthias*) is found in shallow, temperate seas around the world and lives mainly close to the seabed. It was once common but has declined steeply in recent decades, mainly through overfishing combined with its slow rate of reproduction, and is now listed as critically endangered in the northeast Atlantic.

Pete Oxford

Whale Shark, Cenderawasih Bay, West Papua, Indonesia, 2015
Photograph, dimensions variable

Cenderawasih Bay, a remote marine park located on the island of West Papua in eastern Indonesia, is the largest natural park in southeast Asia. Known for its extensive coral reefs, it is also home to the gentle whale shark (*Rhincodon typus*) captured in this image by British-born conservation photographer Pete Oxford. Found in all the world's tropical seas, whale sharks have distinctive white spotted skin that makes them easy to recognize, and local fishermen consider them as symbols of good luck, sometimes feeding them with tidbits of baitfish to ensure that luck. In Cenderawasih Bay, feeding the whale sharks has become a tourist attraction, and swimming close to these giants is a popular activity for both snorkellers and divers. Despite their popularity, little is known about the lives of whale sharks, which hold the record as the world's largest shark: they are thought to reach a maximum size of 18 metres long (59 ft). Plankton feeders, they will travel vast distances to find sufficient quantities of food they need to survive, and while they feed at the surface of the water – as in this photograph – they can dive to depths up to 2 kilometres (1.25 mi). To date, there has been no record of a female whale shark giving birth, and it remains mostly unknown how the young pups are raised. Oxford has based his photographic career on capturing life in some of the world's most remote – and pristine – locations with the stated mission of hoping that his arresting images convert more people to conservationism.

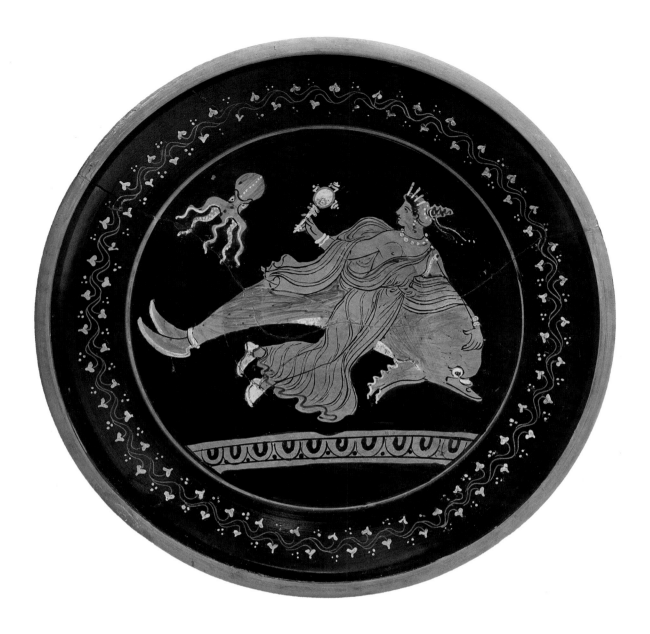

Workshop of the Darius Painter

Plate with a Nereid and Dolphin, c.340–320 BC
Glazed terracotta, Diam. 27.8 cm / 11 in
State Hermitage Museum, St Petersburg

A beautiful nereid, or sea nymph, is depicted in stunning detail with a dolphin and octopus on this plate from the fourth century BC. In Greek mythology, the nereids were the daughters (fifty or a hundred, depending on the source) of Nereus and Doris. Doris, herself a sea nymph, was the daughter of the Titans Ocean and Tethys, while Nereus was the eldest son of the primordial deities Pontus, the sea, and Gaia, the Earth. The nereids are consistently portrayed as benign guardians of sailors and fishermen who often come to the aid of those in distress at sea. They are usually represented as beautiful maidens, frequently accompanying Poseidon, supreme god of the sea, and shown with sea creatures such as dolphins or seahorses. Individually, they represented different features of the sea, such as waves, foam, currents or sand, as well as specific sailing skills. This plate may show the nereid Amphitrite, who had the power to still the winds and so calm the sea. According to Greek myth, Amphitrite, one of the most beautiful nereids, was spied by Poseidon at a dance on the island of Naxos, but rather than marry him, she fled. Poseidon sent a dolphin to search for her, and she was eventually found in the depths of the sea. Amphitrite and Poseidon were married, and she became the queen of the sea (see p.92). This plate is attributed to the workshop of the Darius Painter (*fl. c.*340–320 BC), who probably lived in modern Puglia and who is known for his works in the Ornate Style of south Italian red-figure vase painting.

Anonymous

'Jonah and the Whale', from a *Jami al-Tavarikh* (*Compendium of Chronicles*), c.1400
Ink, opaque watercolour, gold and silver on paper, 33.7 × 49.5 cm / 13¼ × 19½ in
Metropolitan Museum of Art, New York

Widely depicted by artists across centuries, the story of Jonah and the whale (see p.131) is included in the Old Testament as well as in the Qur'an, where Jonah is also considered a prophet – the only one of the Twelve Minor Prophets to be named in the Islamic tome. This large folio leaf comes from a copy of the *Jami al-Tavarikh* (*Compendium of Chronicles*) by Rashid al-Din Hamadani, who lived under the fourteenth-century Mongol Ilkhanate. The painting was probably produced in Iran and may reflect a lost tradition of wall painting there. In the tale, Jonah attempted to sidestep a command by God to prophesy against the wickedness of the people of Nineveh and instead set sail for Tarshish. When a storm threatened to sink the ship, he admitted to being the cause of God's anger and was thrown overboard to calm the seas. He was swallowed by a whale and remained in its belly for three days, praying to God and promising to do his bidding; God then commanded the whale to release him. Here, a naked Jonah is vomited up by the whale and an angel flies in to clothe him. The gourd vine above him represents a later gift from God, to shade him from the sun. Despite usually being depicted as a whale, the creature that swallowed Jonah is described in Hebrew as *dag gadol*, which simply means 'big fish'. Some biblical scholars have suggested that the whale was actually a great white shark. However, even the largest blue whales feed on microscopic plankton and would be completely unable to swallow a man.

287

نتو ... بحالیکی دریدپاه دودیوان دیبای نفرد روعرآون نهر صوعیها رصح نادراروریا

Anonymous

The Gods and Asuras Churn the Ocean of Milk, from *Razmnama*, c.1598–99
Opaque watercolour, ink and gold on paper, 30 × 18 cm / 11¾ × 7 in
Free Library of Philadelphia

Although the figures in this illustration are wearing costumes associated with the Islamic Mughal court that ruled India from 1526 to 1858, the story in which they are taking part is not Islamic but Hindu. Hindu cosmology contains seven oceans, made of different substances such as syrup, butter and treacle, of which the Ocean of Milk is the fifth from the centre. In an episode from the Mahabharata, one of the founding texts of ancient India, the Devas, or gods, and the Asuras – divine beings conceived as demonic anti-gods – combine to churn the Ocean of Milk to release a magic elixir called *amrit*, which bestows immortality on those who drink it. The deities placed a mountain on the back of a giant tortoise in the middle of the ocean and rotated it back and forth by using the Serpent, Vasuki, as their churning string. They churned the milk for a millennium, releasing initially a choking poison that was valiantly swallowed by the god Shiva, turning his throat blue. When the *amrit* was finally released, the gods and demons fought over its possession before the gods were ultimately victorious. This illustration from *Razmnama*, or *Book of War* – a Persian translation of the Mahabharata written at the behest of Emperor Akbar – shows the ocean's release of *amrit* plus a wish-granting tree and a celestial steed. The subtle greens of the background and creamy yellows of the costumes stand out against the pale grey of the ocean and milky white of the elephants and other creatures.

Jarinyanu David Downs

Moses and Aaron Leading the Jewish People Across the Red Sea, 1989
Synthetic polymer paint on canvas, 2 × 1.4 m / 6 ft 6 in × 4 ft 6 in
National Gallery of Australia, Canberra

Born in Australia's Western Desert region, Jarinyanu David Downs (c.1925–1995) lived a traditional Aboriginal life, working as a drover on a stock route in the desert until he moved to Fitzroy Crossing in Western Australia in the 1960s. There, he converted to Christianity and began to produce shields and boomerangs before turning to painting in the early 1980s. His work reflects his indigenous culture and his Christian beliefs, and his compulsion to connect the two. This painting, dating from 1989, uses an ancestral narrative to interpret the Old Testament

story of Moses, Aaron and the Jewish people fleeing across the Red Sea to escape the Egyptians. For the Western Desert peoples, there is a parallel between the biblical story and their own narrative of the Tingari, creator beings who are typically described as two figures leading people across the desert. The sea appears as a slender blue arc – its small size reflecting its absence from Aboriginal desert culture – where the Egyptians and their horses drown. Guiding the escapees to the promised land are tilly lamps – old kerosene lamps – Downs remembered from his

childhood. Among the dozens of footprints are two sets that are much larger than the rest, which symbolize Moses and Aaron. Each footprint has six toes, showing that – as with the Tingari – their makers were not mere mortals but were possessed with supernatural powers. The painting summarizes Downs' own belief that Aboriginal spirituality and Christian teaching asked and answered the same questions.

Anonymous

Adire eleko (Wrapper), 1950–66
Hand-painted starch resist and indigo-dyed cotton, W. 1.7 m / 5 ft 6 in
Museum of Applied Arts and Sciences, Sydney

This Yoruba *adire eleko* cloth wrap, made in western Nigeria in the mid-twentieth century, displays the popular Olokun design, representing the goddess of the sea. Olokun is an *orisha* – a spirit sent by the supreme god, Olodumare, to assist humanity – who rules over the sea and all other bodies of water, as well as over other water spirits. In coastal areas, Olokun is referred to as a male god and is responsible more generally for his followers' wealth and prosperity, while inland, the deity is considered female. *Adire* is cloth that has been resist-dyed using indigo, and *eleko* refers to the technique used to create the design. A paste made of cassava flour is boiled with alum to make a heavy starch, with which the artist paints designs including plants and flowers, animals, geometric shapes and other regular patterns. (This wrapper has the letters 'OK' painted on solid chess-board squares, as if to indicate its high quality.) The cloth is then dipped into the dyeing vat, where the cassava-painted areas resist the indigo, resulting in a white-on-blue design. After drying, the cloth is beaten with a wooden mallet, producing a high sheen.

During the dyeing process, women make regular offerings to the goddess Iya Mapo, who is believed to assist in the work. *Adire* cloths are stitched together from two similar lengths of fabric and worn by men and women, wrapped around the body and secured by twisting the ends. Most today are stencilled rather than hand-painted, although special cloths are still made for religious ceremonies.

Nicolas Floc'h

Productive Structures, Artificial Reefs, -23m, Tateyama, Japan, 2013
Carbon print on fine art matte paper, 80 × 100 cm / 2 ft 8 in × 3 ft 3 in

This submerged structure covered in living organisms may appear at home beneath the ocean, but it is too geometrically precise and symmetrical to occur in nature. It is an example of an artificial reef, a structure made from hollow cubes of concrete or metal beams deliberately planted on the seabed to encourage the creation of underwater ecosystems similar to those that live around natural reef habitats. French artist Nicolas Floc'h (b. 1970) has photographed artificial reefs since 2010 (he sculpts them, too, at one-tenth size), and for this project joined the schooner *Tara Pacific* in 2013 to document some of the many 'underwater cities' in the waters off Japan, some of which date back to the seventeenth century. Japan has as many as 20,000 sites at depths of between 10 and 80 metres (30–260 ft), each with thousands of artificial reefs, some of which tower 35 metres (115 ft) high. Once submerged, the artificial structures are slowly colonized and become the centres of dense communities of corals, ferns, molluscs and fish. Floc'h captured the reefs in his favoured black-and-white medium to show their eerie beauty while also documenting their important scientific function. The artificial reefs are generally located in protected marine areas, where their presence prevents huge trawlers from dredge-fishing and forces a reconsideration of more sustainable ways of fishing. They also provide a habitat for sea life, offering protection and allowing different parts of the ocean to regenerate as changing conditions, such as climate and human disruption, destroy natural coral reefs.

Schmidt Ocean Institute

Hydrothermal Vent, 2019
Photograph, dimensions variable

Looking like a scene from science fiction, this otherworldly environment lies 2,000 metres (2.25 mi) below the Gulf of California, where pink plumes of superheated, mineral-rich fluid billow from the ocean floor. The spellbinding image was taken by a deep-sea underwater camera on a remotely operated vehicle during a Schmidt Ocean Institute expedition led by microbiologist Mandy Joye. Joye's team discovered a remarkable seafloor habitat: a valley of enormous hydrothermal vents along a meandering path of faults and fissures in the East Pacific Rise, a tectonic plate boundary in the bed of the Pacific Ocean. The vents are like underwater hot springs, where seawater that has seeped into the Earth's crust is superheated and forced back out into the ocean. Colossal mineral towers were observed spewing noxious, sherbet-coloured cocktails of chemicals and metals at an astonishing 366° Celsius (690° F). Each one rippled with mirror pools – mesmerizing reflective puddles that, due to the extraordinary temperatures, form underneath jutting rock forms known as flanges. The seafloor is a remarkable natural laboratory, and the possibility for making new scientific discoveries there is vast, giving researchers new perspectives on how the world works. Joye, who studies the micro-organisms living in these seemingly inhospitable sites, was amazed to find that virtually every surface was teeming with colourful life forms, some of which might one day be used to develop antibiotics or anti-viral medicines. These habitats also give scientists a glimpse into the primordial processes that formed the planet, adding to an understanding of how life on Earth developed.

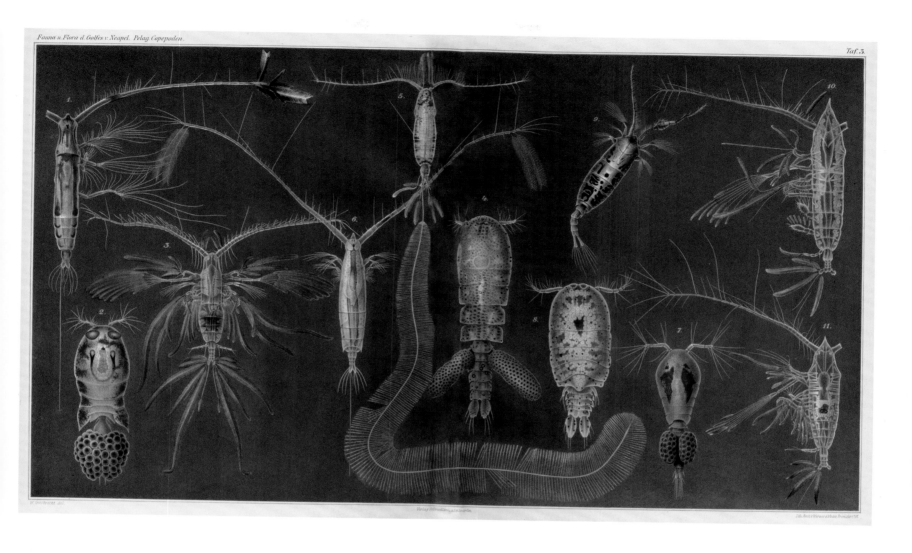

Fauna u. Flora d. Golfes v. Neapel. Pelag. Copepoden. Taf. 5.

Wilhelm Giesbrecht

Plate from *Systematics and Geographical Distribution of the Pelagic
Copepods of the Gulf of Naples and the Adjacent Seas*, 1892
Lithograph, H. 34 cm / 13⅜ in
Marine Biological Laboratory, Woods Hole Oceanographic Institution Library, Massachusetts

This lithograph is a beautiful testament to what has been dubbed the 'golden age of copepodology', a period from about 1890 to 1910 when naturalists made remarkable advances in the study of these tiny aquatic crustaceans whose name, meaning 'oar feet' suggests the way they use their filamentous antennae to move jerkily through the water. Copepods live in virtually every water habitat in the world, including in many types of fresh water, and both in the open ocean and on the seabed. Of around thirteen thousand species that are known – there are likely many more – more than ten thousand inhabit the oceans. Because copepods are so widely distributed, they have become a useful indicator of biodiversity; those that live a planktonic life at sea, drifting with the current or moving themselves along, are an important source of food for other, larger forms of marine life. The study of copepods grew in popularity in the decades after Darwin published his theory of evolution in 1859, as naturalists rushed to catalogue Earth's creatures and the relationships between them. These illustrations – enlarged between twenty and eighty times their natural size to display the variety of shape and structure within the 'basic' copepod body plan – were created by Prussian zoologist Wilhelm Giesbrecht (1854–1913), a pioneer of copepod studies. Born in Danzig (now Gdansk, Poland), he studied for a doctorate at Kiel, where he examined the copepods of the Baltic Sea before moving to the zoological station in Naples, Italy, to continue his work in the Mediterranean. After decades of meticulous research, he published his studies in 1892, including fifty-four plates, of which three, including this one, were published in full colour.

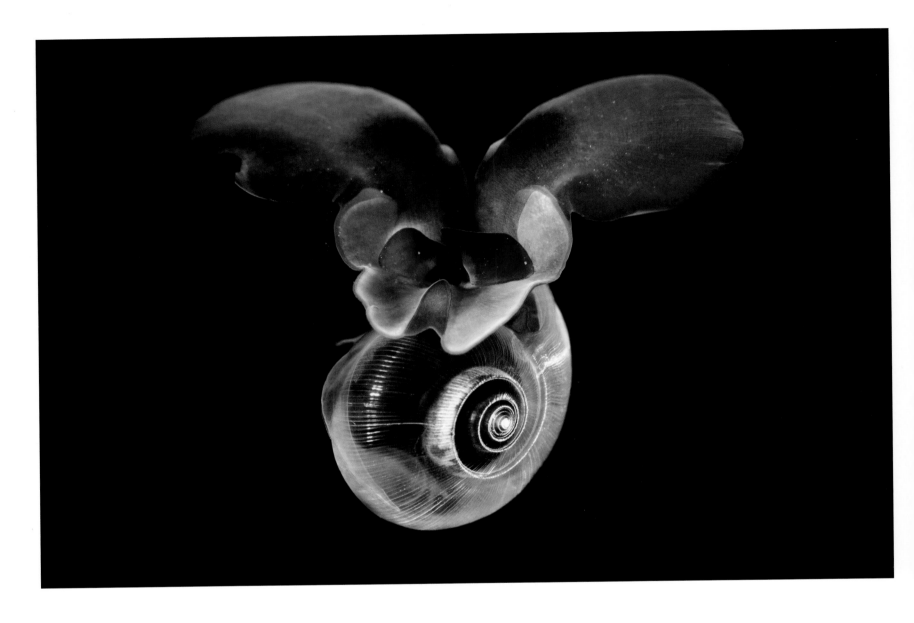

Alexander Semenov

Sea Butterfly, 2013
Digital photograph, dimensions variable

Oftentimes marine creatures surprise us with remarkable body shapes and otherworldly colourations. This is certainly the case with sea butterflies (suborder Thecosomata) – a little-known mollusc that, instead of crawling on the seabed, flutters almost weightlessly across currents in search of food. Similar to other animals of the order Pteropoda, the animal has evolutionarily developed two winglike lobes that it can flap rhythmically to propel itself through the water. The shell of sea butterflies tends to be thin, light and translucent, as is the case with

this species (*Limacina helicina*) photographed in the Arctic Sea by Russian marine biologist Alexander Semenov, head of the divers' team at Moscow State University's White Sea Biological Station. Widespread across seas around the globe, sea butterflies feed on plankton that they entangle in a mucous web. An important link in the marine food chain, they can be as small as a lentil or as large as an orange and are a source of food for whales, sea birds and many other fish. Most abundant in the Arctic and Antarctic waters, sea butterflies can congregate in large masses

that attract whales, which earned them the simple but apt moniker of 'whale food' from Nordic fishermen. Planktonic organisms such as these have complex biorhythms linked to the currents, temperature and lighting conditions of the environment they live in, making them highly susceptible to climate change such as ocean acidification, and cannot be studied in a laboratory. Tiny species such as *Limacina helicina* also require highly specialized underwater photographic equipment and lighting in order to capture their remarkable natural beauty.

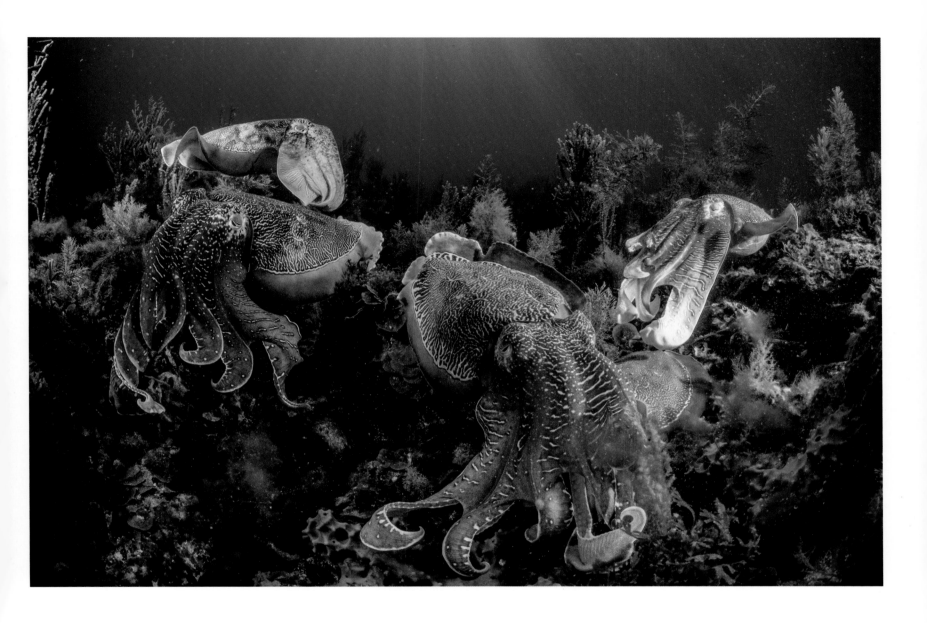

Scott Portelli

Australian Giant Cuttlefish, Upper Spencer Gulf, South Australia, 2016
Photograph, dimensions variable

Four ghostly cuttlefish clamber over a reef as part of a mass spawning event near the Australian coast. In the excitement of their encounters, the males switch from their usual cryptic skin colours to strikingly bright patterns, while flaring the frilly margins of their tentacles. The Australian giant cuttlefish, *Sepia apama*, is the largest known species of cuttlefish and is found only around the southern coastal waters of Australia. The breeding behaviour of these molluscs peaks in May and June, involving thousands of individuals gathering at particular sites, where they indulge in elaborate displays before the males fertilize the females by transferring packages of sperm (spermatophores). Each female then lays up to three hundred leathery eggs, carefully inserting them into the safety of rock crevices. Giant cuttlefish live for around two years and many die soon after spawning, providing easy prey for predators, which include fish, dolphins and fur seals. This image of cuttlefish was shot by Scott Portelli, a professional wildlife photographer based in Sydney, Australia. He travels widely and has photographed many animals, from bears, big cats and elephants to whales and marine invertebrates, receiving several international awards for captivating images that highlight the importance of wildlife conservation. A hallmark of his work is the employment of non-invasive techniques in natural environments, thus minimizing disturbance while capturing photographs of the highest quality.

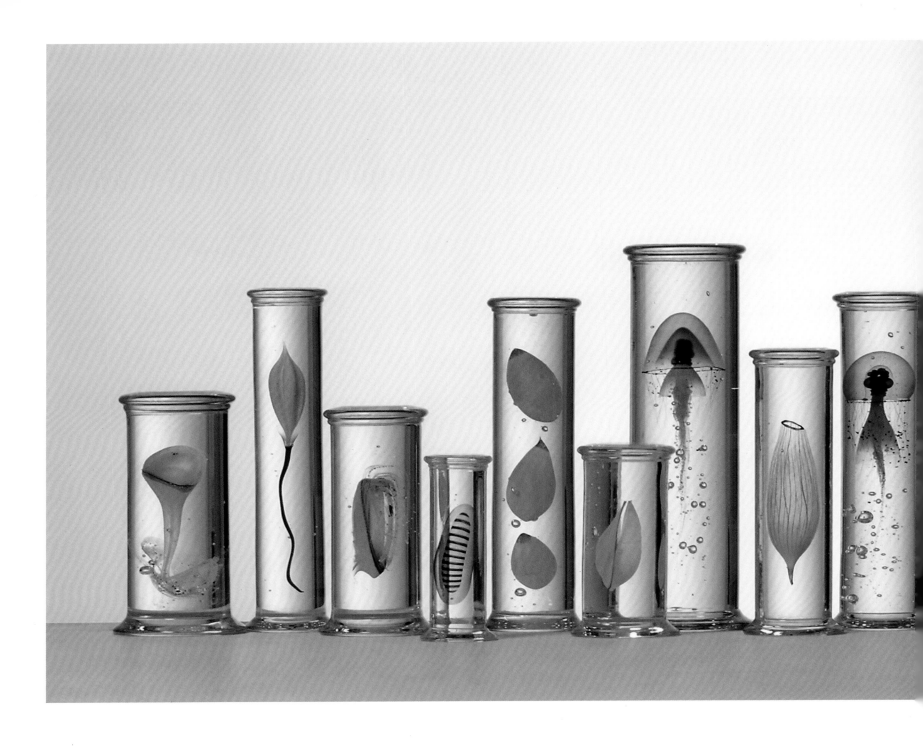

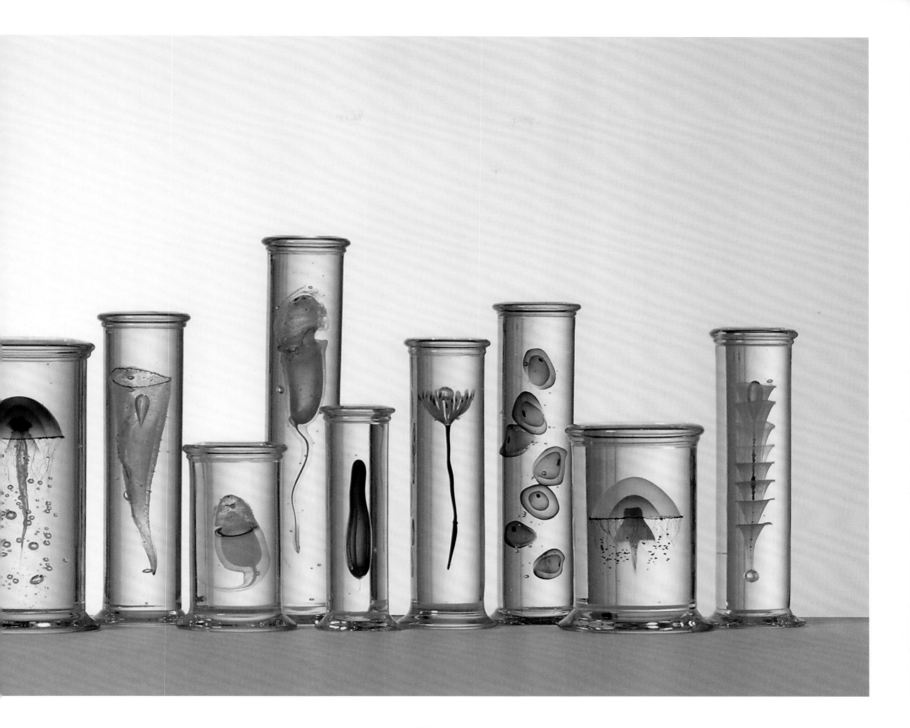

Steffen Dam

Specimens from an Imaginary Voyage, 2017
18 glass jars, dimensions variable
Royal Albert Memorial Museum & Art Gallery, Exeter, UK

Delicate and graceful specimens in tall glass cylinders are seemingly caught in suspended animation; streams of bubbles suggest movement, but the creatures are frozen still. A closer look reveals that each one is made from solid glass and entirely invented: ocean organisms from another world. Danish glass artist Steffen Dam (b. 1961) took his inspiration for these sculptures from the collection of echinoderms – starfish, sea urchins and similar species – amassed by Victorian biologist Walter Percy Sladen and donated to the Royal Albert Memorial Museum & Art Gallery in Exeter, England. Sladen played a significant part in identifying and describing specimens collected on the voyage of the HMS *Challenger* (1872–76), a scientific expedition that laid the foundations for modern oceanography. Working from his studio in a 1930s schoolhouse in rural Denmark, Dam uses assorted techniques to create his otherworldly forms, from traditional glassblowing and casting to more experimental methods. Dam is known for harnessing unusual visual effects arising from faults and irregularities in the glass-making process. Bubbles, flecks of dirt, soot residue and other aberrations that would normally be rejected are embraced and their creative potential explored. Dam's art is born from a curiosity about the world that was nourished from an early age by his grandfather's natural-history books. Evoking sixteenth-century *wunderkammers*, or cabinets of curiosities, his collections of imaginary marine species induce a similar sense of wonder while acknowledging the scientific impossibility of achieving a complete understanding of the oceans and their inhabitants.

297

Asteroidea.

180. 11.

2

a

1

e

b

Astropecten
aurantiacus.

6/1

d

c

a

m

p

4

o

r

n

r

a

3

Paul Pfurtscheller

Astropecten, No. 11, Pfurtscheller's Zoological Wall Chart, early 20th century
Colour lithograph, 1.4 × 1.2 m / 4 ft 6 in × 4 ft
Humboldt-Universität, Berlin

Austrian zoologist and artist Paul Pfurtscheller (1855–1927) studied at the University of Vienna, after which he became a science teacher at the Vienna High School and at the Franz-Josef Gymnasium, retiring from the latter in 1911. As visual aids for his lessons, Pfurtscheller created a series of large wall charts (*Zoologische Wandtafeln*), thirty-eight in total, showing the structure of animal bodies, including their internal organs, across a wide range of species, from mammals, amphibians and fish to flies, bees and spiders, as well as other invertebrates, including this splendid starfish. Although he had no formal training in art, Pfurtscheller's talent for drawing is clearly visible in this chart of the class *Asteroidea*. The central image shows an adult red comb star (*Astropecten aurantiacus*) partially dissected to reveal the internal organs, and with an arm flexed upwards to show the rows of tube-feet used by the animal as it moves slowly over the seafloor substrate. Beneath are two diagrams showing aspects of the internal structure of the sea star, enabling the teacher to explain in some detail the physiology of this remarkable echinoderm, especially the unique water vascular system from which the tube feet project through holes in the skeleton. A system of canals joins the tube feet, forcing water into the feet to extend them and push against the seabed before relaxing and allowing the feet to contract. Water is pulled in through the sea star's upper surface, distributed by a circular canal and then moved outwards down central grooves in each of the arms.

Mark Dion

The Field Station of the Melancholy Marine Biologist, 2017
Mixed media, 4.9 × 7.4 × 2.7 m / 16 ft 4 in × 24 ft 1 in × 9 ft
Installation view, Storm King, Cornwall, NY, 2018

First installed at Algiers Point in New Orleans in 2017, *The Field Station of the Melancholy Marine Biologist* consists of a dilapidated wooden cabin filled with objects belonging to a fictional marine biologist. The cabin is locked, its contents viewable only through the picture windows; inside is a crowded scene, including work benches with preserved marine species for study, ocean maps, charts of fish, nets, empty jars and vials, tools, life jackets, binoculars and a microscope. Setting out to provoke reflection on climate change, American artist Mark Dion (b. 1961)

has said that his installation captures a moment 'where somebody studying the natural world realizes that the future's not looking so good ... that we are going to lose a great amount of the natural wonders that have been here in previous centuries.' Since its first installation, *The Field Station of the Melancholy Marine Biologist* has been presented at Storm King Art Center in New York State (2018) and at Governor's Island (2021), where Dion adapted its contents to reflect the ecology of New York Harbor. Through his work – often modelled after the curiosity cabinets of

the sixteenth and seventeenth centuries – Dion probes institutions of knowledge and power by appropriating objects and display techniques from places such as libraries, archives and museums. His interventions ask viewers to reconsider their relationship with the natural world, challenging them to dig deeper into the science and knowledge behind environmental politics and public discourse.

Albertus Seba

Arrow Squids (Teuthida), from *An Accurate Description of the Very Rich Thesaurus of the Principal and Rarest Natural Objects*, vol. 3, 1758
Hand-coloured engraving, 54 × 69.4 cm / 21¼ × 27¼ in
Smithsonian Libraries, Washington DC

These colourful arrow squids were once part of the most impressive collection of naturalia in the history of the West. Between 1700 and 1736, Albertus Seba (1665–1736), a Dutch pharmacist and zoologist, curated an immense cabinet of curiosities featuring rare pressed plants, stuffed tropical birds, desiccated fish, delicate shells, coral and starfish. Collecting natural wonders was a way to make sense of the mystery of life and what at the time were considered to be God's creations. Cabinets of curiosities became fashionable during the Italian Renaissance before

quickly spreading across Europe, initially as a form of domestic entertainment and later as an educational and research tool for early naturalists. As colonialist trade routes brought ever more unusual and wondrous creatures to European ports, natural scientists sought to classify species and organize the natural world. To this purpose, Seba enlisted many artists and engravers – including Pieter Tanjé for this plate – to compile a stunning visual record of his collection in a monumental four-volume account, *An Accurate Description of the Very Rich*

Thesaurus of the Principal and Rarest Natural Objects (1734–65). This plate shows the front and back of the arrow squid and its egg clusters, along with the animal's distinctively shaped bone. Considered among the most intelligent of invertebrates, the squid uses a pair of two long tentacles to grab its prey while its other eight arms smother it in a deadly embrace.

Anonymous

Stirrup Jar with Octopus, c.1200–1100 BC
Terracotta, H. 26 cm / 10¼ in; Diam. 21.5 cm / 8½ in
Metropolitan Museum of Art, New York

This Bronze Age stirrup jar (so called after the arrangement of the handles) from the twelfth century BC is Mycenaean, but it was inspired by Minoan Marine style wares dating some two or three centuries earlier. The tentacles of the stylized octopus reach round the body of the vase to meet those of another on the opposite side, and in between the creatures' arms are fish, flowers, compass-drawn concentric curves and, on the shoulder of the vase, a border of sea stones – the octopus's lair. Mycenaean culture drew heavily on Minoan artistic and economic traditions, and it is

likely that this inspiration also encompassed society and religion, based on such evidence as seal stones and wall paintings. Although this jug would have been used to hold olive oil or another liquid, it has been plausibly suggested that all Minoan vessels decorated in the Marine style were meant for ritual use. It is impossible to say if the Mycenaean painter or owner of this vase was aware of any sacred context relating to its decoration, however; cult vessels in the shape of triton shells and argonauts have been found in demonstrably religious contexts on Crete, and

marine scenes occur in shrines, foundation deposits and tombs (see p.226). Gold octopuses have been found in the shaft graves at Mycenae, probably originally stitched onto funerary clothing. It has been suggested that octopuses may represent the idea of regeneration after death, since they have the ability to grow another tentacle when one has been lost.

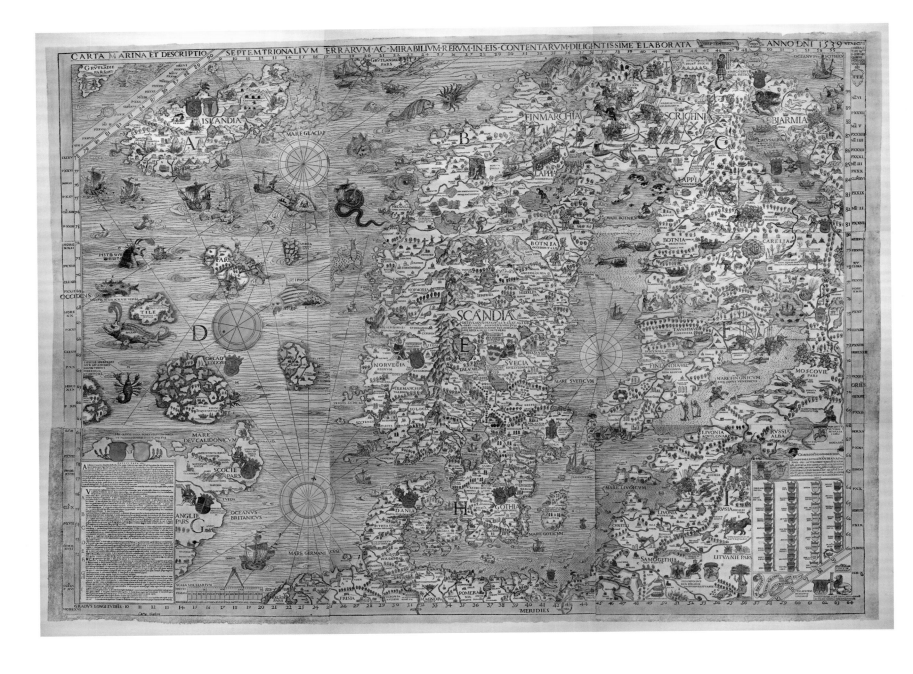

Olaus Magnus

Carta marina et descriptio septentrionalium terrarium, 1539
Woodblock print, 9 sheets, each 50 × 66 cm / 19½ × 26 in
James Ford Bell Library, University of Minnesota, Minneapolis

The *Marine Map and Description of the Northern Lands* by Swedish cartographer Olaus Magnus (1490–1557), originally printed as a woodcut in 1539 and reproduced here in colour, is the earliest reasonably accurate representation of Scandinavia. Created in nine plans, numbered with the letters A through I, it is both a terrestrial map and a sea chart. On land, the map reveals the structures, activities and even politics of Scandinavia. At sea, close to shore, there are scenes of children swimming, fishermen drawing in their catch and boats fighting to stay afloat, while offshore in the deep, sea monsters abound: sea swine with dragons' feet and an eye in the navel appear in the waters south of Iceland, giant whales are shown as big as islands, and the fearsome kraken (possibly the giant squid, *Architeuthis dux*) haunts the seas off Norway and Greenland, along with the leviathan, a huge sea serpent. These are not merely decorative elements to fill the empty seas, nor metaphors for lurking dangers, but were intended to identify actual marine life: many are identified in the map's key. Magnus was a Catholic priest who left Sweden upon its conversion to Lutheranism during the Reformation, and his map drew on ancient Ptolemaic geography as well as contemporary descriptions by mariners and his own research. Magnus discussed the sea creatures in detail in his *Historia de gentibus septentrionalibus* ('Description of the Northern Peoples', 1555), classifying and analyzing them based on a wide range of Renaissance sources, etymologies and current modes of scientific evidence.

Pl. XXVI.

T. 2. P. 256.

Denys-Montfort del.

LE POULPE COLOSSAL.

E. Voysard S.

Pierre Denys de Montfort and Georges Louis Leclerc Buffon

Le Poulpe Colossal, from *Histoire naturelle,
générale et particulière des mollusques*, 1801–2
Engraving, 20.5 × 13.5 cm / 8 × 5¼ in
Smithsonian Libraries, Washington DC

This engraving depicts a gigantic octopus emerging from the ocean and wrapping its long tentacles around a wooden three-masted sailing ship. Two large eyes stare out towards the viewer as the arms of the enormous mollusc secure a firm grip on the masts and rigging of the unfortunate vessel. The illustration is from the two-volume *Histoire naturelle, générale et particulière des mollusques* (1801–2), a continuation of one of the most famous works of French naturalist Georges Louis Leclerc Buffon (1707–1788), *Histoire Naturelle, générale et particulière, avec la description du Cabinet du Roi*, which was published in thirty-six volumes between 1749 and 1789. The plate is entitled *Le Poulpe Colossal* (*Giant Octopus*) and is the work of Pierre Denys de Montfort (1766–1820), who also edited the volume. A French naturalist with a particular interest in molluscs, Denys de Montfort was fascinated by the possible existence of giant species. The illustration is said to have been inspired by descriptions from French sailors who were reportedly attacked by such a creature (or possibly a giant squid) off the coast of Angola. In 1783 an 8-metre-long (26-ft) tentacle from such a mollusc was found in the stomach of a sperm whale. However, it was not until 1857 that the existence of such huge invertebrates was established with the naming of the octopus's relative, the giant squid (*Architeuthis dux*). The giant squid can grow to more than 12 metres (39 ft) and has a wide distribution in the oceans, although it is rare in polar and tropical waters. It can dive to a depth of 1,000 metres (3,280 ft), and sperm whales are known to dive to great depths in search of squid as prey.

Ryusui Katsuma and Shukoku Sekijyukan

Umi no sachi (*The Bounty of the Sea*), 1778
Woodblock print, each page 29.5 × 20.5 cm / 11⅝ × 8 in
British Library, London

'Seen from the bridge, crabs look like red maple leaves scattered on the stream.' / 'The crab is wielding its reckless pincers to cut the algae.' / 'I wonder if the red spot near the bamboo water pipe is a crab or a maple leaf?' So read three haiku – short Japanese poems of three phrases and seventeen syllables – in honour of the humble crab. Illustrated by printmaker Ryusui Katsuma (1697–1773) and edited by Shukoku Sekijyukan (1711–1796), these pages are from the first volume of *Umi no sachi* (*The Bounty of the Sea*), two late eighteenth-century volumes of haikus devoted to

fish and shellfish. On the left page two crabs are depicted in considerable detail, the upper showing the dorsal surface and the lower crab showing its underside, with the segments and texture of the claws picked out with a high degree of accuracy. The species shown is probably the gazami crab (*Portunus trituberculatus*), also known as the blue crab or horse crab. It is one of the most heavily fished of all crabs and is considered highly nutritious. On the right page is a golden threadfin bream (*Nemipterus virgatus*), an edible fish found in the

western Pacific from south Japan to northern Australia. A characteristic feature of this species is the filament trailing from the top of the tail fin, which is clearly visible in the illustration. Flanking the fish are two pairs of edible bivalve molluscs: egg cockles (*Fulvia mutica*) to the right and Asari clams (*Ruditapes philippinarum*) to the left.

Hara Yōyūsai

Inrō with Squid, Shells and Seaweed Design, early 19th century
Case (*inrō*): powdered gold and coloured lacquer on black lacquer with mother-of-pearl and gold inlays;
Fastener (*ojime*): ivory carved with abstract design; Toggle (*netsuke*): ivory carved in the shape of a crab, 8.3 × 5.1 cm / 3¼ × 2 in
Metropolitan Museum of Art, New York

Emerging between fronds of red-brown seaweed as it creeps through dark water, with two long tentacles snaking out to feel among a collection of mussels, whelks and starfish, the shimmering opalescent body of a squid is represented curving around both sides of this Japanese *inrō* case by the Edo period artist Hara Yōyūsai (1772–1845). The *inrō* is a traditional carrying case of stacked compartments for holding small personal objects and medicines, and is often an accessory worn around the waist of a kimono (see p.143). Here, the master lacquer artist Yōyūsai,

working during the early nineteenth century for the Doi clan rulers of Japan's Shimosa Province, Honshu, has used mother-of-pearl inlay on gold-brushed stippled black lacquer ground to conjure the shimmering squid and inlaid and painted gold for the various shellfish and crustaceans. The cephalopod's luminescent presence offers a beautiful encapsulation of the Japanese Rinpa school's fixation on natural subjects seen through a stylized, otherworldly lens and a celebration of an animal that is central to Japanese cuisine and culture. Historically, Japan was

the country most active in squid fishing and remains one of the leading worldwide consumers of squid and cuttlefish. References to the sea and its inhabitants also continue beyond the *inrō* case. The cord – that cinches the *inrō* to the kimono behind the obi, or fabric belt – matches in colour to the seaweed on the case, suggesting a playful extension of the vegetation out from the object, and is gathered at its end by a charming carved ivory crab netsuke, or toggle.

Rudolf Leuckart, Hinrich Nitsche and Carl Chun

Leuckart Chart, Series I, Chart 1: Coelenterata, Anthozoa, Octatinaria, Corallium rubrum, 1877
Chromolithograph on cloth backing, 1.4 × 1.1 m / 4 ft 8 in × 3 ft 6 in
Marine Biological Laboratory, Woods Hole Oceanographic Institution Library, Massachusetts

Dating from 1877, this brightly painted chart – the PowerPoint presentation of its day – was the first in a series of large wall charts produced between 1877 and 1892 by the celebrated German zoologist Rudolf Leuckart (1822–1898), with the assistance of two more zoologists, Hinrich Nitsche (1845–1902) and Carl Chun (1852–1914). Leuckart's *Wandtafeln,* or wall charts, were intended as aids to teach zoology in schools and universities across the world; eventually the series stretched to 116 charts. Often called the father of parasitology for his work on the tapeworm,

among other organisms, Leuckart was also an innovator in zoology. He was the first to demonstrate that, despite sharing a radial symmetry, coelenterates (such as the jellyfish) and echinoderms (starfish) did not share a close relationship. The charts, measuring up to 1.8 by 1.2 metres (6 by 4 ft), were the first real large-scale illustrations used specifically for education. This chart details red coral, jellyfish and a sea anemone drawn in large, anatomically correct detail. Leuckart's assistants – Nitsche and Chun – were also pioneers. Nitsche studied *bryozoa,* aquatic

invertebrates that lived in sedentary colonies, while Chun led the first German expedition into the deep sea, proving that there was life in the lowest depths (see p.134). Before Chun's *Valdivia* expedition, which set sail in 1898, it was believed that nothing lived in the ocean below a depth of 500 metres (1,640 ft). However, Chun found so many species on the nine-month voyage that it took until 1940 – long after his death – to catalogue all the deep-sea organisms he discovered.

PLATE V.

1. BOLOCERA TUEDIÆ.
2. ANTHEA CEREUS.
3. AIPTASIA COUCHII.
4. SAGARTIA COCCINEA
5. S. TROGLODYTES.

Philip Henry Gosse

Plate V, from *Actinologia Britannica, A History
of the British Sea-Anemones and Corals*, 1860
Chromolithograph, 18 × 11 cm / 7 × 4 in
Smithsonian Libraries, Washington DC

English naturalist and artist Philip Henry Gosse (1810–1888) was fascinated by marine biology, particularly the life to be found on the seashore and in rock pools. This title page illustration from Gosse's *Actinologia Britannica: A History of the British Sea-Anemones and Corals*, published in 1860 and considered by many to be his finest work, is one of eleven chromolithographs made from Gosse's own watercolour paintings. Clockwise from the lower left, Gosse illustrates five species in a naturalistic setting, (although in a grouping unlikely to occur naturally):

the deeplet sea anemone (*Bolocera tuediae*), a dumpy species with short, thick tentacles; a snakelocks anemone (*Anthea cereus*, now named *Anthea sulcata*) with a mass of coiling tentacles; a trumpet anemone (*Aiptasia couchii*) with its characteristic slender column; *Sagartia coccinea* (now *Sagartiogeton laceratus*), a small anemone with an orange-tinted column; and a mud sagartia (*S. troglodytes*, now *Cylista troglodytes*), another small species, shown from above in a retracted state. In the accompanying text, Gosse delves into the fascinating details of each marine animal, including its

physical characteristics and behaviours, and the origins of the specimens on which he based his drawings. Gosse's other books, notably *A Naturalist's Rambles on the Devonshire Coast* (1853) and *A Year at the Shore* (1865), did much to bring his studies to a popular audience. By keeping sea creatures in indoor tanks, he also helped foster the Victorian fashion for decorative aquaria, especially through another of his books, *The Aquarium; An Unveiling of the Wonders of the Deep Sea* (1854). In 1853 he set up and stocked the first public aquarium at the London Zoo.

Percy Trompf

The Marine Wonders of the Great Barrier Coral Reef, 1933
Lithograph, 64 × 102 cm / 25 × 40 in
Private collection

This colourful poster was produced by the Queensland Government Tourist Bureau in 1933 to encourage travellers to discover the 'Marine Wonders of the Great Barrier Coral Reef'. The image is split into two contrasting parts: In the smaller top section, three men enjoy a glorious day in a boat on the sea, while in the much larger main section, the vibrant coral reef below the surface teems with tropical fish and marine life. Located off Australia's northeastern coast in the Pacific Ocean, the Great Barrier Reef is one of the world's largest single living organisms and

the largest coral reef on the planet, making up about 10 per cent of all coral reef ecosystems. Covering a staggering area of 344,400 square kilometres (approx. 133,000 sq mi), the reef extends from shallow estuaries close to the coastline to deep oceanic waters, covering a unique range of depths from 35 metres (115 ft) to more than 200 metres (650 ft). That vast area comprises 3,000 individual reefs and is home to more than 1,500 species of tropical fish, 200 types of bird, 20 types of reptile and many other oceanic species. Australian

commercial artist Percy Trompf (1902–1964), who was given the job of translating this natural wonder into an enticing image to encourage tourists to visit, started his career designing confectionery packaging but became best known for his posters for the Australian National Travel Association. His optimistic, bright and colourful posters were a powerful antidote to the Depression of the 1930s and very popular, particularly overseas.

W. Saville-Kent, del et phot' ad nat.

Riddle & Couchman, Imp. London, S.E.

BARRIER REEF ANEMONES.

William Saville-Kent

Barrier Reef Anemones, from *The Great Barrier Reef of Australia: Its Products and Potentialities*, 1893
Chromolithograph, 34.6 × 25.5 cm / 13⅝ × 10 in
Ernst Mayr Library of the Museum of Comparative Zoology, Harvard University, Cambridge, Massachusetts

Although the two segments of shimmering anemone tentacles depicted here are not the most accurate of marine illustrations, they manage to capture something of the vibrant vitality of life as it once was in Australia's Great Barrier Reef. A two-banded clown-fish and a prawn are included for scale, hinting at the symbiotic relationship that these creatures share with the colourful polyps. The lithograph is one of sixteen based on original watercolour sketches that British marine biologist William Saville-Kent (1845–1908) included in *The Great Barrier Reef of Australia*, the first popular science book to extensively document the then-thriving coral reef, published in 1893. In 1884, having worked in the British Museum's Natural History Department and at various English aquariums, Saville-Kent travelled to Australia where, as Commissioner of Fisheries, he became enamoured with the dazzling corals, anemones, fish and other life-forms he saw on the Queensland coast. Resolving to raise public awareness of this underappreciated ecosystem, he conceived of an extensively illustrated book utilizing photography and lithography alongside a wealth of written information to promote a deeper understanding of the world's largest reef. The book proved popular with British readers, many of whom were aware of coral reefs but had not recognized that they were living systems comprising millions of organisms. Saville-Kent's book revealed a previously unknown world, which has since become gravely endangered by human activity: overfishing and agricultural runoff have altered its balance and structure, while climate change is causing massive coral loss.

Mlle Hipolyte (Ana Brecevic)

Coralium, c.2018
Hand-cut paper pieces, 1 × 2 m / 3 ft × 6 ft 6 in
Private collection

Within the bounds of a large, rectangular wooden frame, a coral reef appears to have been squeezed together in a charmingly amorphous congregation. Among the eye-popping colours and staggering formal diversity, certain coral species are identifiable, including white-fringed ochre foliose, delicate red sea fan, brainlike platygyra and the yellow dome of a great star coral covered in spiked polyps, as well as miniature creamy-white staghorn corals. The natural, organic subject of the undersea reef has been painstakingly rendered in cut and folded paper by

the Lyon-based French artist Mlle Hipolyte. Hipolyte, whose three-dimensional paper works are all one-offs, entirely folded, cut, glued and painted by hand, finds the natural world a constant source of artistic inspiration. *Coralium* – which took approximately four months to create and shows her widest and most advanced range of paper sculpture techniques, including quilling, scoring and extremely precise shaping – represents a personal strand of artistic activism. For Hipolyte, nothing is more demonstrative of the issue of species decline and extinction due

to the current human-made climate emergency than coral bleaching and the decimation of the world's coral reefs. With 14 per cent of the world's coral reefs lost to coral bleaching in the last decade alone, Hipolyte's *Coralium* stands as a striking memorial to all that is being lost, the delicacy of the medium encapsulating and eloquently accentuating the fragility of her natural subject.

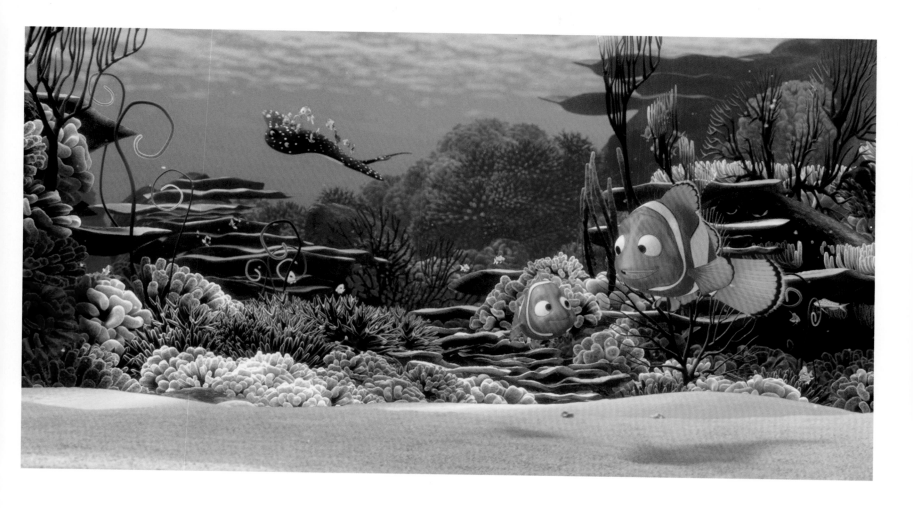

Pixar Animation Studios and Walt Disney Pictures

Finding Nemo, 2003
Animated film, dimensions variable

The clownfish, with its distinctive bright orange colouring and black-and-white striped markings, is among the most recognizable and popular of reef dwellers. It became a cultural icon in 2003 with the release of Pixar's computer-animated adventure *Finding Nemo*, which tells the story of an overprotective clownfish named Marlin as he searches for his missing son, Nemo, who has been stolen from his home by a diver and imprisoned in a dentist's fish tank. Marlin is helped by an absentminded regal blue tang named Dory, and together the two find themselves in various encounters with vegetarian sharks, surfing turtles, a forest of jellyfish and ravenous seagulls. To achieve a high degree of realism in the underwater environments and to ensure the naturalistic motion of the characters, the film's animators studied fish biology and oceanography, visited aquariums and even went diving in Hawaii. Clownfish are found in the warm waters of the Indian and Pacific Oceans, particularly the Great Barrier Reef and the Red Sea. Although *Finding Nemo* advocated against keeping fish in captivity, the film has been identified as causing a spike in the demand for home aquariums and the mass purchase of clownfish as pets – a trend that has led to the decimation of reef species in Vanuatu in the South Pacific Ocean and in some coastal areas of Thailand, Sri Lanka and the Philippines. *Finding Nemo*, directed by Andrew Stanton with Lee Unkrich, was the first Pixar film to win an Oscar for Best Animated Feature and has since become the bestselling DVD title of all time.

Martin Stock

Tidalflat with a Gully in the Last Light of the Day,
Nationalparc Schleswig-Holstein Waddensea, 2006
Photograph, dimensions variable

What looks like an abstract painting is in fact an aerial photograph of a tidal creek in Germany's Wadden Sea at sunset taken by German biologist Martin Stock (b. 1957), who has specialized in photographing the region since first visiting it as an undergraduate. What the Germans call *Priele*, or tideways, form veinlike furrows in the mudflats during low tide. The Wadden Sea UNESCO World Heritage Site stretches about 500 kilometres (310 mi) from the North Sea coast of Denmark along the German coast to southern Friesland in the Netherlands. It is the largest unbroken area of intertidal sand and mudflats in the world, consisting of a barrier of dune islands and sandy shoals and an area of tidal flats and salt marshes that is covered by the tide and revealed twice a day. The region's ecosystem is home to a unique biodiversity that needs to be protected to maintain the delicate ecological balance both on land and underwater. The mudflats attract hikers at low tide, who are drawn by the many animals that become active at that time, as well as by the serene, still landscape. The stillness is illusory, however – and can be dangerous. The water rises silently among the *Priele*, and unwary hikers can very quickly find themselves surrounded by deep water with no way to escape. Nevertheless, a mudflat hike (*Wattwanderung* in German) is a unique experience that few people ever forget. It is a moment when the mudflat seems to become alive with many animals being active and the sounds of the gurgling water surrounding the silence.

Bryan Lowry

Sunrise: Underwater Lava Flows and the Poupou Ocean Entry,
Hawaii Volcanoes National Park, Big Island of Hawaii, 2009
Photograph, dimensions variable

Bright hot lava flows into the cool blue waters of the Hawaiian coastline, the intense, fiery glare surrounded by a toxic cloud of steam. This hellishly sublime image is the work of Bryan Lowry, a photographer who specializes in the portrayal of volcanic activity on the famous Pacific islands. Lowry relishes remote destinations, braving long and arduous hikes in order to reach the most secluded and spectacular outposts. Kīlauea, on Big Island, is the most active of Hawaii's volcanoes. It is estimated that it emerged from the sea 100,000 years ago but that it is much older, perhaps as old as 280,000 years. Kilauea is considered a shield volcano because of the low profile caused by the thin viscosity of its lava, which runs off to the sea instead of stratifying closer to the crater. When lava, which can be as hot as 1,250° Celsius (2,280° F) comes into contact with the cool marine water, it often generates dramatic steam plumes of hydrochloric acid that fill the surrounding atmosphere with a thick haze. Under certain conditions, hydrovolcanic explosions often take place, especially when the sea water is particularly cold or the lava flows quickly. Over the millennia, the cooling lava has extended new land into the sea, building a petrified delta or steep submarine slopes. No marine animals or algae can populate the ocean entry and surrounding area due to the extremely inhospitable living conditions imposed by scalding temperatures and highly toxic chemical compounds that pollute the water as well as the air.

The Oceanic Swimming Crab,
Neptúnus pelágicus.
A Crab that swims with the
grace of a Swallow's Flight.

This Crab is among Crustaceans what the Albatross is among Birds, sustaining itself for Days together without needing rest. It feeds upon living Prey, and chaces it with the Speed of a Shark.

Olivia Fanny Tonge

The Oceanic Swimming Crab, c.1910
Watercolour, 18 × 25.7 cm / 7 × 10⅛ in
Natural History Museum, London

This incredibly detailed and colourful illustration of a female flower crab (*Portunus pelagicus*) is the work of Olivia Fanny Tonge (1858–1949), one of the very first female natural history illustrators to travel alone to India at the beginning of the twentieth century. The daughter of Lewis Roper Fitzmaurice, a natural history illustrator and landscape painter, Olivia was short-sighted, a limitation that steered her career away from landscape painting and brought her to focus instead on depicting smaller creatures. Married at the age of nineteen, Tonge put her painting aside to raise her two daughters and pursue other activities, such as writing and needlework. After the passing of her husband, with her daughters long since grown, she embarked on her first trip to India in 1908, at the age of fifty. On her journeys over the next five years, Tonge compiled sixteen thirty-page sketchbooks documenting the local fauna and flora of India and Pakistan, enriching each page with personal notes and observations in the margins. The flower crab (*Portunus pelagicus*) illustrated here is distinguished by its unusually elongated claws armed with sharp spines, and the flattened back legs that resemble paddles, allowing the crustacean to swim faster than other crab species. Considered a delicacy throughout Asia, the flower crab has been mass-bred in aquaculture for many decades due to its versatility and resilience. While many crab species are scavengers, feeding on vegetal or deceased animals, the flower crab is a hunter that feeds on bottom-dwelling creatures such as clams and snails.

Anonymous

Te Tauti (Porcupine) Fish Helmet, 1900s
Human hair, fish skin and plant fibre, 25 × 24 × 29 cm / 10 × 9½ × 11½ in
Museum of New Zealand, Te Papa Tongarewa, Wellington

The bleached-white brittle shell of this warrior's helmet is formed from the densely spiked body of a pufferfish, the head of which has been cut away and the cavity lined with plaited screwpine palm leaves. This armour – it was intended to be ceremonial, rather than used in conflict – was produced by members of the Kiribati culture, an Austronesian civilization centred on the sixteen Gilbert Islands, a chain of coral islands and atolls in the central-west Pacific Ocean. The fish is probably the spot-fin porcupinefish, which is found in all the world's tropical seas, but which usually favours the types of reef and lagoon typical of the Gilbert Islands. Capturing and drying the fish in its distended 'puffed' state, whereby it protects itself from predators, Kiribati warriors sought to personify the fearsome threat of a fish whose barbs carry a neurotoxin 1,200 times more deadly than cyanide. By the time of this helmet's creation in the nineteenth century, the Kiribati islands had long since been mapped by European settlers, whose trade and missionary activities had interrupted the armed tribal conflicts between northern and southern islanders. But ceremonial armour continued to be produced as important symbols of the historic warrior culture of the Pacific Islanders – where certain groups even trained children in combat from early ages – and protected as family heirlooms across generations. Armour was also traded in exchange for supplies with the crews of European whaling ships that docked throughout the nineteenth century.

Carl Linnaeus

Hippocampus hippocampus Specimens, c.1758
Taxidermy mounted on paper, 8.8 × 6.9 cm / 3½ × 2¾ in
Linnaean Society of London

The equine heads, pronounced snouts, curled tails and demure demeanour make these mounted seahorse specimens instantly recognizable. They come from the collections of Swedish naturalist Carl Linnaeus (1707–1778), renowned for introducing the binomial ('two-named') system for classifying and naming living things. Linnaeus was also the first person to describe a seahorse in 1758, calling it *Syngnathus hippocampus*. Derived from Greek, this translates to a 'horselike sea creature' (*hippocampus*) with a 'grown-together jaw' (*syngnathus*). At that time, the genus name encompassed both seahorses and pipefish. Naming species can be a complex process, however. As more information on the marine world emerged, the seahorses were classed as a separate genus from pipefish and were renamed *Hippocampus*, *Syngnathus hippocampus* thus becoming *Hippocampus hippocampus*. These specimens were both labelled *Hippocampus antiquorum*, a synonym of the two other names, even though they are actually different species. (In addition, no one knows for sure whether Linnaeus's original description of the seahorse was based on these or other specimens.) Today more than 140 seahorse species names exist in the scientific literature, and 47 species of seahorse are officially recognized. For more than eighty years, *H. hippocampus* was considered the correct name for the short-snouted seahorse, with *H. guttulatus* referring to the long-snouted, or spiny, species. In 2007, however, a researcher consulting Linnaeus's original notes suggested that *H. hippocampus* should be used to refer to the long-snouted seahorse. The names for the short-snouted and long-snouted taxa continue to be hotly debated by seahorse afficionados today.

Anonymous

Dona Fish, c.1950s–60s
Wood, pigments, metal and mixed media, H. 75 cm / 29½ in
Private collection

This 'dona' or 'woman' fish, made by the Ovimbundu people of Angola, represents Mami Wata, a native deity of complex symbolism and power. Mami Wata (Mother Water) is probably rooted in traditional water divinities of west, central and southern Africa, mixed during the colonial period with European influences that resulted, by the nineteenth century, in a transcultural Mami Wata cult that extends today to areas of the African diaspora in the Americas. These African cultures were often matriarchal, and although Mami Wata can be male, she is usually considered female and is often portrayed as a mermaidlike figure, with the upper body of a woman and the lower body of a fish or serpent. Mami Wata is a common name for the West African manatee, and the spirit may be based on that mammal, while the mermaid image may have resulted from contact with European ships and sailors. Mami Wata is a multifaceted, contradictory deity, at once nurturing and dangerous, healer and injurer – much like water itself, which brings about fertility and well-being but can also destroy lives and property. Mami Wata favours devotees with spiritual wisdom and worldly wealth but is also responsible for natural disasters, swimming accidents and social upheaval. She is commonly depicted holding a mirror, which represents her ability to transcend time, moving from present to future. Disciples worship her by dancing to a trancelike state of divine possession and by offering stereotypically female gifts: jewellery, pomades, powders and soaps, and delectable food and drink, including alcohol.

Friedrich Johann Justin Bertuch

Illustration from *Bilderbuch für Kinder*, 1801
Hand-coloured engraving, 26.1 × 18.3 cm / 10¼ × 7¼ in
Universitätsbibliothek Heidelberg, Germany

A German publisher and patron of the arts, Friedrich Johann Justin Bertuch (1747–1822) firmly believed in the life-bettering power of the arts and the importance of educating people about the wonders of art and nature from an early age. Located in Weimar, his company became one of the largest publishers in Germany, notably producing Bertuch's *Bilderbuch für Kinder* (*Picture Book for Children*) between 1790 and 1830 – twelve encyclopaedic volumes containing 1,185 colour plates and some 6,000 engravings charting an impressive collection of animals, plants, flowers,

fruits and minerals, along with many other types of instructional objects from the realms of natural history and science. This hand-coloured plate presents a selection of pufferfish, along with an ocean sunfish in the bottom left corner. At first glance, it might seem like an odd grouping, since pufferfish and sunfish belong to different species. In addition, the illustrations are not to scale: sunfish can grow to a colossal 3.5 metres (11 ft) in length and weigh up to 2.3 tonnes (2.5 t), while these species of pufferfish only range between 15 to 30 centimetres (6–12 in)

in length. However, the two are, in fact, related. Their ancestral link becomes visible in sunfish fry, which closely resemble miniature pufferfish, complete with body spines that will eventually retract and disappear into the smooth body that characterizes the adult. The facial structure of both species – a round mouth filled with sharp and noticeably large, beaklike front teeth – is another similarity, and unlike other fish, both sunfish and pufferfish wave their dorsal and anal fins to propel themselves through the water.

Ryusai (隆斉)

Fugu Fish Netsuke, mid-19th century
Carved ivory, L. 4.2 cm / 1½ in
British Museum, London

Created and signed by the Japanese artist Ryusai (active mid-nineteenth century), this splendid ivory carving of a fugu, or pufferfish, is more than a charming miniature sculpture. Netsuke are small portable sculptures with a deep history in Japanese culture. As the traditional kimono lacked pockets, netsuke were part of a system that allowed objects to be carried strung from men's belts. Objects called *sagemono*, such as tobacco pouches, pipes, writing implements or purses, would be suspended on a silk cord looped over the belt and held in place by the netsuke, which acted as a kind of anchor. From such a practical beginning, netsuke, which frequently featured natural objects such as plants and animals, including fish and other marine creatures, developed into collectible works of art. This beautiful netsuke is an accurate representation of one of Japan's most famous fish, the fugu, notorious for its potentially dangerous role in Japanese cuisine. The several species of pufferfish, in the family *Tetraodontidae*, live mostly in tropical or subtropical waters, and most are highly toxic, giving them protection against predators. The most prestigious edible species in Japan is the tiger pufferfish (*Takifugu rubripes*). A fugu dish must be prepared with great care by qualified chefs who remove the poisonous parts before serving what is widely regarded as a delicacy. This netsuke, however, was likely seen as a good-luck charm, as *fugu/fuku* is a homonym of the Japanese word for 'happiness'.

Sigalit Landau

Salt-Crystal Bridal Gown IV, 2014
Archival inkjet print, 1.6 × 1.1 m / 6 ft 4 in × 3 ft 7 in

Ghostly and bodiless, an apparition appears suspended underwater. Although it is clear that this garment is constructed from cloth, it is not behaving as one might expect. It does not float or waft in the currents of the water; rather it appears stiff, resembling a hard suit of armour rather than soft fabric. The dress, which was originally black, was sunk into the Dead Sea, a landlocked lake that borders Jordan, Israel, and the West Bank, the lowest place on Earth and, thanks to its mineral content, one that is devoid of any life other than algae and microorganisms. The lake's exceptionally high salt content (34.2 per cent) normally means that people and objects would float easily in its waters, but this traditional Hasidic garment was tethered to the seabed by Israeli artist Sigalit Landau (b. 1969) and collaborator Yotam From, so that it remained submerged for several months and slowly accumulated a thick, salty crystalline crust. The dress is a reproduction of the gown worn by Leah, the lead character in the play *The Dybbuk* by S. Ansky. In Jewish mythology, a *dybbuk* is a restless and malicious spirit that possesses its host to complete a specific task so that it can finally rest. By the time Landau and From hoisted the dress out of the Dead Sea, it had become totally caked with white salt crystals, losing its previous form, colour and reference to unsettled spirits – and instead becoming a shimmering and bejewelled white wedding gown, symbolizing the transformative power of art and the sea.

320

Christoph Gerigk

East-Canopus, 1999
Photographed on 35 mm diapositive film, dimensions variable

Christoph Gerigk (b. 1965), a German photographer who specializes in underwater images, shot this large stone head of a sphinx lying on the seabed off the Nile Delta. The likeness of a Ptolemaic king of Egypt, depicted as a pharaoh, it was discovered on the site of the ancient city of Canopus, which disappeared beneath the sea around 1,200 years ago. Although of Greek origin, the Ptolemaic dynasty to which this king belonged ruled Egypt from 323 to 30 BC. The cities of Canopus and Thonis-Heracleion, nowadays both submerged in the bay of Aboukir, were founded in the delta in the seventh century BC. The cities, 40 kilometres (25 mi) away from modern-day Alexandria, once flourished with magnificent temples dedicated to both Egyptian and Greek gods and grew rich on trade, as every merchant was obliged to pay taxes at the river's mouth on the Mediterranean. Submerged for centuries after several natural disasters, including an earthquake and tsunami, it was only with the start of pioneering underwater excavations in 1999, led by archeologist Franck Goddio and his team at the European Institute for Underwater Archeology (IEASM), that the magnificence and extent of the underwater cities was revealed. Using technologies such as magnetometry – which uses changes in magnetic fields to define constructed areas – archaeologists have discovered jewellery, ceramics, statues, temple remains and port structures, as well as numerous shipwrecks. Preserved by the ocean, the treasures provide a new insight into Egypt's exchanges with its Mediterranean neighbours and its trading past.

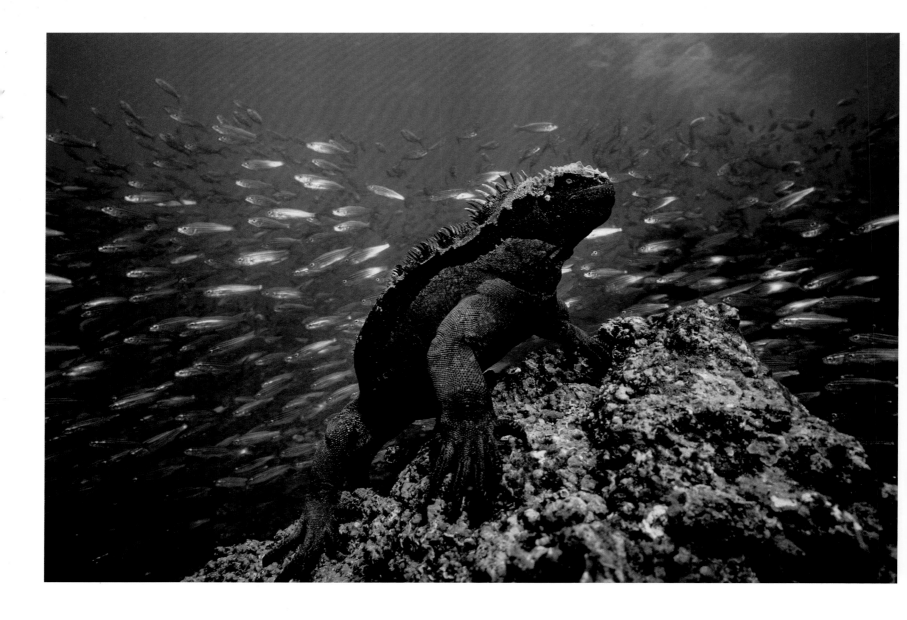

Howard Hall

Marine Iguana, Galapagos Islands, 1987
Photograph, dimensions variable

The marine iguana (*Amblyrhynchus cristatus*) is the only lizard capable of living and feeding in the sea: despite the silvery fish swimming nearby in this image, they live off a diet of algae that is scraped from rocks with their powerful jaws. Adaptations to marine life include a flattened tail to aid in swimming and robust limbs with long claws that help it cling firmly to rocks as it feeds in the swirling surf. When submerged, iguanas' heartbeats slow to conserve energy, allowing long bouts of underwater foraging. A large male can dive to 30 metres (98 ft) and stay below the surface for up to an hour. In a further adaptation to their high-salt diet, iguanas filter their blood near the nose and excrete salt crystals onto their snouts. The large lizard is endemic to the Galapagos Islands, Ecuador, which are renowned for their wildlife. They are home to a limited number of species, many of which are unique, including the giant tortoise, the Sally Lightfoot crab, and the Galapagos sea lion. One theory is that animals originally reached the remote islands on floating rafts of vegetation and then evolved there separately from the rest of the world. The islands' unique contribution to science came when a study of the different beaks of finches living on the separate islands helped Charles Darwin, who visited in 1835, begin to formulate his theory of evolution. This image was taken by American underwater photographer and Emmy-winning cinematographer Howard Hall (b. 1949), whose images have appeared in publications such as *BBC Wildlife*, *National Geographic* magazine, *Natural History* magazine and *Ocean Realm*.

Abdullah Nashaath

1,000 Maldivian *Rufiyaa* Banknote, 2015
Pigments printed on polymer substrate, 15 × 7 cm / 6 × 2¾ in

The Maldives' Golden Jubilee was celebrated in 2015, marking fifty years of the country's independence. To commemorate the anniversary, a new series of bank notes was unveiled, known as the *Ran Dhihafaheh* ('Golden Fifty'). A competition held to design the notes was won by Abdullah Nashaath (b. 1985), whose concept involved different colours for each denomination of banknote, illustrated with scenes from Maldivian life, examples of Maldivian crafts, or animals and sea life of the islands. The blue 1,000 Maldivian *rufiyaa* note features a green turtle and a pair of reef manta rays swimming among corals within a sketch map of the Maldives on the front; the back illustrates a whale shark. National bank notes traditionally represent aspects of a country's history and culture, and this Maldivian note beautifully illustrates the oceanic environment of this island nation. Located in the Indian Ocean, the archipelago forms the top of the Chagos-Laccadive Ridge, a submarine mountain chain. Referred to as the Money Isles in the second century AD, it was the source of vast numbers of cowrie shells that were used as currency in Asia, Africa and Oceania from the fourth century BC well into the twentieth century. The Maldives are home to five of the world's seven species of sea turtle, including the endangered green turtle (*Chelonia mydas*) shown on the front of the note. The gentle whale shark (*Rhincodon typus*) on the back is the largest living fish and can be found in the waters of the archipelago all year round. As a low-lying nation – more than 80 per cent of the almost 1,200 islands are less than 1 metre above sea level – the Maldives are one of the lands most at risk from rising ocean levels due to climate change.

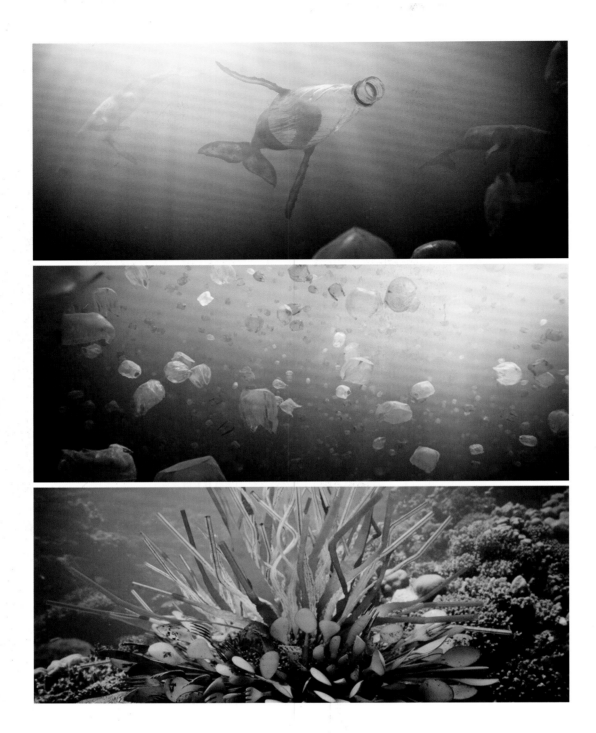

Pascal Schelbli

Stills from *The Beauty*, 2019
Animated short film, dimensions variable

Directed by Swiss filmmaker Pascal Schelbli (b. 1987), the short film *The Beauty* mixes stunning live-action underwater scenes with innovative computer-generated animation to explore the issue of ocean pollution and propose what life under the sea might be like were it to become inextricably integrated with plastic waste. The film opens with a magnificent school of fish darting and weaving through cerulean waters, but as the camera moves closer, the cloud of activity is revealed to be not fish but a mass of discarded sandals. On the seabed are plants made from plastic drinking straws and cutlery, while swimming overhead are bubble-wrap pufferfish, plastic-bag jellyfish and majestic whales with bodies formed from plastic bottles. The chilling satire presents a world that is at once stunning and contaminated, where nature has ostensibly 'solved' the problem of pollution – yet it ultimately jolts viewers with the reality of oceans choked by the 12.7 million tonnes (14 million t) of plastic added to them each year. The four-minute film, which was made over a period of two years while Schelbli was studying at the Baden-Württemberg Film Academy in Ludwigsburg, won a prestigious Student Academy Award in 2020. The greatest challenge for Schelbli and his team was to incorporate the animated elements convincingly into the underwater footage shot off the coast of Egypt. The visually impressive results strike the perfect balance, bringing together Schelbli's filmmaking talents with his passion for the environment and his aim of raising awareness of the ocean's plight.

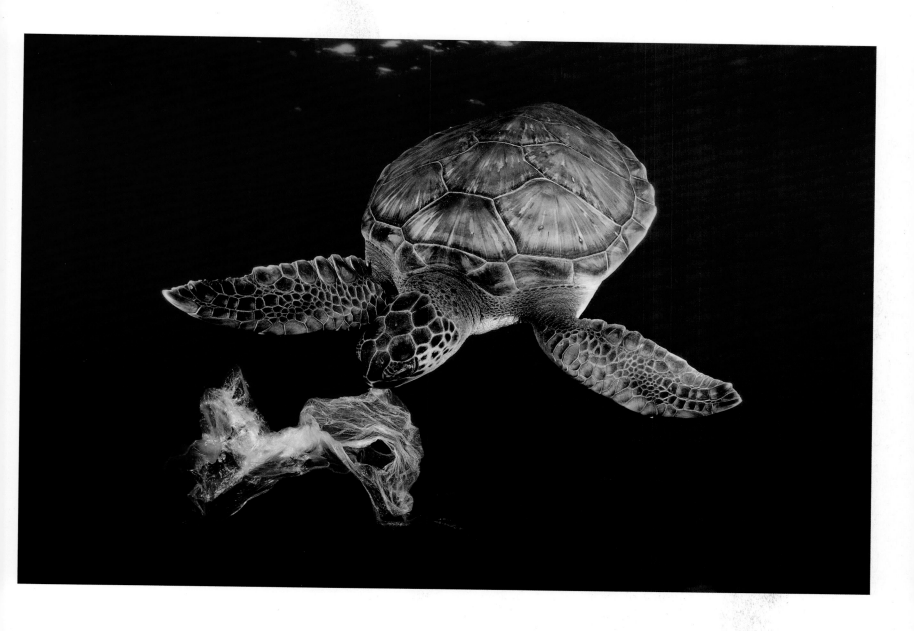

Sergi Garcia Fernandez

Green Sea Turtle Trying to Eat Plastic Bag,
Tenerife, Canary Islands, Spain, c.2015
Digital photograph, dimensions variable

What at first appears to be a young green sea turtle (*Chelonia mydas*) enjoying a jellyfish snack, closer inspection reveals to be far more disturbing. Captured by award-winning Spanish photographer Sergi Garcia Fernandez (b. 1975) in the waters off Tenerife in the Canary Islands, Spain, the turtle is in fact trying to eat a plastic bag that it has probably mistaken for its natural prey. Many turtles die after ingesting inedible items, especially plastic: a dire consequence of human pollution of the marine environment, a problem starkly captured in this image. The green sea turtle is one of seven species of marine turtle found in the oceans in habitats ranging from beds of seagrass to coral reefs. Green sea turtles live mostly in coastal waters in temperate and tropical seas. They grow to up to 114 centimetres (4 ft) in length of shell (carapace) and may weigh as much as 190 kilograms (420 lbs). When young, they feed on invertebrates such as worms, coelenterates and crustaceans, as well as on seagrasses and algae, but as adults they switch to a mainly vegetarian diet, tearing at tough marine plants and seaweeds using their finely serrated teeth. Their common name derives from the greenish colour of the turtle's flesh, the shiny carapace being usually shades of orange and brown, as shown so clearly here.

Stephen Hillenburg and Nickelodeon Animation Studio

SpongeBob SquarePants, 2010
Still from animated television series, dimensions variable

This goofy, happy-go-lucky cartoon sponge attempting to catch a jellyfish is known the world over as the titular protagonist of Nickelodeon's animated television series *SpongeBob SquarePants*. The show was created by former marine biology teacher Stephen Hillenburg (1961–2018) and is loved for its surreal humour and zany slapstick gags that demonstrate a total disregard for the physical limitations of life at the bottom of the ocean. A relentlessly optimistic and kind-hearted hero, SpongeBob is based on a character from Hillenburg's 1980s comic book

The Intertidal Zone, a visual aid designed to teach his students about tide-pool animals. Retraining as an animator in the 1990s, Hillenburg developed the comic into an eccentric cartoon series, which follows the adventures of SpongeBob and his friends in Bikini Bottom, beneath Bikini Atoll in the Pacific Ocean. SpongeBob, who works as a cook at the Krusty Krab restaurant and just wants to be everybody's friend, lives with his pet snail, Gary, in a pineapple next door to Squidward Tentacles, who is constantly annoyed by his neighbour's hyperactive antics and those of his

best friend, the overweight starfish Patrick Star. Originally the iconic character was a natural sponge, but Hillenburg decided that a square synthetic sponge would be much funnier, giving him orange freckles, buck teeth and large blue eyes, and dressing him in a shirt, tie and brown shorts. Since premiering in 1999, the global hit show has been dubbed into more than sixty languages and is one of America's longest-running animated series.

Christine Wertheim, Margaret Wertheim, Anitra Menning and Heather McCarren

Pod World – Hyperbolic, 2006–2019
Wool, cotton, Victorian glass coral, wire, rocks
and sand, 38.1 × 38.1 × 38.1 cm / 15 × 15 × 15 in
Institute for Figuring, Los Angeles

This vivid specimen of red coral was not collected from the shallow coastal waters of a tropical atoll but is a beautifully crafted section of the *Crochet Coral Reef*, a collaborative, multidisciplinary project launched in 2005 by Australian twin sisters Christine and Margaret Wertheim (b. 1958). A unique nexus of art, science, geometry and environmental reflection, *Crochet Coral Reef* is an ever-evolving archipelago of woollen installations that not only emulates the structures and aesthetics of natural reefs but also enacts the evolutionary and symbiotic processes by which the living organisms thrive. Just as life on Earth is underpinned by the code of DNA, so these fibre forms are material incarnations of a symbolic code – the stitch patterns of crochet. More than forty reefs have so far been created and exhibited to great acclaim across the world, with more than ten thousand people contributing to this ongoing eco-art initiative. To participate, artists must learn a technique called hyperbolic crochet. The method was invented by the Latvian mathematician Dr Daina Taimina in order to study the natural structure of hyperbolic geometry visible in complex irregular forms such as the branching of corals or the expanding of sponges – or, when oversimplified, to create the curls that form the bodies of crocheted corals. *Crochet Coral Reef* is aimed at making audiences and artists more sensitive to the ecological importance of coral and the threats that colonies around the world face due to water pollution and rising water temperature, which in turn cause detrimental discolouration known as coral bleaching.

Peter Scoones

Coral Reef with Anthias, Red Sea, before 2006
Photograph, dimensions variable

Pioneering British underwater photographer and cinematographer Peter Scoones (1937–2014) called anthias (*Pseudanthias squamipinnis*) the photographer's fish. He was a master of capturing the contrast between the dancing, dazzlingly red schools feeding on plankton and the brilliant blue of the open water. Then within a split second, the fish would vanish into the protection of the reef's nooks and crannies when they felt threatened. This school, photographed on a coral reef in the Red Sea, is composed mostly of females, which greatly outnumber the larger, purple-red male anthias. In order to keep a consistent ratio, should one of the males be taken by a predator, it will be replaced by one of the females, which changes sex. This sexual fluidity has evolved as a successful survival strategy. The process of changing takes about two weeks and includes not only a new reproductive system but a change in size, shape and colour. If a community of anthias forms with too many males, male anthias may change their sex again and return to being female. Plankton, the main food supply for anthias, becomes more abundant further away from the reef, but that is also where a fish runs the greatest risk of being eaten itself. By schooling, individual anthias benefit from protection in terms of more eyes on the lookout. The fish react to each other, making the school as watchful as its wariest member. There's safety in numbers – and other fish realize this too. By mimicking the body shape and colour of the anthias, the Midas Blenny can hide among them, allowing a normally solitary fish to gain the advantages of a school.

Versace and Rosenthal

Les Trésors de la Mer Service Plate, 1994,
Porcelain, Diam. 30 cm / 12 in

Manufactured by the German porcelain company Rosenthal, this plate, measuring 30 centimetres (12 in) across, is one piece of a dinner service designed by the venerable fashion house Versace. Edged in gold, the colour closely associated with the flamboyance of the late Gianni Versace (1946–1997) and his sister Donatella (b. 1955), the plate's rim is a dark, deep blue while the centre is a lighter mid-blue. On this porcelain sea sits the sea god Neptune at the top of the plate. Around the rim are shells and starfish, while the bottom centre is given over to spindly coral. The sea imagery forms part of a design palette, Trésor de la Mer (Treasures of the Sea), that first appeared in the Versace Spring/Summer 1992 show, inspired by the oceanside childhood home of the Versace siblings. In his original design, Gianni sought to recreate the multicoloured poetry of vibrant coral, gleaming pearls, bountiful shells and starfish as he remembered it. When it was first introduced, the print caused a sensation. Almost thirty years later, Donatella Versace revisited the print for her Spring/Summer 2021 show. Her concept, *Versacepolis* – a sunken city whose inhabitants resurface to find their world profoundly changed – resonated with her following the emergence of the COVID-19 pandemic. As a modern couture house, Versace does not limit itself to only designing garments. Successful prints, such as the Treasures of the Sea, are extended to other ranges, such as homeware products, as can be seen in Versace's collaboration with Rosenthal dating back to 1992.

Antigua and Barbuda Post Office

20,000 Leagues Under the Sea Marine Life,
International Year of the Ocean, 1998
Sheet of 25 40¢ stamps
Private collection

Issued by Antigua and Barbuda in August 1998, this colourful stamp sheet creates a scene that comes straight from the pages of Jules Verne's classic underwater adventure novel *20,000 Leagues Under the Sea* (see p.133). The United Nations designated 1998 the International Year of the Ocean in an attempt to draw attention to the importance of the seas to the planet's well-being, and countries around the world issued stamps to mark this first celebration of the ocean. When torn, each of the twenty-five stamps depicts a different image of local marine life,

against a background of a giant octopus and a submarine as imagined by Verne. Left to right from the top row, the stamps feature: a spotted eagle ray, manta ray, hawksbill turtle, jellyfish, queen angelfish, octopus, emperor angelfish, regal angel-fish, porkfish, raccoon butterflyfish, Atlantic barracuda, seahorse, nautilus, trumpet fish, white tip shark, a Spanish galleon, black tip shark, long nosed butterfly fish, green moray eel, Captain Nemo, a treasure chest, hammerhead shark, divers, lion fish and clownfish. Though some of the images

are clearly fictionalized, the stamps also highlight species in need of conservation, such as the hawksbill turtle (*Eretmochelys imbricata*). Although the hawksbill, named for its sharp, pointed beak, is one of the most common sea turtles of Antigua, it is critically endangered. Its translucent shell makes it highly desirable and it has long been exploited for use in tortoiseshell jewellery, which although illegal, continues.

Yann Arthus-Bertrand

The Great Blue Hole, Lighthouse Reef, Belize (17°19' N - 87°32' W), 2012
Photograph, dimensions variable

Best known for his 1999 groundbreaking book *Earth from Above*, Yann Arthus-Bertrand (b. 1946) has spent a lengthy career documenting human impact on the planet. Working as a photographer and journalist, Parisian-born Arthus-Bertrand founded Altitude Agency in 1991 to specialize in aerial photography, understanding the unique perspective only an aerial image can provide in recording large-scale changes in the natural environment, from rising oceans to melting ice caps. *The Great Blue Hole* looks at the role the oceans play in the planet's health by capturing

Lighthouse Reef off the coast of Belize, which sits at sea level and is imperilled by rising waters. The relationship between tropical islands and sea levels is precarious: in his 2012 documentary *Planet Ocean*, Arthus-Bertrand sought to record the damage the oceans have sustained at a time when the extent of their role in our lives is only just being understood. The beauty of his photography stands in stark contrast to the devastation it records, as the photographer deliberately sets out to shock the viewer into action. As much as Arthus-Bertrand is an award-winning

photographer – among other awards, he holds an honorary fellowship of the Royal Photographic Society and the Royal Geographic Society's Cherry Kearton medal – whose work has appeared in countless publications, he is also a pioneering environmentalist who strives to awaken his viewers' conscience. Most recently, he has turned his attention to the oceans and communities of Indonesia and Mauritius, both of which are at risk from any rise in sea levels.

Timeline

1

2

3

4.6 billion years ago The oceans begin forming as 'planetesimals' that slowly amass to form Earth. Over millions of years, volatile elements and compounds – including water vapour – fizz from the molten rocks of the cooling planet. Then, when the temperature drops below water's boiling point, rain falls continuously for centuries. Draining into hollows on the Earth's surface, this liquid becomes trapped by the forces of gravity to form primeval oceans.

4.4 billion years ago By 150 million years after Earth's formation, an ancient ocean likely covers the entire planet.

3.5 billion years ago The first life forms emerge as simple, single-celled microbes that probably live near deep-sea hydrothermal vents. Gaining energy from sulphur contained in the superheated fluids, minerals and gases escaping from deep within the planet, they kick-start life on Earth.

2.4 billion years ago Cyanobacteria have evolved that can turn light and water into energy, releasing oxygen in the process. Oxygen accumulates in the oceans and atmosphere, helping Earth become habitable for a broader range of species.

580 million years ago The first recorded complex life forms – the Ediacarans – appear. Strange, largely immobile organisms made of tubes, they live on the seabed.

542–488 million years ago The largest evolutionary explosion in history takes place, giving rise to modern ecosystems and all the basic types of animals alive today.

Among the biggest and fiercest creatures living in the oceans is the lobster-sized Amplectobelua, which cruises above the seafloor and slices into its prey with spiny claws. On the seafloor, spongelike creatures called Archaeocyaths grow in dense mounds and become prolific reef builders, while early arthropods known as trilobites also flourish.

485 million years ago The first vertebrates – the jawless fishes – appear during the Ordovician Period. ↖ 1, see p.225

c.400 million years ago Sharks come into existence, descendants of small, leaf-shaped fish with no eyes, fins or bones.

372–359 million years ago Major extinction events kill off 75 per cent of species on Earth, including many classes of fish. This allows sharks to dominate the oceans.

252 million years ago Another mass extinction event takes place, wiping out around 96 per cent of all marine life, including trilobites; a handful of shark lineages survive.

250 million years ago The first ichthyosaurs emerge. Growing to 25 metres (80 ft) long, with streamlined bodies, fishlike tails and sharp teeth, they become top predators.

230 million years ago Marine turtles evolve from land-dwelling turtles, their claws and limbs becoming flippers; the oldest known sea turtle is *Desmatochelys padillai*.

195 million years ago Plesiosaurs – such as ichthyosaurs, marine relatives of lizards – are in their ascendency. Their ability to swim quickly makes them highly successful predators. ↑ 2, see p.224

The oldest known group of modern sharks, the Hexanchiformes, or six-gill sharks, have evolved and are soon followed by most modern shark groups.

145 million years ago Sharks are once again common and diverse. Earth's climate is relatively warm and ice-free, and there are numerous shallow, inland seas. Marine reptiles, ammonites (now-extinct molluscs) and rudists (now-extinct bivalves) are common. On land, dinosaurs roam.

120 million years ago Marine turtles resemble the sea turtles that survive today.

90–100 million years ago Ichthyosaurs, large marine reptiles, become extinct. Rudist bivalves build reefs.

66 million years ago The majority of Earth's organisms become extinct, due mainly to an asteroid strike, including marine plesiosaurs, ammonites and rudist bivalves and all non-avian dinosaurs on land. Sharks survive in the oceans, but many large species of shark die off.

60–35 million years ago Sharks increase in size; *Otodus obliquus*, the now-extinct 12-metre (40-ft) mackerel shark, appears.

35 million years ago Whales evolve from four-legged, land-dwelling mammalian ancestors. Fossils of Basilosaurus are now believed to be the link between the two. As some of these whales begin feeding on a different diet, they lose their teeth and evolve to become baleen filter feeders.

The first barnacles appear.

Ocean temperatures plunge as a result of a fall in atmospheric carbon dioxide and shifts in tectonic plates as South America and Australia break away from Antarctica, dramatically shifting ocean currents and affecting marine food webs across the globe. Marine mammals diversify rapidly, evolving new ways to feed, move around and keep warm in the chilled ocean waters.

20 million years ago The 18-metre-long (60-ft) megalodon shark (*Otodus megalodon*) appears, the largest predatory shark ever.

5.3 million years ago Baleen whales get bigger in response to changes in the ocean environment.

5 million years ago By now, the first human ancestors have evolved.

167,000 years ago

5500 BC

1000 BC

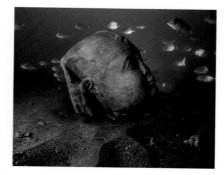

600 BC

167,000 years ago	A pile of mussel, whelk and giant periwinkle shells is left in a cave on the southern coast of South Africa; researchers who later unearth them conclude they are the remains of the earliest recorded human seafood meal.
110,000 years ago	Neanderthals cook shellfish in caves in coastal Italy.
71,000–59,000 years ago	An ice age locks up water in glaciers, lowering sea levels and encouraging the first long-range seafaring by reducing the distances between landmasses. Artefacts from a rock shelter show that ancestors of the Aboriginal people had crossed to Australia from Southeast Asia by 65,000 years ago, an estimated distance at the time of 90 kilometres (56 mi).
30,000 years ago	Cultures along the western coastline of today's Pacific Ocean – in the area between what are now Australia and China – start to migrate eastward, possibly as a result of tribal wars, epidemics, a shortage of food or natural disasters, such as large volcanic eruptions and earthquakes. By 26,000 BC, settlers had reached today's Solomon Islands.
20,000–5000 BC	Hunter-gatherers create the earliest known maritime art in what is today Azerbaijan's Gobustan National Park, where some 6,000 rock carvings include designs featuring ancient boats made from reeds.
11,000 BC	Early seafarers carry obsidian, a volcanic glass used to make sharp-edged tools, from mainland Greece to islands in the Aegean Sea, and islands lying west and southwest of Italy.
7000 BC	A carving on a granite pebble shows that the Egyptians are now able to build boats with a steering system and a cabin.

5500 BC	Early divers living on the Arabian Peninsula collect natural pearls from the black-lip pearl oyster (*Pinctada margaritifera*), which are centuries later unearthed by archaeologists.
4000 BC	Ancient Egyptians develop the first sailing vessels; having a sail would have helped them to travel south with the prevailing wind against the current along the Nile River. The oldest known illustration of a sailing vessel is on an earthenware pot dated to 3300–3100 BC, from the Nile village of Naqada.
3500–3200 BC	Early trade brings influences from Mesopotamia, in the Middle East, to Egypt.
3000 BC	Travellers using canoes and rafts move between ports along coastlines from Arabia to the Indian subcontinent.
2400–2300 BC	Egyptians now build more than thirty kinds of vessels, as depicted in the Pyramid Texts – ancient hieroglyphics written on walls inside tombs. The craft are used for fishing, hunting, military uses and carrying goods and people.
c.2000 BC	Aboriginal cultures of the western Arnhem Land in Australia begin painting in the X-ray style, one of the most significant styles of *Garre wakwami*, or 'Dreaming' paintings. ↖ 3, see p.237
2000–1200 BC	The Minoans of the Greek island of Crete in the eastern Mediterranean become the first great maritime power. They travel by ship to trade pottery and other items with other nations. ↖ 4, see p.226
1500–1450 BC	The Marine Style of Minoan pottery emerges. It inspires pottery and other artistic crafts in Mycenaean culture. ↑ 5, see p.301
1200–400 BC	The Phoenicians and Greeks trade throughout the Mediterranean and set up colonies around its shores and islands.

1000 BC	A wave of settlers originally from southern China, culturally defined by its use of ceramics, moves southwest from the Solomon Islands to Polynesia. This Lapita culture reaches today's Santa Cruz Islands, Vanuatu, Loyalty Islands, New Caledonia and Fiji.
	Greeks dive to collect natural sponges from the seabed. According to the poet Homer, the divers pour oil into their ears and mouths to combat the effects of water pressure as they descend up to 30 metres (98 ft) by holding heavy stones. Once on the bottom, they spit out the oil and cut as many sponges free from the bottom as their breath will allow before being pulled back to the surface by a tether.
879 BC	The Greeks begin to venture farther afield, sailing west through the narrow channel separating Europe from Africa, and the Mediterranean from the Atlantic Ocean. Beyond these straits, the early explorers find such a strong current running from north to south that they decide the Atlantic is a vast river, or *okeano* in Greek. The word becomes the root of the word 'ocean'.
c.700 BC	The Egyptian cities of Canopus and Thonis-Heracleion are founded in the Nile Delta. Weakened over time by earthquakes, tsunamis and rising water levels, both cities sink into the sea by around 100 BC. ↑ 6, see p.321
700–500 BC	Natural philosophers start trying to make sense of the enormous bodies of water they see from land. The earliest known map, the Imago Mundi, depicts the Earth as a flat circle surrounded by a ring of water – the oceans – with Babylon (in Mesopotamia) at the centre.

600 BC	The Phoenicians develop sea routes around the Mediterranean and beyond, reaching Africa by 590 BC. Items recovered from shipwrecks show that traded goods of the time included elephant tusks (most likely from Africa), tin, copper, pottery, amber (from the Baltic) and pine nuts.
500 BC	King Xerxes of Persia commissions a diver named Scyllias and his daughter Hydna to salvage treasure from the seabed during one of many wars between the Persians and the Greeks.
	Greek philosopher Pythagoras proposes that the Earth is spherical.
320 BC	The Greek explorer Pytheas travels from the Greek colony of Massalia (now Marseille in France) through today's Strait of Gibraltar, north to Brittany and then around the British Isles and possibly even farther north. He notes that Britain has two tides a day, the amplitude of which depends on the phases of the moon.
240 BC	The Greek astronomer Eratosthenes becomes the first person to calculate the circumference of the Earth. He uses the angles of shadows and the distance between Alexandria and Syene, up the Nile, to arrive at a value between 39,375 and 46,250 kilometres (24,470–28,740 mi). His calculation is close to the modern measurement of 40,030 kilometres (24,875 mi).
200 BC	Ancestors of the Inupiaq, Inuit, Yupik and other Arctic peoples develop hide-wrapped, wooden-framed boats, as well as smaller kayaks, which they use to hunt sea mammals in the Bering Sea between Alaska and Siberia.
200 BC – AD 400	The La Tolita-Tumaco culture of coastal northern Ecuador and southern Colombia, known for its expertise in clay sculpture and metalworking, reaches its height. ↑ 7, see p.262

8

9

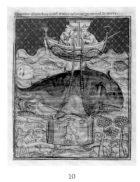

10

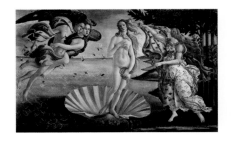

11

150 BC Greek astronomer and geographer Ptolemy writes *Geography*, listing 8,000 places with their geographical features and coordinates in latitude and longitude, and suggests ways of projecting the spherical Earth onto a flat sheet.

100 BC Salvage diving flourishes in major shipping ports of the Mediterranean. The pay for divers increases with depth, reflecting the elevated risk that comes with deeper dives.

AD 50 An unknown Greek-speaking Egyptian author writes *The Periplus of the Erythraean Sea*, an eyewitness account of travel to Africa and India via the Red Sea. It details the locations of trading depots and ports, and describes goods and peoples with sufficient accuracy to enable modern-day researchers to match archaeological sites with the text's descriptions.

AD 100–200 Triangular lateen sails developed by Arab seafarers are adopted by the Greeks in the Mediterranean. They enable vessels to tack into the wind, rendering rowers redundant and revolutionizing marine travel.

China invents the first sternpost rudder, which makes junks more manoeuvrable in the water.

AD 200 Artwork on Peruvian pottery provides the earliest record of divers wearing goggles and holding fish.

AD 300 Polynesians begin to explore, populate and trade in the great Polynesian triangle, eventually settling in today's Cook Islands in AD 700, and Hawaii and Rapa Nui (Easter Island) around AD 900. It is possible they use charts made from sticks and shells similar to those used relatively recently in the region to record and help navigate oceanic features, such as currents and islands. ↑ 8, see p.34

AD 450–900 The Coclé people, in what is now the Coclé Province, Panama, bury the upper echelons of their society in the Sitio Conte necropolis, along with painted pottery, gold and other precious objects. ↑ 9, see p.202

AD 700–1200 The Banjar people from Borneo travel 9,000 kilometres (5,600 mi) across the Indian Ocean to colonize the Comoros Islands and Madagascar.

AD 800 The Vikings of Scandinavia begin making seaborne raids to attack towns in Britain, Ireland, France, Iberia and the western Mediterranean. Adept sailors, they drop lead weights attached to ropes to measure water depth and use the sun's angle to calculate their latitude.

AD 815–820 The 22-metre (72-ft) Osberg ship is built and later used in the burial of two important women. The double-prow longboat shows the Vikings to be skilled shipbuilders.

AD 982 Norwegian explorer Erik the Red sails from Iceland to Greenland, later founding the first European colony there.

1002 Erik the Red's son Leif Erikson sails from Iceland, around Greenland, to the coast of Labrador, becoming the first European to land in North America. He names the new land Vinland and builds a short-lived settlement at L'anse aux Meadows in Newfoundland, Canada.

1070 Embroiderers stitch a visual depiction of the Norman conquest of Britain (in 1066) on the 70-metre (230-ft) Bayeux Tapestry, on which fleets of ships illustrate the strategic importance of crossing the English Channel during the Battle of Hastings.

1031–96 Chinese scientist Shen Kuo describes the magnetic needle compass, which uncovers the concept of true north and enables more accurate navigation. This technology was in use in the West by 1187, when it was written about by English monk Alexander Neckham, but it is not known whether the compass arrived in Europe from the East or was invented independently there. Italian Flavio Gioja is said to have invented a compass for maritime navigation at the start of the 1200s.

1154 The Islamic cartographer al-Idrisi completes *Recreation of Journeys into Distant Lands*, also known as *Tabula Rogeriana*. It comprises a map of the known world engraved on a silver disc and the *Recreation* text, which combines Islamic and Western thinking to show Earth as an island with south at the top in the Islamic tradition but with the world divided latitudinally and longitudinally into climate zones, following Ptolemy.

1250 Polynesians settle in New Zealand.

1300 Ptolemy's maps are reconstructed after the Greek scholar Maximus Planudes rediscovers his work the *Geography*. This prompts a revival of ancient thinking on the world's geography.

Portolan charts, comprising networks of radial lines, are a new kind of sea map now being used by sailors. Depicting coastlines and ports, they enable mariners to understand the direction they need to sail to reach specific points.

c.1300–1325 The *Romance of Alexander* is published. The manuscript depicts Alexander the Great being lowered into the sea in a crude diving bell of coloured glass. It is said the emperor used it to employ combat divers during the siege of Tyre in 325 BC. ↑ 10, see p.44

1400 Tahitians use sophisticated navigational techniques, based on astronomy and mathematics, to sail double-hulled canoes and establish oceanic trade routes between Hawaii and Tahiti.

1405–33 The Chinese-Muslim Admiral Zheng He leads seven ocean-going expeditions of more than 300 vessels – including 125-metre-long (410-ft) 'treasure ships' – and a combined crew of nearly 37,000. The sailors journey from China as far afield as Africa with the intention of extending Chinese influence by impressing neighbouring states.

1415 Europe gains a foothold on the African continent after Prince Henry the Navigator of Portugal captures the Muslim port of Ceuta, south of Gibraltar. Henry encourages further expeditions south along the African coast and is later instrumental in developing new types of ships for long-distance travel, as well as the transatlantic slave trade.

1452–1519 Leonardo da Vinci records finding fossils in Italy and ponders how the bones of fishes and oysters have come to lie at the tops of mountains as well as in shallow seas. His musings imply an understanding that the level of the sea was higher in the ancient past.

1483–84 Italian artist Sandro Botticelli paints his Renaissance masterpiece *The Birth of Venus*. ↑ 11, see p.25

1492 Italian navigator Christopher Columbus, sailing on behalf of Spain, reaches the Caribbean, resulting in lasting contact between indigenous Americans and Europeans. Columbus had sailed west in an attempt to reach Asia, Europeans not knowing of the existence of either the Americas or the Pacific Ocean. The migration of Europeans to this so-called 'New World' resulted in the decimation of indigenous populations by war, disease and abuse.

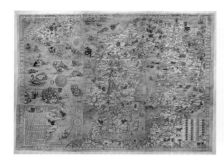

12

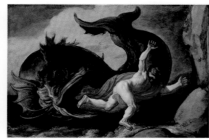

13

14

15

1497–99	Portuguese explorer Vasco da Gama sails from Lisbon, around the Cape of Good Hope on Africa's southern tip, and then east, to become the first European to reach India by sea. His navigational tools are astronomical tables, astrolabes and quadrants. The expedition's return with a cargo of sought-after spices marks the beginning of a sea-based phase of global multiculturalism.
1519–22	Ferdinand Magellan leads an expedition from Spain down the east coast of South America, around Cape Horn, and west across the Pacific. Although Magellan dies on the voyage, his successor, Juan Sebastián Elcano, and seventeen others make it home three years later to become the first people to circumnavigate the world, confirming that Earth is round.
1521	During the above journey, Ferdinand Magellan attempts to measure the depth of the Pacific Ocean. He uses a 730-metre (2,395-ft) weighted line, but it does not reach the seabed.
1535	Guglielmo de Lorena invents the first true diving bell. It incorporates a mechanism that expels breathed air while maintaining sufficient air pressure inside to prevent the water level from rising. When de Lorena and Francesco de Marchi use the bell to explore a sunken barge in Lake Nemi, near Rome, they are able to stay underwater for an hour at a time, which enables them to measure the boat's dimensions and recover submerged items.
1539	Swedish ecclesiastic Olaus Magnus creates the first map of the Nordic countries that includes detailed information and place names. It includes several 'sea monsters', some of which might be related to real animals but others of which likely come from folklore. ↑ 12, see p.302

1553	French naturalist Pierre Belon publishes *De aquatilibus*, describing 185 aquatic animals and fish.
1569	Flemish cartographer Gerardus Mercator produces a map using a cylindrical projection, which distorts features close to the poles but preserves the 90-degree angles between lines of longitude and latitude. The projection makes it easier for sailors to follow bearings on the map, as these too appear straight rather than curved.
1580	English naval admiral Francis Drake circumnavigates the globe.
1606	Dutch explorer Willem Janszoon becomes the first European to map parts of the Australian coast.
1621	Artist Pieter Lastman, important in the development of Dutch history painting, paints the Old Testament story of 'Jonah and the Whale'. ↑ 13, see p.131
1623	Dutch engineer Cornelius Jacobszoon Drebbel builds the first navigable submarine. Made from wood and covered in leather, it is propelled by oars with tight-fitting leather sleeves that keep water out. Air is supplied through tubes attached to floats. Drebbel travels down the River Thames in London in his invention at a depth of 4 metres (13 ft).
1675	The Dutch lensmaker Antonie van Leeuwenhoek invents a powerful single-lens microscope with which he makes the first observations of aquatic microbes, which he describes as 'wee animalcules'.
	The Royal Observatory is founded in Greenwich, London, with the aim of using astronomy to calculate longitude, or an east–west location on the globe, to improve navigation.
1687	William Phips, of the Massachusetts Bay Colony in North America, uses a diving bell to recover treasure from a Spanish galleon sunk in the West Indies.

1690	The English astronomer Edmund Halley develops a diving bell that can receive air from weighted barrels sent down from the surface. The barrels let in water as they descend, pushing air into the bell. A window enables undersea exploration. Dives of up to 90 minutes at depths of 18 metres (60 ft) are recorded.
1698	Halley undertakes a scientific voyage to study variations in the magnetic compass. His studies contribute to an understanding of the trade winds and help establish the relationship between barometric pressure and height above sea level.
1714	Following the loss of four warships and as many as 2,000 lives off the Isles of Scilly, the British government launches the Longitude Prize, offering £20,000 to whoever can work out how to calculate longitude to within half of a degree.
1719	The earliest known coloured study of fish is published by British spy Louis Renard. Detailing marine life around Indonesia, its first part has relatively realistic representations, but the second features more fanciful depictions, including a mermaid. ↑ 14, see p.201
1725	The Italian count Luigi Marsigli publishes *Histoire Physique de la Mer*, the first book devoted to the science of the sea.
1736	Eager to resolve the issue of how to calculate longitude, John Harrison invents the first marine chronometer – a pendulum-less clock that can keep accurate time on a rolling ship. He is given money by the Longitude Prize administrators to develop an improved version.

1761	On a journey from Portsmouth to the West Indies, John Harrison tests a fourth incarnation of his marine chronometer, and it keeps excellent time. Sailors can finally figure out how far east or west they have travelled from 0° longitude, or the prime meridian, and what longitude they are sailing past. Although Harrison receives further recompense from the organizers of the Longitude Prize, the prize is never officially awarded.
1768	British seafarer Captain James Cook begins a three-year circumnavigation from Portsmouth on HMS *Endeavour*. During this and two subsequent expeditions, Cook maps extensive areas and disproves the existence of a great southern landmass. Having use of a chronometer to accurately determine longitude at sea greatly aids Cook's travel across oceans. The visits have a disastrous impact on Pacific Islanders and indigenous populations as a result of violent deaths at the time, as well as through introduced diseases and species. ↑ 15, see p.40
	Steller's sea cow becomes the first marine mammal to be eradicated by humans – through hunting. It goes extinct less than three decades after it was first formally described in its Bering Sea habitat.
1785	American inventor and statesman Benjamin Franklin announces the discovery of the Gulf Stream in a letter to a scientific colleague in France. Although the Spanish adventurer Juan Ponce de León had observed the current as far back as 1513, Franklin widened knowledge of it by producing a map of the current based on whalers' observations.
1807	The United States Coast Survey is founded after President Thomas Jefferson authorizes a survey to be undertaken to ensure the safe passage of goods and people travelling by ship.

1818

16

1866

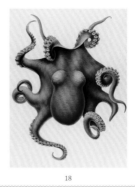

17

1872

18

1903

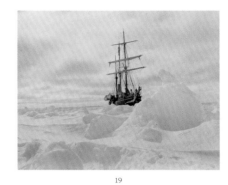

19

1818 On an expedition to search for a seaway through the Arctic (the so-called Northwest Passage) Sir John Ross catches worms and jellyfish at a depth of about 2,000 metres (6,550 ft), offering early evidence of life in the deep ocean.

1830 Mary Anning, a young fossil hunter, discovers an unknown fossil reptile on a beach in Dorset, UK, that is subsequently identified as a plesiosaur, a long-extinct marine animal propelled by four flippers.

1831 British naturalist Charles Darwin joins an expedition on HMS *Beagle* to map the South American coastline and to carry out chronometer surveys all over the globe. The journey helps him develop the theory that coral reefs form when landmasses subside, and that seashells and coral found on elevated terrain arrive there through the land being uplifted. It also lays the foundations for his groundbreaking theory of evolution, published in *On the Origin of Species*, in which he suggests that the deep ocean may be a sanctuary for living fossils.

1843 Edward Forbes publishes *Report on the Mollusca and Radiata of the Aegean Sea* in which he describes eight depth-defined regions characterized by the fauna living within them. He declares that life cannot exist below 500 metres (1,800 ft) in the deep sea. This sparks a twenty-year debate on the existence of the azoic (lifeless) zone. ↑ 16, see p.108

1855 *The Physical Geography of the Sea and Its Meteorology* is published. This is a compilation of the work of Matthew Fontaine Maury, who generated wind and current charts from ships' logs stored at the US Navy's Depot of Charts and Instruments. The publication raises popular interest in the ocean and the science of the sea.

1866 The first successful transatlantic cable is laid between Valentia Island, Ireland, and Newfoundland, Canada. It is able to transmit eight words per minute. ↑ 17, see p.190

1867 Naturalist Louis F. de Pourtalès conducts dredging operations off the southern coast of Florida and finds prolific life existing below 550 metres (1,800 ft).

1868 An expedition on board HMS *Lightning* recovers diverse and numerous specimens of marine life dredging at a depth of 1,188 metres (3,900 ft).

1869–70 Jules Verne publishes the serialized adventure novel *20,000 Leagues Under the Sea*, describing the voyages of the underwater ship *Nautilus*, a fictional submarine ahead of its time.

1870 An expedition on board HMS *Porcupine* finds fresh shells of *Globigerina* and various other animals at 4,450 metres (14,600 ft), dismissing Forbes's azoic theory and proving the deep ocean to have highly favourable conditions for life.

1872 HMS *Challenger* sets sail from Portsmouth, UK, on a three-and-a-half-year circumnavigation to gather scientific data about the oceans. During its 110,000-kilometre (78,250-mi) journey it takes 492 depth soundings and makes 133 dredges, gathering samples of seawater and marine fauna and recording depths, water temperatures and movements of currents. The expedition discovers hundreds of new species and documents underwater mountain chains, including that now known as the Mid-Atlantic Ridge. Its findings form the basis of modern oceanography.

1872 Swiss naturalist Louis Agassiz conducts a biological survey of the Americas, collecting and cataloguing more than 30,000 specimens of marine life.

1872–78 The first modern bathymetric map is made from accurate, high-density soundings taken in the Gulf of Mexico and Caribbean Sea by the research steamer *Blake*.

1872–1964 The United Kingdom, United States and Germany develop various tide-prediction machines.

1874 Commander Charles D. Sigsbee designs the Sigsbee Sounding Machine – based on the earlier Thomson Sounding Machine – that becomes the basic model for wireline sounding in the deep sea for the next fifty years.

1882 The steamship *Albatross* – the world's first large deep-sea oceanographic and fisheries research vessel – begins operations in the United States.

1885 Prince Albert I of Monaco studies locations of bottles that have been washed ashore to determine that the Gulf Stream splits in the northeastern Atlantic, with one branch heading towards Ireland and Great Britain and another past Spain and Africa, and then back west.

1893 Norwegian scientist and explorer Fridtjof Nansen has the *Fram* constructed with a reinforced hull for polar research. His subsequent research confirms the general circulation pattern of the Arctic Ocean and the absence of a northern continent.

1898–99 The German Deep Sea Expedition onboard SS *Valdivia* explores the oceans below 915 metres (3,000 ft). The findings are published in twenty-four volumes, with detailed illustrations of the marine biology encountered. ↑ 18, see p.134

1899–1905 American zoologist Alexander Agassiz makes several expeditions on the *Albatross* to study coral reefs in the Pacific Ocean. The expeditions take soundings and discover an abundant range of marine life.

1903 The Marine Biological Association of San Diego is founded. It later becomes the Scripps Institution of Oceanography, a major centre for marine research.

The first edition of the General Bathymetric Chart of the Oceans (GEBCO) is produced.

1912 The ocean liner RMS *Titanic* sinks after striking an iceberg in the North Atlantic Ocean, killing more than 1,500 people. This prompts a concerted effort to devise an acoustic means of discovering objects in the water ahead of ships.

German meteorologist Alfred Wegener proposes the theory of continental drift, suggesting that modern continents had been part of a single landmass, Pangea, 250 million years before.

1914 Canadian inventor Reginald Fessenden uses his invention, the Fessenden Oscillator, to calculate the distance to an iceberg and the depth of the seabed by timing how long it takes echoes to return from underwater surfaces. This test marks the beginning of the acoustic exploration of the sea.

The Panama Canal opens. This artificial waterway in Central America connects the Atlantic and Pacific Oceans, avoiding the need for ships to take the longer, more hazardous route around the tip of South America.

1914–18 World War I accelerates oceanic acoustic research through programs seeking to detect enemy submarines.

1915 Sir Ernest Shackleton's ship *Endurance* becomes trapped in ice in the Weddell Sea before sinking, stranding the crew and expedition photographer Frank Hurley for more than two years. ↑ 19, see p.38

1924

20

1924
The US Coast and Geodetic Survey conducts the first radio acoustic ranging navigation operations, leading to advances in understanding sound in seawater – a major step towards developing modern electronic navigation systems and oceanic instruments.

1925–27
The German *Meteor* expedition systematically surveys the South Atlantic with echo-sounding equipment, revealing new detail about the shape and structure of the seafloor and confirming that the Mid-Atlantic Ridge is continuous across the South Atlantic Ocean into the Indian Ocean.

1925–39
Surveys around the United States uncover seamounts in the Gulf of Alaska and off California, chart the topography of Southern California's continental borderlands, find many East Coast canyons and reveal a system of fracture zones in the Pacific.

1930
William Beebe and Otis Barton become the first humans to visit the deep sea, reaching 434 metres (1,426 ft). From their steel bathysphere, they observe unusual shrimp and jellyfish, and Beebe later writes that the life they saw was 'almost as unknown as that of Mars or Venus'. ↑ 20, see p.75

1934
Beebe and Barton reach a depth of 925 metres (3,028 ft) and observe deep-sea organisms in their natural habitat for the first time, including some unknown bioluminescent species.

1937
South African-American geophysicist and oceanographer Athelstan Spilhaus invents the bathythermograph, a continuously recording temperature-measuring device. The device is still in use today.

1938
Fishermen off the coast of South Africa haul in a 1.5-metre (5-ft) fish that is later identified as a coelacanth. A true living fossil, scientists had thought they had become extinct with the dinosaurs.

1939

21

1939–45
Research conducted during World War II leads to many new tools for ocean exploration, including deep-ocean camera systems, magnetometers, side-scan sonar instruments and early technology for guiding remotely operated vehicles (ROVs).

1942
Harald Sverdrup and coauthors at the Scripps Institution of Oceanography help to define the field of oceanography when they publish *The Oceans: Their Physics, Chemistry and General Biology*.

1943
Underwater explorers Jacques Cousteau and Émile Gagnan develop the first modern self-contained underwater breathing apparatus (SCUBA) system, with air supplied in response to a diver's intake of breath. The Aqua Lung allows divers to stay underwater for extended periods and explore the oceans more easily, launching diving as a recreational pastime and revolutionizing the science of underwater exploration.

1944
American educator Claude ZoBell, often known as the 'father of marine microbiology', publishes *Marine Microbiology: A Monograph on Hydrobacteriology*.

1948
Swiss physicist Auguste Piccard invents the bathyscaphe *FNRS-2*, the first untethered submersible to carry people into the deep waters of the ocean. No longer limited by the confines of a cable tether, it sets several world diving records.

1950
Charles Darwin's theory about how coral reefs form proves to be right when the US government drills into a coral atoll and finds the oldest coral has been growing for 30 million years.

1951

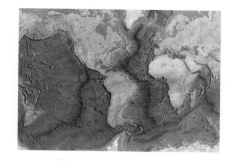

22

1951
The Sea Around Us is published by American scientist Rachel Carson, a scientifically accurate but poetic nonfiction book surveying contemporary knowledge about the world's oceans. It wins the National Book award in 1952, is made into a documentary film, and stays on the *New York Times* bestseller list for a record eighty-six weeks. ↖ 21, see p.214

The British ship HMS *Challenger II* uses modern echo-sounding technology to establish the deepest point in the global ocean, in the Mariana Trench in the Pacific Ocean, at nearly 11 kilometres (6.8 mi). The location is named the Challenger Deep.

1953
American geologist Marie Tharp uses sounding profiles from the Atlantic to confirm that the mid-Atlantic mountain range is incised by a valleylike cleft. Marie's colleagues propose seafloor spreading as a mechanism for continental drift, with new seabed being formed from molten rock in mid-ocean ridges and consumed in oceanic trenches at the boundaries of continents. ↑ 22, see p.10

1955
Oceanographers start towing marine magnetometers behind research vessels and discover magnetic striping on the seafloor. Rocks that formed when Earth's magnetic field was in one position alternate with rocks that formed when the field was reversed. The discovery proves that the seafloor is indeed spreading.

1956
Jacques Cousteau and his team aboard the *Calypso* release the documentary *Le Monde du silence*, one of the first films to use underwater cinematography to capture the beauty and life of the deep sea in colour.

1958
A tsunami caused by a massive earthquake along the Fairweather Fault, Alaska, generates the largest wave in history, in Lituya Bay. It is 524 metres (1,720 ft) high.

1960

23

1960
Auguste Piccard's son, Jacques, and his colleague Don Walsh take the bathyscaphe *Trieste* to the Challenger Deep, more than 10,916 metres (35,813 ft) below the ocean's surface. They see a flatfish at the bottom, confirming that life exists at all depths of the ocean.

1960s
Bioacoustic scientists Roger and Katy Payne are the first observers to recognize that the calls of humpback whales are not sounds made at random but are collectively composed, complex songs. ↑ 23, see p.169

1961
The Scripps Institution of Oceanography begins developing the Deep Tow System, the forerunner of all remotely operated and unmanned oceanographic systems.

1963
California band the Beach Boys release their *Surfin' USA* album, as surfing becomes a popular recreation.

1964
The US Navy deploys the experimental underwater habitat Sealab 1 at a depth of 59 metres (192 ft) to research the potential for humans to live and work underwater. It proves that saturation diving in the open ocean is viable for extended periods.

1965
Canadian geophysicist J. Tuzo Wilson combines aspects of continental drift and seafloor spreading to develop the theory of plate tectonics, in which vast slabs of Earth's crust are in constant motion, moving apart, colliding and sliding past each other.

The new deep-sea submersible *Alvin* is launched by the US Office for Naval Research and the Woods Hole Oceanographic Institution. *Alvin* makes it possible for three people to remain underwater for up to nine hours at depths of up to 5,411 metres (14,800 ft).

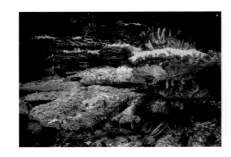

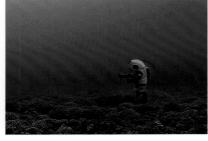

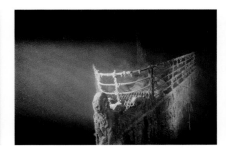

24 25 26 27

1965 The cable-controlled Underwater Recovery Vehicle (CURV), the first successful remotely operated undersea vehicle, is developed in the United States. The following year it recovers a hydrogen bomb lost off Spain in 853 metres (2,800 ft) of water.

Sealab 2, designed to house ten people, is deployed at a depth of 62 metres (205 ft). Aquanaut and astronaut Scott Carpenter lives in the underwater capsule for a record thirty days.

1966 The Convention on Fishing and Conservation of Living Resources of the High Seas comes into force. It calls for international cooperation to prevent over-exploitation of marine resources resulting from recent technological advances.

1968 The Deep Sea Drilling Project (DSDP) commences, aimed at testing the new theory of plate tectonics. Core samples taken by the research vessel *Glomar Challenger* in the mid-Atlantic provide conclusive evidence for seafloor spreading.

1969 Following 'fish-ins' protesting against the violation of traditional fishing rights, a court case acknowledges the right of several Native American tribes to fish with minimum regulation by the US or local governments.

Four divers spend 60 days inside the Tektite habitat at a depth of 15 metres (50 ft) as part of the first nationally sponsored subsea-based scientific program. During the course of the project, more than sixty scientists and engineers live and work beneath the sea.

The refurbished Sealab 2 habitat is redeployed as Sealab 3. Placed in water three times deeper, it soon begins to leak. After a diver dies trying to repair the laboratory, the program is scrapped. Sabotage is suspected but never proven.

1969 *Ben Franklin*, a submersible designed by Jacques Picccard, spends thirty days drifting in the Gulf Stream. The six crew members, including Piccard, use state-of-the-art equipment to measure gravity, Earth's magnetic field, the amount of light absorbed by the water, current speeds and direction, temperature, salinity, depth, water turbulence and sound velocity as they travel a total distance of 2,324 kilometres (1,444 mi).

1970 The National Oceanic and Atmospheric Administration (NOAA) is founded in the United States, ushering in a new era of ocean exploration.

American marine biologist Sylvia Earle leads the first all-female team of aquanauts as part of the Tektite II experiment. The Tektite II missions include the first in-depth ecological studies conducted from a subsea base.

1971–74 *Alvin* is used to conduct the first-ever exploration of a diverging tectonic plate boundary. A multinational team of scientists photographs new volcanic forms, large cracks and fissures in the seabed, and metallic deposits seemingly laid down by hot-water streams.

1973 The International Convention for the Prevention of Pollution from Ships, also known as MARPOL, is adopted.

1974 Peter Benchley writes the book *Jaws*, in which a great white shark attacks swimmers at the beach. It is later made into an award-winning movie. However, it is also criticized for creating a negative stereotype of sharks, hindering their conservation.

1975 The Great Barrier Reef Marine Park is created in Australia to protect the fragile habitat from harmful activities. ↘ 24, see p.308

1977 Scientists aboard *Alvin* in the Pacific discover hydrothermal vents – jets of super-hot fluid flowing from cracks in the seabed – along with communities of unknown organisms. They later realize that life in such locations is based not on photosynthesis, as everywhere else on Earth, but on chemosynthesis. ↘ 25, see p.292

1979 Scientists start using satellites to monitor the extent to which the Arctic Ocean is covered by ice.

The International Whaling Commission bans the hunting by factory ships of all whale species except minkes, and declares the Indian Ocean a whale sanctuary.

Sylvia Earle descends 381 metres (1,250 ft) into the Pacific Ocean in a pressurized suit, setting the world untethered diving record. ↑ 26, see p.77

1982 The United Nations Convention on the Law of the Sea is adopted (it comes into force in 1994).

Work begins in the United States to develop the remotely operated vehicle *Jason* to provide scientists with access to the seafloor from the deck of a ship.

1983 The Ocean Drilling Program (ODP) succeeds the Deep Sea Drilling Project. Over the next two decades, it collects 2,000 deep-sea cores and instigates a new field of study: palaeoceanography, the study of past conditions in the ocean.

1985 *National Geographic* explorer Robert Ballard finds the wreck of the *Titanic*, aided by *Jason*. ↗ 27, see p.79

Famed treasure hunter Mel Fisher finds the wreck of the Spanish galleon *Nuestra Senora de Atocha*, which sank in 1622. Fisher salvages 36 tonnes (40 t) of gold and silver, valued at $450 million – the largest treasure ever recovered from a shipwreck.

1990 The US-initiated Argo project begins deploying ocean-going floats to gather data on temperature and salinity. By 2021 4,000 such floats are in operation around the globe, with newer ones also able to collect data on the health of the oceans' ecosystems.

1992 The US and France launch TOPEX/Poseidon, the first major oceanographic research satellite. It measures the surface height of the oceans to an accuracy of 3.3 centimetres (1.3 in), enhancing understanding of ocean circulation and its effect on climate.

1993 NOAA begins operating the undersea habitat Aquarius in the US Virgin Islands (it later moves to Florida Keys National Marine Sanctuary). An underwater apartment and laboratory, Aquarius helps to revolutionize the study of coral reefs.

1995 Walter Smith and Dave Sandwell of NOAA combine ship-based measurements and satellite data to produce the most detailed map of the ocean floor to date.

1997 Sailor Charles Moore discovers the Great Pacific Garbage Patch, a vast mass of plastic waste caused by gyres in the Pacific Ocean.

2000 The Southampton Oceanography Centre (now the National Oceanography Centre) launches the automated submersible *Autosub*. Equipped with an array of scientific sensors, *Autosub* gathers data from previously inaccessible regions of the ocean, such as those beneath the ice caps.

2003 Scientists conclude that 90 per cent of all predatory fish – such as marlin, large cod, sharks, tuna and swordfish – have been lost from the world's oceans.

The first complete genomes of marine microbes are published, ushering in the genomic era of marine microbiology.

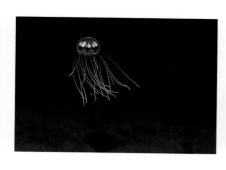

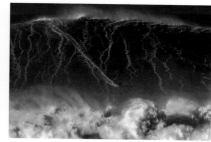

28 29 30 31

2008 The United Nations General Assembly designates 8 June as World Oceans Day.

2009 The first World Oceans Day is observed, with the theme 'Our Oceans, Our Responsibility'.

US President George W. Bush establishes the Marianas Trench Marine National Monument, protecting 246,610 square kilometres (95,216 sq mi) of ocean in the Mariana Archipelago.

2010 The first global census of marine life is completed – a decade of work by 2,700 scientists from 80 nations, it discovers more than 6,000 potentially new species.

The Deepwater Horizon oil rig explodes in the Gulf of Mexico, causing the largest marine oil spill in history.

2011 An expedition to the Mariana Trench discovers giant single-celled amoebas living in the deepest region of the ocean. Scientists also learn that ocean trenches play a larger role in regulating the Earth's chemistry and climate than was previously thought. ↑ 28, see p.81

2012 Arctic sea ice reaches its smallest-ever extent; 2007, 2016 and 2019 are not far behind. ↗ 29, see p.152

Michael Lombardi of the Bahamas Marine EcoCentre develops a portable inflatable underwater habitat that provides divers with a comfortable environment in which to decompress as they return to the surface from deep dives.

Film director James Cameron makes the first solo dive to the bottom of the Mariana Trench in the *Deepsea Challenger*.

American marine biologist Edith Widder uses a bioluminescent lure that mimics the pulsing lights of panicked jellyfish to capture a giant squid in the deep ocean on camera for the first time.

2012 Big-wave surfer Sean Dollar surfs an 18.6-metre (61-ft) wave off California, setting a record for the largest wave ever surfed by the traditional paddle-in method.

2013 A marine heatwave termed the Blob warms water to 2.5° Celsius higher than usual between Alaska to California until 2016.

A mysterious disease, named sea star wasting disease, causes large numbers of starfish to decompose on both coasts of the United States. It is later found to be caused by a virus.

2014 A study finds that more than 5 trillion plastic pieces, weighing more than 226,000 tonnes (250,000 t), are adrift in the ocean.

Science communicator Elin Kelsey initiates Ocean Optimism, a movement highlighting success-ful marine conservation efforts to inspire action to save the oceans.

Scientists discover that twice as much water as is in Earth's surface oceans may be trapped in rocks 400 to 660 kilometres (250–410 mi) below the surface, supporting the idea that water came from within Earth rather than being delivered by asteroids or comets.

2014–17 The combination of rising ocean temperatures due to climate change and a strong El Niño (a natural climatic phenomenon) leads to mass coral bleaching around the world.

2015 Scientists discover a new archaea (a type of prokaryota – simple, singled-celled organisms) in the deep-sea hydrothermal vent known as Loki's Castle. Now named Lokiarchaea, the microbe shares 100 genes for cellular functions with complex life. This suggests it is the closest living prokaryotic relative to the eukaryotes (animals, plants, fungi and protists).

2016 Researchers conclude that the Greenland shark is the longest-living vertebrate on the planet; one specimen is found to be 400 years old.

2017 The first United Nations Oceans Conference takes place; later the UN declares 2021–2030 to be the Decade of Ocean Science for Sustainable Development.

The Seabed 2030 project aims for 100 per cent of the ocean floor to be mapped by 2030. A collaboration between the Nippon Foundation of Japan and GEBCO, it will bring together all available existing bathymetric data and use tracking ships with advanced multibeam bathymetry technology to fill knowledge gaps; currently, less than 15 per cent of the ocean floor has been mapped in detail.

Scientists uncover a huge fragment of prehistoric 'super-continent' off the coast of Mauritius. The discovery leads to speculation that there may be more pieces of this ancient landmass scattered through the Indian Ocean.

2018 A new ocean zone is described. Named the rariphotic (scarce light) zone, it ranges from 130 to at least 309 metres (427–1,014 ft) deep; this part of the ocean can only be explored by submersibles.

A new study shows only 13 per cent of the ocean is undisturbed by human activity.

2019 Conservation efforts by volunteers to save endangered loggerhead sea turtles pay off, as 500,000 eggs hatch along the US's southeast coast.

Scientists find the oceans are heating up 40 per cent faster than estimated five years earlier by the Intergovernmental Panel on Climate Change.

2019 The $4 million Ocean Discovery XPrize is awarded to the GEBCO-Nippon Foundation Alumni team, which is using uncrewed deep-sea vehicles to map the ocean floor.

The UK not-for-profit research institute Nekton makes a live TV-quality video transmission from a submersible 60 metres (197 ft) beneath the Indian Ocean.

A study in California finds plastic at every depth of the ocean.

2020 A 48-day expedition removes more than 100 tonnes (110 t) of plastic waste from the Great Pacific Garbage Patch, the largest ocean cleanup in history. ↘ 30, see p.154

Brazilian Maya Gabeira surfs a 22.4-metre (73.5-ft) wave in Nazaré, Portugal, breaking her own record for the largest wave surfed by a woman. It is the biggest wave surfed by anyone that year. ↑ 31, see p.278

2021 Scientists at Dutch research institute Deltares estimate that 267 million people currently live on land less than 2 metres (6.5 ft) above sea level and are therefore at risk from rising sea levels.

2022 The largest and most complete fossil specimen of an ichthyosaur ever found in the United Kingdom is unearthed at Rutland Water.

The Endurance22 Expedition, documented by photographer Esther Horvath, locates the wreck of Sir Ernest Shackleton's ship *Endurance*, which sank in the Weddell Sea in 1915.

Two billion DNA sequences from 1,700 sediment samples taken at all depths of the ocean reveals that rich and unknown life exists in the abyssal realm, the last *terra incognita* on Earth.

Ocean Zones

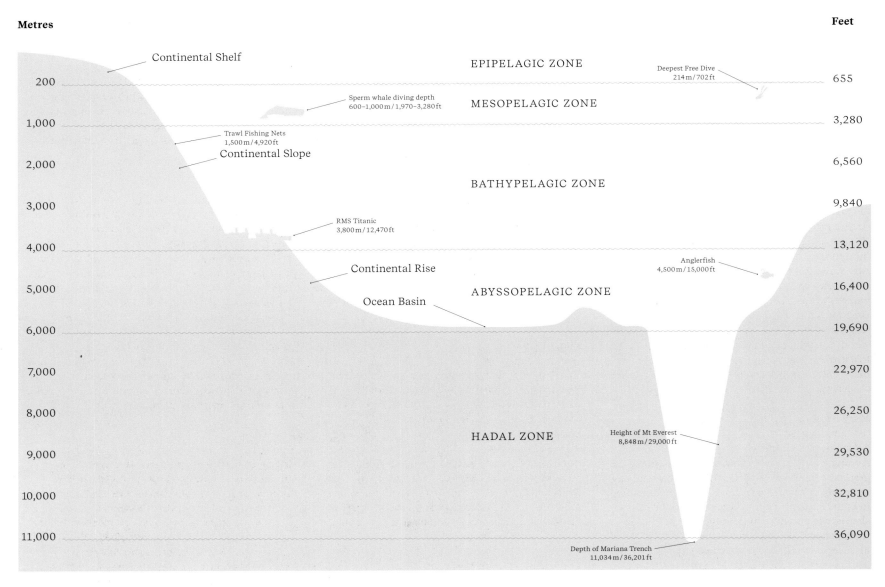

Metres

200

1,000

2,000

3,000

4,000

5,000

6,000

7,000

8,000

9,000

10,000

11,000

Continental Shelf

EPIPELAGIC ZONE

Deepest Free Dive
214 m / 702 ft

Sperm whale diving depth
600–1,000 m / 1,970–3,280 ft

MESOPELAGIC ZONE

Trawl Fishing Nets
1,500 m / 4,920 ft

Continental Slope

BATHYPELAGIC ZONE

RMS Titanic
3,800 m / 12,470 ft

Continental Rise

Anglerfish
4,500 m / 15,000 ft

ABYSSOPELAGIC ZONE

Ocean Basin

HADAL ZONE

Height of Mt Everest
8,848 m / 29,000 ft

Depth of Mariana Trench
11,034 m / 36,201 ft

Feet

655

3,280

6,560

9,840

13,120

16,400

19,690

22,970

26,250

29,530

32,810

36,090

Although the ocean contains more than 99 per cent of all habitable space on Earth, less than 5 per cent of it has been explored. It contains a variety of habitats at various depths. Scientists divide the global ocean into six different zones.

Continental Shelf
The edges of Earth's continents are surrounded by underwater shelves that stretch from 80 to 1,500 kilometres (50–930 mi) into the ocean. Continental shelves are submerged beneath shallow shelf seas – part of the epipelagic zone – where easy sunlight penetration supports an abundance of plant and animal life.

Intertidal Zone
The intertidal zone is where land and ocean meet. Its topography varies from steep rocky cliffs to long sandy beaches and mud flats, and it is submerged and revealed once or twice a day. The intertidal zone has four subdivisions: the spray zone, and the high, middle and low intertidal zones. Constant change makes the intertidal zone an extreme ecosystem.

Epipelagic Zone (Sunlight Zone)
The epipelagic zone, or upper open ocean, extends from the surface down to 200 metres (655 ft). Warmed by the sun and with an abundance of light, the water temperature ranges between –2 and 36° Celsius (28–97° F). The sunlight allows algae to photosynthesize, creating around half of the oxygen in Earth's atmosphere. Around 90 per cent of marine life lives in this zone.

Mesopelagic Zone (Twilight Zone)
Starting at 200 metres (655 ft), the mesopelagic zone, or middle open ocean, descends to 1,000 metres (3,280 ft). Here, a small amount of light penetrates the waters in the middle of the day. The water temperature drops dramatically between 500 and 800 meters (1,640–2,625 ft), a phenomenon known as thermocline. Hardy fish and invertebrates survive here, relying on prey or food particles that sink from the sunlight zone above. The twilight zone regulates the planet by absorbing 25 per cent of carbon dioxide from the atmosphere.

Bathypelagic Zone (Midnight Zone)
Between 1,000 and 4,000 metres (3,280–13,120 ft), the bathypelagic zone, or lower open ocean, is fifteen times the size of the epipelagic zone. In the upper third of the deep ocean, the water temperature remains a fairly constant 4° Celsius (39° F). No sunlight penetrates this deep, and the only light comes from bioluminescent animals when they hunt or mate. Sperm whales swim down to the bathypelagic zone to feed.

Abyssopelagic Zone (The Abyss)
From the Greek abyss meaning 'no bottom', the middle layer of the deep ocean goes from 4,000 to 6,000 metres (13,120–19,685 ft). The temperature hovers around 2 to 3° Celsius (36–37° F). The huge water pressure at this depth can be survived only by a few invertebrates. The desert of the ocean, the abyss is completely dark with almost no oxygen.

Hadal Zone (The Trenches)
The deepest part of the ocean is not continuous but made up of deep canyons known as trenches. The best known is the Mariana Trench in the Pacific Ocean, one of five trenches known to be deeper than 10,000 metres (32,810 ft).

Select Biographies

Ansel Adams
(United States, 1902–1984)
Ansel Adams was a pioneering photographer best known for his majestic, formally assured landscapes of the American West. A vocal proponent for the establishment of photography as an art form, he helped found the photography department at the Museum of Modern Art in New York in 1940. From 1934 to 1971, Adams was the director of the Sierra Club, and in 1980, he was awarded the Presidential Medal of Freedom for his documentation of America's national parks and his tireless activism for environmental conservation.

al-Qazwini
(Iran, c.1203–1283)
While living in Wasit in Iraq and working as a judge, in 1270 the Arab cosmographer and geographer Abu Yahya Zakariya ibn Muhammad ibn Mahmud al-Qazwini compiled an illustrated treatise of the marvels of the Universe entitled *The Wonders of Creation and the Oddities of Existence*. The manuscript was widely read and copied across the Islamic world. Showing al-Qazwini's spiritual approach to astronomy, astrology, geography and natural history, the compilation is divided into two parts: the heavenly realm and the earthly realm.

Mary Anning
(Britain, 1799–1847)
Relatively little is known about the life of Mary Anning, despite the fact that she made some of the greatest contributions to the field of palaeontology in Britain. Born and raised in humble surroundings in Lyme Regis on the south coast of England, she learned about fossil hunting from her father, the amateur fossil collector Richard Anning. Mary discovered the first known complete specimen of the ichthyosaur and most notably uncovered the first known complete plesiosaur fossil. With the growing popularity of fossils in the Victorian era, Anning opened a fossil shop in Lyme Regis, and it became a hub for palaeontologists and geologists.

Anna Atkins
(Britain, 1799–1871)
Anna Atkins was trained in botany by her father and became a skilled illustrator and plant collector. She used the cyanotype process invented by her mentor, the astronomer Sir John Herschel – in which sunlight was used to create a photogram on chemically treated paper – to record the images printed in 1843–53 in *Photographs of British Algae: Cyanotype Impressions*.

John James Audubon
(United States, 1785–1851)
Born in Haiti and brought up in France, Audubon moved to the United States in 1803. He tried various business ventures before combining his skill as an artist with his lifelong interest in ornithology in a project to find, identify and draw the birds of North America. The project took some fourteen years as Audubon travelled the country. Each bird was placed against a background of plants, depicted either by Audubon or by his assistant, Joseph Wilson. The resulting book, *Birds of America* (1827–38), with its huge lithographs of nearly five hundred bird species, is considered a landmark of natural history illustration.

Ferdinand Bauer
(Austria, 1760–1826)
Orphaned as an infant, Ferdinand Bauer was brought up with his brother Franz by the monk, anatomist and botanist Dr Norbert Boccius, who taught them natural history and illustration. The brothers worked at the Royal Botanical Garden at Schloss Schönbrunn in Vienna before Ferdinand accompanied Professor John Sibthorp of Oxford University to Greece and Turkey. Bauer later became the natural history artist on Matthew Flinders' expedition on HMS *Investigator* to circumnavigate Australia (1801–5). He brought back hundreds of pencil drawings of the native flora and fauna, including images of many bird species that were previously undescribed.

Pierre Belon
(France, 1517–1564)
The French naturalist, writer and explorer Pierre Belon studied botany before travelling through the eastern Mediterranean, observing and recording the local flora and fauna. He wrote several notable books, including works on zoology such as *La nature et diversité des poissons* (*The Nature and Diversity of Fishes*, 1551), in which he discussed the dolphin in great detail, and *L'histoire de la nature des oiseaux* (*Natural History of Birds*, 1555). These in-depth studies and comparisons between the skeletons of birds and humans were the earliest examples in the field of comparative anatomy.

Leopold and Rudolf Blaschka
(Bohemia, 1822–1895; 1857–1939)
Trained as a goldsmith and gem cutter, Leopold Blaschka joined the family glass-making business and developed a technique of 'glass-spinning' that allowed him to create intricate and detailed models. After moving to Dresden, he began to make glass models of flowers and marine invertebrates. Blaschka, who was joined in his work by his son Rudolf in about 1880, made some ten thousand marine specimen sculptures over the course of thirty years, often taken from the study of live specimens. Before the days of underwater photography, the Blaschkas' models were important educational resources and were widely purchased by universities and museums. Rudolf continued working alone after his father's death in 1895.

Jacques Cousteau
(France, 1910–1997)
Renowned underwater explorer and marine conservationist Jacques-Yves Cousteau began experimenting with underwater filmmaking during World War II while a member of the French Resistance. In 1943, in collaboration with the engineer Émile Gagnan, he invented the Aqua-Lung, the first fully automatic compressed-air system for divers. He would go on to design a small, manoeuvrable seafloor submarine and various underwater cameras, and to experiment with new forms of lighting that would illuminate depths of more than 100 metres (330 ft). His 1956 film *Le monde du silence* (*The Silent World*) was an international sensation, bringing the underwater world to the general public. In 1974 he founded the nonprofit Cousteau Society dedicated to marine conservation.

Leonardo da Vinci
(Italy, 1452–1519)
One of the greatest artists of any age, da Vinci was a polymath for whom the term 'Renaissance man' was coined. Born in Tuscany, he showed artistic talent at a young age and was apprenticed to the artist Verrocchio in Florence. He worked for seventeen years in Milan for Duke Ludovico Sforza before moving to Venice and then back to Florence, where he worked for Cesare Borgia; later he worked in Rome for Pope Leo X before moving to France at the invitation of King Francis I. Da Vinci completed few paintings, but they include such masterpieces as *The Last Supper*, *Mona Lisa* and *The Virgin of the Rocks*. He is renowned for his closely observed sketches of the natural world and human anatomy, as well as his military and mechanical designs.

Mark Dion
(United States, 1961–)
The work of artist Mark Dion looks at the role of institutions and thought systems in the way we approach the fields of science, natural history, ornithology and knowledge. He uses scientific methodology in collecting and displaying specimens in order to explore the idea of public knowledge. Dion often collaborates with natural history museums, aquariums, zoos and other public institutions to develop his critical approach. He was born in Massachusetts and studied fine art at the Hartford Art School and the School of Visual Arts in New York before taking part in the Whitney Museum's Independent Study Program. He lives and works in New York.

David Doubilet
(United States, 1946–)
David Doubilet is one of the world's leading underwater photographers, creating a visual voice for the world's oceans. First published by *National Geographic* in 1972, he has contributed to the magazine regularly ever since, with more than seventy stories to date from around the world. Doubilet was a pioneer of split-field imaging, where elements both above and below the water appear in focus in a single photograph. Throughout his career he has earned numerous awards, including the Explorers Club Lowell Thomas Award and Lennart Nilsson Award for Scientific Photography, and is a member of the Academy of Achievement, Royal Photographic Society and International Diving Hall of Fame, and a founding Fellow of the International League of Conservation Photographers.

Sylvia Earle
(United States, 1935–)
Sylvia Earle is a marine biologist, oceanographer and activist who earned a PhD from Duke University in algology, the study of algae. She is a pioneer in the development of piloted and robotic undersea exploration equipment. In 1979 Earle descended to the seafloor at a depth of 381 metres (1,250 ft) in an atmospheric diving apparatus called a JIM suit, setting a record for the deepest untethered dive ever carried out by a woman – it still stands today. In 2008 she founded Mission Blue to raise awareness of the threat to the world's oceans of overfishing and pollution.

Conrad Gessner
(Switzerland, 1516–1565)
A naturalist and physician, Conrad Gessner was a prolific writer best known for his compilations of information on animals and plants. He was born in Zurich to a poor family, his schooling funded by a great-uncle. He showed such promise that after the death of his father, some of his teachers sponsored his further study. He found a teaching position in Zurich, then left to study medicine in Basel. He spent the majority of his career practising medicine in Zurich but also wrote notable works, including the monumental five-volume *Historiae animalium* (*Histories of the Animals*, 1551–87).

Ernst Haeckel
(Germany, 1834–1919)
The biologist Ernst Haeckel was an enthusiastic supporter of Charles Darwin's theory of evolution, and his research led him to coin many important biological terms, including 'ecology' – the study of the way that organisms relate to their environment. Several of his evolutionary claims turned out to be wrong, however, and he was accused of faking his research into embryology. He nevertheless remained a major scientific figure of his day. A talented artist, Haeckel made hundreds of sketches and watercolours of plants and animals.

Damien Hirst
(Britain, 1965–)
The prominent British contemporary artist Damien Hirst is a central figure in a generation that emerged in the 1990s known as the Young British Artists (YBAs). Much of his work explores mortality, and he became renowned for his presentation of dead animals preserved in formaldehyde and exhibited in vitrines. Hirst studied at Goldsmiths' College in London from 1986 to 1989. In 1995 he won the prestigious Turner Prize for contemporary art, and he has continued to make controversial and provocative work.

Katsushika Hokusai
(Japan, 1760–1849)
Katsushika Hokusai was one of the most influential Japanese artists of the late Tokugawa or Edo period, specializing in *ukiyo-e* ('depictions of the floating world'). His long career encompassed portraits, book illustration and erotica, but he is best known for the woodcut landscape prints he produced late in his life, such as the series *Thirty-Six Views of Mount Fuji*. His work was an important influence on the development of *japonisme* in Europe, where his prints appealed particularly to the Impressionists.

Frank Hurley
(Australia, 1885–1962)
The self-taught photographer Frank Hurley bought his first camera at the age of seventeen, by which time he had already run away from his suburban Sydney home to work in a steel mill. He soon gained a reputation for striking images, many of which involved him placing himself in extreme danger. He took several trips to Antarctica, where he served as the official photographer for Sir Ernest Shackleton's ill-fated 1914 expedition, which was marooned until 1916. Hurley joined the Australian Imperial Force in 1917, photographing the Battle of Passchendaele. A pioneer, he was an early adopter of colour photography and made many documentaries later in life.

Ogata Kōrin
(Japan, 1658–1716)
The son of a wealthy merchant, Ogata Kōrin was taught by leading Japanese artists of his time but became noteworthy for his development of an impressionistic style of painting based on idealized rather than naturalistic forms. A member of the renowned Rimpa School, he is best known for painting on folding screens covered in gold foil.

Yayoi Kusama
(Japan, 1929–)
The Japanese contemporary artist Yayoi Kusama now works predominantly with installations, which are at once representational and abstract. Prone to hallucinations from an early age, Kusama transforms these experiences – how she sees the world – into her art. Repetitive patterns, often polka dots, are obsessively mirrored and extended into infinite spaces that envelop the viewer into their world. Her early work comprised paintings, referred to as 'infinity nets', of obsessively repeated tiny marks across large canvases, as well as performance.

Jean-Baptiste Lamarck
(France, 1744–1829)
Jean-Baptiste Pierre Antoine de Monet, chevalier de Lamarck was a pioneering biologist and one of the first proponents of a theory of evolution. His early career was spent as a botanist at the Jardin du Roi (the royal botanic garden) in Paris under Georges-Louis Leclerc, Comte de Buffon, and he was elected to the Academie des Sciences in 1779.

When the Jardin was turned into the Muséum national d'Histoire naturelle, Lamarck was appointed professor of insects, worms and microscopic animals. His major work from then on was to classify this group of animals, which he would later call 'invertebrates'. He also coined the term 'biology'.

Carl Linnaeus
(Sweden, 1707–1778)
Known in Swedish as Carl von Linné, Linnaeus was a naturalist and explorer who became the founding father of modern taxonomy. The foundations of his system of naming, ranking and classifying organisms are still in use today, albeit with many changes. Growing up in southern Sweden, Linnaeus began studying medicine at the Lunds Universitet but soon transferred to Uppsala Universitet. In 1735 he published his *Systema Naturae* (*The System of Nature*), which laid out his taxonomy of three kingdoms – stones, plants and animals – and their subdivision into classes, orders, genera, species and varieties.

Olaus Magnus
(Sweden/Poland, 1490–1557)
The writer Olaus Magnus was a Swedish Catholic clergyman who moved to Poland after the Swedish Reformation. He wrote numerous works, including *Carta Marina*, which includes the most accurate map of northern Europe for the period.

Henri Matisse
(France, 1869–1954)
A painter, draughtsman and sculptor, Henri Matisse's innovations in the use of colour and form are regarded as some of the most important contributions to modern art. Matisse started his career as a lawyer and only began to study art at the age of twenty-one. He is one of the artists associated with Fauvism, a painting movement from the early twentieth century that employed swathes of colours to create brilliant canvases that tread the line between abstraction and figuration.

Matthew Fontaine Maury
(United States, 1806–1873)
Having spent a decade serving in the United States Navy, Matthew Fontaine Maury began writing about navigation in the 1830s and in 1842 became superintendent of the Depot of Charts and Instruments of the Navy Department in Washington DC. Over the next decade he established an international reputation for his studies of oceanography and meteorology, and his system of recording oceanographic data was adopted globally. He wrote *The Physical Geography of the Sea*, the first oceanographic textbook, in 1855.

Adolphe Millot

(France, 1857–1921)

Born in Paris, Adolphe Millot was a member of the prestigious Salon des Artists Français. Millot was responsible for illustrating many of the natural history sections of the well-known French encyclopaedia *Le Petit Larousse*, which first appeared in 1905. A highly regarded lithographer and entomologist, Millot worked as a senior illustrator for the Musée Nationale d'Histoire Naturelle in Paris, established by King Louis XIII in 1635 as the royal garden for medicinal plants.

Claude Monet

(France, 1840–1926)

Claude Monet was a leading member of the Impressionist movement whose 1874 painting gave the style its name. For sixty years, Monet explored ways of translating the natural world into paint, with pictures that take viewers from the streets of Paris to the tranquil gardens of Giverny, where he painted his famous water lily pictures. Monet's contribution to the painting tradition paved the path for twentieth-century Modernism and revolutionized the way we view nature.

Georgia O'Keeffe

(United States, 1887–1986)

One of the leading American artists of the twentieth century, Georgia O'Keeffe had a conventional training before turning her back on realism in her twenties to experiment with abstraction. Her work was first exhibited in 1916 by the photographer and gallery owner Alfred Stieglitz, whom she married in 1924. Among her favourite subjects were flowers, of which she made huge close-up paintings into which some critics read a sexual significance. From 1929 O'Keeffe spent much of her time painting landscapes and animal bones in New Mexico, where she moved permanently in 1949.

Albertus Seba

(Netherlands, 1665–1736)

The Dutch pharmacist Albertus Seba, who was born in Germany but spent his life in Amsterdam, created a renowned collection of curiosities. After amassing a huge number of specimens, he commissioned illustrations that he incorporated into a four-volume catalogue, *Locupletissimi rerum naturalium thesauri* (*Thesaurus of Natural Things*, 1734–65). The catalogue recorded everything from birds and butterflies to snakes and crocodiles, and even fantastical creatures such as dragons and a hydra. Seba's early research on natural history and taxonomy influenced Carl Linnaeus. His collection was sold at auction in 1752, and much of it was later confiscated by Napoleon and taken to the Museum of Natural History in Paris.

Hiroshi Sugimoto

(Japan, 1948–)

Tokyo-born-and-raised but a resident of New York since 1974, Hiroshi Sugimoto has created work that extends from photography to art installations and architecture. He studied politics and sociology in Tokyo in 1970, then retrained as an artist. His photography has been widely exhibited, as has his architecture – his 2014 glass teahouse was initially exhibited at the Venice Biennale. In 2018 his architectural firm completed the redesign of the lobby of the Hirschhorn Museum and Sculpture Garden in Washington DC.

Marie Tharp

(United States, 1920–2006)

Marie Tharp obtained degrees in geology and mathematics before working at the Lamont Geological Laboratory in New York, at first locating aeroplanes lost at sea during World War II. She and her colleague Bruce Heezen began the systematic mapping of ocean-floor topography, Heezen collecting data from research ships and Tharp mapping the results. In 1977 they published their landmark map of the whole ocean floor, painted by the Austrian cartographer Heinrich C. Berann.

Charles Frederick Tunnicliffe

(Britain, 1901–1979)

Raised on a farm in Cheshire, Charles Tunnicliffe drew farm animals on the walls of black creosoted farm buildings with white chalk before winning a scholarship to the nearby Macclesfied School of Art and Design in 1916. Another scholarship took him to London's Royal College of Art. Returning north in 1928, he initially worked as an engraver and illustrator before concentrating on painting birds from the 1930s. As well as illustrating books for the children's Ladybird series, he also wrote and illustrated his own books from his Anglesey home in North Wales, where he lived from 1947 until his death.

Tupaia

(Society Islands, c.1725–1770)

Tupaia was a Polynesian navigator who joined Captain James Cook as translator on the *Endeavour*'s voyage of 1769 to New Zealand and Australia. Relying on personal experience and family knowledge, Tupaia impressed Cook's colleague Sir Joseph Banks with his geographical knowledge, although Cook himself preferred to rely on his own explorations.

Vincent van Gogh

(Netherlands, 1853–1890)

Vincent van Gogh is one of the foremost figures in the history of twentieth-century art. While his career as an artist was short, lasting only from around 1880 to his death, he was a prolific and imaginative painter whose innovations in brushwork and colour inspired generations of artists. In 1888, he moved to Arles, France, where the brilliancy of the light inspired him to make paintings of seascapes, flowers and fields, which remain some of his best-known works to this day.

Josiah Wedgwood

(Britain, 1730–1795)

Josiah Wedgwood was a successful potter and entrepreneur, whose business tactics are credited as some of the first examples of modern marketing. His goods were highly favoured by the upper classes during a time of increased demand as a result of the Industrial Revolution. Wedgwood founded an eponymous china and porcelain company in 1759, which is still active to this day.

Edward Wilson

(Britain, 1872–1912)

A scientist and medical doctor, Edward Wilson was also a talented artist, and he joined Robert Falcon Scott's expeditions to Antarctica in 1911 and 1912 as the scientist and expedition artist. Wilson was only twenty-nine when he first set sail for the South Pole on HMS *Discovery*. He had overcome tuberculosis in 1901 and was recruited to the expedition only three weeks before it sailed. As the expedition zoologist, he would paint animal specimens before they were preserved for collection, recording details such as colour that would otherwise be lost. On their second expedition, on HMS *Terra Nova* in 1912, Wilson died with Scott as they battled through bad weather to return to the ship.

Glossary

Anthropomorphism
The tendency for humans to interpret the physical appearance and behaviour of animals as similar to, comparable to or the same as those of humans.

Arthropoda
A highly diverse phylum of jointed-limbed animals, including crustaceans and copepods, among others.

Behaviour
Responses to stimuli exhibited by an individual. Behaviours may be shared by members of a species and may be voluntary or involuntary.

Binomial nomenclature
The universal system of naming living organisms with two names: a capitalized genus name plus a species name.

Biodiversity
Biological diversity, or the variety of life on Earth, considered at all levels. This includes genetic variety within species, the variety of species themselves and habitat variety within an ecosystem.

Cartilaginous
Constructed from cartilage, a firm but elastic skeletal tissue that is found as a protective layer at the joints of bones or for maintaining structural rigidity, such as in the walls of airways. The skeletons of fish such as sharks and rays are entirely cartilaginous.

Chromolithograph
A colour lithograph.

Class
A level of taxonomic classification below phylum. There are approximately 108 animal classes, including Mammalia (mammals) and Aves (birds).

Codex
An ancient manuscript in the form of a book.

Diorama
A three-dimensional replica of an environment populated by taxidermy models of animals found within it, usually for museum display.

Ecosystem
The system or web of movement of energy and nutrients between living (biotic) organisms and the (abiotic) environment.

Endangered
A classification bestowed by the International Union for Conservation of Nature indicating that a species is in danger of extinction.

Endemic
An indigenous species that is found only in a specific region owing to factors that limit its distribution and migration.

Engraving
A technique by which a design is scored into a surface such as stone, leather or wood by the use of a sharp tool, called a burin. Also the name for a print produced by transferring ink from this incised surface onto paper.

Extinction
The termination of a species. Extinction may occur for many reasons, such as competition by an invasive species or overhunting by humans.

Family
A level of classification below order and above genus. There are thousands of animal families, for example family *Acanthuridae*, which includes more than eighty species of tropical marine fish.

Fauna
The animal life contained within an environment, as opposed to flora.

Flora
The plant life (sometimes including fungi and other non-animal life) contained within an environment, as opposed to fauna.

Fossil
The remains of deceased organisms within rock, usually slowly altered through geochemical processes. Fossils are generally formed from hard organic tissue such as bone, but soft tissues such as collagen and feathers may be fossilized under excellent conditions. Footprints and burrows are also classed as types of fossils.

Genus
A level of classification below family and above species. There are hundreds of thousands of genera. Genera names are written in italics and capitalized.

Gyre
A large system of rotating ocean currents that are more permanent than other types of currents, such as eddies or whirlpools. There are five major gyres in the world's oceans: the North and South Pacific Subtropical Gyres, the North and South Atlantic Subtropical Gyres, and the Indian Ocean Subtropical Gyre.

Habitat
A type of area defined by its particular environment, incorporating both living and nonliving factors within which organisms live.

Ichthyology
The branch of zoology concerned with the evolution, structure, behaviour and conservation of jawless, cartilaginous and bony fish.

Invertebrate
A 'catch-all' term for any animal that is not a vertebrate. By this definition, 95 per cent of animals are 'invertebrates'.

Kingdom
The highest level of taxonomic classification. Currently seven kingdoms are recognized – for example, Animalia and Plantae (animals and plants).

Larva
The immature development stage of many invertebrates, fishes and amphibians prior to metamorphosis into the adult form. Usually a radically different morphology from that of adults, with a less complex body.

Lithograph
A printing technique developed at the turn of the nineteenth century, in which an image drawn onto a flat surface (initially a stone tablet, hence *lithograph*, 'drawing on stone') is transferred to a paper sheet.

Mammalia
The class of animals to which humans belong. Mammals are warm-blooded vertebrates, which are distinguished by many things, among which are the possession of hair, (usually) the birth of live young and the secretion of milk for feeding young.

Micrograph
A photograph taken through a microscope.

Mollusca
A phylum of animals with soft, usually unsegmented bodies with or without shells, such as snails, mussels and octopuses.

Native
A species that occurs naturally in a particular country or region. These may occur in a number of places within a country or region (indigenous) or be restricted to just one place (endemic).

Natural history
A term for the study of subjects that roughly correspond with geology and biology since the Renaissance. Today 'natural history' is a loosely defined term for many, usually descriptive-based, forms of biological investigation.

Non-native
Not historically found in an area, having been introduced recently into an ecosystem.

Order
A level of classification hierarchy below class and above family. There are thousands of different animal orders, for example the order Cetacea (whales, dolphins, and porpoises).

Pelagic
Relating to the open sea. In fish, refers to animals that live in the upper layers of the open sea.

Further Reading

Phylum
The second-highest level of classification, below kingdom. There are at least thirty animal phyla depending on the classification system followed. For example, phylum Cnidaria, which includes more than nine thousand species of mostly marine animals, such as jellyfish, sea anemones and corals.

Phytoplankton
A group of microscopic, photosynthetic algae that are the foundation of marine food chains. It is estimated that phytoplankton produce half of the oxygen on Earth.

Scanning electron microscope
A microscope in which the surface of a specimen is scanned by a beam of electrons that are reflected to form an image.

Species
A population of organisms more genetically similar to each other than to organisms outside the group. Variations within this population may be classed as subspecies. In many vertebrates, 'species' is classically defined as the largest population of a group of animals that is able to produce fertile offspring by breeding (the 'biological species model').

Specimen
An example of a species, or any material related to it, usually acquisitioned into a museum or private collection for reference. 'Type' specimens (or holotypes) are the specimens after which species are described and named.

Subspecies
A group of animals that genetically belong within a species but have characteristics that make them distinct from other members of the species in small ways.

Taxonomy
The branch of biology concerned with the classification, naming and identification of organisms.

Vertebrate
All species of animals in the subphylum Vertebrata, which have the distinguishing feature of a vertebral column, including jawless fish, cartilaginous fish, bony fish, amphibians, reptiles, mammals and birds.

Woodblock
A block of wood engraved in relief and used for printing an image, typically called a woodcut print.

Zoology
The branch of biology concerned with members of the kingdom Animalia.

Zooplankton
A group of tiny marine animals, from microscopic protozoans to fish larvae, that float or drift with water currents. Along with phytoplankton, they form the basis of most marine food chains.

The American Museum of Natural History. *Ocean: The World's Last Wilderness Revealed*. London: DK Publishing, 2006.

Bascom, Willard and Kim McCoy. *Waves and Beaches: The Powerful Dynamics of Sea and Coast*. Ventura, California: Patagonia, 2020. (First published 1964)

Bass, George F. *Beneath the Seven Seas*. London and New York: Thames & Hudson, 2005.

Bellows, Andy Masaki, Marina Dougall and Brigitte Berg, eds. *Science Is Fiction: The Films of Jean Painlevé*. Cambridge, MA: MIT Press, 2000.

Carson, Rachel. *The Sea Around Us*. Oxford University Press, 2018. (First published 1950)

Corson, Trevor. *The Secret Life of Lobsters: How Fishermen and Scientists Are Unraveling the Mysteries of Our Favorite Crustacean*. New York: HarperCollins, 2004.

Cousteau, Jacques. *The Silent World*. National Geographic Society / HarperCollins, 2004. (First published 1953)

Dipper, Frances. *Ocean*. London: DK Publishing, 2006.

Dipper, Frances. *The Marine World: A Natural History of Ocean Life*. Cornell University Press, 2016.

DK Publishing. *Ocean: The Definitive Visual Guide*. London: 2014.

Doubilet, David. *Water Light Time*. London and New York: Phaidon, 1999.

Doubilet, David. *Two Worlds: Above and Below the Sea*. London and New York: Phaidon, 2021.

Earle, Sylvia A. *Ocean: A Global Odyssey*. National Geographic, 2021.

Felt, Hali. *Soundings: The Story of the Remarkable Woman Who Mapped the Ocean Floor*. New York: Henry Holt and Company, 2012.

Ford, Ben, Jessi J. Halligan and Alexis Catsambis, eds. *Our Blue Planet: An Introduction to Maritime and Underwater Archaeology*. Oxford and New York: Oxford University Press, 2020

Gershwin, Lisa-Ann. *Jellyfish: A Natural History*. Brighton, UK: The Ivy Press, 2016.

Hessler, Stefanie, ed. *Tidalectics: Imagining an Oceanic Worldview through Art and Science*. Cambridge, MA: MIT Press, 2018.

Hird, Tom. *Blowfish's Oceanopedia: 291 Extraordinary Things You Didn't Know About the Sea*. London: Atlantic Books, 2017.

Kaplan, Eugene H. *Sensuous Seas: Tales of a Marine Biologist*. Princeton, NJ and Woodstock, Oxfordshire: Princeton University Press, 2006.

King, Richard J. *Ahab's Rolling Sea: A Natural History of Moby-Dick*. Chicago and London: University of Chicago Press, 2019.

Kurlansky, Mark. *Cod: A Biography of the Fish that Changed the World*. London: Penguin Books, 1998. (First published 1997)

Kurlansky, Mark. *The Big Oyster: History on the Half Shell*. New York: Random House, 2006.

The Linnaean Society of London. *L: 50 Objects, Stories and Discoveries from The Linnean Society of London*. London: Linnaean Society of London, 2020.

McCalman, Iain. *The Reef: A Passionate History: The Great Barrier Reef from Captain Cook to Climate Change*. New York: Scientific American / Farrar, Strauss and Giroux, 2013.

Montgomery, Sy. *The Soul of an Octopus: A Surprising Exploration into the Wonder of Consciousness*. New York: Atria, 2015.

Nouvian, Claire. *The Deep: The Extraordinary Creatures of the Abyss*. Chicago: University of Chicago Press, 2007.

Roberts, Callum. *The Unnatural History of the Sea*. Washington DC: Island Press/Shearwater Books, 2007.

Scales, Helen. *The Brilliant Abyss: True Tales of Exploring the Deep Sea, Discovering Hidden Life and Selling the Seabed*. London: Bloomsbury, 2021.

Smithsonian Institution. *Oceanology: The Secrets of the Sea Revealed*. DK Publishing, 2020.

Williams, Wendy. *Kraken: The Curious, Exciting, and Slightly Disturbing Science of Squid*. New York: Abrams Image, 2011.

Index

Publisher's Acknowledgements

A project of this size requires the commitment, advice and expertise of many people. We are particularly indebted to our consultant editor Anne-Marie Melster for her vital contribution to the shaping of this book and her exhaustive knowledge.

Special thanks are due to our international advisory panel for their knowledge, passion and advice in the selection of the works for inclusion:

Doug Allan
Award-winning wildlife and documentary cameraman, Bristol, UK

Noah S. Chesnin
Associate Director, New York Seascape Program, Wildlife Conservation Society

Dr Frances Dipper
Independent marine biologist and author, Cambridge, UK

David Doubilet
Award-winning underwater photographer, New York

Sonia Shechet Epstein
Executive Editor and Associate Curator of Science and Film, Museum of the Moving Image, New York

Sarah Gille
Professor and Department Chair, Scripps Institution of Oceanography, University of California San Diego

Tom 'The Blowfish' Hird
Marine biologist, conservationist, broadcaster and author, UK

Dr Tammy Horton
Research Scientist, National Oceanography Centre, Southampton, UK

Dr Richard King
Author and Visiting Associate Professor, Sea Education Association, Woods Hole, Massachusetts

Professor Dr Carsten Lüter
Curator of Marine Invertebrates, Museum für Naturkunde, Berlin

Anne-Marie Melster
Interdisciplinary Curator, Cofounder and Executive Director, ARTPORT_making waves, Germany

Jon Swanson
Curator of Collections and Exhibitions, Minnesota Marine Art Museum

Dr Charlie Veron
Former Chief Scientist at the Australian Institute of Marine Science, Coral Reef Researcher and Author

We are particularly grateful to Rosie Pickles for researching and compiling the longlist of entries for inclusion. Additional thanks are due to Jenny Faithfull and Jen Veall for their picture research, Tim Cooke for his editorial support and to Caitlin Arnell Argles, Sara Bader, Vanessa Bird, Diane Fortenberry, Simon Hunegs, Rebecca Morrill, João Mota, Anna Macklin, Sarah Massey, Laine Morreau, Maia Murphy, Evie Nicholson, Celia Ongley and Michele Robecchi for their invaluable assistance.

Finally, we would like to thank all the artists, illustrators, photographers, collectors, libraries, institutions and museums who have given us permission to include their images.

Text Credits

The publisher is grateful to Anne-Marie Melster for writing the introduction, Carolyn Fry for writing the timeline and additional thanks go to the following writers for their texts:

Doug Allan: 17, 54, 65, 76, 133, 152–53, 159, 169, 177, 230, 266, 269–70, 281, 328; **Giovanni Aloi:** 12, 19, 25, 39, 56, 68, 80, 82, 91, 94–95, 101, 103, 107, 116, 125, 127, 130, 148, 166, 173, 186, 191, 193, 201, 203, 208, 213, 231–33, 240, 248, 254, 256, 259–60, 277, 294, 300, 313–14, 318, 327; **Sara Bader:** 15, 75, 126, 207, 214, 243, 245, 264, 283; **Tim Cooke:** 16, 28, 30, 35, 37, 47, 48–50, 58, 63–64, 66, 70, 83, 108, 113, 117, 119, 124, 128, 137–39, 141, 147, 150, 157, 160–61, 168, 172, 176, 179, 183, 188, 195, 206, 209, 217, 220, 223, 234–36, 239, 241–42, 246, 257, 278–79, 282, 285, 289, 291, 306, 308, 321, 329, 330–31; **Sonia Shechet Epstein:** 73, 258, 299; **Diane Fortenberry:** 13, 31–32, 40, 59, 77–78, 84, 88, 90, 92–93, 96, 99, 105, 109, 129, 156, 197–99, 202, 226–27, 237, 252, 261–63, 286–87, 290, 301–2, 317, 323; **Carolyn Fry:** 38, 224, 268, 316, 332–39; **Tom Furness:** 14, 23, 45, 52, 61, 69, 86, 100, 110, 112, 178, 182, 189, 204–5, 215, 265, 305, 310, 315; **Helena Gautier:** 81, 229, 267, 271, 288; **Tom Hird:** 140, 210–11; **Elizabeth Kessler:** 43; **Anne-Marie Melster:** 6–9, 24, 42, 55, 85, 111, 121, 132, 171, 228, 249, 312; **David B Miller:** 10; **Rebecca Morrill:** 29, 174; **Ross Piper:** 118, 200; **Dennis P Reinhartz:** 34; **Michele Robecchi:** 27, 154, 170, 221; **James Smith:** 21, 26, 44, 87, 122–23, 135, 158, 180–81, 196, 219, 247, 320; **David Trigg:** 33, 36, 41, 57, 60, 72, 79, 89, 97–98, 104, 106, 131, 144, 149, 155, 162, 164, 175, 190, 192, 212, 238, 253, 255, 272–73, 275, 280, 292, 297, 309, 311, 324, 326; **Martin Walters:** 11, 18, 46, 51, 53, 67, 71, 74, 102, 114–15, 120, 134, 142–43, 145–46, 151, 160, 163, 165, 167, 184–85, 187, 218, 222, 225, 244, 251, 274, 284, 293, 295, 298, 303–4, 307, 319, 322, 325.

Picture Credits

Every reasonable effort has been made to identify owners of copyright. Errors and omissions will be corrected in subsequent editions.

Aarhus | Billeder/Artwork: Johan Gjøde: 180; ACTION MAN® & © 2022 Hasbro, Inc. Used with permission. Photo: Rob Wisdom (actionmanhq. co.uk): 117; © ADAGP, Paris and DACS, London 2022/Private collection: 66; Courtesy Doug Aitken, Parley for the Oceans and MOCA, Los Angeles/photo by Shawn Heinrichs: 158; Doug Allan: 266; Copyright © The Ansel Adams Publishing Rights Trust: 261; adoc-photos/Corbis via Getty Images: 191; © The Aga Khan Museum, AKM167: 105; © Estate of Eileen Agar. All rights reserved 2022/Bridgeman Images/Victoria and Albert Museum, London: 204; agefotostock/Collection: United Archives Cinema Collection/Photographer: United Archives: 61; akg-images: 90, 228; akg-images/Fototeca Gilardi: 116; Alamy Stock Photo/ArcadeImages: 60; Alamy Stock Photo/The Picture Art Collection: 13; Album/Alamy Stock Photo: 88, 207; American Folk Art Museum/Gift of Miriam Troop Zuger in memory of Mary Black, historian, writer, Director of First Museum of Early American folk arts, 1964-1969: 138; © Dhamarrandji Bumbatjiwuy/Copyright Agency. Licensed by DACS 2022/ANMM Collection Purchased with the assistance of Stephen Grant of the GrantPirrie Gallery.: 263; © Billy Missi /Copyright Agency. Licensed by DACS 2022/ANMM Collection: 220; © The Annex Galleries: 72; © Ingo Arndt/naturepl.com: 159; Artefact/Alamy Stock Photo: 131, 335.13; Artmedia/Alamy Stock Photo: 122; © ARS, NY and DACS, London 2022/ Courtesy Joan Jonas and Gladstone Gallery: 24; © Yann Arthus-Bertrand: 331; Image © Ashmolean Museum, University of Oxford/Bridgeman Image: 115, 227; Stefan Auth/imageBROKER/Alamy Stock Photo: 91; © Laurent Ballesta: 119; Subhankar Banerjee: 249; © Franco Banfi/ naturepl.com: 241; Warren Baverstock: 230; © Romare Bearden Foundation/VAGA at ARS, NY and DACS, London 2022. Photo: Courtesy Romare Bearden Foundation: 59; © Daniel Beltrá, Courtesy Catherine Edelman Gallery, Chicago: 155; Bibliothèque nationale de France: 42, 216; Image from the Biodiversity Heritage Library/Contributed by Harvard University, Museum of Comparative Zoology, Ernst Mayr Library: 201, 303, 309, 335.14; Image from the Biodiversity Heritage Library/ Contributed by MBLWHOI Library: 101, 134, 203, 293, 335.18; Image from the Biodiversity Heritage Library/Contributed by NCSU Libraries (archive.org): 254; Image from the Biodiversity Heritage Library/ Contributed by Smithsonian Libraries: 53, 94, 300, 307; Image from the Biodiversity Heritage Library/Contributed by University Library, University of Illinois Urbana Champaign: 30; Image from the Biodiversity Heritage Library/Contributed by University of Toronto, Robarts Library.: 111; BIOSPHOTO/Sergi Garcia Fernandez/Alamy Stock Photo: 325; Sandro Bocci – Julia Set Lab: 63; Theo Bosboom, www.theobosboom.nl: 160; Ana Brecevic/photographer: Pierre Chivoret: 310; Bridgeman Images: 23; Purchased with funds from various donors, by exchange/Bridgeman Images: 199; © British Library Board. All Rights Reserved/Bridgeman Images: 40, 41, 304, 335.15; © Edward Burtynsky, courtesy Flowers Gallery, London/Nicholas Metivier Gallery, Toronto: 173; Rachel Carson/Staples Press, Ltd. Photo: Ian Bavington Jones: 214, 337.21; Photo © Christie's Images/Bridgeman Images: 217; © Georgia O'Keeffe Museum/DACS 2022/Photo © Christie's Images/Bridgeman Images: 248; © 2022. Christie's Images, London/Scala, Florence: 218; © Christo 1983/ © ADAGP, Paris and DACS, London 2022/Photo: Wolfgang Volz: 247; Chronicle/Alamy Stock Photo: 75, 337.20; © Brandon Cole/naturepl.com: 68; © Commonwealth of Australia (Geoscience Australia) 2021: 83; The Cousteau Society: 78; Jem Cresswell: 167; Copyright Matthew Cusick: 37; Steffen Dam is represented by Joanna Bird Contemporary Collections, London: 297; © The Danish Poster Museum in Den Gamle By, Aarhus: 113; Evan Darling: 161; @jasondecairestaylor: 181; © De Morgan Foundation/Bridgeman Images: 33; © 2022. Digital Image Museum Associates /LACMA/Art Resource NY/Scala, Florence: 139; Courtesy Mark Dion and Tanya Bonakdar Gallery, New York/Los Angeles. Photo by Jerry L. Thompson: 299; © Disney: 133; © 2003 Disney/AF archive/Alamy Stock Photo: 311; © Les Documents Cinématographiques/Archives Jean Painlevé: 73; Copyright © Billy Doolan/Photo: Jamie Durrant, Essentials Magazine: 137; Reproduced with the permission of Dorset Fine Arts: 150; © David Doubilet: 17; © Estate of Jarinyanu David Downs, courtesy Mangkaja Arts/Photo: © National Gallery of Australia, Canberra/ Purchased 1989/Bridgeman Images: 289; © Dumbarton Oaks, Pre-Columbian Collection, Washington, DC: 178; DU Photography/Alamy Stock Photo: 237, 332.3; With thanks to the Dutch Puppetry Museum, Vorchten: 28; © Eames Office, LLC. (www.eamesoffice.com) All rights reserved: 238; Gift of Eastman Kodak Company/Bridgeman Images 256; Bernhard Edmaier Photography: 183; Copyright: Filmakademie Baden-Württemberg | Pascal Schelbli: 324; Photo © Fine Art Images/ Bridgeman Images: 27; © Nicolas Floc'h: 291; © Sue Flood/naturepl.com: 152, 339.29; Courtesy Zaria Forman: 280; Fowler Museum at UCLA. Photograph by Don Cole: 317; © Free Library of Philadelphia/Rare Book Department, Free Library of Philadelphia/Bridgeman Images: 288; funkyfood London - Paul Williams/Alamy Stock Photo: 226, 333.4; Galerie Etoz: 283; © Jean Gaumy/Magnum Photos: 186; © Cy Gavin/ Courtesy Cy Gavin and David Zwirner: 171; Photo Christoph Gerigk © Franck Goddio/Hilti Foundation: 321, 333.6; Mitchell Gilmore: 20; Glenna Gordon: 84; Granger Historical Picture Archive/Alamy Stock Photo: 274; David Gruber and John Sparks: 164; © Andreas Gursky/ Courtesy Sprüth Magers Berlin London/DACS 2022: 12; © Colton Hash - www.coltonhash.com: 106; © David Hall/seaphotos.com: 206; © Howard Hall/Blue Planet Archive: 322; © Maggi Hambling/Bridgeman Images/ Tim Graham via Getty Images: 244; Scott Harrison – Daily Salt: 15; Jorge Hauser: 271; Heidelberg University Library: 318; Heritage Image Partnership Ltd/Historica Graphica Collection/Alamy Stock Photo: 273; © Hermès, Paris, 2022: 52; © Richard Herrmann/naturepl.com: 157; © Damien Hirst and Science Ltd. All rights reserved, DACS/Artimage 2022. Photo: Prudence Cuming Associates Ltd: 221; Historical Museum of Crete, Ethnographic Collection © Society of Cretan Historical Studies: 197; © David Hockney: 156; © Justin Hofman: 175; Peter Horree/Alamy Stock Photo: 92; © Esther Horvath: 39; Houghton Library, Harvard University, Cambridge, Mass.: 96; Wade Hughes FRGS, Image made under permit issued by Kingdom of Tonga: 270; © Humboldt Innovation, Berlin/© Humboldt-Universitaet zu Berlin/Bridgeman Images: 298; Frank Hurley/Royal Geographical Society via Getty Images: 38, 336.19; Sayaka Ichinoseki, Website: ocean-traveler.net, Instagram and Twitter: @sayaka_ici_uw: 210; © AKI INOMATA, Courtesy Maho Kubota Gallery: 231; Karim Iliya: irisphoto18/123RF.COM: 330; © Jean Jullien for Surfer Magazine: 153; Library of Congress, Geography and Map Division/painted by Atelier H.C. Berann/Lans'/Tirol: 10, 337.22; Library of Congress, LC-DIG-ds-04508: 190, 336.17; Library of Congress, LC-DIG-ppmsca-28723: 253; Permission of the Linnean Society of London: 316; © Ole Jørgen Liodden/ naturepl.com: 269; © Bryan Lowry/Blue Planet Archive: 313; ManBd, Malaysia: 209; Photo by Fosco Maraini/Gabinetto Vieusseux Property © Alinari Archives: 255; Marine Biological Services Archives. CC BY-NC Still Image: 'Leuckart Chart, Series 1, Chart 1: Coelenterata; Anthozoa: Octatinaria, Corallium rubrum', 2011-11-30, https://hdl.handle. net/1912/16055: 306; The Mariner's Museum and Park: 192; © Kerry James Marshall/Courtesy Kerry James Marshall and Jack Shainman Gallery, New York: 85; By Courtney Mattison (b. 1985): 149; © Steve McCurry/Magnum Photos: 187; The Metropolitan Museum of Art, New York/Amelia P. Lazarus Fund, 1910: 182; Image copyright The Metropolitan Museum of Art/Art Resource/Scala, Florence: 87; The Metropolitan Museum of Art, New York/H.O. Havemeyer Collection, Bequest of Mrs. H.O. Havemeyer, 1929: 127; The Metropolitan Museum of Art, New York/Rogers Fund: 305; The Metropolitan Museum of Art, New York/The Jefferson R. Burdick Collection, Gift of Jefferson R. Burdick: 142; The Metropolitan Museum of Art/Gift of A. Hyatt Mayor, 1976: 193; The Metropolitan Museum of Art/Gift of Christen Sveaas, in Celebration of the Museum's 150th Anniversary, 2019: 130; The Metropolitan Museum of Art/Gift of Margaret B. Zorach, 1980: 262, 333.7; The Metropolitan Museum of Art/Gift of Mr. and Mrs. Erving Wolf, in memory of Diane R. Wolf, 1977: 205; The Metropolitan Museum of Art/ Purchase, Joseph Pulitzer Bequest, 1933: 287; The Metropolitan Museum of Art/Purchase, Louise Eldridge McBurney Gift, 1953: 301, 333.5; The Metropolitan Museum of Art/Purchase, Mary and James G. Wallach Foundation Gift, 2013: 128; Photograph by Susan Middleton © 2014: 46; Photo: © Minneapolis Institute of Arts, MN, USA/Bridgeman Images: 143; Courtesy Mission Blue/Sylvia Earle Alliance: 77, 338.26; MIT Museum: 112; Cristina Mittermeier/SeaLegacy: 140; Gift of Mobilia Gallery in memory of the artist's father. Museum no.: 2016.87. Boston, Museum of Fine Arts. © 2022. Museum of Fine Arts, Boston. All rights reserved/Scala, Florence: 69; Bruce Morser/Hiram Henriquez/National Geographic: 11; Copyright 1971–1973 Edward Mpata/National Museum of African Art, Smithsonian Institution/Gift of Ambassador and Mrs. W. Beverly Carter, Jr.: 172; © Juan Carlos Muñoz/naturepl.com: 48; © Dhambit Munungurr, courtesy Salon Indigenous Art Projects, Darwin/National Gallery of Victoria, Melbourne. Commissioned by the National Gallery of Victoria, Melbourne Purchased with funds supported by the Orloff Family Charitable Trust, 2020: 55; Museum of Applied Arts & Sciences/Gift of C M Petrie, 1998; transferred from National Textile Museum of Australia, 2008: 290; Museum of Fine Arts, Boston/ Fenollosa-Weld Collection: 251; © 2022. Museum of Fine Arts Boston/ Henry Lillie Pierce Fund. Inv. 99.22. All rights reserved/Scala, Florence: 29; © 2022. Museum of Fine Arts, Boston. All rights reserved/Scala, Florence: 202, 334.9; © 2022. Museum of Fine Arts, Boston/Gift of John D. Constable. Museum no.: 2002.761/All rights reserved/Scala, Florence: 235; © Alex Mustard/naturepl.com: 151; © Mystic Seaport Museum, 1959.1129: 188; Nantucket Historical Association, Gift of Dr. and Mrs. William Gardner: 243; © Yoshitomo Nara: 49; NASA: 64; NASA/GSFC/Jeff Schmaltz/MODIS Land Rapid Response Team: 82; NASA/MSFC: 43; NASA/SVS: 35; Photo: Nasjonalmuseet, Oslo/Larsen, Frode: 93; National Gallery of Victoria, Melbourne, Gift from The L. W. Thompson Collection, 2003. This digital record has been made available on NGV Collection Online through the generous support of Digitization Champion Ms Carol Grigor through Metal Manufactures Limited.: 71; © National Maritime Museum, Greenwich, London: 145; © National Museum of Wales: 19; © Natural History Museum, London/Bridgeman Images: 110; Natural History Museum of Milan, Giorgio Bardelli: 148; Netflix/Craig Foster, Sea Change Project: 47; The New York Public Library, Spencer Collection: 258; © Flip Nicklin/naturepl.com: 50; Niedersächsische Staats- und Universitätsbibliothek Göttingen: 132; NOAA Central Library Historical Collection: 109; Image Courtesy NOAA Office of Ocean Exploration and Research, 2016 Deepwater Exploration of the Marianas: 81, 339.28; © NRF-SAIAB: 200; Ntombephi Ntobela © Ubuhle International: 170; © Lindsay Olson: 168; © Catherine Opie, Courtesy Regen Projects, Los Angeles and Lehmann Maupin, New York, Hong Kong, London, and Seoul: 125; © Julian Opie, courtesy Alan Cristea Gallery 2020: 176; Gift of Jennifer Orange, 1995. CC BY-NC-ND 4.0. Te Papa (FE010482): 315; Courtesy Ran Ortner: 277; Kelsey Oseid: 267; © Pete Oxford/naturepl.com: 285; Octavio Passos via Getty Images: 278, 339.31; Panteek.com: 70; Roger Payne/Capitol Records/Courtesy Ocean Alliance: 169, 337.23; © Doug Perrine/Blue Planet Archive: 65; Marcus Pfister/NordSüd Verlag AG: 177; © 2022. Photo Scala, Florence: 232; © 2022. Photo Scala, Florence/bpk, Bildagentur fuer Kunst, Kultur und Geschichte, Berlin: 195; © 2022. Photo Scala, Florence/bpk, Bildagentur für Kunst, Kultur und Geschichte, Berlin/Photo: Jörg P. Anders: 44, 334.10; © 2022. Photo Scala, Florence/Courtesy the Ministero Beni e Att. Culturali e del Turismo: 25, 334.11; The Picture Art Collection/Alamy Stock Photo: 114; © Huang Yong Ping/© ADAGP, Paris and DACS, London 2022/Courtesy Huang Yong Ping and kamel mennour, Paris/Photo: © Emmanuel LE GUELLEC: 97; Rights Courtesy Plattsburg State Art Museum, State University of New York, USA, Rockwell Kent Collection, Bequest of Sally Kent Gorton. All rights reserved: 265; Scott Portelli, wildlife, nature and underwater photographer: 295; Portland Art Museum, Portland, Oregon, 54.5. Acquired by exchange of objects from the Indian Collection Subscription Fund: 45; Courtesy Paula do Prado. Image by Document Photography: 246; Public domain: 21, 189, 323; © Audun Rikardsen: 16; Image Courtesy Duke Riley Studio: 264; © Succession H. Matisse/DACS 2022/Photo © 2022 RMN-Grand Palais/Dist./Photographer: Jacqueline Hyde. Photo Scala, Florence: 219; © NNtonio Rod: 240; Rosenthal meets Versace: 329; David Rumsey Map Collection, David Rumsey Map Center, Stanford Libraries: 108, 336.16; © Sebastião Salgado/nbpictures.com: 129; Scala, Florence/© 2021. Album: 120; © Succession Yves Klein/Courtesy of ADAGP, Paris and DACS, London 2022/Scala, Florence/© 2022. Christie's Images, London: 56; Scala, Florence/Gift of the Estate of William R. Current: © 2021. Museum of Fine Arts, Boston. All rights reserved: 260; Scala, Florence/© 2021. Digital Image Museum Associates/LACMA/Art Resource NY: 104; Scala, Florence/© 1988, Larry Fuente. © 2021. Photo Smithsonian American Art Museum/Art Resource: 223; © Center for Creative Photography, The University of Arizona Foundation/DACS 2022/Scala, Florence/The Lane Collection. © 2021. Museum of Fine Arts, Boston. All rights reserved: 259; © Estate of Roy Lichtenstein/DACS 2022/Scala, Florence/The Roy Lichtenstein Study Collection, gift of the Roy Lichtenstein Foundation. Inv.: 2019.83. New York, Whitney Museum of American Art. © 2021. Digital image Whitney Museum of American Art/DACS 2022: 57; Scala, Florence/Purchase, The Martin Foundation Inc. Gift, 1967/The Metropolitan Museum of Art. © 2021. All rights reserved/© ARS, NY and DACS, London 2022: 86; Scala, Florence/© 2021. Image copyright The Metropolitan Museum of Art/Art Resource: 275; Scala, Florence/Photo © Smithsonian Institution. New York, Cooper-Hewitt - Smithsonian Design Museum. © 2021. Cooper-Hewitt, Smithsonian Design Museum/Art Resource, NY: 242; Scala, Florence/ Photographer: David Soyer. Mulhouse, Le Musée de l'Impression sur Etoffes. © 2021. RMN-Grand Palais: 146; Scala, Florence/William Sturgis Bigelow Collection and Denman Waldo Ross. Museum. © 2021. Museum of Fine Arts, Boston. All rights reserved: 257; Photo Courtesy Schmidt Ocean Institute: 292, 338.25; © Dana Schutz. Courtesy Dana Schutz, David Zwirner and Thomas Dane Gallery: 121; Science History Images/ Alamy Stock Photo: 165; Science Photo Library/Alexander Semenov: 294; Science Photo Library/Eye of Science: 284; Science Photo Library/Masato Hattori: 225, 332.1; Science Photo Library/Natural History Museum, London: 51, 95, 103, 224, 332.2, 314; Science Photo Library/Oxford Science Archive: 100; © Peter Scoones/naturepl.com: 328; Scott Polar Research Institute, University of Cambridge, with permission: 268; © Keith Shackleton/Courtesy Rountree Tryon Galleries: 272; Shawshots/Alamy Stock Photo: 308, 338.24; Igor Siwanowicz: 163; Brian Skerry: 184; Smithsonian Institution Archives, Acc. 12-492, Image No. SIA2012-6538: 166; © Smoking Dogs Films, All Rights Reserved, DACS 2022/Courtesy Smoking Dogs Films and Lisson Gallery: 174; Courtesy Snøhetta/Photo © Ivar Kvaal: 123; © Salvador Dali, Fundació Gala-Salvador Dalí, DACS 2022/Photograph Courtesy Sotheby's, Inc. © 2014: 14; SOUP: Tomato – Photograph © Mandy Barker: 144; © Henley Spiers: 67; Photograph © The State Hermitage Museum/photo by Svetlana Suetova: 286; M. Stock - wattenmeerbilder.de: 312; Stock Connection Blue/Photographer: Arthur Ruffino/Alamy Stock Photo: 236; Studio Ghibli/Nippon Television Network Corporation (NTV)/Album/Alamy Stock Photo: 211; William Sturgis Bigelow Collection. Museum no.: 11.44635. Boston, Museum of Fine Arts. © 2022. Museum of Fine Arts, Boston. All rights reserved/ Scala, Florence: 102; Copyright Hiroshi Sugimoto/Courtesy Hiroshi Sugimoto and Marian Goodman Gallery: 126; Adam P. Summers: 162; Rachael Talibart, rachaeltalibart.com: 89; Translated from the English language edition © Tiny Owl Publishing Ltd 2015, based on an original work first published in Iran, text and illustrations copyright © Nazaar Publications 2012: 141; © The Trustees of the British Museum: 31, 99, 319; Twentieth Century Fox/Photofest: 279; Copyright UBG. University of Groningen Library, Special Collections: 234; United Plankton Pictures/ Nickelodeon/Photo12/Alamy Stock Photo: 326; Universal Music/Capitol Records, LLC: 124; © 1975 Universal Pictures. Courtesy Universal Studios Licensing LLC: 118; University of Minnesota Libraries, James Ford Bell Library: 302, 335.12; Courtesy the University of St Andrews Libraries and Museums, ms 32(0): 198; University of Victoria Legacy Art Galleries, Gift from the Collection of George and Christiane Smyth. Courtesy the Estate of Eugene Hunt: 282; © Masa Ushioda/Blue Planet Archive: 54; V&A Images/Alamy Stock Photo: 135; Iris Van Herpen. Courtesy Patricia Kahn: 58; Bruno Van Saen (BE): 80; Copyright Verdura: 147; © Victoria and Albert Museum, London: 233, 239; Walters Art Museum: 32; © Frederick Warne & Co., 1962. Photo: Ian Bavington Jones: 245; Christine and Margaret Wertheim and the Institute for Figuring. Pod World - Hyperbolic at the 2019 Venice Biennale. Photo courtesy 58th International Art Exhibition - La Biennale di Venezia, May You Live in Interesting Times, by Francesco Galli.: 327; Wikimedia Commons: 196, 212; Wikimedia Commons. CC-PD-Mark: 76; Wikioo.org – The Encyclopedia of Fine Arts: 213; © Wildlife Conservation Society. Reproduced by permission of the WCS Archives: 74; © Tony Wu/naturepl.com: 185; Tan Zi Xi, Multimedia artist: 154, 339.30; © Solvin Zankl/naturepl.com: 18.